THE

ECCLESIOLOGIST

PUBLISHED BY THE CAMBRIDGE CAMDEN SOCIETY

"Donec templa refeceris"

SECOND EDITION

VOLUME I

CAMBRIDGE STEVENSON

RIVINGTONS LONDON PARKER OXFORD

MDCCCXLIII

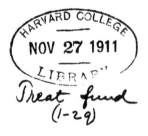
CAMBRIDGE:
PRINTED BY METCALFE AND PALMER, TRINITY-STREET.

TO THE READER.

I AM as much surprised as you can be at the speed with which I have got through my task, and the early moment at which I present myself with my promised volume in my hands. But I do not suppose you will be offended at so unusual a fault, if it be one, as that of exceeding a duty whose object is the service of the Church. The days upon which she has fallen— not that they are evil days, but, if rightly improved, the contrary —will not brook the loss of an hour, or the risk of an opportunity. Questions must be answered when they are put, or the asker loses all interest in the answer: a step gained must be forthwith recorded, or those who are advancing know not that they may safely go on to a new position; and erroneous church-building must be exposed while there is yet time to retrace false steps, or we only irritate self-love instead of suggesting a useful and a welcome warning: and these considerations, some of which weigh with every Editor of a periodical, are especially impera- tive on one whose business it is to stay mischief actually in progress, and stir up public attention to essential but obsolete

principles and views; and so I have felt like a servant sent
from one end of town to the other in a time of panic, and have
not been over careful to observe the strict directions I received
to reach S. Martin's, S. Clement's, and S. Paul's, at such and
such minutes of the clock respectively; but have looked steadily
before me to catch every open space and every little opportu-
nity, bolting past the cross streets while the throng was waiting
for a waggon to emerge, slipping into each vacancy in the stream
of passers-by made by the salutation of two friends or the idle
curiosity of a diverging shop-gazer: and so here I am at last in
S. Paul's church yard from Waterloo Place, in one-third less
time than I was allowed to perform the journey, with a
goodly volume completed for Messrs. Rivington to publish,
relieved from any obligation to go on, and at liberty to start,
like every other Cambridge man, to visit the Rhine or the
Pyramids in the long vacation. And, if, in this haste to do
my work and satisfy my masters, I have made some mistakes
and got into some difficulties, have run my shoulder against a
baker's basket or a chimney-sweeper's bag, or trodden on the
toes of a gouty gentleman, only just stopping for an instant to
assure him very earnestly how sorry I was, and very sincerely
that I did not intend it; I hope this will be forgiven, at least
by my employers, for the sake of the important errand upon
which I was sent, and the general zeal and fidelity which made
me more concerned about delivering it correctly and in time,
than about the manner of conveying it.

I fear the tone in which I write now will furnish but a poor
apology for that which perhaps has sometimes given offence on
former occasions; but allowance will, I hope, be made for that
wish to do my work in good humour, and without a thought of
malice or ill-will, to which, if I know myself, it is to be assigned.
I have undertaken to point out defects in church-building, and

infringements of religious reverence or ecclesiastical propriety, with the object of putting a timely stop to errors which, if unchecked, would probably multiply, and with the full disposition to attribute them to an inconsiderate following of custom, and the long disuse of an adequate study of sound principles and right morals. And if I have succeeded in compelling a better attention to these matters, I will in the same good humour sub_mit to any imputations of self-trust and conceit, which it was not unnatural for persons to charge upon me, who could not conceive in their minds the deep and earnest feelings excited by the anomalies against which I have protested, and for which a worthier excuse will be found by those who could.

This patience of mine has, as usual, brought its own reward: and after labouring on for some time through a good deal more of evil than of good report, I find myself at last, and in an incredibly short time, surrounded not only by approvers and favourers, but by coadjutors, whose authority in the several departments of my undertaking at once gives an indubitable sanction to what I have done already, and the best promise of success in what, with their assistance, yet remains to be done.

To them particularly, as well as to our readers in general, I return my hearty acknowledgments: to such as have doubted or decried me, I respectfully submit the request to consider the argument derived from success, and to ask whether views promulgated against so many disadvantages and so much opposition, and nevertheless so gradually but surely winning sympathy and support, every day more and more influential and authoritative, may not have in them more of truth, and less that is to be distrusted and discountenanced, than at first appeared: and to the public in general I give, what under such circumstances is scarcely necessary, my hearty assurance that I shall not cease to

carry on the same endeavour so long as any thing remains to be done; with a sincere disposition to submit to admonition and to take advice, and an earnest desire to avoid giving offence by my criticisms or animadversions.

C. C. S.

INDEX OF SUBJECTS.

	Page
Abington, Great, church of	172
Acton church	102
Adel church, Yorkshire	204
Alexandria, designs for church at, furnished by the C. C. S.	54, 180
ALTAR, the term why used	30, 52
Desecration of	176
Mede's remarks on reverence due to	177
Rails	59
Alwalton church, restored	83
Amberley church	173
Andover new church	210
Anglo-Saxon remains	165, 167, 190
Archdeaconries of Bristol and Chichester, circular addressed to by the C. C. S.	74
ARCHITECTURE,	
Cathedral and parish church, difference between	181
Knowledge of, how to obtain	87
Military	123
Modern church, Hints on	133
Ardingley church	13
Argyleshire, Ecclesiology of	56, 74
Arley Park, new church at	141
Artificial stone, fonts of, condemned	127
Aston Cantelow, new church at,	113, 180
Bakewell church	103
Baptisteries at Luton and Trunch	126
Barlavington church	172
Barmouth chapel	101
Barrington church	62
Barry, C. Esq., his letter on S. Stephen's chapel	117
Bath Abbey church, notice of pues in	146
Bells, consecration of	74
inscriptions on	147
Bermondsey, church desecration	211
Bethnal Green—new churches at	
S. Andrew's	195
S. James the Great	195
S. James the Less	196
Bignor church	172
Birmingham, S. Mark	56
Bishopstone church	32
Blackheath, Holy Trinity	141
Blatchington church	172
Bletchingley church, singular recess in	210
Blindley Heath, new church at	179
Bocking church	102
Bourn church, roof of	72
Bradninch church restored	18
Braithwaite, Mr., his method of wood-stamping	137, 210
Brasses, Monumental,—	
Illustrations of	13, 31, 130
Paper by Mr. Addington on	160
Stolen	116
Bretteville church	101
Bridgewater, new church at	59
Lettern at	174
Bristol, eagles at	174
Brookfield, new church	11, 19, 59
Burlington Quay, new church	56
Burstow church, singular recess in	210
Bury S. Edmund's—	
Eagle at	174
New church at	20
Byland Abbey	211
Byzantine Architecture	121
Cam new church	197
Cambridge—	
S. Andrew's, remarks on the old church	67
—— new church	187
S. Botolph's church restored	143, 211, 212
S. Edward's font restored, 74, 120, 202	
S. Mary the Great	131, 209
—— Hints for restoration of	164
S. Michael's, supposed confessional at	207
S. Peter's new church	51, 67, 81
S. Paul's new church	9
S. Sepulchre's, restoration of	5, 22, 29, 43, 51, 115, 143, 203
Christ's College, eagle at	175
S. John's College, eagle at	143, 174
CAMBRIDGE CAMDEN SOCIETY:	
21st meeting of	6
22nd	22
23rd	22
24th	53
25th	73
26th	119
27th	135
Brief account of	15
Circular letter to Archdeaconries of Bristol and Chichester	74
Committee of, Remonstrance addressed to	25
—— Answer of, to	26

	Page
CAMBRIDGE CAMDEN SOCIETY—*continued*	
Co-operation with, Suggestions for,	17, 87
Field-day of	61
Laws, alterations in	8
Subscriptions to	16
Statement of Accounts	28
Castle Rising, Anglo-Saxon church at	167
Cathedrals, difference between and Parish Churches	181
Cement, objections to	209
CHANCEL,	
Definition of	44
Proportions of	111
Screens	59
Chancery Lane, new church in	197
Channel Islands, church desecration in	204
Cherryhinton, Chancel of	71
Chesterton church, repairs of	112, 132
—— Poppy-heads	29
Chichester, Circular letter to the Archdeaconry of	74
Cathedral, repairs of	164, 211
Chiltington, West, church	172
Choir, seats for	59
CHURCH—see *Desecration, Restoration.*	
CHURCHES, NEW:	
Alexandria	180
Andover	210
Arley Park	141
Aston Cantelow	113, 180
Bethnal Green—	
S. Andrew	195
S. James the Great	195
S. James the Less	196
Birmingham, S. Mark	56
Blackheath, Holy Trinity	141
Blindley Heath	179
Bridgewater	59
Brookfield, Kentish Town	11, 19
Burlington Quay	56
Bury S. Edmund's	20
Cam	197
Camberwell	68
Cambridge—	
S. Andrew's	187
S. Paul's	9
S. Peter's	51, 67, 81
Chancery Lane	197
Crockham Hill	198
East Grafton	81
Eastover	179
Enfield, S. James	210
Farncombe, S. John	197
Finsbury, S. Paul's	113
Fradley	58
Friar's Mount, Shoreditch	200
Grafton, East	81
Hackney Road, S. Peter's	196
Ham	198

	Page
CHURCHES, NEW—*continued.*	
Hanwell	56
Hartshill	58
Hook, Kingston	141
Islington, S. Peter's	197
Kingston, Hook	141
Kingston-on-Thames	56
Llangorwen	47
Llantillio	4
Mile End, S. Bartholomew	198
Northampton—	
S. Andrew's	198
S. Catharine's	198
Poplar, Holy Trinity	20
Radipole	199
Roehampton	48, 81
Rugby	12
Shaftesbury	56
Shoreditch, Friar's Mount	200
Southwark—	
S. Mary's	20
S. Peter's	112
S. Saviour's	111
Spitalfields, All Saints	195
Stepney, S. Thomas	141
Streatham	20
Turnham Green	56
Westminster, S. Margaret	141
Wimbledon	56
Woking	56
Worthing	82, 148, 210
Wrotham	82
Zeals	56
Church Enlargement	107
Clymping church	18
Coates church	172
Competition in Architecture, evils of,	69, 85
Compton church, desecration of	208
Confessionals	206
Co-operation with the C.C.S., Hints for	17, 37
Corbel-heads, notice of	147
Cothelstone Font	126
Coton Spire injured	202
Cotterstock church	19
Coventry, Trinity ch., brass eagle at	174
Coutances, Black Book of	29
Crockham Hill, new church at	198
Crypt at Warrington church	175
Daglingworth church	167
Daix church, near Dijon	99
Dean, W., church	172
DESECRATION, CHURCH:	
Bermondsey, S. James	211
Channel Islands	204
Compton, Surrey	208
Ely Chapel, London	208
Southwark, S. Saviour's	146
Upton	101
Wensley Font	211
Witton, Hunts.	129

	Page
Ditton, Fen, Chancel of	72
Down and Connor Architectural Society	180
Durham Cathedral	101
Eagle desks and letterns	143, 173
East church	102
East Grafton, new church at	81
Eastover, new church at	179
ECCLESIOLOGIST:	
Design of the	1
Orthography of	78
Elford, restoration at	48
Elmham, South, Saxon remains at	165
Ely Chapel	208
Encaustic tiles	39
Enfield S. James, new church	210
Enlargement of churches	107
Exeter Diocesan Society, 9, 18, 178, 208	
Exminster, church restoration at	178
Farncombe, S. John's new church	197
Fen Ditton, Chancel of	72
Finedon church	182
Finsbury, S. Paul's new church	113
Flixton, Anglo-Saxon remains at,	166
FONT:	
Artificial stone condemned	127
Inscription for a desecrated	32
——— translations of	84, 116
Legend on Keysoe	124
Fountains' Abbey	101
Foxton church	68
Fradley new church	58
Freemasonry revived	169
French, Mr. his Altar-cloths 53, 84, 209	
Friar's Mount, Shoreditch, new church at	200
Galilee, western	182
George's, S., Romanist church	194
Gilling-castle, painted glass at	139
Gillingham church	102
Glass—see Stained Glass.	
Grafton, East, new church	81
Grantchester church	73, 104
Greenstead church, restored	143
Guernsey, consecration of churches in	29
Guildford, S. Nicholas, new reredos in	48
Hackney Road, new church in	196
Ham new church	198
Hanham, new Eagle at	211
Hanover Square, S. George's church, painted glass in	66
Hanwell new church	56
Hardham church	172
Harlton, reredos of	25
Hartshill new church	58
Hasely, Great, church restored	13
Heraldry, Ancient	138
Hereford Cathedral	50
Hook, Kingston, new church at	141
Houghton church	173
Iffley church restored	13
	Page
---	---
Incorporated Society for Building Churches and Chapels, alteration in its Rules	51, 147, 152
Petition to	157
Iona Crosses	55
Islington, S. Peter's new church	197
Ivy, whether to be permitted on church walls	147
Jevington church	173
Keysoe Font, legend on	120, 124
Kingrule church	172
King's college, lettern at	173
Old gateway	134
Kingston-on-Thames, new church at	56
Ladbrook church restored	115
Lancets, western triplets of	170
Leicester, S. Margaret's church, repairs of	83
S. Mary's church, repairs of	115
Letterns, notice of	173
Leulingen church, Picardy	188
Lichfield Architectural Society	9
Lismore Cathedral	55
Llangorwen, new church	47
Llantillio, new church	8
Lucy-le-bois church	105
Lustleigh church	208
Luke, S., Old-street	114
Luton church, baptistery in	126
Lyndewood on Fonts	127
Malden, ruined Chapel at	64
Marden, East, church	172
Mede, on reverence due to Altars	177
Meldreth church	22, 63
Merston church	172
Meysey Hampton church restored	143
Mile End, S. Bartholomew, new church	194
Military Architecture	123
Models, ancient working, study of recommended	169
Monksilver, wooden Eagle at	174
Monkton Farleigh Priory	24, 29
Monuments, Museum of, proposed	175
Mount Bures' church	101
NEW CHURCHES—see CHURCHES, NEW	
Nomenclature of Architectural styles	192
Northampton, new churches of S. Andrew and S. Catharine, at	198
Northborough church	103
Open-seats versus Pues	145, 170
Orientation	132
Ottery S. Mary, illustrations of	18
Over church, Chancel of	72
OXFORD ARCHITECTURAL SOCIETY:	
Meetings of	110, 122, 160
Mr. Rickman's drawings purchased by	123
Painted Glass—see Stained Glass.	
Perigueux, S. Front, Cathedral of	121
Peterborough Cathedral, Eagle in	210
Pews—see Pues.	

	Page
Piscinæ . . .	126
Plantagenet style .	168, 192
Poplar, new church at .	20
Pues, History of .	22
Loss of accommodation from .	29
Open-seats *versus* .	145, 170
Orthography of word .	80
Purton church . .	101
Radipole, new church at .	199
Ramsey Abbey, Lettern at .	174
Raskelf church, Painted Glass at	140
Red-Cross Shield, Inscription on	50
.. Translation of	131
Reed, Mr. his patent Tiles .	212
RESTORATION, CHURCH :	
Alwalton . .	83
Bradninch . .	18
Cambridge—	
S. Botolph .	143, 211, 212
S. Edward's Font .	74, 202
S. Sepulchre .	5, 22, 29, 43, 51,
	115, 143, 203
Chesterton .	112, 132
Chichester Cathedral .	211
Coton Spire .	202
Elford . .	48
Exminster .	178
Greenstead .	143
Hasely, Great .	13
Hereford Cathedral .	50
Iffley . .	13
Ladbrook .	115
Leicester, S. Margaret's .	83
S. Mary's .	115
Meldreth .	22
Meysey Hampton .	143
Sampford Brett .	114
Scraptoft Font .	179
Shoreham, Old .	12
Stafford, S. Mary	64, 180
Stamford, S. Mary .	202
Steeple Aston .	111
Stourbridge, S. Mary	206
Swaffham Bulbeck .	143
Teddington .	202
Temple church .	41, 126
Wareham .	202
Yarmouth .	201
York Minster .	51, 200
Rickman, Mr., Drawings by, pur-	
chased by Oxford Arch. Soc. .	123
Ringshall church, corbel-heads at	147
Rochester castle .	193
Roehampton, new church at .	48, 81
Romanesque Architecture — Mr.	
Sharpe's paper on .	121
Modern, objections to .	161
Rood-screens, Early-English .	198
Roofs, wooden or *foliated* .	8
High-pitched . .	71
Rose window, proposed for west front	
of Chichester cathedral .	211

	Page
Round Towers of Ireland .	22
Royston, subterranean chapel at	64, 84
Rugby new church . .	12
Ryhall church, supposed confessional	
in . .	207
Salisbury Diocesan Association .	45
Sall church, ruinous state of .	116
Sampford Brett church, repairs of	114
Scott, G. G. Esq., churches by .	56
Scotland and Scotch architecture 60, 89,	
	109
Scraptoft Font . .	128, 179
Sepulchre, Church of the Holy, re-	
storation of, . 5, 22, 29, 43, 51, 115, \	
	143, 203
Shaftesbury, new church at .	56
Sharpe, E. Esq., his paper on Ro-	
manesque and Byzantine archi-	
tecture, . .	121
Early-English church by .	21
Shoreditch, Friar's Mount, new church	
at . . .	200
Shoreham, Old, church restored .	12
Singleton church . .	172
Sketch, an imaginary .	76
Sketchers, Hints to .	105
Snettisham church, Galilee at .	182
Southampton, eagle-desks at .	174
Southwark, new churches in—	
S. Mary's . .	20
S. Peter's . .	112
S. Saviour's .	111, 146
Southwick church, singular recess in	210
Spitalfields, All Saints, new church	195
Stafford, S. Mary's church, restored	
	64, 180
Stained glass . .	189
———— Foreign .	207
Stalls for Choir, position of .	51
Stamford, S. Mary's church, repairs	
of . .	202
Stanton, Fen, east window .	31
Stedham church .	173
Steeple Aston church, repairs of	111
S. Stephen's chapel .	117, 183
Stepney, S. Thomas, new church	141
Stourbridge chapel .	206
Streatham new church .	20, 97
Styles, Architectural, nomenclature	
of . .	192
Swaffham Bulbeck church restored	142
Teddington church .	202
Temple church .	41, 126
Thakeham church .	172
Than church . .	31
Thorney church .	172
Tiles, encaustic .	39
Tiles, Reed's patent .	212
Trumpington church .	72
Supposed confessional in	207
Trunch church, baptistery at .	126
Turnham Green, new church at	26

	Page		Page
Upton church, Bucks,	101	Witton church desecrated	129
Waltham Cold, and Up, churches of	172	Woking, new church at	56
Wanborough church	101	Wood seats	128, 145
Wareham church, repair of	202	Proportions of	108
Warrington church, crypt at	175	Worthing, new church at	82, 148, 210
Wells cathedral, lettern at	173	Wrotham, new church at	82
Wensley Font, desecrated	211	Yarmouth church, repairs of	201
Westminster, S. Margaret's, new		York Minster, restoration of	51, 200
church at	141	Painted glass at	191
Whittlesford, wood-seats at	22, 25	S. Mary Bishop's Hill Junior, an	
Wiggenhall S. Mary, stained glass		Anglo-Saxon church	190
at	139	Zealand, New, design for parish	
Williment,Mr,his stained glass	66,83,203	churches in, by the C. C. S.	4, 31, 51
Wimbledon, new church at	56	Zeals, new church at	56
Wittering, West, church	172		

INDEX TO REVIEWS.

	Page		Page
Barr's Church Architecture	48	Medley's Remarks on Church Ar-	
Churches and Church Services	204	chitecture	15
Churches of Yorkshire	205	Milford Malvoisin	49
Examples of Gothic Tiles	39	Petit's Church Architecture	91
Honour of the Sanctuary	49	Poole's Appropriate Character of	
Lincolnshire churches, in the Hol-		Church Architecture	125
land district	67	Westminster Abbey, Hand-Book to	157
Markland's Sepulchral Memorials	43	Winkles' Cathedrals	15

INDEX TO SIGNATURES.

	Page		Page
Admirer and Well-wisher	45	Howson, J. S.	61, 91, 109
Aetophilus	173	Jebb, John	172
Airy, Rev. W.	125	Member, A	130, 192, 206
Anglicanus	161	Pues,Writer of the History of,	81, 146
Barry, Charles	118	Salvin, A.	168
Camdenian, A	73	Suckling, Alfred	166, 190
Cathedralis	129	Τὰ ἀρχαῖα ἔθη κρατείτω	132, 164
C. F. P.	83, 147	Viator	146
Clericus	145	W. B.	59
Conservative, An Architectural	186	W. S.	32
Δημότης	207	Well-wisher and Admirer	45
E. A. F.	168	Wyatt, T. H.	46
Etymologus	78	✠	50
γ	120		
Hope, A. J. B.	193	✠ G	110, 175

THE

ECCLESIOLOGIST.

PUBLISHED BY THE CAMBRIDGE CAMDEN SOCIETY.

"*Donec templa refereris.*"

No. I. NOVEMBER, 1841.

ADDRESS.

THE principal design of the present periodical is to furnish such members of the Cambridge Camden Society as may reside at a distance from the University, with the information which they have a right to expect, but at present cannot easily obtain unless at long intervals and from uncertain sources, respecting its proceedings, researches, publications, meetings, grants of money, and election of members. The want of such information, which virtually excludes many zealous members of the Society from co-operating as effectively as they are desirous to do, and the manifest impossibility of regularly supplying it by means of written correspondence to nearly five hundred individuals dispersed over all parts of the kingdom, has rendered the publication of such a periodical as the present an advisable, if not a necessary, expedient. THE ECCLESIOLOGIST is therefore, strictly speaking, a periodical report of the Society, primarily addressed to, and intended for the use of, the members of that body. But it is contemplated at the same time to conduct the publication in such a manner that its pages may convey both interesting and useful information to all connected with or in any way engaged in church-building, or the study of ecclesiastical architecture and antiquities. It is intended to give with each number, among other matters pertaining to Ecclesiology in general, critical notices of churches

recently completed, or in the progress of building: to give
publicity to projects of church building or church enlargement,
and thereby, it is hoped, to aid the erection or the endowment
of the edifices in contemplation: to suggest, where it can be
done without unwarrantable interference or presumption, alter-
ations or improvements in the arrangements and decorations of
new designs: to describe accurately and impartially the restor-
ations of ancient churches : to point out those which, from their
dilapidated condition, antiquity, or architectural interest, are pecu-
liarly deserving of repair, and to suggest the means of effecting
it: and to supply notices and reviews of any antiquarian researches,
books, or essays, connected with the subject of Ecclesiology.
At the same time it is intended to afford, by means of this
periodical, a convenient medium of communication between
architects and ecclesiologists, who may or may not belong to
the Society, and the Society itself ; and to afford facilities for
proposing and obtaining answers to questions on any points of
taste or architectural propriety upon which the clergy may wish
to consult the Society—a practice which has, since the insti-
tution of the Society, been resorted to by them to a very
considerable extent, and from which, it is hoped, satisfactory
and useful assistance has been in many instances obtained,
Papers read before the Society at their general meetings ; ex-
tracts from their correspondence, if of peculiar interest or
importance ; notices of presents received or made by them;
and accounts of churches visited and deposited in the Society's
records, with various other matters of a like nature, will be
occasionally inserted as circumstances may permit. It is an-
ticipated, moreover, that THE ECCLESIOLOGIST may be made
an important means of strengthening the connection and in-
creasing the co-operation between the Cambridge Camden,
the Oxford Architectural, and other Societies of kindred cha-
racter and pursuits now beginning to be established in several
parts of the kingdom, and already flourishing under happy
auspices in two of our principal cities.

With respect to the non-resident members of the Cam-
bridge Camden Society, for whom we have stated that THE
ECCLESIOLOGIST is mainly intended, it is presumed that no
better means can be devised for supplying the want, which

is generally felt and complained of by them, of regular
and authentick information about the proceedings, publica-
tions, and expenditure of the Society, in which they are
themselves so intimately concerned. Every member will
naturally feel an interest in hearing of the prosperity, and
taking part in the operations, of a band of zealous Church-
men, to which he attached himself, not from curiosity, or
fancy, or caprice, or mere personal gratification, but from a
hearty wish to join them in the good work of restoring GOD's
temples to their ancient honours, and of raising from the dust
the mighty works of an age long since past away. The good
of the Church is the one great end to which all the Society's
resources and all its energies have hitherto been and will con-
tinue to be devoted. And in carrying this object into effect,
they have issued a considerable number of publications, the
circulation of which, although in some instances already very
large, may in all probability be materially promoted by the
periodical issue of a paper such as THE' ECCLESIOLOGIST;
and the benefit which they were designed to confer may be
in consequence proportionally increased.

It is earnestly hoped that the motive of this little publi-
cation, liable as it undoubtedly is to misconstruction, will not
be mistaken. The Society have not the slightest wish to make
it the instrument of proclaiming throughout the land a fame
which they neither possess nor are desirous to acquire by any
such . means. They do not wish to obtrude themselves
upon the notice of any. Their object is altogether different.
To render it subservient to the good of the Church, to which
the Society deems it no small privilege to be the humblest
handmaid; to convey practical suggestions upon points of
church architecture at present too much forgotten or neglected;
to supply, from their already large and constantly increasing
stores of drawings, engravings, and surveys of English and
foreign churches, examples and precedents upon doubtful points
or disputed usages; and to assist by· advice the clergy or
churchwardens in carrying into effect, with propriety and cor-
rect taste, proposed alterations and improvements;—these and
similar aidances are their highest ambition and their sole desire.
And the Society trusts that this distinct avowal of the motives

which have induced them to undertake the publication of
THE ECCLESIOLOGIST, while it releases them from the charge
of forwardness or presumption, will at the same time serve
to apprise the clergy in general where they may at all times
find advice in practical difficulties, co-operation in their designs,
and sympathy in their labours.

PARISH CHURCHES IN NEW ZEALAND.

\ THE Lord Bishop of New Zealand having requested the Cambridge
Camden Society to furnish him with designs and models for the
Cathedral church of the new Diocese, and for the Parish churches
which will be first erected, it cannot but be deeply interesting to
members of that Society to be made acquainted with the steps which
his Lordship proposes to take with respect to the erection of temples
for the worship of Almighty GOD, on his arrival in his Diocese.

As soon as possible after setting foot in New Zealand, it is his
intention to use as a temporary church, a tent which he carries with
him for that purpose ; an Altar, with its necessary appurtenances, being
erected in its eastern end. Here the daily service of our Church will
be commenced on the first morning after the Bishop's arrival, never
thenceforth to be silenced till the end of all things.

A piece of ground will next be marked out and consecrated for
the site of the future Cathedral ; not with any intention of erecting
hastily a building, which might by courtesy bear that name, but that
the remains of those who depart in the true faith may be interred in
consecrated ground ; and, if need be, that a temporary wooden edifice
may serve at present for the offices of prayer and praise. In a .coun-
try where labour is worth three times as much as it is in England, the
erection of a Choir is to the most sanguine mind as much as, perhaps
more than, can be hoped for during the present generation. But
whatever is built will be built solidly and substantially, and as our
ancestors built.

The ingenuity of the natives in carving is well known ; and it is the
Bishop's design to convert this faculty to the glory of God. For this
purpose the Cambridge Camden Society will furnish working models
of the actual size, of Norman capitals, sections of mouldings, orna-
mented pier, door, and window arches : and these, it is hoped, it may
be easy for the natives to imitate in the stone of their own country,
which is said to be well adapted for building.

One model of a parish-church will at present be sufficient ; be-
cause the churches will be, at first, two hundred miles apart. Norman
is the style adopted ; because, as the work will be chiefly done by
native artists, it seems natural to teach them first that style which first
prevailed in our own country ; while its rudeness and massiveness, and

the grotesque character of its sculpture, will probably render it easier to be understood and appreciated by them. These churches will, like the Cathedral, be built slowly—divine service being carried on in consecrated ground, under temporary sheds erected within the rising church walls : and to every church there will be a distinct and spacious Chancel.

It is indeed matter of heartfelt delight to the Society, that it is enabled to be of service to so interesting a branch of the ONE Catholick and Apostolick Church, as that about to be established in New Zealand, where the population has not yet gained so much ground as to allow no other care to the church-builder, than how to erect most quickly the largest edifices. And they have the assurance that their plans will be carried into effect with the greatest possible fidelity and propriety, from the fact, that a member of their Committee will accompany the Prelate to the new see in the capacity of his Chaplain, and will continue in communication with the Society upon all subjects connected with their architectural operations in the country.

We hope shortly to be able to lay before the members of our Society a view of the model parish-church, the general plan of which has already been agreed upon, and has been approved of by his Lordship ; and they, we are sure, will in the mean time say, with respect to the temples about to be erected in so distant a land—" Peace be within thy walls, and plenteousness within thy palaces !"

S. SEPULCHRE'S CHURCH, CAMBRIDGE.

IN consequence of the fall of a considerable portion of this venerable and interesting church, a committee has been formed for its immediate and effectual restoration, consisting chiefly of members of the Cambridge Camden Society, to which the direction of the works has been entrusted. The architect, Anthony Salvin, Esq., is an honorary member of the Society, and has presented his plans for their approbation. The sum of £1000. at least will be required for the completion of the repairs ; and of this £300. will be raised by the Parish, and the remainder, it is hoped, will be obtained by the means of a circular issued by the Committee, stating the cause of the failure, the proposed restoration, and the means of carrying them into effect. The works are at present in active progress ; the upper part of the round tower, which was added as a bell-chamber in the fifteenth century, having been now taken off as far as the corbel-table which marks the original altitude: and it is intended to surmount this with a conical roof, as nearly like the ancient covering as can be ascertained from existing appearances.

The fall of the groining in the south part of the circular Aisle, caused by the walls in that place having given way from the foundations being sapped by making graves too close to them, has consider-

ably shattered the round tower, to which the groining seems to have been an essential support. The arches of the triforium have given way at the crowns in several instances, which seems to have been partly caused by an imperfection in their original construction, and it has been found necessary to throw a strong iron band round the building externally, to prevent the fall of the whole fabrick. When however the superincumbent weight of the belfry story is removed and the foundations of the piers and walls strengthened by beds of concrete, no danger can be apprehended from the injured state of the venerable tower.

It is now almost impossible to ascertain the original form of this ancient church, which was consecrated in the year 1101; for the round tower is the only portion that remains of the old edifice, the body of the church east of the tower being a late Perpendicular erection. It is intended to build, if possible, an additional Aisle to this part, in order to compensate for the loss of accommodation caused by the entire clearance of pews and galleries from the interior of the tower, which was till recently completed disfigured by them. Within the memory of man, a very curiously carved railing or fence of black oak, possibly of the date of the church, used to surround the interior at the height of the triforium. This fence, which is described as having had many grotesque figures carved upon it, was taken down many years ago *and burnt.*

The progress of the works in repairing this interesting church, we shall from time to time report to our readers. At present we refer them to the circular which has been issued; a copy of which they can at any time receive by post, upon application to the Secretaries.

Subscriptions are to be paid to the account of the " S. Sepulchre's Church Restoration Fund," with Messrs. MORTLOCKS, Bankers, Cambridge.

REPORT OF THE TWENTY-FIRST MEETING OF THE CAMBRIDGE CAMDEN SOCIETY,

ON MONDAY, NOVEMBER 8, 1841.

THE President took the chair at half-past seven o'clock, and the election of members immediately took place.

The LORD BISHOP of NEW ZEALAND,
The BISHOP of ROSS and ARGYLL,
The BISHOP of NEW JERSEY, U.S.,
The LORD BISHOP of DOWN and CONNOR,

were admitted Patrons by acclamation.

The following candidates were balloted for, and elected:—

Airey, Rev. W. Trinity college; Keysoe, Kimbolton
Babington, T. A. Esq. Trinity college
Bankes, Rev. Dr. Trinity hall; Dullingham
Barry, Rev. C. U. Trinity hall
Bayley, Ven. H. V. Trinity college; Archdeacon of Stow; West Meon, Hants.
Beadon, Rev. Hyde, S. John's college; Latton, Cricklade, Wilts.
Bell, Thomas, Esq. 17, New Broad street, London
Blackall, Rev. S. Fellow of S. John's college
Blick, Rev. C. Fellow of S. John's college

Boultbee, T. P. Esq. Fellow of S. John's college
Browne, Rev. E. H. late Fellow of Emmanuel college; S. Sidwell's, Exeter
Browne, Rev. T. Murray, Trinity college; Standish, Gloucestershire
Chevallier, Rev. T. late Fellow of S. Catharine's hall; Durham University
Constable, Marmaduke, Esq. Walcot, Brigg, Lincolnshire
Conybeare, Rev. W. J. Fellow of Trinity college
Cotton, Alexander, Esq. Hildersham hall
Cotton, Rev. G. L. Fellow of Trinity college; Rugby
Currey, Rev. G. Fellow of S. John's college
Davenport, A. Esq. Christ's college
Dodsworth, Rev. W. Trinity college; Regent's Park, London
Finch, Rev. W. Christchurch, Oxford; Warboys, Hunts.
Fisher, O. Esq. Jesus college
Franks, Rev. J. C. late Chaplain of Trinity college
Freeman, Rev. J. S. Peter's college; East Winch, Norfolk
Fussell, J. C. G. Esq. Trinity college
Grey, Hon. and Rev. F. C. Trinity college; Buxton
Griffith, E. G. Esq. Trinity college; Downshire hill, Hampstead
Harper, F. W. Esq. Fellow of S. John's college
Hasted, Rev. J. Christ college; Bury S. Edmunds
Heale, H. N. Esq. Christ college; Highfield, Hemel Hempstead, Herts.
Heathcote, Rev. G. S. John's college, Oxford; Conington, Hunts.
Hedley, Rev. T. A. Trinity college; Gloucester
Hooper, R. Esq. Trinity college
Howlett, Rev. J. H. Fellow of S. John's college
Hutchinson, Rev. J. S. John's college
Johnstone, Rev. G. Sidney Sussex College; Broughton, Hunts.
Keeling, Rev. W. Fellow of S. John's college
Kingdon, Rev. S. N. Fellow of Sidney Sussex college
Knox, T. F. Esq. Trinity college
Laishley, G. N. Esq. Trinity college
Lemann, Rev. F. G. Merton, Suffolk
Lewthwaite, S. Esq. Fellow of Magdalene college
Lightfoot, J. Esq. Liverpool
Lloyd, J. P. Esq. Ch. Ch. Oxon. Dan-yr-alt, Llangadoch, Caermarthenshire
Manning, Ven. E. Oxon., Archdeacon of Chichester; Petworth, Sussex
Miller, Rev. J. K. late Fellow of Trinity college; Walkeringham, Gainsborough, Lincolnshire.
Mills, Rev. T. Stutton, Ipswich
Mould, R. A. Esq. Trinity college
Mouncey, D. Esq. S. Peter's college
Musgrave, Ven. C. Archdeacon of Craven, late Fellow of Trinity college; Halifax
Newcome, Rev. W. Hockwold hall, Brandon, Norfolk
Penrose, F. C. Esq. Magdalene college
Prower, Rev. J. M. Oxon; Purton, Cricklade, Wilts.
Reyner, Rev. G. F. Fellow of S. John's college
Ridsdale, Rev. R. Clare hall; Tillington, Sussex
Rooper, Rev. W. H. University college, Oxon. Abbots Ripton, Hunts.
Saunders, Barnett, Esq. Queens' college
Sharpe, E. Esq. Architect, Caius college; Lancaster
Shilleto, Rev. R. Trinity college
Smith, Thomas, Esq. Architect, Hertford
Spence, Rev. G. Jesus college
Suckling, R. J. Esq. Caius college
Taylor, J. Esq. Moseley hall, Birmingham
Thackeray, Dr. Cambridge
Thurlow, Rev. T. S. John's college; Baynard's Park, Guildford
Thurlow, T. L. Esq. Trinity college; Baynard's Park, Guildford
Walker, Rev. S. E. Trinity college; S. Columb, Cornwall
Wood, W. S. Esq. Fellow of S. John's college
Wratislaw, A. Esq. Trinity college

The Secretary proceeded to read a list of about one hundred and sixty drawings, besides engravings and other presents, received since the last meeting in May, and the names of nearly four hundred churches which have been visited, and for the most part reported, by Members during the summer.

A report was then read from the Committee, from which it appeared, that since the last meeting of the Society the paper on the Greek Origin of the Monogram I H S had been published; that the First Part of the Few Words to Churchwardens had reached a ninth edition; that a Second Part had since been published, and is in a third edition; that a tract, entitled a Few Words to Churchbuilders, had just appeared, illustrated by plates and furnished with an Appendix, containing lists of models for Windows, Fonts, and Rood-screens; that the Church Schemes had reached a ninth edition; that a Fourth Number of the Illustrations of Monumental Brasses is on the eve of appearing; and that a pamphlet on Stow Church, Lincolnshire, had been prepared, and is now ready.

That applications had been received and answered from the following places:—

Foxton, Cambridgeshire	Hawkhurst, Kent
Balsham, Cambridgeshire	Morville, Salop
Brixworth, Northamptonshire	Iffley, Oxfordshire
S. Mary, Chester	Bradninch, Devon
East Tisted, Hampshire	Bridgerule, Devon
East Bourne, Sussex	Rodmell, Sussex
Raine, Essex	Barrington, Cambridgeshire
Hexham Abbey Church	Saintbury, Gloucester
Kingston-next-Lewes, Sussex	All Saints, Pallant, Chichester
Pyecombe, Sussex	Wingate, Durham
Daglingworth, Gloucestershire	Oxenhall, Gloucester.

That the Society had also furnished designs for a new church, to be erected in the parish of Llantillio, near Ragland, South Wales.

That notice had been given in the Few Words to Churchbuilders of a contemplated scheme for erecting by national subscription a Model church, on a large and splendid scale, to be dedicated in honour of S. Alban, the Protomartyr of England.

A long and very interesting paper was then read by Philip Freeman, Esq., Fellow and Tutor of S. Peter's College, on the wooden, or *foliated,* roofs of the Suffolk churches. This paper was illustrated by a series of drawings; and the author advanced some new and ingenious suggestions upon the principles of construction of these roofs.

The following resolutions were passed by the Society, on the recommendation of the Committee:

"That for Laws VI. and VII. the following Laws be substituted.

"Law VI. Every Member shall pay an annual subscription of one guinea, to be due on the 1st of January in each year. It shall be competent to any Member to compound for all future subscriptions by one payment of ten guineas.

" NOTE.—This Law is only to apply to Members elected after January 1st, 1842. The last day for the proposal of candidates, under the present system, will be the 29th of November, which allows one week for the suspension of the candidates' names before the last meeting of the present Term.

"Law VII. If any Members' subscription be in arrears for one year, he may be removed from the Society, after due notice, at the discretion of the Committee."

It was also resolved, that a notice subjoined to the Laws in the last Report of the Society, which at present stands as follows—" Members of the Oxford Society for promoting the study of Gothick Architecture are admitted to attend the meetings of the Cambridge Camden Society, and have the privilege of purchasing the Society's publications on the same terms as are granted to the Members of the Society"—be thus altered, and stand as Law XVIII.:

" Law XVIII. The Society shall from time to time admit such Associations, formed on Church principles for the study of ecclesiastical architecture and antiquities, as shall desire it, to the privilege of attending the meetings of the Society and purchasing its publications on the same terms as are granted to its Members."

In compliance with this Law it was unanimously agreed, " That the Exeter Diocesan Society and the Lichfield Society for the encouragement of Ecclesiastical Architecture should be admitted to the same privileges as were granted to the Oxford Society for promoting the study of Gothick Architecture."

The meeting adjourned about ten o'clock.

NEW CHURCHES.

A CHURCH has recently been erected in a very populous part of Cambridge, called New Town, and is now nearly completed, the whole of the exterior being finished, and the interior in a state of rapid progress. There are circumstances which render it very difficult for us to speak of this building; for while on the one hand it is our duty, if we would benefit the cause of Church Architecture, to criticise fairly and frankly every building in which its true principles seem to us to have been in any degree violated, on the other hand the want of church room which has long existed in the parish of Barnwell, the fearful increase of that want during the last few years on account of the rapidity with which the population has decupled itself, the zeal, energy, and self-denial of those who have undertaken the arduous work of meeting this deficiency, above all the liberality with which the Reverend the Patron and the Incumbent of the living have become bound for the debt still remaining on the church,—these considerations seem to make it an invidious thing that we should speak at all of this edifice, unless it be in terms of praise. And if we thought that any remarks of ours could have the effect of prejudicing in the smallest degree the completion of the work, we should remember that the truth is not to be spoken at all times, and keep silence. Faults of architecture however, though they cannot now be recalled, may in future be avoided ; and it is the hope of pre-

venting the erection of any more churches in this town in the same
style as that of Christchurch and the present edifice, which induces
us to lay before our readers the following remarks.

We shall divide our objections to this church into three heads: ·

I. The most important requisite in erecting a church is that it
be built in such a way that the Rubricks and Canons of the Church
of England may be consistently observed, and the Sacraments rubric·
ally and decently administered. But how can the Chancel " remain
as it hath done in times past," when there is no Chancel whatever ? How
can the Minister " baptize *publickly* at the stone Font," such Font stand-
ing " in the ancient usual place," when, if it did stand so, he would
be so enclosed by galleries, that most surely he would not be seen or
heard, so that " every man present may be put in remembrance of his
own profession made to GOD in his Baptism." And how can that due
reverence be paid to the Communion-table which "was in this Church
for many years after the Reformation," if there is no fit place ap-
propriated to its reception, and if the Vestry (with all its name-
less appurtenances) is close by, and a door opens almost on to the
Altar-rails ?

Neither let it be said, " If we have not money enough to build a
church with a Chancel, we must have one without." No one would
say, If we cannot build a church with pews, let us have one without:
and yet these are anything but necessary, as a Chancel is. But the
excuse will not serve in the present instance, because funds were
forthcoming for more than a Nave, inasmuch as a Tower was built.
This, as we shall observe presently, ought never to have been thought
of, if it involved the sacrifice of the Chancel.

II. It is commonly supposed that a building, to be churchlike and
in correct taste, must be necessarily more expensive than one which is
the contrary. There cannot be a greater mistake. The most church-
like of modern churches, Littlemore, near, Oxford, was also one that
cost as little as any, the total expense not amounting to £1000 : whereas
we have seen designs for a church (fortunately never erected), with a
capacity of course bearing no proportion to the difference of cost,
which, presenting the most hideous amalgamation of various styles,
and evincing the most thorough ignorance or disregard of the true
principles of Christian Architecture, would have cost at least £40,000.
There is therefore no reason *à priori* why a church which costs
£5,000 should not, *so far as it goes,* be as good a design, and built
with as true a feeling of the beautiful and the Catholick, as Lincoln
Minster itself. This is a point on which we can never too much in-
sist. *Many very good, and equally large, churches have been built for
much less money than this one cost.* In the present case there was no
occasion to imitate Debased Perpendicular ; Early-English costs as
little, or less. No doubt an architect has a right to adopt any style
he pleases ; only having once adopted it he should adhere to it con-
sistently. This in the present instance has not been done. We doubt
if there ever was a church which, being built at the time when the Cle-
restory and Aisles of this may be supposed to have been erected, should
present also a west window and doorway of an earlier character.

But there are many arrangements and details in this church which

on every other ground are quite indefensible, even on the score of cheapness. Such are the huge clock ; the disproportionate octagonal Turrets ; the great four-centered Belfry windows without cusping or mouldings ; the figures 1 8 4 1 in the spandrils of the clock ; the square clerestory-windows ; the enormous windows in the Aisles ; the mullions made to stand on the same plane as the wall ; the square heads ; the want of foliation ; the jambs without mouldings ; the graduated parapet of the Nave; the thin mullions and tracery of the east window, the difference between the supports of the western and the other galleries ; the startling contrast of the red brick and the white quoins of dressed ashlar; the trellis-work of black bricks ; and many other things which time forbids us to notice.

III. Again, a church which costs little need not be a cheap church, and a church which costs a great deal may be one. A cheap church, is one which makes the greatest show for the least money.

Now herein lies the fault of modern churchbuilders. They *will* have the ornamental part of the church, at whatever cost to the church itself. · But that day is nearly gone by ; and we may hope that the sun of Ecclesiastical Architecture, after suffering a long , eclipse, is again beginning to shine; that a generation more pious, if not more rich, than ourselves may rival our ancestors in their glorious minsters, their long-drawn vistas of stone vaultings, pier behind pier and bay behind bay, their carved rood-screens glittering with gold and eloquent with figures, their capitals flowers, wanting only life to be equal to Nature's ; nay, that they will even emulate those glorious conceptions, the one the most sublime, the other the most beautiful that ever entered into the human mind, the West Front of Peterborough, and the Angels' Choir at Lincoln.

And here we are again obliged to find fault with the church under consideration. What need was there for a Tower ? A bell-gable was often used by our ancestors ; and it might often be employed with advantage by us. There was a temptation, we allow, in the commanding site of the church to erect a Tower; but the Chancel was necessary, and the Tower was not ; and at no great distance of time funds might have been raised for a structure that should have been the ornament of the town, whilst the Church's service might have been carried on meanwhile within the Chancel and Nave.

But if ornamental appendages are bad when any thing real is given up for their sake, much more are they so when they are imitations of that which they really are not. Stucco, and paint, and composition, and graining, are not out of place in the theatre or the ball-room; but in God's House every thing should be *real.* Plainness need not be inconsistent with reverence : pretence is, and must be. Our readers will see that we refer to the mouldings of the pier-arches which are *cast in plaister ;* to the pieces of wood in the roof which, appearing to be purlins and principals, have in fact little to do with its support ; to the varnish which is intended to make deal look like oak; and other imitations of the same kind. Such a principle is what we refer to by the word *cheap ;* and this is the fault we have to find with the church before us, and (we need not add) in many more that have been built, and are yet building.

We trust that the plainness of speech we have used will not be likely, as assuredly we do not intend it, to give offence. We are content, as well as obliged, to abide the consequence. If the architect is able to prove us wrong, we shall gladly own ourselves mistaken; if not, we doubt not that he will receive our suggestions in the same friendly spirit in which they are written, emanating from those who might be pardoned for attaching what he may think an exaggerated importance to one department of his art, which he is not singular in having overlooked, and which modern architects have unfortunately so many motives for making yield to more popular considerations.

In pleasing contrast to the church just described, may be mentioned one now about to be built at Brookfield, in Kentish Town, S. Pancras, Middlesex. "It is proposed to build in the best possible manner, of stone and oak, a church without galleries for 500 persons; the windows of the Chancel are to be enriched with stained glass; there is to be an open roof of oak; the whole of the sittings for rich and poor are to be exactly similar, open stalls of oak: one-third of the sittings are to be for ever free for the poor, each free sitting is to be assigned to some poor person; a fund is to be provided for the maintenance and repairs of the fabrick." Some further account of this design will be given in our next number.

CHURCHES UNDER RESTORATION.

S. Nicholas, Old Shoreham, Sussex.—Some account of the restoration of this church, which was put under the direction of the Cambridge Camden Society by the Appropriators, the President and Fellows of Magdalene college, Oxford, has been given in the first volume of the Society's Transactions.

The following brief statement is partly copied from a circular which was put forth in behalf of the repairs.

" Originally cruciform, with north and south chapels to the Chancel,— the north Transept had become a ruin, and was walled off from the church : the chapels were so thoroughly destroyed that the foundations are scarcely visible; the four Belfry arches, presenting a noble specimen of Norman mouldings (circ. 1130), had been clogged and disfigured with whitewash ; the Tower, each side of which was originally arcaded, had been completely loaded with rough-cast, and the southern lights of the Nave transformed into square windows, with wooden mullions. Nor was the Chancel less injured. The eastern window, a beautiful specimen of the earliest Decorated (circ. 1320), had been completely destroyed, and its place was supplied by two non-descript lights, with circular heads. Of the open wood roof, only a single beam, beautifully ornamented with the toothed moulding, remains. To supply the Window on the north side, a square hole was cut in the wall, plugged up in cold weather with a piece of wood of the same shape. The pews, which crowded the Nave, almost seemed to have been placed there for the express purpose of being ugly. The earth had accumulated on the south side to the height of about four feet, rendering the church, of course, in the highest degree damp and unhealthy.

" The present churchwarden, Mr. Turner, of Little Buckingham in the parish of Old Shoreham, determined in September 1840, with a spirit worthy of another and a better age, to restore the church to some degree of its

original splendour. Magdalene college, Oxford, granted £100 for the repairs of the Chancel, and £25 for that of the Nave. When the paper above referred to was published, the earth had been removed from the sides of the Nave, the fine Norman door in the south Transept disclosed and restored, the Tower stripped of its rough-cast, and progress had been made in the restoration of the ruined Transept."

Since that time, great progress has been made. The east window has been restored; it has four lights, with plain geometrical tracery; two similar windows, of two lights, have been restored in the south of the Chancel; and one on the north, blocked a few years since by a monument, re-opened. The north Transept is all but complete; a window has been inserted in the Norman buttress on its north side, chevronée all round : this is copied exactly from one similarly situated in Clymping church, Sussex. A fine Early English Cross surmounts the east end : the arrangement of mouldings at the gable resembles that at Ardingley, Sussex.

All the restorations have been effected in Caen stone, and in the most substantial manner.

A large sum is still wanted for the substitution of open seats for pews, and the repairs of the roof.

The parish is small and poor. The parishioners have exerted themselves to the full extent of their means : and the undertaking must cease, if those who would not themselves " dwell in cieled houses while the House of the Lord lieth waste," will not assist in so good a work.

Subscriptions for the purpose will be thankfully received by Messrs. Hall, West, Borrer, and Hall, Union Bank, Brighton.

The church of GREAT HASELY, OXFORDSHIRE, which must be well known to Ecclesiologists from the interesting account which the Oxford Architectural Society have published of it, is undergoing a thorough restoration, under the superintendance of that Society. The noble Decorated east window, now cut in half by the plaister cieling, will be thus restored to its original beauty. We rejoice to see so prosperous a subscription, and heartily wish all success to the work.

The church of IFFLEY, OXFORDSHIRE, one of the finest Norman parish-churches in England, is also to be restored; and, judging from the prospectus, with excellent taste and feeling. It is also under the care, we believe, of the Oxford Architectural Society.

ILLUSTRATIONS OF MONUMENTAL BRASSES.

OF this work three numbers have now been published, and a fourth will appear in about a fortnight. To those Members of the Society who have not seen the present numbers of the series, it will be well to say a few words in explanation of its nature and design.

The study of Monumental Brasses is one of the most interesting and curious departments of Ecclesiology : and it is moreover one to which, till very recently, but little attention had been paid. The consequence of this apathy or ignorance respecting their nature and use,

was, that many fine and ancient specimens were either concealed in our churches by pewing, or subjected to the constant wear and tear of heedless feet, being altogether uncared for and unprotected, or, what is infinitely worse, were actually being almost every week taken up and carried off, or sold as waste metal. Several instances of this worse than puritanical outrage have recently come to the knowledge of the Society. Again, the great value of Monumental Brasses in illustrating ancient dresses, &c., was too little regarded : and the remarkable beauty of many examples, merely as specimens of ancient art, seemed, most unaccountably, to have attracted little attention even from professed antiquaries themselves.

Many existing Brasses have been engraved in various works on ecclesiastical architecture and antiquities ; but these, with hardly any exception, were of much too costly a nature to make the subjects very extensively known. Besides, few of them had been engraved *accurately :* a mere drawing, by the eye, of the original, frequently very inaccurate in details, and very imperfectly copied by the engraver, was all that had been attempted ; and the *perfect* representation of a Brass, reduced to a scale, had, till very lately, perhaps hardly ever been produced. For the above reasons the Cambridge Camden Society were induced to commence a series of " Illustrations of Monumental Brasses," which, from its cheapness, accuracy, and artistical elegance, should supply a deficiency which they conceived to exist on this subject. The method they have adopted to secure these important ends are, first to copy by means of black lead, or heel-ball, on tissue paper, the original brass with the greatest nicety, and then to put the copy in the hands of the first London lithographers to engrave on a regular scale of reduction. Each number of the work contains four such engravings, with as many vignettes of architectural details, each accompanied with a biographical and descriptive notice, compiled with much care from the resources, hardly attainable by those who do not reside at an University, of the Publick Library at Cambridge. The work is printed in quarto size, and the price to each member *who is a subscriber* is five shillings each part ; to others, eight shillings ; and copies on India paper may be procured at a higher price.

The expense of bringing out this series is necessarily very considerable ; and the Society feel it right to state that they have not met with that encouragement from the Members of the Society which the elegance, cheapness, and interesting nature of the work had led them confidently to expect. And so far from its being, as it ought to be, a source of profit to the Society's funds, it at present barely pays its own cost.

About two numbers of the series appear annually ; and it is earnestly hoped that the *chief* work which the Society has yet produced will meet with much greater patronage from the Members in general than it has yet met with. It is needless to say that every number may be procured from any of the Society's agents, or through the London publishers, Messrs. Rivington.

ECCLESIOLOGICAL PUBLICATIONS.

It is intended in a future number to give more detailed accounts of the operations and success of the several sister societies in union with the Cambridge Camden Society. That lately instituted at Lichfield appears to have been formed under most promising auspices. The last publications of the Oxford Society, on Stanton Harcourt and Fotheringhay churches, must be so well known and so highly esteemed as not to need any notice here. The Exeter Diocesan Society has just published a little tract, written by the Rev. J. Medley, the Secretary, entitled "Elementary Remarks on Church Architecture," which we can most safely recommend. We have also pleasure in noticing that the publication of "Winkles' Cathedrals" has been recommended. The first number of this third and concluding volume contains some beautiful views of Lichfield Cathedral. There is much room however for regret, that the accompanying letter-press is not of a higher order, whether in an architectural, a religious, or a historical point of view; or at least in typographical accuracy.

CAMBRIDGE CAMDEN SOCIETY.

It has seemed advisable to give in this introductory number the following brief account of the Society's constitution and regulations:

The Society was instituted in May, 1839, in order " to promote the study of Ecclesiastical Architecture and Antiquities, and the restoration of mutilated Architectural remains." It is composed of Members of the University of Cambridge; who are proposed by any Member of the Society in a fixed form, and who, after the suspension of their names at least for a week in the Society's rooms, are ballotted for at an ordinary Meeting. Any other persons are eligible according to the same form, provided that their names be first approved of by the Committee.

Honorary Members are admitted in the same way as those who are not Members of the University.

The Chancellor and High Steward of the University, their Lordships the Bishops, and the Bishops of the Scotch and American Churches, together with the Heads of Houses in the University, are admitted as Patrons, without ballot, on communicating their pleasure to belong to the Society.

The Society meets for dispatch of business, and for the hearing of papers, at least twice in each Term. The days of meeting for the years 1841-1842 are as follows:—Nov. 8th, 22nd, Dec. 6th, 1841; Feb. 7th, 21st, April 18th, May 11th, 1842 (Third Anniversary).

NOTICES.

The Secretaries request that Members will inform them of their changes of residence, and will furnish them with corrections of any errors which may appear in the Society's Report.

In order to obviate the difficulty which many Members have experienced in obtaining the Society's publications, it is requested that such as cannot conveniently correspond with the agents established in the principal cities and towns (a list of whom is given on the wrapper

of the present number), will point out the channel through which, in each case, the Society's publishers can communicate with them. There are several copies of the First Part of the Society's "Transactions," which was distributed gratis to all who were Members at the time of its publication, which have not yet been claimed in pursuance with the circular then issued by the Secretaries. These may be obtained upon application to the Publishers.

The Treasurer of the Cambridge Camden Society is anxious to explain fully the alterations in the terms of subscription adverted to in the report of the meeting of the Society, in page 8. The present law fixes the subscription of each Member at ten shillings for ten successive Terms, together with an entrance fee of ten shillings; the life composition being five guineas. The new law, which will come into force in the case of Members elected after January 1st, 1842, raises the subscription to one guinea annually, or a single payment of ten guineas.

All persons elected during the present year, that is, at the Meetings on November 22 and December 6, will be subject to the old regulations. The names of candidates for the last-mentioned day of election must be in the hands of the Secretaries on or before the 29th instant.

Since some misapprehension has existed as to the method of paying the sums due to the Society, it is requested that such sums may be forwarded by Post-office order to A. S. EDDIS, Esq.. of Trinity college, Treasurer of the Cambridge Camden Society, or be paid through Messrs. SMITH, PAYNE, & SMITH'S, to his account with Messrs. MORTLOCK, Bankers, Cambridge.

As the efficiency of the Society must necessarily depend in a great measure on the state of its funds, it is earnestly hoped that such Members as are in arrears will take the earliest opportunity of paying what is due from them.

THE ECCLESIOLOGIST.

The present number of ' The Ecclesiologist' is forwarded gratis to every Member of the Cambridge Camden Society. It is confidently expected by the Committee that the Members will generally be glad to encourage a publication, the want of which they have probably all felt. As no part of the Society's funds can be permanently employed in this work, it must depend for its continuance on the support which it shall receive from Members and others interested in like objects. All therefore who are desirous of aiding the undertaking, are requested to forward their names and addresses as soon as possible to B. WEBB, Esq., Trinity College, or F. A. PALEY, Esq., S. John's College, Honorary Secretaries of the Cambridge Camden Society (to whom also all other communications should be directed). In case a sufficient number of patrons should thus be obtained to make the paper cover the original expense, the Subscribers will be informed of the fact by receiving the second number, together with a request to pay in advance through the channel then pointed out, an annual Subscription of Five Shillings; which will entitle them to twelve sheets, published at convenient intervals during the year, the copies being transmitted free of expense through the post.

[*Second Edition. October* 1842.]

Published by T. STEVENSON, *Cambridge:* J. H. PARKER, *Oxford:* RIVINGTONS, *London.—Price* 4d.

METCALFE AND PALMER, PRINTERS, CAMBRIDGE.

THE

ECCLESIOLOGIST.

PUBLISHED BY THE CAMBRIDGE CAMDEN SOCIETY.

"𝔅onec templa refeceris."

No. II. NOVEMBER, 1841.

SUGGESTIONS FOR CO-OPERATION WITH THE OBJECTS OF THE SOCIETY.

" WHAT am I to do next ?" is a question not unfrequently put to us here at head-quarters, in some shape or other, by new Members in the country, on their receiving notice of their having been elected. " What am I to do next, if anything ? I have joined the Cambridge Camden Society, because I saw that great good might result to the Church from its labours : but am I expected or qualified, individually, to do any thing further towards its objects ? or does nothing remain but presently to pay my subscription, and so have done with it ?"

Now it is of vital importance to the efficiency of our Society that this question be rightly and fully answered, and that too in various forms, according to the quarter from which it comes, and the circumstances and opportunities of the querist. We propose therefore in this and the succeeding numbers of the *Ecclesiologist*, to throw out such suggestions and directions for co-operation with the objects of the Society as may suffice to set every member of its body in proper and healthy action, and so to enable the whole to perform its functions with life and vigour. And first, for a general reply to the query above stated. It is by no means contemplated that the usefulness of any Member of the Society should cease with the accession of his name to its lists, or his subscription to its funds. These are very important points, no doubt—especially the latter ; and in the case of many, it is all they can be expected to do for us, owing to more pressing calls on their attention. But in the generality of cases we hope for something more ; we would not have it thought that our only object is to provide a machinery at Cambridge, in order to a process the reverse of alchemy—in order that so much gold being subjected to its operation, may come forth transmuted into so many restored Perpendicular Windows, or so many tracts on Church Architecture.

I. We will first take the least promising case of querist—the case in which he is not in Holy Orders, nor has in any other way any controul over a church; is not rich, nor high in station, nor otherwise influential towards church restorations; has not even any knowledge of church architecture. What is querist No. I. to do ? Surely *he* may fold both his hands, in a Camdenian point of view, so soon as he has

stretched out one of them to convey to us his contributions, and assure us of our having his best wishes! Now it is very true that he cannot undertake, perhaps, to become a clergyman, or a churchwarden, for our special convenience; or to grow rich or influential at a short notice, for the same laudable purpose: but still we assert that he has it in his power, individually, to promote what is in fact the main object of our Society. For, what is its motto? A happily chosen one, we must think, "Donec templa refeceris." What a boundless field, by the way, though in theory limited! How does its sensible horizon flee onward as the "panting" Society "toils after it in vain," still descrying new objects to be accomplished, the more it accomplishes! But how came our "temples" to need this "refection?" Sooth to say, it was just for want of a Camden Society; or rather for want of that which would have made this and similar Societies unnecessary, namely, a generally diffused knowledge of church architecture. Had this been abroad in the land for the last hundred years even, how different might the state of our churches have been now; how many a goodly window and elaborate carving would remain to us, spared because it was appreciated; how much more we should have of open roofs, and open benches, and propriety; how much less of flat cielings, and pews, and deformity. And the spirit which would have prevented so much mischief then, it is our object to awaken now, to remedy it in some measure, and yet more to prevent a repetition of it. This we must look to as a main instrument of our usefulness,—the spirit of love and admiration for our venerable churches, founded on a careful study and just apprehension of their excellencies, full as every part of them is both of meaning and beauty. Such a spirit, known to have gone abroad extensively, and to be daily spreading from man to man, will have the effect of checking by its very existence, and sometimes by its more active interposition, those ignorant and reckless acts of "im-provement," which our churches have had such reason to rue: it will be less easy, and less safe, to carry on the old contraband system in these matters, when it is known that there is a pretty numerous corps out on the preventive service. Our suggestions then to querist No. I. is, to study church architecture, and invite others to the study of it: so will he justify the recommendation made of him at his election, that he was "believed to be disposed to aid the Society's designs." He will find in the Society's publications, works recommended to his perusal: we may mention especially, Bloxam's Architecture, the Oxford Glossary, Pugin's True Principles of Pointed Architecture, Poole's Two Letters on the Structure and Decorations of Churches, the Cambridge Camden Society's Hints on the Practical Study of Church Architecture; and finally—we had nearly forgotten to mention it—THE ECCLESIOLOGIST.

(To be continued.)

THE Exeter Society is about to publish some illustrations of the church of S. Mary, Ottery. The restoration of Bradninch church, and par-ticularly of its famous Rood-screen, is proceeding under the eye of this Society, which we are happy to say already numbers above 100 members.

Notices of the restoration of Hexham Abbey church and of some others are unavoidably postponed for want of room.

NEW CHURCHES.

WE gave in our last Number a brief account of the church which it is proposed to erect at BROOKFIELD, Kentish Town. Some alterations have since been made (partly, we believe, in consequence of our suggestions) in the plan: and the feeling displayed in the design is so thoroughly Catholick, that we return with great pleasure to the same topic.

The Chancel is now to be about twenty feet in length; and this, though in an ancient building it would still be small, is unspeakably better proportioned than nine-tenths of modern churches. There is a robing-room on the north side; thus occupying the correct position for a sacristy. The Altar is raised on two steps, and the Chancel on two flights of three each. Might we suggest that it would be more in accordance with ancient usage if the case were reversed?

The position of the pulpit, and the entrance to it by a winding staircase in the north pier of the Chancel arch, are excellent. The position which the kneeling-desk and lettern are to occupy is not marked. At the east end of the Nave are stalls for the choir; and this seems a perfectly unobjectionable arrangement, though they might, without any deviation from Church rules, have been placed on each side the Chancel.

The Aisles bear a much fairer proportion to the Nave than they did in the first plan; it would be better however were the seats placed next to the wall, not to the piers; and the passage thus made interior, and not exterior.

The position of the Font is at the south-west of the Nave, under the Belfry arch. We should rather have seen it on the south side of the western entrance. We recommend, for the reasons given at §. 28 of our 'Few Words to Churchbuilders,' that it should be octagonal, instead of hexagonal as marked in the plan.

The triple lancet at the west end has, for a small church, no authority. Two lancets would have been more appropriate; tall, narrow, and far apart. The western façade would be improved, had the Aisles been carried out even with it; and there is a superabundance of pedimented buttresses in the whole exterior. The pinnacle cross at the west end is excellent. Might not a single row of toothed moulding be introduced with good effect into the door?

The part on which we can bestow least praise (except for its position, which is admirable) is the Tower. In the lowest stage, the small lights might well be spared. The second stage wants height; and the arcading above the Belfry windows, and the style of the pinnacles have, we fear, no authority whatever. Were the windows on each side the Belfry copied from that to Cotterstock, engraved at p. 34 of the Companion to the Glossary, the effect would, we think, be singularly beautiful. We could have wished that a Clerestory had been extended over the Aisles, even had it been small, and consisting only of a row of quatrefoiled circles.

We cannot leave this building without expressing our warmest

wishes for the success of so Catholic a design; the framers of which have not " offered unto the Lord of that which cost them nothing."

The church lately consecrated at BURY S. EDMUND's contains very little on which we can bestow any praise. There is no Chancel; the Aisles however are well developed, and there is a good-sized Clerestory. The style is Early-English; the windows in the Clerestory form a succession of triplets; and the Aisles are lighted by double lancets. Neither of these arrangements are very becoming. The Tower and Spire form however the worst feature of the building; the huge doorways in the lowest, and the elongation of the second stage, are particularly objectionable.

The three following churches are engraved in the Companion to the British Almanack, and mentioned in terms of high approbation:

STREATHAM church is so utterly unlike every other architectural building of our own country, that it is by no means easy to describe it. The style has been called by a variety of names with more or less appropriateness: it is, in fact, a poor adaptation of the Romanesque of the south of Europe. The church has a Nave and two Aisles, with a long thin Tower at the south-west angle. This latter is 113 feet in height and 15 feet square; and is panelled in three enormously lofty lancets. The cost of this building was £6000. Why were our own ecclesiastical styles deserted for forms which are at best imperfectly developed, and which are adapted only to the necessities of a burning climate?

S. MARY's, SOUTHWARK, to be erected for £4200, has some commendable points. It is Early-English; the plan is cruciform, with a bell-gable at the west end. The roof is of good pitch; that of the Transepts being considerably lower than the rest. There is, we are glad to see, a Chancel, though it is of most disproportionate size; there is an eastern triplet, in which the arrangement of the string-courses strikes us as particularly objectionable; and the gable ornament is quite without authority. North and south of the Chancel is a complication of flying buttresses and Clerestory windows over small vestries: these materially impair the effect of the building. The situation (we are told) is on a very confined piece of ground, near the Old Kent Road, *which allows of no approach on the west side, and accordingly that end of the building is to be left quite plain,* as it cannot be viewed from any publick road. Here we have a key to the radical defect in modern churchbuilding.

TRINITY, POPLAR. This is a Grecian building, standing north and south; the pulpit projects *from the wall immediately over the Altar,* and is formed of Keene's cement; the galleries are supported by cast-iron columns, which serve as water-drains! Comment were needless.

We have been favoured with the sight of a model for a small Early-English Chapel about to be erected at CHEADLE. It is a small and plain, but very neat and correct design. The sides are lighted by single lancets, the east end by a triplet, and the west by a window of two lights. The labels of the side lancets are carried in a horizontal line, so as just to pass over the heads of the pedimented buttresses. We should much prefer to see the latter carried up a little higher,

and the string passing just *under* the pediments. We would also bring the lancets a little lower, and carry the string underneath them round the buttresses. The roof is of a very good pitch, and is to be of open timbers internally. There is a small bell-gable at the west end. The Altar is of stone, elevated on steps, without rails ; and the seats are all open benches. Upon the whole, the simplicity and good taste of this design deserve much commendation. We believe that there is sufficient authority for the unusual arrangement of *diagonal* buttresses at the corners.

Copies of an engraving, beautifully etched by Le Keux, and dedicated to the Cambridge Camden and Oxford Architectural Societies, of an Early-English church designed by Edmund Sharpe, Esq. M.A. of Lancaster, are on sale at Mr. Stevenson's ; and a proof impression, presented by the architect, is deposited in our portfolio. The church has not been built ; but the design is so chaste, elegant, and correct a specimen of Early-English architecture, and so greatly superior in all its details to the wretched modern imitations of that glorious style, that we sincerely hope it will soon be selected for erection with the best of materials, and with a liberal outlay for completing in the most perfect manner a truly Catholick edifice. The church is to consist of a Chancel, Nave, two Aisles, and a beautiful and lofty Tower at the west end. As the Chancel is not shewn in the engraving, we can of course give no opinion upon that highly important part of a design, the east Window. There is no Clerestory ; but the Nave and Aisles have separate roofs and gables (as in the Temple church, London,) which are to be finished internally with uniform quadripartite vaulting springing from clustered columns. They are externally of a fair elevation ; but modern architects in general seem quite afraid of venturing upon a good pitch for a Nave or Chancel roof. The Aisles are each of five bays, with double lancet windows between the buttresses. The west end of each Aisle is lighted by a triple lancet. We believe a single lancet would have been more consistent with ancient models ; at least we know of no instance in which a triplet is used in . this position in a small church. The ancient architects, who are supposed to have attached a symbolical meaning to a triple lancet, might have placed it at the east end of the Aisle, but would have intentionally put an inferior window at the west. However, we of course do not insist upon confining modern architects to the same principle. The general composition of the Tower bears a considerable resemblance to that of S. Mary's church, Stamford—one of the finest Early-English Towers in existence. The belfry windows are triple lancets, and the second stage is pierced on three sides with as many lights, under an arcade with long banded shafts,—too long, perhaps, to be strictly consistent with the character of an external arcade, but withal eminently chaste and beautiful. The Tower is surmounted by a lofty octagonal broach spire, having three tiers of single spire-lights disposed in alternate faces, and ribbed at the angles. The whole contour of this Tower is very good : it is not too much to say that it is one of the best modern designs we have seen. But we must protest against *supporters* to a coat-of-arms ; and the west door is by no means a very ecclesiastical design.

REPORT OF THE TWENTY-SECOND MEETING OF THE CAMRIDGE CAMDEN SOCIETY.

ON MONDAY, NOVEMBER, 22, 1841.

THE President took the chair at half-past seven o'clock.

The following candidates ware balloted for, and elected :—

Bayles, Rev. P. Corpus Christi college; Colchester
Berners, Rev. R. Everton, Suffolk
Boyce, W. Esq. Emmanuel college
Carlyon, Rev. P. Emmanuel college; 3, High-street, Colchester
Clarke, J. Esq. Corpus Christi college
Cooper, G. H. Esq. Trinity college
Evans, W. S. Esq. Trinity college
Field, T. Esq.·S. John's college
Francis, C. Esq. Trinity hall
Gould, Rev. E. Sproughton Rectory, Suffolk
Gray, S. Esq. S. John's college
Law, Rev. W. Great Linford, Newport Pagnell
Monkhouse, C. J. Esq. Trinity college
Oakes, H. P. Esq. Emmanuel college
Parkinson, J. A. Esq. Corpus Christi college
Perram, G. J. Esq. Clare hall
Tompkins, R. Esq. S. John's college
Turner, Rev. M. Emmanuel college; S. Matthew's, Ipswich
Woollaston, T. S. Esq. Fellow of S. Peter's college
Worlledge, E. Esq. Clare hall

A few presents having been acknowledged,

A report was read from the Committee, in which some remarks were made on the appearance of the *Ecclesiologist.*—It was announced that £25. had been granted to S. Sepulchre's, and £5. to the restoration of the church of the Holy Trinity, Meldreth : that £5. had been voted for procuring working-drawings of the beautiful wood-seats in the church of SS. Mary and Andrew, Whittlesford; that it had been determined to vault S. Sepulchre's with stone ; and that an Appendix to the Few Words to Churchbuilders had been published, containing lists of Fonts, Windows, and Rood-screens, intended to serve as models.

A paper was then read by the Rev. J. M. Neale, B.A. chaplain of Downing College, on the History of Pews.

A paper was read by H. G. Nicholls, Esq. of Trinity College, illustrated by several sketches, on the round towers of Ireland.

The meeting adjourned at ten o'clock.

———————

REPORT OF THE TWENTY-THIRD MEETING OF THE CAMBRIDGE CAMDEN SOCIETY.

ON MONDAY, DECEMBER 6, 1841.

IN the absence of the President, Professor WILLIS, V.-P., took the chair at half-past seven o'clock.

The following candidates were balloted for, and elected :—

Ainger, G. H. Esq. S. John's college
Babington, C. C. Esq. S. John's college
Barker, J. Esq. Christ college
Barr, A. Esq. Emmanuel college
Bennett, H. E. Esq. S. John's college
Berthon, E. L. Esq. Magdalene college
Birkett, Rev. R. Emmanuel college
Blades, Mr. J. Cambridge
Bryan, R. Esq. Trinity college
Bunch, Rev. R. J. Fellow of Emmanuel college
Bunning, J. B. Esq. Architect, 34, Guildford-street, London
Butler, Rev. Dr. Sidney Sussex college, Chancellor of Peterborough ; Gayton
Chisholm, A. Esq. S. John's college
Clark, W. G. Esq. Trinity college
Clarke, J. Esq. S. John's college
Cory, Rev. Robert, Fellow of Emmanuel college
Deane, Rev. J. B. Pembroke college ; Finsbury Circus, London
Deck, Mr. Norris, Cambridge
Field, J. W. Esq. S. John's college
Fleming, J. Esq. S. John's college
Frost, Rev. P. Fellow of S. John's college
Galton, F. Esq. Trinity college
‑Gladstone, Right Hon. W. E., M.P.
‑ Glynne, Sir Stephen R., Bart., Hawarden, Flintshire
Grasett, H. Esq. Clare hall
Gray, W. Esq. Thirsk
Grenside, W. B. Esq. S. Peter's college
Halkett, Rev. D. S. Trinity college ; Richmond Hill, Surrey
Halkett, H. Esq. Trinity college
Hartnell, E. G. Esq. Trinity college
Haskoll, J. Esq. Clare hall
Lefevre, Right Hon. J. S., M.P. Speaker of the House of Commons; Trinity
 college
Lefevre, J. G. Shaw, Esq. Auditor and late Fellow of Trinity college
Lower, H. M. Esq. S. Peter's college
Lyons, G. J. Esq. Trinity college
‑‑Manners, Lord John, Trinity college
Maude, G. S. Esq. S. Catharine's hall
M'Ewen, Rev. A. Magdalene college ; Semington, Melksham, Wilts.
Meggison, A. Esq. Trinity college
Oldham, J. A. Esq. Trinity college
Oliver, J. Esq. Queens' college
Pattinson, W. H. Esq. Caius college
Randolph, E. Esq. Jesus college
Read, W. Esq. S. John's college
Roberts, J. H. Esq. Clare hall
Scudamore, Rev. W. E. late Fellow of S. John's coll.; Ditchingham, Bungay
Selwyn, Rev. W., S. John's college; Branstone, Lincolnshire
Sherwood, Rev. T. M. Downing college ; Newent, Gloucestershire
Simpson, Rev. R. Trinity college
Slade, J. Esq. S. John's college
Snow, J. P. Esq. Trinity college
Tabor, R. S. Esq. Trinity college
Tate, Rev. A. Fellow of Emmanuel college
Thomas, J. H. Esq. S. Peter's college
Thornton, H. S. Esq. Trinity college
Thornton, Rev. W. J. Trinity college ; Llanwarne, Ross
Thorp, D. L. Esq. M.D. Caius college ; Cheltenham
Turner, J. B. Esq. Caius college
Walter, Mr., Architect, Cambridge
Webb, H. Esq. Doctors' Commons, London

Webster, S. K. Esq. Emmanuel college
Weston, G. F. Esq. Christ college
Williams, H. G. Esq. Emmanuel college

The President having taken the chair, the Lord Bishop of Exeter was admitted a Patron by acclamation.

The President announced that the Lord Bishop of London had intimated to the Committee his wish that his name should be erased from the list of patrons, on the ground of objections to one of the Society's Tracts; but as his Lordship had kindly condescended to specify his objections, he had presumed to submit to his Lordship explanations on those points which were still under his Lordship's consideration.

A list of churches sent in since the last meeting was then read by the Secretary; as also of presents received; among which were plates of the stained glass lately put up in S. George's church, Hanover-square, from T. Willement, Esq., and an inventory of goods belonging to the church of S. Mary, Steeple-Ashton, Wilts., in the 34th of King Henry VIII., from the Rev. W. C. Lukis.

The following Report was then read from the Committee:—

"In presenting their usual Report, the Committee first beg leave to congratulate the Society on the accession of sixty-four members during the last fortnight; making a total of one hundred and sixty-one fellow-labourers who have been added this Term to our body.

"The reception which the *Ecclesiologist* has met with from those whose approbation, were the Committee at liberty to mention their names, would confer honour on any literary undertaking, has more than compensated to them for the pain they have received at finding, in other quarters, their earnest endeavours for the good of the Society and its objects so much misunderstood. Before noticing this, we proceed to other matters.

"The number of subscribers is not at present sufficiently large to cover the expence of the work: but as names are pouring in every day, the Committee thought themselves justified, all circumstances considered, in bringing out a second number, which may be expected in a few days.

"A memorial has been presented to the Incorporated Society for Building and Repairing Churches and Chapels, suggesting a modification in their Instructions, and containing objections to some of their printed recommendations.

"Applications have been received from Spilsby, Lincolnshire, for a design for stained glass: from Brookfield, Kentish Town, for advice respecting the church which it is proposed to erect there: from Huntingdon, for a design for a pinnacle Cross.

"His Grace the Chancellor has presented £20. towards the S. Sepulchre's restoration fund.

"£40. have been placed at the Society's disposal for a Font about to be erected in Ryde.

"The Illustrations of Monumental Brasses (Part IV.) are before you.

"The History of Pews, which was read at your last Meeting, has been printed, and will appear in a few days.

"The President of the Society has, with the sanction of the Lord

Bishop of Gloucester and Bristol, kindly allowed the Committee to address a series of questions to every clergyman in his archdeaconry, from which it is hoped that much ecclesiological information will be gained.

"A Sub-committee has been appointed to consider the comparative expense and accommodation of pews and open wood-seats: their report will be read, and printed at the end of the History of Pews.

"Working drawings of the fine Perpendicular wood-seats at Whittlesford, have been completed, and are in the Society's portfolio: they are at the service of any one who may wish to have them for models.

"Working drawings of the fine Reredos at Harlton are in preparation; and the Committee have granted a sum for the preparation of working drawings of pinnacle Crosses.

"The following Remonstrance has this week been received by the Committee:—

"'We, the undersigned Members of the Cambridge Camden Society, feel ourselves compelled to remonstrate with the Committee on the character of a paper which appeared in their recent publication, 'The Ecclesiologist.' The subject of the paper referred to is the church now nearly completed in New Town: and its object appears to be to throw ridicule not only on that church, but on every similar attempt to supply the religious destitution of our overgrown population. The flippant tone in which this paper is written, appears to us singularly offensive. The following sentence may serve as a specimen—'As the Altar is not yet put up, and, *probably, not yet thought of,* we cannot say where it will be placed: indeed, *we are inclined to fear that it has been forgotten altogether.*'

"Fully convinced as we are of the benefits which the taste for architecture, fostered by the Camden Society in those who are to be our future parochial Clergy, may be the means of conferring upon the Church, we feel the more regret at observing such attempts as these to give a party character to its publications. We fear from this and other indications, that there exists in some quarters a desire to convert the Society into an engine of polemical theology, instead of an instrument for promoting the study and the practice of Ecclesiastical Architecture. We desire, therefore, to remind the Committee that it is their duty to guard against such a prostitution of its influence to purposes alien from its design. And we would beg them to remember, that as the objects of the Camden Society are co-extensive with the whole Church of England, and as its members are not confined to any particular party in the Church, it is, therefore, in the highest degree improper that any school of religious belief which is by the Church permitted to exist within her body, should, in our publications, be spoken of with disrespect.

"Signed by

"R. Willis, Jacksonian Professor, and Vice-President of the Society.
"J. M. Heath, Fellow and Tutor of Trinity College.
"A. Sedgwick, Woodwardian Professor.
"W. H. Thompson, Fellow and Assistant Tutor of Trinity.
"J. Grote, Fellow of Trinity College.
"W. C. Mathison, Fellow and Assistant Tutor of Trinity.
"W. J. Conybeare, Fellow of Trinity College.
"W. T. Travis, Chaplain of Trinity College.
"P. H. Frere, Fellow and Tutor of Downing.
"A. Thacker, Fellow of Trinity College.
"M. A. Atkinson, Fellow and Assistant Tutor of Trinity.
"Henry Calthrop, Senior Fellow and Tutor of Corpus."

" Your Committee feel called upon to take some public notice of
the above Remonstrance, signed by twelve members of the Society (one
of them being a member of the Committee), which, though addressed
to them in their official capacity, was inserted in the Cambridge news-
paper the day after they received it. They readily and sincerely express
the regret which they have felt on learning that the observations on
the church at New Town, contained in the first number of ' *The
Ecclesiologist*,' have given pain to any persons connected with that
district, and been thought likely, though most assuredly not designed,
to prejudice their efforts for its completion. But when they are
charged with a desire ' to throw ridicule, not only on that church, but
on every similar attempt to supply the religious destitution of our
over-grown population,' it seems only needful to draw a distinction,
which the Remonstrants have overlooked, between *the object* and *the
manner of effecting it.* More than one member of your Committee
have, in this very instance, shewn by deeds as well as words that they
admit the obligation which lies upon them, as Churchmen, to make
provision for extending the ministrations of the Church to those who
are now destitute of them; and they are persuaded they need not
assure any one who is conversant with the publications of the Society,
that a higher feeling than love of what is merely pleasing to the eye
or to the fancy led to the formation of the Society, and has given life
to the exertions of its members. But with regard to *the manner* in
which the object is to be effected, they claim for themselves that liberty
of forming and expressing an opinion which is allowed to every indi-
vidual, without which no improvement in the style of modern churches
can be ever hoped for, and through which alone those errors, which
modern architects have been candid enough to acknowledge in their
own designs, can be pointed out for the avoidance of their successors.
The opinion expressed in their publications with respect to the cha-
racter and arrangements of a church, and its conformity with rules
formed upon experience and investigation of our Rubricks and Canons,
they are not at liberty to repudiate ; and they gladly take this oppor-
tunity of correcting a misapprehension which exists in the minds of
some, as to the reasons why they have insisted on the value of atten-
tion to rules of architectural and ecclesiastical propriety. They pro-
test most decidedly against the assumption that theirs is simply the
province of ' taste,' or that the views which they put forth concern-
ing the erection of new churches are advanced in disregard of the
spiritual interests of souls perishing for lack of knowledge. They
have acted and spoken as Churchmen no less than as antiquaries,
desirous to make taste subservient (as it may be to a high degree) to
the promotion of sound religion, and under the strong conviction
that the arrangements to which they have invited attention have far
too great an influence to be sacrificed, as they too often are, more to
the architect's want of knowledge, than to any real necessity of the
case. For they do not hesitate to avow that they cannot look upon it
as an unqualified good (to speak without reference to any particular
instance) when a congregation, untrained in the faith and discipline of
the Church of England, is brought together in a place where the

sacraments can scarcely be decently and rubrically administered, and which possibly presents to the unlearned parishioner no mark of distinction from some neighbouring conventicle; and that they do not esteem it a trifling oversight, if such distinctions are needlessly disregarded.

"On these grounds they vindicate their conduct in presuming to pass judgment on any new church of which they cannot speak with entire approbation; and while they repeat their regret that the liberal and zealous patron and incumbent of S. Andrew's the Less should have been pained in any degree by an article in which no allusion was made or conceived to either of them, they cannot conceal their belief that a church might have been built for the same sum, whose style of architecture and plan of internal arrangement should have been after some approved ancient model, and that resources adequate to furnish more costly materials would have been forthcoming if such a plan had been pursued.

"But while they deny in the strongest terms the object with which this article has been charged by the Remonstrants, and regret that it was written in a bantering tone (for they do not admit that it can justly be called 'flippant,' or scornful) which has given offence to some of their members, it is impossible that they should fail to perceive that the remonstrance looks beyond this single article, and deals in insinuations which, they are persuaded, it is impossible to establish. They trust that they have never been forgetful of 'the duty of guarding against a prostitution of the influence of the Society to purposes alien from its designs;' and they answer the expression of 'regret at observing such attempts as these to give a party character to its publications,' and of 'fear that there exists in some quarters, a desire to convert the Society into an engine of polemical theology,' by begging the Remonstrants 'to remember that, as the objects of the Camden Society are co-extensive with the whole Church of England,' the Committee have never recognized the existence of 'any particular party in the Church;' and that 'it is in the highest degree improper that any school of religious belief which is by the Church permitted to exist within her body' should be hastily confounded with the fanatics of the seventeenth century, who have been spoken of in our publications in terms of unequivocal condemnation. Yet the logical connexion of the sentences of the remonstrance obliges them to regard it as insinuating that there is a party in the Church whose symbol is the disregard of Altars; inasmuch as the expression of 'fear that the Altar was forgotten altogether,' has been spoken of as 'an attempt to give a party character to our publications.'

"The article however was aimed throughout at architectural rather than doctrinal errors; and if the architect has felt himself aggrieved by it, as the person responsible for the right employment of the funds which the patron had difficultly and barely raised by a generous outlay from his own resources, and by repeated appeals to the public, the Committee are ready to make amends, in the most fitting manner, by offering their suggestions on the plan of a third church, which, as they understand, he has been employed to build in this town, and thus

assisting him to avoid those errors which they have, the more un-
sparingly as conscious of no ill-will to himself, pointed out in his
former production.

" It would be injurious in the extreme to suppose that so grave an
accusation would have been made without a careful examination of
the publications which the Remonstrants have condemned; and the
Committee will be glad at all times therefore to receive from those
gentlemen any intimation as to any specific points to which they
severally object. They will not stir up religious strife in the Uni-
versity, nor prolong a contest they have neither provoked nor antici-
pated. Neither have they any wish to stand upon argument, where no
principle is involved. Having vindicated their right to exercise their
criticism, and the justice of that which they have exercised in the pre-
sent instance, there is no acknowledgment they are not willing to make
of regret at having even unconsciously given pain. It is enough for
them to know it has been felt by those, whose exertions in a holy
cause entitle them to respect and gratitude. They have therefore
resolved to republish the first number of the *Ecclesiologist,* omitting
the article which has been objected to, and substituting for it such
a description of the church at New Town, as in manner as well as
matter shall afford no just ground of complaint or animadversion.
[The charge thus incurred will not be placed to the account of the
Society.]"

STATEMENT *of* ACCOUNTS *from May* 8, 1841, *to Dec.* 4, 1841.

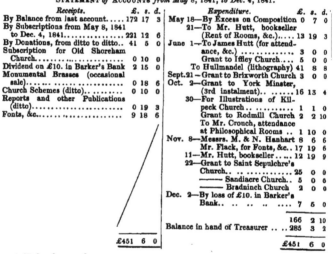

Receipts.	£.	s.	d.
By Balance from last account.....	172	17	3
By Subscriptions from May 8, 1841			
to Dec. 4, 1841................	221	12	6
By Donations, from ditto to ditto..	41	5	0
Subscription for Old Shoreham			
Church........	0	10	0
Dividend on £10. in Barker's Bank	2	15	0
Monumental Brasses (occasional			
sale)......	0	18	6
Church Schemes (ditto)..	0	10	0
Reports and other Publications			
(ditto)......................	0	19	3
Fonts, &c...... ,,.............	9	18	6
	£451	6	0

Expenditure.	£.	s.	d.
May 18—By Excess on Composition	0	7	0
21—To Mr. Hutt, bookseller			
(Rent of Rooms, &c.)....	13	19	3
June 1—To James Hutt (for attend-			
ance, &c.)	3	0	0
Grant to Iffley Church....	5	0	0
To Hullmandel (lithography)	41	8	8
Sept. 21—Grant to Brixworth Church	3	0	0
Oct. 2—Grant to York Minster,			
(3rd instalment)..	16	13	4
30—For Illustrations of Kil-			
peck Church..	1	1	0
Grant to Rodmill Church	2	2	10
To Mr. Cronch, attendance			
at Philosophical Rooms ..	1	10	0
Nov. 8—Messrs. M. & N. Hanhart	8	6	6
Mr. Flack, for Fonts, &c..	17	19	6
11—Mr. Hutt, bookseller	12	19	9
22—Grant to Saint Sepulchre's			
Church..	25	0	0
——— Sandiacre Church..	5	0	6
——— Bradninch Church	2	0	0
Dec. 2—By loss of £10. in Barker's			
Bank..	7	6	0
	166	2	10
Balance in hand of Treasurer	285	3	2
	£451	6	0

Audited and approved
R. PHELPS, } *Auditors.*
JAMES HILDYARD,

A. S. EDDIS, *Treasurer.*

Professor Willis explained his reasons for affixing his name to the above-mentioned memorial ; and the President pointed out the misapprehension under which he conceived the memorialists to labour.

A report was then read by H. Goodwin, Esq., B.A., Fellow of Caius College, from the Sub-committee appointed to examine the comparative accommodation and expense of pews and open seats. Some plans and sketches were brought forward in illustration of this paper ; and a copy of one of the poppy-heads in the church of S. Andrew, Chesterton, carved in oak, was exhibited.

A paper was read from the Rev. W. C. Lukis, B.A. Trinity College, containing a translation of the contemporary account given in the Black Book of the Bishop of Coutances, of the consecrations of the churches S. Michael, S. Sampson, and S. Saviour's, in Guernsey.

Another paper was read from the Rev. W. C. Lukis, on the Cluniac Priory of S. Mary Magdalene, Monkton Farleigh, illustrated by several drawings ; and an impression from a private seal of one of the monks in that Priory. The meeting adjourned a little before ten o'clock.

S. SEPULCHRE'S CHURCH.
PROGRESS OF THE WORKS.

THE restoration of this fine old church is proceeding steadily, and may now be soon completed, should the funds prove sufficient for the purpose. The timber frame of the conical roof already surmounts the round Tower. It is of a very high pitch, but seems excellently proportioned to the size of the Tower, to which it imparts a graceful, yet strictly primitive appearance. It is placed immediately upon a low course of brickwork, in the middle of which a strong band of iron, encircling the top of the Tower, is firmly bonded, in addition to one which we before described as carried round about midway, to keep the shattered fabrick from further injury. The utility and permanent strength of this kind of constructive aid has been amply tested in the well-known case of the Tower of Salisbury Cathedral, in building which iron clamps were abundantly used, and are doubtless to this day the sole support of that stupendous edifice. The masonry of S. Sepulchre's church proves to have been of a very weak and inferior description, consisting of a mere shell of Barnack stone, raised, in all probability, without the aid of line or rule, and filled in with gravel and rubble mixed with great quantities of coarse earthy mortar, of very little strength or consistency. The south wall of the Aisle, which had declined seriously from its perpendicular position, has been taken down to within about six feet of the ground, and will be forthwith rebuilt in a manner capable of sustaining the stone groining with greater security than before. Plain single Norman lights will be substituted for the unsightly Perpendicular insertions which disfigured, as well as weakened, the walls of the circular Aisle. These are about a yard in thickness, and are cased outside with dressed ashlar, and inside with regular courses of small round flints mixed with rubble, which have been much used in the construction of the church. A fragment of an ancient stone coffin has been discovered by the workmen : and a great part of the stonework of a small but very curious doorway, which

had been used as steps in a much later part of the fabrick. Seven of the voussoirs, the two imposts, each cut into four plain cushion capitals to fit as many half jamb-shafts, and a considerable portion of the jambs themselves, have been recovered. These voussoirs are ornamented in the soffit with a large and deep triple chevron moulding, which is a very interesting and important fact, as a moulded soffit hardly ever occurs in Norman work, and is considered by Mr. Millers, in his account of Ely Cathedral, though, as we conceive, without sufficient reason, as a distinctive mark of Saxon work. However this may be, the doorway is evidently of equal, if not of greater antiquity than the rest of the church, and the pieces are carefully preserved, with a view to having them replaced in some appropriate part.

By removing the superstructure from the round Tower, about 300 tons weight of material, exclusive of four heavy bells, have been removed. So great was the pressure, that several stones have started on the south side between two of the pier arches. Upon removing the whitewash and plaster from these and other parts of the church, fresco paintings in red and black have been found. It has also been satisfactorily ascertained that the church originally consisted simply of the circular Tower, with the Aisle continued round it, a portion of which was removed when the present Chancel and north Aisle were erected.

THE WORD "ALTAR."

Sir,—Could you devote a small space in the next number of the *Ecclesiologist* to explain why the word *Altar* is always used in the publications of the Cambridge Camden Society, instead of *Communion-table*, as it is called in the rubrick and canons of our Church ; as it would give satisfaction to myself, and many other members of the Society. I remain, Your obedient Servant,

To *the Editor of the Ecclesiologist*. ———.

We willingly comply with the wish of our correspondent : and we do so by informing him, for instance, that we do *not always* use the word ALTAR, (see our "Few Words to Churchwardens," part II. pp. 10, 11, and Report for 1841, p. 9.) Nor does our Church *always* use the term TABLE (see the Coronation Service, passim): and she has repeatedly used it in occasional forms of prayer ; *e.g.* in that 'for averting God's Visitation,' pp. 3, 4, 30, 31, 56, 57, 58, 59, 70, 71, 72, 79, and in that of 1634, pp. 34, 35. But the reasons for our using the word *Altar*, when we do use it, right or wrong, are as follows :—

1. Because it is consonant with primitive antiquity. " And whereas it offendeth many that we sometimes call the Lord's table an Altar, and dispose of it Altarwise : in oppugning whereof it hath been charged with Popery, and constantly (but ignorantly) affirmed, that in the Primitive Church it was not named an Altar for ccc years after Christ : to give satisfaction herein, and hereabout, both to priest and people, I avow, upon certaine knowledge out of my poore reading, that for all the time articulate, the word Table is not above thrice used, but ever Altar ; and of Ecclesiastical writers within that time, Dionysius Areopagita hath it, and that but once, and occasionally, which assertion (I am sure) cannot be refuted : and therefore if we

Professor Willis explained his reasons for affixing his name to the above-mentioned memorial ; and the President pointed out the misapprehension under which he conceived the memorialists to labour.

A report was then read by H. Goodwin, Esq., B.A., Fellow of Caius College, from the Sub-committee appointed to examine the comparative accommodation and expense of pews and open seats. Some plans and sketches were brought forward in illustration of this paper ; and a copy of one of the poppy-heads in the church of S. Andrew, Chesterton, carved in oak, was exhibited.

A paper was read from the Rev. W. C. Lukis, B.A. Trinity College, containing a translation of the contemporary account given in the Black Book of the Bishop of Coutances, of the consecrations of the churches S. Michael, S. Sampson, and S. Saviour's, in Guernsey.

Another paper was read from the Rev. W. C. Lukis, on the Cluniac Priory of S. Mary Magdalene, Monkton Farleigh, illustrated by several drawings ; and an impression from a private seal of one of the monks in that Priory. The meeting adjourned a little before ten o'clock.

S. SEPULCHRE'S CHURCH.
PROGRESS OF THE WORKS.

THE restoration of this fine old church is proceeding steadily, and may now be soon completed, should the funds prove sufficient for the purpose. The timber frame of the conical roof already surmounts the round Tower. It is of a very high pitch, but seems excellently proportioned to the size of the Tower, to which it imparts a graceful, yet strictly primitive appearance. It is placed immediately upon a low course of brickwork, in the middle of which a strong band of iron, encircling the top of the Tower, is firmly bonded, in addition to one which we before described as carried round about midway, to keep the shattered fabrick from further injury. The utility and permanent strength of this kind of constructive aid has been amply tested in the well-known case of the Tower of Salisbury Cathedral, in building which iron clamps were abundantly used, and are doubtless to this day the sole support of that stupendous edifice. The masonry of S. Sepulchre's church proves to have been of a very weak and inferior description, consisting of a mere shell of Barnack stone, raised, in all probability, without the aid of line or rule, and filled in with gravel and rubble mixed with great quantities of coarse earthy mortar, of very little strength or consistency. The south wall of the Aisle, which had declined seriously from its perpendicular position, has been taken down to within about six feet of the ground, and will be forthwith rebuilt in a manner capable of sustaining the stone groining with greater security than before. Plain single Norman lights will be substituted for the unsightly Perpendicular insertions which disfigured, as well as weakened, the walls of the circular Aisle. These are about a yard in thickness, and are cased outside with dressed ashlar, and inside with regular courses of small round flints mixed with rubble, which have been much used in the construction of the church. A fragment of an ancient stone coffin has been discovered by the workmen : and a great part of the stonework of a small but very curious doorway, which

had been used as steps in a much later part of the fabrick. Seven of the voussoirs, the two imposts, each cut into four plain cushion capitals to fit as many half jamb-shafts, and a considerable portion of the jambs themselves, have been recovered. These voussoirs are ornamented in the soffit with a large and deep triple chevron moulding, which is a very interesting and important fact, as a moulded soffit hardly ever occurs in Norman work, and is considered by Mr. Millers, in his account of Ely Cathedral, though, as we conceive, without sufficient reason, as a distinctive mark of Saxon work. However this may be, the doorway is evidently of equal, if not of greater antiquity than the rest of the church, and the pieces are carefully preserved, with a view to having them replaced in some appropriate part.

By removing the superstructure from the round Tower, about 300 tons weight of material, exclusive of four heavy bells, have been removed. So great was the pressure, that several stones have started on the south side between two of the pier arches. Upon removing the whitewash and plaster from these and other parts of the church, fresco paintings in red and black have been found. It has also been satisfactorily ascertained that the church originally consisted simply of the circular Tower, with the Aisle continued round it, a portion of which was removed when the present Chancel and north Aisle were erected.

THE WORD "ALTAR."

Sir,—Could you devote a small space in the next number of the *Ecclesiologist* to explain why the word *Altar* is always used in the publications of the Cambridge Camden Society, instead of *Communion-table*, as it is called in the rubrick and canons of our Church ; as it would give satisfaction to myself, and many other members of the Society. I remain, Your obedient Servant,

To the Editor of the Ecclesiologist. ———.

We willingly comply with the wish of our correspondent: and we do so by informing him, for instance, that we do *not always* use the word Altar, (see our "Few Words to Churchwardens," part II. pp. 10, 11, and Report for 1841, p. 9.) Nor does our Church *always* use the term Table (see the Coronation Service, passim): and she has repeatedly used it in occasional forms of prayer ; *e.g.* in that 'for averting God's Visitation,' pp. 3, 4, 30, 31, 56, 57, 58, 59, 70, 71, 72, 79, and in that of 1634, pp. 34, 35. But the reasons for our using the word *Altar*, when we do use it, right or wrong, are as follows :—

1. Because it is consonant with primitive antiquity. "And whereas it offendeth many that we sometimes call the Lord's table an Altar, and dispose of it Altarwise : in oppugning whereof it hath been charged with Popery, and constantly (but ignorantly) affirmed, that in the Primitive Church it was not named an Altar for ccc years after Christ: to give satisfaction herein, and hereabout, both to priest and people, I avow, upon certaine knowledge out of my poore reading, that for all the time articulate, the word Table is not above thrice used, but ever Altar ; and of Ecclesiastical writers within that time, Dionysius Areopagita hath it, and that but once, and occasionally, which assertion (I am sure) cannot be refuted : and therefore if we

will, as we profess to do, follow the course and practice of the ancient Primitive Apostolical Church, we ought not to traduce or be offended at the name, thing, or use of Altar, whereat a manifold sacrifice is offered to God."—Bp. Montague's *Primary Visit. Art.* vii. 12.

2. Because the term was used by the great Doctors of our own Church —Andrewes, Overall, Hall, Bramhall, Jeremy Taylor, Whitgift, Hooker, and Waterland. (Works, vol. viii. p. 331.) See especially Dr. Lawrence's *Sermon preached at Cambridge,* Feb. 7, 1635, pp. 22 et seq. ; and Reeves's *Explanation of the most sacred Catechism,* pp. 133 et seq.

3. Because in many passages of our Tracts, as also in our Church Schemes, we are speaking historically of the Altars before the Reformation ; where it would be absurd to employ the other word. When not so speaking, (as in the Church Schemes,) we have also used the word *Table.*

4. Because the Rubrick, (authorized by the first Rubrick of our Prayer-Book,) which orders two lights " for the signification that Christ is the very true light of the world," orders them to be placed "on the High Altar."

5. Because the word is so generally used in common parlance, that, were the above reasons insufficient, there could be no objection to the use of the term.

NEW ZEALAND.

The Lord Bishop of this diocese will shortly sail, bearing with him the best wishes and prayers of all who, like ourselves, long to see the ministrations and discipline of our Church extended wherever the British name is known. The Committee of the Cambridge Camden Society have furnished him with the design for a parish church, which we mentioned in our last number. It is modified from that of Than church, near Caen, in Normandy, and consists of Chancel, Nave, two Aisles to each, Transepts, and central Tower. The Chancel is raised on two steps ; the Altar on five more. The Vestry is screened off by a parclose of carved oak, at the south-west corner of the south Chancel aisle. The Tower is surmounted by a pyramidal capping; the Clerestory of the Nave is simply arcaded, every third compartment being pierced for a light. But we need not dwell at any length on the design, as a lithograph of it is about to be published.

PUBLICATIONS of the CAMBRIDGE CAMDEN SOCIETY.

Since our last number, the fourth part of the "Illustrations of Monumental Brasses" has appeared. The first memoir which it contains is that of Dr. Hawford, Master of Christ's College during the first half of the reign of Queen Elizabeth, and a firm upholder, in the face of great opposition, of the rites and ceremonies of our Church, and the discipline and statutes of our University. The vignette represents the magnificent East window of the church of SS. Peter and Paul, Fen Stanton, Huntingdonshire, which it is proposed by the Cambridge Camden Society to restore. The subject of the next paper is John Tame, Esq., who built the church of S. Mary, Fairford, Gloucestershire, and presented to it the stained glass which is so well known. Of this glass an account is given in the paper. In the vignette are

represented the piscina, sedilia, and magnum sedile of S. Mary, Meysey Hampton, Gloucestershire. The third plate represents Dr. Thomas Nelond, twenty-sixth Prior of S. Pancras, Lewes, and Rector of Cowfold, Sussex. Little being known respecting this ecclesiastic, the writer of the paper has thrown his remarks into the form of a contemporary letter, giving an account of the funeral of Dr. Nelond. In the vignette we have the Chancel and Sanctum sanctorum from Bishopstone, Sussex, a church remarkable for its Saxon Tower and north Aisle. The last plate represents Sir Andrew Luttrell, from the church of S. Andrew, Irnham, Lincolnshire, and an elaborate history of his family is given in the adjoined paper. The vignette represents the monument of one of the Luttrells in the same church.

THE History of Pews, which was read before the Society on Monday, November 22, has just appeared. An Appendix has also been published, containing, under the title of The Statistics of Pews, the report of the Sub-committee on the comparative accommodation and expence of pews and open benches, which establishes this very important fact—that where the comparison is most favourable for pews, with respect to the number accommodated, PEWS INVOLVE A LOSS OF TWENTY PER CENT. AS COMPARED WITH OPEN SEATS.

INSCRIPTION FOR A FONT

REMOVED FROM THE CHURCH, AND USED AS A VASE FOR FLOWERS
IN A GARDEN.

ὦ ξεῖν' ἄγγειλον τάδ' ἐπισκόπῳ, ὅττι με τῇδε
εἶδες ὑπ' ἀργαλέης ἀνθοφοροῦντα τύχης,
ὃς τὸ πρὶν, ἱδρυθεὶς ἱεροῖς ἐνὶ δώμασι Χριστοῦ,
ἄνθεα φυταλίαις οὐρανίαις ἔφερον.
εἰς ἐμὲ γὰρ βαφθέντες ἐν ὕδατι Πνεύματί θ' Ἁγνῷ
ἀνθρώπων παῖδες τέκν' ἐγένοντο Θεοῦ.
νῦν δέ μοι ἄλλα μέμηλ', ἐμὰ δ' ἄνθεα γήϊνα πάντα.
ὦ πότμος ἀλγινόεις, ὦ κλέος οὐκέτ' ἐμόν.

W. S.

NOTICE.

The number of subscribers to the *Ecclesiologist* is now such as to justify the Committee in announcing a continuance of the publication. The annual payment of five shillings, which will entitle subscribers to twelve sheets, published at convenient intervals, and transmitted post-free, may be most readily paid by a post-office order, addressed to *Mr. Stevenson, Cambridge.* It is very desirable that those who intending to subscribe have not yet given in their names, should do so as soon as possible, either to the Secretaries, or to the Publisher, Mr. Stevenson.

[*Second Edition. October* 1842.]

Published by T. STEVENSON, *Cambridge:* J. H. PARKER, *Oxford:*
RIVINGTONS, *London.—Price* 4d.

METCALFE AND PALMER, PRINTERS, CAMBRIDGE.

THE

ECCLESIOLOGIST

PUBLISHED BY THE CAMBRIDGE CAMDEN SOCIETY.

"**Donec templa refeceris.**"

No. III. JANUARY, 1842.

SUGGESTIONS FOR COOPERATION WITH THE OBJECTS OF THE SOCIETY.

(Continued.)

HAVING, in our last number, disposed of the least satisfactory case of a convert to Camdenian enterprise, we proceed, according to promise, to offer a few suggestions to other individuals, who may have been inspired by the same commendable zeal for church architecture and church restoration, but who feel themselves to be in certain respects but indifferently qualified to carry their desirable intentions into execution.

Now it is clear that most aid in the cause may be looked for from those who not only possess correct knowledge and taste in ecclesiastical architecture, but who have means to effect, or at least influence to procure, the repair and preservation of existing beauties, the removal of barbarisms, and the prevention of further mutilations, in churches over which they exercise any controul, or in which they take any especial interest. And if such should add to these qualifications leisure and inclination for research, and prompt activity in corresponding with us or other determined opposers of modern innovation in our ancient churches, they will be true and efficient Camdenians in every sense of the word, and will act so as to deserve the best thanks of our Society, and of every good Churchman of sympathetic feeling.

But it much more frequently happens, that an individual has knowledge without adequate means, or (the most dangerous position of all) means without knowledge; or he finds no one in his neighbourhood to share in his exertions or attend to his suggestions; or he is discouraged by the opposition he meets with in his endeavours to restore things to something like their primitive order, or disheartened by finding how little individual effort avails in stemming the tide of innovation which

threatens to obliterate the last vestiges of ancient splendour which the stormy days of past times have yet spared to us. To all such we say simply, *Persevere.* There is that feeling abroad which will not allow any one, zealous in the Church's cause, to remain long an isolated being, or to be regarded as of suspicious character and more than half a Jesuit, just because he admires and would fain restore rood-screens, and stained glass, and open-seats; and would substitute costly appurtenances for cheap make-shifts in celebrating the ordinances of the Church. Where individual exertion leads the way, there others will follow in the track; and where a cause is really a good one, there efficient supporters will readily be found.

But there is one highly important suggestion which we will venture here to make. It is this: that such as have inclination and means to further Camdenian purposes, should never act without the advice of those who, though themselves destitute of means, may be amply competent to direct and superintend the application of them for others. Thus knowledge and means must ever co-operate with and accompany each other: for as misdirected zeal has ever been productive of the most lamentable consequences, so misapplied resources may do, and too often have done, far more harm than good. To do a thing correctly is not necessarily more expensive than to do it amiss; and again, to do actual mischief may cost just as much as to do positive good. Many a fine church might have been built with the money which has been expended in the last century in wilfully mutilating Gothick window tracery, or giving a theatrical effect to a carved oak roof. There have been no Camdenians abroad in the land; taste has not been early nurtured and matured in the bosom of the Church by a study of her grandest edifices, her chastest ornaments; and their almost total destruction in the lapse of years has been the inevitable consequence.

Some persons are hardly aware how much may be done even in the most unpromising cases, by a little well-timed advice, or a little good-natured expostulation: for although parish functionaries are not always possessed of refined taste, it is a mistake to regard them invariably as irreclaimable barbarians. Others, again, will find with pleasure that much deference will sometimes be paid to their opinions as members of the Cambridge Camden Society. A solitary wanderer over the country, with his pencil and note-book, and a church-scheme for his passport, may in a single day procure the restoration of half-a-dozen fine old Fonts, and that at the expense of about as many words on his part, simply by pointing out their age and describing their beauties. Thousands of curious relics of antiquity yet lie in neglect and decay in village churches, merely because their use is not known, and therefore their value not appreciated. We well remember interfering with success for the preservation of a remarkably fine old carved oak pulpit, which, as no one appeared to know its age or comprehend its excellence, was condemned to be removed and superseded by a cumbrous modern fabric, at the very useless expense of about £40. At another time we happened to walk into a carpenter's shop just as he had sawn into several pieces a noble old rood-screen to make frames for newly-painted tables of the Commandments; and this because nobody in the

parish could tell what its use had been. On another occasion we remember to have seen a large slice of exquisite Decorated tracery cut away from a Parclose, because (will it be credited?) its contiguity discomposed the capacious wig of the occupant of a neighbouring pew! who, however, very gravely promised us to make up for his fault by giving the poor mutilated wood-work "a good jacket of blue paint next Michaelmas." Once we found a very good Altar-table of the seventeenth century ejected, and its room supplied by an enormous rough iron-clasped church chest! And once we discovered that an extremely curious pavement of ancient encaustic tiles had been remorselessly covered over with a new deal floor, because forsooth a lady could not logically comprehend a sermon while her feet were cold. Any one might relate similar cases, who has cared to observe them: the frequency of their occurrence is a proof of how much there is to be done in preventing the perpetration of such enormities. Therefore we say to all, that there is no lack of work, if there be none of energy on their own parts to perform it.

To the mere antiquarian we would say, Send careful written accounts—if possible, accurate drawings—of churches and architectural details, to the Secretaries at Cambridge; and your Society will know how to apply them. Make extensive use of the Church-schemes; give information on ecclesiological subjects wherever you can; and endeavour to impart to all you can a zeal and relish for your own favourite and useful study.

We may venture to add the expression of our gratitude to a great number of ladies, who, though the constitution of our Society does not allow us to receive them as members, have nevertheless acted, and do daily act, in our behalf, with a zeal which many of our body would do well to imitate. For their influence in furthering our cause they are entitled to our best thanks; and of their taste and proficiency in the knowledge of ecclesiology we are daily receiving the most convincing assurances.

ENCAUSTIC TILES.

ONE of the most interesting works which have recently appeared on the subject of Ecclesiastical Antiquities, is that entitled " Examples of Inlaid Gothic Tiles."* Of this publication the Editor has presented us with a copy; and we advise all who are desirous to see this fine department of ancient art revived in all its primitive excellence, to examine it for themselves. The book is a small quarto volume, containing twenty-four specimens of painted tiles, of the actual size and colour: the engravings are struck off on paper tinted to suit the colour of the patterns on the original tiles, and the tiles themselves are of a deep brownish red. The specimens seem judiciously selected, and are excellent models for imitation. We trust that Messrs. Chamberlain, the manufacturers of encaustic tiles at Worcester, will adopt these, and

* Nichols and Son, Westminster.

D 2

such as these, rather than the patterns we have seen from their works, which are too much in the style of modern oil-cloth designs, to please a critical eye.

Of ancient encaustic tiles there are three sorts.

1. Where the pattern is in relief, and of the same colour as the ground. These appear the most ancient: the devices upon them (as indeed upon most others) are usually heraldic, that is, either actual bearings, such as plain ordinaries, or lions passant, rampant, combatant, addorsed, reguardant, &c., mullets, and similar designs. The colour varies from black to red, all the intermediate shades being sometimes found in the same piece of pavement, and probably produced by different degrees of heat in the burning, rather than by any difference in the material of which they are composed. These tiles are usually from three to five inches square: they are probably in a few instances of Norman era, and are of rare occurrence. Some excellent examples are preserved in the Castle of Castle Rising, Norfolk. They appear to have been glazed by being burnt to a vitrified state.

2. The second kind of encaustic tile is where the pattern is impressed or indented. In this case the lines are usually rather fine, (about the thickness of ordinary wire,) and the patterns simple ; for the most part consisting of interlaced circles, or parts of circles, in the centre of the tile. These appear to be of Early-English date : two specimens are in the possession of the Cambridge Camden Society, but they are not commonly met with. To the same age and class we refer those small plain glazed tiles, of a greenish-blue tint, which are by no means uncommon, though antiquarian taste seems to have thought them hardly worthy of notice, as they are little known by description. With this tile Byland Abbey and many small country churches were paved. The forms are usually either square or semi-circular : they were perhaps used in considerably later times.

3. The third kind is the most common, the largest, most varied, and by far the most beautiful. It is of this sort that the work before us gives specimens. They are from three to six inches square, appear to have been highly glazed (though the glazing seldom remains at the present time), and seem to have been made by filling with a clay which bakes yellow or white, an indented pattern in a sun-dried or half-burnt brick which bakes red. These tiles are of course durable in proportion to the depth of the white or yellow clay. A mere surface-pattern would be trampled out very shortly : and we think that the tiles from the manufactory of Messrs. Chamberlain should be inlaid rather deeper than they appear to be. It is probable that this kind of tile was not used before the end of the thirteenth century. The very perfect and beautiful specimens in S. Cross's Hospital, near Winchester, (paintings of some of which may be seen in our folio of drawings,) are traditionally, we believe, called Norman, but they are probably of not earlier date than the Decorated west window : there appear, however, to be several kinds of encaustic tiles in that church, which must be discriminated from each other as of different styles. The heraldic bearings upon them will, of course, not unfrequently determine the precise date of such tiles. They very commonly occur of such a device, that several tiles placed contiguously compose a complete pattern.

The work before us is, we are very glad to find, the first of a series, which, as it will prove highly interesting and valuable, we hope will obtain an extensive circulation. One suggestion we will venture to make ; namely, that where the pattern on the tiles is carried quite to the edge of the brick, the outline of the latter should be given. From the want of this, the tinted paper being the same colour as the pattern, some of the engravings look like broken bricks, *e. g.* Nos. 7, 8, 23, 24. The arms in the last example are incorrectly blazoned in p. 2. The shield is not paly of six, but paly of eight ; and the mitre in chief should have been mentioned, because it is a curious example of an early method of distinguishing a Bishop's arms by adding the badge of a mitre instead of impaling them with those of the see.

THE TEMPLE CHURCH, LONDON.

MOST of our readers are doubtless aware that this beautiful and curious church is at present in course of reparation, on a scale of costliness and magnificence which has no parallel within the last few centuries. We wish now to give some account of the alterations in progress, and to call attention to the noble example set by the honourable Societies at whose charges the works are undertaken.

The church consists of a circular Nave with surrounding Aisle of Transition character, and a spacious Chancel with Aisles, of the purest Early-English. The building had shared the same fate as most of the religious edifices of this country : the coloured enrichments of the walls and vaulting had been painted out ; the Purbeck marble shafts had been concealed by paint and whitewash ; and the stained glass quite destroyed. But in the mean time some attempts had been made to secure the comfort and snugness which our more immediate ancestors seem to have valued so highly. The walls were wainscoted to the height of seven or eight feet ; the interior was furnished with spacious pues, which had high walls and locked doors ; and the central arch from the Chancel to the circular Nave (a very curious specimen of architecture), was entirely blocked up by a massive partition, surmounted by an organ with its usual cumbrous and grotesque ornaments. The Altar-screen was profusely decorated with the most inappropriate symbols : cherubs, garlands, vases, and it is even said the ox-scull, were to be seen in every part of it. The pulpit and its satellites were of course not neglected ; and the whole mass of timber, from its ridiculous dimensions and assumed importance, actually reduced the apparent size of the church to about half its proper proportion. But besides this, in order to produce yet greater warmth and dryness, the floor was covered to a depth of several feet, by a layer of rubbish, which encroached considerably on the bases of the columns.

So far, however, the fabrick of the church remained nearly untouched, and the very concealments perhaps preserved much that would otherwise have been destroyed. But the indiscriminate admission of monumental compositions and tablets completed the mischief. Every

flat surface in the church became covered with a field of monuments of the most heterogeneous and unseemly character; and to procure more room, the very pillars were hacked away to admit a variety of slabs. In some cases the larger monuments were placed in cavities cut out of the heart of the external walls, and even windows were blocked up to make room for others.

Such was the almost hopeless state of the building, when, some doubts having arisen as to its stability, a committee was chosen about two years since from the two Societies, to examine into the general state of repair, to obtain professional assistance, and to report accordingly. The Committee exerted themselves nobly, and after some time presented a statement, distinguished as much for its accuracy and completeness, as for the taste and judgment of its recommendations.

This document advised among other things,—that the floor should be reduced to its original level, and the area paved with coloured encaustic tiles, copied from existing specimens of the same age as the building ; that the pues and accompaniments should be entirely removed, and a triple row of richly-carved stalls ranged longitudinally along each Aisle, the Chancel being furnished with suitable open-seats ; that the organ should be removed, and the beautiful Chancel-arch set free ; the shafts stripped of their plaister, renewed where necessary, and polished highly ; the roof and walls decorated in designs closely followed from coeval remains, and executed in the brightest tints of the original ; the windows, and particularly those at the east end, filled with stained glass of the style of the thirteenth century; and, above all, the monuments unreservedly ejected. This last measure seemed the more necessary, as it was obvious that they had in many cases materially injured the stability of the sacred building.

This general sketch will serve to shew the grandeur of the, scheme of restoration proposed by the Committee : and we must express our regret that a report, so interesting in its scope and able in its execution, and so valuable in at least a historical point of view, in connection with so famous an edifice, should not have been made publick, as well for its intrinsic value as for the sake of its example.

It reflects no little praise on the Templars that this plan was forthwith put into execution, and, in spite of occasional opposition, has been steadily progressing. Some were found to desire the re-erection of the organ-screen, and some objected to the decoration of the vaulting : but these obstacles speedily gave way, to be replaced however, it is to be feared, by a worse ; even by a wish to bring back the monuments, with all their ugliness and all their hurtfulness. We have heard with equal pain and astonishment, that this subject is actually now in contention; but we can scarcely think that any one, in this day of revived architectural taste, will be found to go any great lengths in the defence of such hideous, as well as injurious, deformities.

But it becomes doubtless a matter of grave consideration, how to retain these sepulchral memorials without an offensive contrast to the restored edifice ; for it is heartless to destroy wantonly any monumental record, however ugly may be its shape or wretched its execution. The Committee, we understand, strongly recommended the erection of a

cloister to contain them : and certainly this plan, though costly, is the
very best which could be devised.* Should however any impediments
render the adoption of this design unfeasible, we would suggest a
method which seems likely to meet the views of both parties in the
controversy. Why might not the surface of the blank arches in the
lowest stage of arcade in the circular Nave be faced with plates of brass
or other metal, on which all the inscriptions from these offensive monu-
ments might be accurately copied in strict chronological order? Thus
the very words of the epitaphs would be retained, and their value as
records would be increased by their arrangement according to date.
And if the legends were incised in a proper letter, with ornamented
capitals, the effect to the building would be very good, as it would
harmonize with the rest, and would relieve a large area of ashlar.
Every word would be legible from the convenient situation of the
arcade; and the surface being much more than sufficient for present
wants, might be made available for future additions. While on this
subject, we would refer to a "Letter on the Sepulchral Memorials of
past and present times, by J. H. Markland, Esq.;"† which contains
not only many judicious remarks on the subject generally, illustrated
by very apposite quotations, but suggests at some length a scheme
somewhat similar to that here recommended—the inscription, namely,
of the monumental records of deceased benefactors upon stones in-
serted in the walls, or rather upon the walls themselves. To this we
would object, that it is better to leave the fabrick of the church quite
untouched and distinct ; besides that there is no authority for such
incisions : whereas brass or other metal is eminently fit for such an use,
both by its allowing a smaller and more ornamental letter, and by its
having every advantage of being a mere adjunct to the building, with-
out any of the usual objections. And again, there is direct authority
for facing a large area with brass in the way described, as many of our
readers will remember, in the south Transept of the Cathedral church
of Amiens.

But to return to the Temple church : we shall look out anxiously for
the decision of the Templars on this important point, and on several
other matters connected with the internal arrangements, more particu-
larly those relating to the Altar. The present sketch will give
such as are interested—and who can not be interested in this beautiful
and curious church?—a general view of the proposed restorations.
We hope to be able to furnish our readers, at a future period, with
more minute accounts of the several parts of the work.

S. Sepulchre's, Cambridge.—Scarcely less interesting, though not
nearly so costly as the restoration of the round church of London, is
that of its Cambridge sister. Since the publication of our last number,
the wall of the south part of the circular Aisle has been firmly rebuilt
with (as far as possible) the original ashlar, and the vaulting very
successfully restored. In this wall plain Norman windows have been

* A beautiful Chapel on the south side of the Temple church was destroyed not
many years since. It is obvious how useful this might have been made for some
such purpose as this.
† Rivingtons. (Since expanded into "Remarks on English Churches."]

introduced, and two corresponding windows have been inserted on the north side, in the room of the Perpendicular additions. The rafters of the Aisle are also fixed, so that the general outline of the church is fairly discernible. The conical top also has been boarded, previously to the reception of the Northamptonshire slates, which have been selected for the material of the roof. The west window in the clerestory is also supplanted by one copied exactly from the original one remaining to the east. Further investigations have made it evident that the fragments described in our last as belonging to a door, belong really to the original arch into the apse. It is proposed shortly to publish a view of the church as restored, the proceeds of which will be applied to the fund.

THE NECESSITY OF CHANCELS.

To the Editor of the Ecclesiologist.

SIR,—I trust you will excuse an architect, who is extensively engaged in Ecclesiastical buildings, and who has derived much benefit from the works of the Cambridge Camden Society, in asking explanation on a point which has caused him much practical difficulty, and which may be comprehended in this question, "What is the correct definition of a Chancel?"

Having lately submitted to a Church Committee a design constructed like the Temple church, with three high-pitched roofs, but with the centre or Nave projecting one compartment eastward of the Aisles, and my conscience being upbraided by reading your urgent remonstrances against the omission of a Chancel; I sent a second plan, having a regular and distinct Chancel, as usually seen in old churches, accompanied by the best arguments I could think of; among which was this— that the Temple church, and many others which have three gables in the east end in one range, are no precedents for the omission of a Chancel, being themselves *Chancels*. I was however strongly opposed, but would not yield an inch, and am on the point of gaining my object, chiefly through the instrumentality of one of your Society's works, which I sent them.

I have, however, been sadly discomfited by seeing a passage which had before escaped my notice in the last *Ecclesiologist*; mentioning that a church had lately been built at Rugby, in which modern errors had been avoided, by making it to consist simply of a "Chancel and Aisles." And on enquiry, I find that this church either terminates with a straight east end, or with a very slight projection of the centre compartment, and is indeed as nearly as possible the same thing I have been in my ignorance so stoutly opposing. If this Committee see the notice referred to, they will of course have the laugh against me, and I shall lose my Chancel at once, as they will say that their whole church shall be called a Chancel. Indeed, if unexplained, your notice of this church will be made an excuse for the general omission of all pretensions to a distinct Chancel. May I therefore, to prevent misapprehension, request some explanation of this point in the next *Ecclesiologist?* I can conceive of a building for the sole uses of an ecclesiastical or collegiate

body, of an order of knighthood, or even for a private family, being
in itself a Chancel without a Nave, though even these buildings have
most usually an anti-chapel, which answers to the latter feature ; but I
cannot conceive of a building for parochial uses, and for all classes of
worshippers without distinction, being a Chancel without a Nave,
rather than a Nave without a Chancel. And if it come under the
latter class, it would appear to be a dangerous precedent to bring
forward as a design in which modern errors had been avoided, as it
would evidently embody the worst and the most universal of them all.

The question being of general, rather than of individual importance,
I will not personally intrude myself upon your attention, but have the
honour to subscribe myself,

<div align="right">

AN ADMIRER AND WELL WISHER
TO THE ECCLESIOLOGIST.

</div>

[Our correspondent will see, by referring to the passage in our first
Number of the *Ecclesiologist*, page 12, that we have by no means held
up the new church at Rugby as a model for imitation in all things, but
simply stated that "it has avoided *many* of the faults of modern church-
building." We by no means wish to defend the omission of a Chancel
in the design,—for even in the smallest chapel we hold that this is an
essential part of the structure. Our correspondent is unquestionably
right in considering the whole portion of the Temple church east of the
circular portion or Nave, as a Chancel with Aisles; nor does that
example in the least defend the construction of a *Nave* with three gables
in one range at the east end, and a Tower at the west. Every church,
of whatever kind, size, or shape, should have a distinct Chancel *at least*
one-third of the length of the Nave, and separated from the latter, in-
ternally at least, if not externally, by a well-defined mark, a chancel-arch
if possible, or at least by a screen and raised floor. We refer our cor-
respondent to our "Few Words to Church-Builders," for our opinions
on this subject. The paragraph in No. I. of this periodical, was written
in reference to architectural details and material, rather than to its
ground-plan; the latter we think extremely objectionable. We are
most willing to admit that specific exception should have been taken to
this grave fault of omitting a Chancel, in giving our meed of qualified
praise to the church in question. It was by an oversight that the de-
sign was said to comprise a *Chancel* and Aisles, instead of a *Nave* and
Aisles.—ED.]

<div align="center">

* * *

SALISBURY DIOCESAN CHURCH-BUILDING
ASSOCIATION.

To the Editor of the Ecclesiologist.

</div>

SIR,—I beg to forward you a copy of some "Suggestions," which, on
my recommendation, the Board of the above Society have had printed
for distribution amongst applicants. I am aware that to those who
understand and value the proprieties of Church Architecture, they may
appear unnecessary and obtrusive.

I have however, in the capacity of Consulting Architect to that Society, had plans submitted for approval where the usual and correct method of placing the church has been wilfully reversed; where the window-cills have ranged with the capping of the pues; where no Chancel has been provided; and even where that important feature has been conceded, it has been kept level with the floor of the western porch.

To provide against the recurrence of such anomalies as these, and to draw the attention of those originating church-extension to the facility and advantage of adopting the clerestory and open roof without tie-beam, would I felt be an instalment (however small) towards the liquidation of that heavy debt still due from our generation to Ecclesiastical Architecture.

I should regret that the Committee of the Camden Society believed that Architects generally were unmindful of, or unwilling to cooperate in, their endeavours to elevate the character of this study.

I have taken the liberty to forward you this paper, and the accompanying copy of a letter on the subject of "open roofs," to prove that such at least is not the case with

Your most obedient servant,

THOS. HENRY WYATT.

The following Suggestions are offered by the Committee to Parties applying for Aid towards Building or Enlarging Churches :—

1. Churches should stand as nearly East and West as circumstances will permit.
2. Height in the walls considered of great advantage. Where means are limited, simple and *correct* arrangement and good outline, with plainness of finishing, is to be preferred to ineffective attempts at ornamental detail. Rough hammer-dressed walls, either in range or random courses, with free-stone quoins and dressings, far from being considered objectionable, may be made pleasing in effect, and ecclesiastical in character.
3. Considerable effect will be produced by keeping the cills of windows raised as much as practicable above the floor of the church.
4. Both for propriety as well as for effect, it is desirable to raise the space appropriated to the Communion two or three steps; and where a distinct Chancel is obtained, the floor of that portion eastward of the arch should also be raised one or two steps above the level of the Aisles.
5. In cases where the applicants are willing to forego the assistance of the Parent Society, and are desirous of adopting the more correct form of open roof *without tie-beam*, the Diocesan Architect* will be at liberty to report his opinion as to the safety of such construction; for it cannot be doubted, that, in cases where the accommodation required is not considerable, and consequently where the width may be so far reduced as not to involve the necessity of placing any of the congregation at too great a distance from the Clergyman, an open roof, giving height and character to the church, may be introduced with perfect safety and great advantage, due attention being paid to thickness of the walls, the projection of buttresses, and the distribution of the several parts of roof.
6. Where the accommodation required is very considerable, and the area of the church must necessarily be on an extended scale, it is impossible to obtain ecclesiastical character by embracing the whole span under one flat roof; a practice too frequently adopted under a false impression of economy. It has been practically proved, that in those cases a *clere-story*, partaking of the same character and richness as the rest of the building, may, with good management, be constructed so as to add but little to the intended outlay.

* T. H. Wyatt, Esq., 75 Great Russell-street, London.

7. The harsh and unpleasant colour of the slate-covering generally adopted, cannot but be considered objectionable, as it rarely assimilates in tint to the walls supporting it. It is suggested, that where the roof is of considerable pitch (which it always should be) and stone or brick-tile of subdued colour can be obtained, their adoption would be attended with advantageous effect.

8. The Font, of suitable dimensions, should occupy a position as near the principal entrance as practicable.

9. After various experiments as to the best width for the seats, the "Incorporated Society" have come to the decision* of adopting 2 ft. 9 in. in the clear of each pew and free seat; 20 in. being allowed for adults, and 15 in. for children. The Board entirely concur in this recommendation.

The sloping back in pews and free seats, though undoubtedly giving additional comfort in sitting, yet, with a width of 2 ft. 9 in., creates some difficulty with regard to kneeling. It is suggested, that almost all the advantage derived from this plan might be obtained by making the seats 14 or 15 inches wide, the backs being kept perpendicular.

10. A centre gangway or aisle (unoccupied by benches) must be considered desirable, so that an uninterrupted view of the Chancel may be obtained from the west end. From this plan it by no means follows that the seats appropriated to the poor need be disadvantageously situated.

11. The most favourable position for the pulpit and reading-desk must depend, more or less, on the plan of the church. It would be well, however, to bear in mind the propriety of marking their *distinct purposes.*

12. It is not necessary to dwell on the great importance of ensuring a circulation of air round all those timbers which are exposed to damp; yet the numerous cases in which serious injury and expense have been incurred by want of proper precaution, induces the Board to call particular attention to this subject.

* See the Incorporated Society's *revised* Instructions, p. 152, of the present volume. [2nd Edition.]

A CHURCH AS IT SHOULD BE.

A NEW church has been recently consecrated by the Lord Bishop of S. David's, at LLANGORWEN, Cardiganshire. It appears from the description given of it to be, in its architecture and arrangements, one of the most complete and successful imitations of ancient models that the present age has produced. The style is Early-English: there is a Chancel 29 by 27, and a Nave 72 by 33 feet. *The Tower is to be subsequently erected.* The interior fittings are perfect: low open stalls of oak and chesnut (all free); a carved eagle and Litany-desk; a rood-screen; an Altar of Bath stone, with an arcaded reredos behind it, and a table of Prothesis; and a small raised platform is railed off on the north side of the chancel-arch for a reading-pew. The Chancel is paved with Painswick stone, and is entered by a step, while the Altar is elevated on three more. In the lower part of the Chancel, against the walls, are plain but handsome benches for the Clergy when present, and for communicants at the holy Eucharist. The design of the Chancel and Altar is taken from Littlemore church, near Oxford, and is considered to be an improvement upon it, from the greater length of the new building, and its being broken by the chancel-arch. The consecration of this church was performed in Welsh, the service having been translated into that language, and first used on the occasion. The Bishop entered the church, followed by many of his Clergy in surplices, walking in slow and solemn procession; the former took his seat at the Altar in an ancient

carved chair, and deposited the deed of endowment on the Altar, the Clergy sitting in the chancel-stalls. After the service, donations towards the erection of a Tower were made at the offertory. This is indeed the right way to build, endow, and consecrate churches, and the surest means of bringing a blessing upon the good undertaking.

We may here mention with equal approbation the example lately set by the inhabitants of the hamlet of ROEHAMPTON, Surrey. The present proprietary chapel, a building quite destitute of ecclesiastical character, is about to be removed, and in its place it is purposed to erect a Chapel (to which a district will be assigned) of suitable style and accommodation. The contributions in aid of this work (as in the last) were, in compliance with ancient usage, collected at the offertory : and it will be gratifying to all Churchmen to hear, that the revival of this holy practice was eminently successful, £614. 19*s.* 8*d.* having been offered on the Altar, while only £16. 13*s.* 2*d.* were received from non-communicants at the doors. We have been favoured with a view of the general design for the church, which possesses much merit: we may on another occasion offer some remarks on particular features of the plan.

We wish to notice a good example of church restoration at ELFORD, near Lichfield. It appears that in the Stafford MSS. at Blithfield, a view has been preserved of some stained glass which was to be found in this church in May 1530; but which has "since disappeared, having either perished through neglect, or been destroyed in the havock of the Reformation, or the far more extensive and iniquitous sacrilege of the great Rebellion." These and other particulars are given in a little tract very beautifully printed for private circulation by the Rector, the Rev. F. E. Paget. As a step to the entire restoration of the church, the Tower has been put into complete repair, and furnished with a window of Decorated character, copied from one existing in the church. This window has been filled with stained glass, copied from the design so fortunately preserved, by Mr. Wailes, of Newcastle-upon-Tyne. The figures represented are those of some former pious benefactors of the church : Sir Richard Stafford and Sir Thomas Stanley; Maud Camville and Isabel Vernon ; Maud de Arderne and Cecilia de Arderne.

A reredos of carved oak has lately been erected, at an expense of £60, in the church of S. Nicholas, GUILDFORD, Surrey. The idea is taken from the Altar-screen in the Cathedral church of Winchester. It consists of a series of Perpendicular panelling, in cinqfoiled ogee lights, with trefoiled circles in the spandrels : immediately over the Altar is a rich projecting canopy, crocketed, pinnacled, and finialed ; and bearing the letters I H C surrounded with foliage in front. The execution of the details is good.

NEW WORKS.

THE increasing demand for Ecclesiological information has induced Mr. Parker, of Oxford, to add one more to the already rather numerous manuals on the subject of Church Architecture. We allude to a little volume entitled "Anglican Church Architecture," dedicated by the

author, Mr. James Barr, to the Oxford Architectural Society, and illustrated with the wood-cuts (by this time, we should suppose, pretty well known to most) of the Glossary of Architecture.

Of this work we are sorry that we cannot speak in terms of commendation. In the first place, there did not appear to be any sufficient cause for publishing a book which does not contain any information, so far as we have been able to discover, but what has already been given by Mr. Bloxam's work on the same subject, the Glossary of Architecture, our own "Hints on the Study of Ecclesiastical Architecture," and "Few Words to Church-Builders," Mr. Medley's "Elementary Remarks," and similar works. A good deal of the matter, too, contained in Mr. Barr's new work, seems of so very plain and self-evident a character, as to be little more than gratuitous information ; and the total want of even the semblance of originality makes it difficult to regard the work otherwise than as a sort of intruder upon the ground already occupied by others. There are also occasional inaccuracies both of style and matter ; and the professional advice given does not in every instance quite harmonize with our own notions of Catholick proprieties. Thus, we doubt whether a clock made to project from the walls of a tower by being stuck on a cast-iron bracket, would be very "picturesque ;" and we object to "railing off a compartment of the Nave for the reception of the Altar," because there is no authority for so doing. To be told that a Chancel may be vaulted with stone, and paved with painted tiles, and that the windows should be of stained glass; that roofs and open-seats should be of oak, and the bases of the columns not be raised above the level of the pues ; and that churches ought to be built of stone, with similar pieces of information, is not what we expect to find in a *new* book on the proprieties of Church Architecture. To say that "*all* the old Chancels anterior to the Reformation were much elevated, and approached by *many* steps," is a bold assertion. Some, it is certain, were even lower than the Nave, as they remain to this day. There is no reason whatever that the style of a Font should correspond with that of the edifice in which it is placed ; and to say that a central approach to the Altar imparts a *repose* and dignity to a church, is to say what means nothing at all, unless that it makes people go to sleep. We think, moreover, we could point out some plagiarisms of a rather unwarrantable description.

"Milford Malvoisin, or Pews and Pew-holders," has just made its appearance, and is likely to rival "S. Antholin's" in its popularity, and we hope its usefulness. The early part of the book gives so graphic and forcible an account of the spoliation of a church under Puritan rule, and the ejectment and suffering of the Clergyman and his family, that it will do more to make people *realise* the horrors of those times than any argument or eloquence. The evils of the pue system are most vividly exhibited in a sort of history of a particular PUE : and we are persuaded that the goodnatured irony, and yet the gravity and earnestness of the writer, will do much in shaking the prejudices of many, who respect pues merely because they are, and from a most laudable fear, so far as it goes, of innovations. We most heartily recommend the book to all Ecclesiologists.

Mr. Burns has published a little tract (No. 40 of his series) called " The Honour of the Sanctuary," well fitted for distribution in parishes where the churches are needing or undergoing repair.

ON A RED-CROSS SHIELD,

SUPPOSED TO BE DEDICATED IN THE CHURCH OF THE HOLY
SEPULCHRE, CAMBRIDGE.

VIDI egomet quondam armatos se inferre superbo
 Agmine, et ardenti spargere tela manu.
Quæ valui, non parva : Crucis vis fida subegit
 Lunatas acies vertere terga fugâ.
Nunc humiles video in terram procumbere, flexo
 Poplite, et infanti verba referre prece.
Quæ valeo, majora tamen : nam dia* salutis
 Infernas acies Signa fugare valent.

Trinity College. ✠

HEREFORD CATHEDRAL.

FOR the substantial repair of this noble and ancient, but now dilapidated church, the sum of about £20,000 is required. We earnestly hope that the restoration of so fine and venerable a structure will be regarded (as the repair of every cathedral should be) as *a national undertaking*. Let us have nothing done in a cheap, shabby, temporary manner : no attempts to avert for a time the impending ruin ; no limitation of contributions towards the work to the Clergy and inhabitants of the diocese ; no complaints that the contemplated repairs are unnecessarily extensive ; and above all, no excuses that the restoration of a particular cathedral is a matter of no concern or interest to the publick at large. *All* are deeply interested in the preservation of one of the few out of the many once existing monuments of ancestral skill, piety, and liberality. To complete this great undertaking in a manner worthy of the fabrick, would go far to remove the charge under which England now justly labours, not only of apathy and backwardness in the maintenance of things pertaining to the grandeur and solemnity of the Church's worship, but of ingratitude to the great and good founders of these inimitable temples—nay, of dereliction in our duty to God and the Church. May the present work prove the goodly first-fruits of the revived feeling of love and admiration for the Church, her structures, her ordinances, and all her ancient glories—too long, alas, despised, neglected, condemned, and overthrown, but even yet to rise again, we trust, with chastened though undiminished splendour.

The contemplated repairs of Hereford Cathedral include the complete restoration of the tower, and of the arches which support it ; the rebuilding and refitting of the Ladye Chapel and east end of the Choir; the erection of entirely new wood-work in the latter; and the reparation and embellishment of the whole of the interior.

* Vide D. Joh. Chrysost. Hom. in D. Matt. LIV.

It is a remarkable, and if true, very lamentable fact, that the central tower of York Cathedral is found to be in as dangerous a condition as that of Hereford. This is, indeed, at present, but a report; but should it prove true, the repairs must instantly be undertaken at any sacrifice. The fall of this mighty fabrick must necessarily demolish an immense portion of the pile underneath; and these are not times when (as in a similar disaster at Ely Cathedral in the fourteenth century) the whole of the damage done would or could be immediately repaired, with even greater costliness than before.

NOTICES.

AMONG various presents received by us since our last meeting, are about thirty rubbings of monumental Brasses, including two impressions of chalices; some of them of remarkable rarity, size, and beauty. Our collection now contains about a hundred impressions, exclusive of those already engraved by us.

A third edition (much enlarged, and almost entirely re-written) of our "Hints on the Practical Study of Ecclesiastical Antiquities" is in the press, and will be ready in a very few days.

A large sum is yet wanting for the completion of S. Sepulchre's church. It is intended to pave the circular Nave with encaustic tiles, which are to be manufactured after ancient models selected by us for the express purpose. We hope yet for a considerable addition to the donations already received in furtherance of this interesting object.

The ancient and dilapidated church of S. Peter's, in this town, is shortly to be taken down and rebuilt on a large and costly scale. There is reason to believe that the design will be neither hastily nor injudiciously adopted, a committee having been appointed for the purpose of selecting and approving plans for erection. Subscriptions for the purpose, together with other particulars respecting the plan in contemplation, are announced in the local papers.

The designs furnished by the Committee for a new church to be erected in New Zealand, will shortly be published on a large and splendid scale. It is intended to give about nine views, comprising elevations and transverse and longitudinal sections, executed in lithography, in folio size, to form a volume corresponding with the Oxford Society's beautiful drawings of Stanton Harcourt church, or procurable in single engravings. The price will probably not exceed half-a-guinea. Notice of their publication will however be duly given.

The Committee of the Incorporated Society for building and enlarging churches have, at the instance of the Cambridge Camden and its sister Societies, kindly consented to reconsider and alter their Instructions, to many of which strong objection has been made.

The EDITOR has to thank several correspondents for much useful information, and many expressions of sympathy and encouragement. He regrets that it will seldom be in his power, from the limited size of the publication, to give letters entire. One correspondent has

pointed out the seventh Canon of Convocation, 1640, (Sparrow's Collection,) which declares that "the Holy Table" "is and may be called an Altar in that sense in which the primitive Church called it an Altar, and in no other." This is the same Canon which is quoted at the close of the Society's " Hints on the Practical Study of Ecclesiastical Architecture."—Another correspondent, after remarking that the common term " Communion Table" occurs nowhere in the Prayer-Book, and only once in any formulary (in the heading of the lxxxiind Canon), adduces the following texts, Hebrews xiii. 10, Rev. vi. 9, viii. 3, as shewing that Holy Scripture recognises the idea of an Altar under the Christian dispensation. The first is used in the famous passage about Altars in Bishop Andrewes' Answer to Cardinal Perron, pp. 6, 7, quoted together with some other curious and valuable extracts in a note to Bishop Montague's 'Articles of Inquiry' (Cambridge Edit. *Stevenson*, 1841,) p. 120.—To *Philocosmus* we must promise an early attention to the subject which he recommends to our attention—the law of the Anglican Church concerning the material of Altars. Mr. Poole's statement on this subject appears to be hasty and untenable. Bishop Montague (Art. iii. 7, p. 50.) asks, " Is your Communion Table or Altar of stone, wainscot, joyners work, strong, fair, and decent?" thus distinctly recognising stone as a material. The injunctions of Queen Elizabeth *allowed* and *authorised*, not *commanded* the abolition of stone Altars. However, the point certainly deserves, as our correspondent suggests, a careful consideration.

As several members have expressed surprise at not receiving copies of the *second* number of the *Ecclesiologist*, the Secretaries wish to state generally, that none are considered subscribers who did not forward their names, as requested, upon receipt of the *first* number, which was forwarded gratuitously to every member. Persons wishing to subscribe are requested to send their names, together with a payment of *five shillings*, (by post-office order, or otherwise,) to the publisher, Mr. Stevenson, Cambridge. There will be twelve sheets, or numbers, published annually ; but the Committee do not bind themselves to bring out a number in each month, since their objects may perhaps be best answered by an attention to the quantity of matter on hand, and to the expediency of publishing at particular seasons. And this plan, it is conceived, will not create any inconvenience from its irregularity, since the copies will be transmitted post-free to subscribers, direct from Cambridge, without the intervention of the usual but indirect system for dispersing monthly or periodical publications.

[Second Edition.]

Published by T. STEVENSON, *Cambridge :* J. H. PARKER, *Oxford :* RIVINGTONS, *London.—Price* 4*d.*

METCALFE AND PALMER, PRINTERS, CAMBRIDGE.

THE

ECCLESIOLOGIST

PUBLISHED BY THE CAMBRIDGE CAMDEN SOCIETY.

"𝕭onec templa referris."

No. IV. FEBRUARY, 1842.

REPORT OF THE TWENTY-FOURTH MEETING OF THE
CAMBRIDGE CAMDEN SOCIETY.

On MONDAY, February 7, 1842.

THE President took the chair at half-past seven o'clock. The following
members were then ballotted for and elected :—

Allen, Mr. T. W., Maidstone, Kent.
Blew, Rev. W. J. M.A., Oxon ; Warwick-street, Pall-Mall East, London.
Chambers, C. Esq. B.A., Emmanuel College.
Coombe, Rev. T. M.A., Oxon ; Waterbeach, Cambridgeshire.
Ford, W. Esq. M.A. late Fellow of King's College ; Gray's Inn, London.
Green, T. A. Esq., Paverham Bury, Bedford.
Grimshawe, S. Esq., Brasenose College, Oxford ; Ernwood, Buxton.
Harrison, Rev. H. M.A., Trinity College ; Bedgebury, Lamberhurst, Kent.
Haskoll, W. Esq., Captain R.N. ; Walworth, Surrey.
Hawks, Rev. W. M.A., Trinity Hall ; Saltash, Cornwall.
Hopkinson, W. Esq. Stamford.
Parsons, Rev. D. A. M.A., Oriel College, Oxford ; Marden Vicarage, Devizes.
Picton, J. O. Esq., Queens' College.
Pownall, Rev. C. C. B. M.A. E.S.A., Clare Hall ; Milton Earnest Vicarage,
 Bedford.
Rawle, Rev. R. M.A., late Fellow of Trinity College ; Cheadle, Staffordshire.
Savile, The Hon. and Rev. P. Y. M.A., Trinity College ; Methley, Leeds.
Scott, G. G. Esq., Architect, 20, Spring Gardens, London.
Warburton, R. E. E. Esq. M.A. Corpus Christi College, Oxford ; Arley Park,
 Northwich, Cheshire.

A list of presents received since the last meeting was then read ;
comprising a large number of Brasses, engravings, and original draw-
ings, besides a collection of specimens of the most approved building
stones and marbles. A Communion-cloth and napkin of damask, woven
with religious emblems, presented by the manufacturer, Mr. French, of
Bolton-le-moors, Lancashire, was exhibited.

The following report was then read from the Committee.

" On again meeting the Society, the Committee wish to offer their
congratulations on the success which has attended the Society's proceed-
ings during the past vacation. They would refer more particularly to

the large number of Members elected this evening, as a proof that the Society was justified in increasing the terms of subscription, on the ground of its increased usefulness and extended operations. " The sale of the Society's publications continues to be most satisfactory. The two tracts to Churchwardens have each reached a new edition, after a careful revision and correction. In such alterations as have been made, the Committee do not consider themselves to have expressed any condemnation of the principle of symbolism as applied to Ecclesiastical edifices,—a principle against which (as they conceive) no real arguments have been adduced; but trust that these modifications may make the Society's publications more generally useful to the parties for whom they were intended.

" The third edition of the 'Hints on the Practical Study of Ecclesiastical Antiquities' will appear in the course of a few days.

" The January Number of the *Ecclesiologist* is before you; and it is proposed to publish the IVth Number without delay. The Committee have to regret that the Members, for whose benefit this periodical was especially designed, have not come forward so generally as was expected in its support. The main body of the subscribers—the list of which is steadily increasing—is composed of persons not immediately connected with us.

" The Society was informed during the last term, that with the kind consent of the Diocesan, and the Archdeacon (our President), circulars had been addressed to every Clergyman of the Archdeaconry of Bristol, requesting information upon certain Ecclesiological points. We have already received, in answer to these applications, a large number of curious and valuable notices, illustrated in many cases by carefully drawn ground-plans and sketches of details: for these we take the present opportunity of returning, once for all, our most sincere thanks.

" Since the last meeting of the Society, twenty-two applications have been received for advice, opinions, or assistance, from the following places :—

COVENTRY, Holy Trinity.	DRONFORD, Hampshire.
STAFFORD, S. Mary.	ROEHAMPTON, Surrey.
SALTASH, Cornwall.	EAST BOURNE, Sussex.
STOGUMBER, Somerset.	BROOKFIELD, Middlesex.
BRIDGERULE, Devon.	COTTENHAM, Cambridgeshire.
LAUNCELLS, Cornwall.	TOVIL, Kent.
ALMONDSBURY, Gloucestershire.	RICKINGALL, Suffolk.
ELFORD, Staffordshire.	S. EDWARD'S, Cambridge.
CORRINGHAM, Essex.	KENWYN, Cornwall.
GREAT WAKERING, Essex.	S. ALKMUND'S, Derby.
CHELTENHAM, (a new church).	

" The Committee has also been in communication with the Rev. J. Evans, on behalf of the Rev. J. Winder, with respect to a new British church at Alexandria. Of these cases some have been of the most flattering description; and the Committee believe that in most the suggestions which they have been able to give have been satisfactory to the applicants.

" Among many presents, of which a list has been read to the Society, is a specimen of a beautiful Communion-cloth and napkin, presented by

the manufacturer, Mr. G. J. French, of Bolton-le-moors, Lancashire. The Society will view any effort for securing greater reverence in the administration of divine offices with satisfaction; and more particularly so when, as in this case, the effort was suggested by the influence of their own publication.

" The memorial presented from your Committee to the Incorporated Society for the Repairing, Building, and Enlarging Churches and Chapels, suggesting the expediency of revising some of that Society's Instructions, was supported by similar petitions from the Oxford, Exeter, Lichfield, Durham, and Bristol Associations. The Incorporated Society has appointed a Sub-committee to report on the subject, which is now in communication with ourselves and our sister Societies, on the points which seem to require modification.

" The Committee propose publishing a lithographed view of the Holy Sepulchre church, as it will appear when completely restored. They again solicit increased contributions in aid of the repairs. The architect is preparing for publication the plans of the model parish church for New Zealand; and the Committee confidently ·anticipate that this work will receive general encouragement. The profits will be devoted to defraying the expence of the models which will be sent out to the Bishop."

A series of papers was then read by J. S. Howson, Esq., M.A., of Trinity College. The first paper contained a succinct but elaborate sketch of the early ecclesiastical history of Argyllshire, showing in conclusion that many traces of Scandinavian architecture might *à priori* be expected in a Diocese which for a long time was subject to the metropolitical see of Drontheim, and mentioning some curious instances in which late Scotch architecture presents features of decidedly Flamboyant character.

The second paper, on the Parochial Chapels, was deferred, and the third, on the Cathedral churches in the district, then read. This gave an interesting account of the Cathedrals of Iona and Lismore. Passing over the fourth of the series, on the Religious Houses, Mr. Howson proceeded to read the fifth, on Sepulchral Crosses.

The different Crosses yet remaining (thirty) were enumerated in the order of parishes, and then successively described, the different symbols occurring on each being explained so far as they could be interpreted. He mentioned the belief that all the Crosses, such as that at Inveraray, came originally from Iona, (whence their popular name of *Iona Crosses*); and lamented the destruction of the three hundred and fifty-nine Crosses which before the Reformation reached from the monastery to the cemetery in that sacred island. Some curious particulars were adduced with respect to the armorial bearings of some ancient Argyllshire families, showing how the different Crosses may be assigned to particular clans from a consideration of the partial introduction of some favourite charge.

In conclusion, Mr. Howson proved the Scandinavian origin of this kind of monuments, but showed that their use, and their rudeness, remained till a comparatively late period.

The sixth and last paper contained an account of the principal

E 2

burying places and monuments in the county, illustrated by numerous sketches.

Notice was given that a paper was preparing for the next Meeting on the ceremonies formerly observed in the consecration of Bells; and one on the Crypt and Chapel of S. Stephen, Westminster.

The Meeting adjourned at a little before ten o'clock.

NEW CHURCHES.

WE have been favoured with several designs for New Churches, erected, or in the course of erection, by GEORGE GILBERT SCOTT, ESQ., the architect of the Bishops' Memorial at Oxford. There is so much beauty in several of the arrangements, and we are so well persuaded that the faults are those of the age, the merits those of the architect, that we intend briefly to consider such of his designs as have come under our notice. We feel sure that Mr. Scott will give us credit for the admiration which we feel for his talents, and the sincerity with which we hope that he may have full scope for their exercise; and impute our observations, if in any thing we seem to speak harshly, to the necessity which obliges us, as a Church Society, to judge of things absolutely, not relatively; which makes us say—not, "this is good for the present age," but, "this would not have been allowed in an age more pious than ours." We take the buildings as we find them: we know that many of those before us have been spoilt by the "improvements" of Church Building committees, or from want of funds; and in the only instance in which Mr. Scott has been allowed to follow his own taste, he has produced, as we shall presently see, a very beautiful and Catholick church. Therefore, if we censure any thing, we are to be considered as censuring not so much the architect, as the church committees whom he was, or thought himself, obliged to please.

We will mention the places which lie before us, arranging them under the styles in which they are designed:

In Norman,	1. S. —— KINGSTON-UPON-THAMES.
In Early-English, ...	2. S. —— WOKING, SURREY.
	3. S. —— HANWELL, MIDDLESEX.
	4. Christ Church, TURNHAM GREEN.
	5. Holy Trinity, SHAFTESBURY.
	6. S. Mark, BIRMINGHAM.
	7. S. —— BURLINGTON QUAY.
In Decorated,	8. S. —— ZEALS, WILTS.
In Perpendicular ...	9. S. Mary, WIMBLEDON, SURREY.

In the first place, we must mention that fatal fault of which we have so often spoken—THE ABSENCE OR CURTAILED PROPORTIONS OF THE CHANCEL. In these designs, 1, 3, 5, 6, 7, have no Chancel whatever; and 4 has merely a pentagonal Apse.

Again, the stunted proportions and unseemly position of the Transepts are a great blemish to all these buildings, except 8, where they

are of fair size; and 2 and 9, which have none. Transepts are always stumbling-blocks to modern architects; because they must, if of fair proportions, involve a great loss of "available space;" since the extreme ends can hardly be used—as assuredly in former times they never were used—by worshippers. In the present state of things we are no great advocates for their introduction at all, (see our 'Few Words to Church-builders,' § 9); and when they are placed very near to the east end, as in 6 and 7, or apparently used for a porch, as in 5, they cannot be sufficiently reprobated.

The position of the Tower, in many of the designs before us, is excellent. Modern architects are generally afraid of placing it anywhere but at the west end (unless by way of variety they prefer the east). A different arrangement is often rendered desirable by the nature of the ground: it gives breadth and boldness to the western façade; it breaks the monotony of having the two sides exactly alike; it allows greater scope for the west window; it can never be a blemish, and is sometimes necessary for the beauty of the building. For example: the magnificent tower of King's College Chapel was to have been erected at the S.W. or N.W. angle: in any other position it would have ruined the building. In the designs before us, 1 and 6 have the tower at the N.W. angle; No. 3 at the S.W. For this deviation from modern stiffness, we beg leave, in behalf of all true Ecclesiologists, to thank Mr. Scott; and we hope that ere long he will boldly place a tower in the middle of the north or south sides of the Nave, regardless of the foolish outcry raised against a church that "stands all on one side."

We will now offer a few remarks on some of the buildings before us. Of the Early-English buildings, 2 and 7 are plain chapels, with bell-gables. 2 is perhaps the most church-like building of the whole; it has Chancel, Nave, and north Porch. (It is wonderful, by the way, how much afraid modern churchbuilders are of porches; perhaps lest they should be confused with their stunted Transepts.) There are two single lancets on each side of the Chancel, and three on each side of the Nave. In them we have to lament that almost universal fault, by which the glass, instead of being almost flush with the walls, is sunk in a deep countersplay. We must again repeat that a western triplet is all but a solecism—we mean for small churches. Two lights, as in our own once beautiful church of S. Andrew's, Barnwell, are more usual and have a fine effect.

No. 7, which in its general design we have noticed above, has a very pretty gable, and a niche, containing the figure of a Saint, below. The west window of four lights is perhaps a little too ambitious, but very good in its details.

In the larger buildings, 3, 4, and 6, have towers terminating in octagonal broach spires, of very good design. 4 is peculiarly excellent, and worthy of any ancient architect. We do not, however, much like the introduction of a spherical triangle, or foliated circle, in the stage beneath the belfry window: not that it wants authority, but that its perpetual occurrence seems to indicate a difficulty as to how to dispose of the place usually now-a-days occupied by a clock. The corbel-table in 4, seems to us deserving of great praise.

The Tower of 5 we do not at all like. It is battlemented, with angular pinnacles, and has an octagonal turret at the north-west angle; presenting at a distance the complete contour of a Perpendicular Tower.

In the windows of his Naves and Aisles, Mr. Scott has avoided the common fault of a series of triplets : his usual arrangement is a couplet (we should much prefer a single lancet) in each bay. The external shafts, and other details, of some of these couplets are very good.

Only two of these churches have a Clerestory : 5, where it consists of five plain and poor lancets ; and 3, which has a quatrefoil and trefoil alternately,—a conception which strikes us as very good.

Almost all Mr. Scott's buttresses labour under the disadvantage of being over-chamfered ; a fault so easily avoided, and so inappropriate in small churches, that we cannot but hope to see it corrected in the future designs of the architect.

The doorways are all reproductions of the same design,—very fair, but without any remarkable feature. We are glad to see that the doors have excellent iron-work.

8 is a small Decorated Cross church: the Chancel is of very fair proportions ; the east window of four lights, and good. The Transepts would have pleased us better, had they been of the same height with the Chancel, instead of aspiring to that of the Nave. We beg leave to protest, once for all, against the practice (based on some few and irregular examples) by which the doors in the Transepts are placed north and south, instead of east and west. The octagonal Tower we cannot much commend.

We will, in conclusion, mention a church now erecting at Hartshill, near Newcastle-under-Line ; where, through the munificence of the pious founder, Mr. Scott has been allowed to carry out a most beautiful design. The church has a good Chancel, Nave, two Aisles, S. Porch, and Tower with octagonal spire ; also a well-developed clerestory. Judging from a pen-and-ink sketch, we should call it admirable : the style is Decorated. The only thing we could wish altered (and this we believe is also the architect's wish) is, the position of the porch, which now stands in the last, or westernmost bay, instead of the last but one. The interior arrangements are excellent : there will be open-seats, a stone pulpit with winding staircase, and, we believe, a roodscreen. All the Chancel windows, and the heads of those in the Aisles, will have stained glass. The pavement will consist of enamelled tiles, the work of the sole founder.

The church which it is proposed to erect in the village of Fradley, is (if we may judge from the engraving prefixed to Mr. Gresley's Parochial Sermons, published for its benefit) likely to resemble a village church in old times more than any other it has been our lot to see. It consists of a Chancel of fair proportions, a Nave, and a low Tower between the two ; the style being Early Decorated ; the design of the east window is remarkably good. The only part which we do not admire is the arrangement of the belfry-windows,—we should have preferred one like that in Plate xxxix. 32, of the ' Companion to the Glossary.'

The Holy Trinity, Bridgewater, is a specimen of the modern school of cheap Early-English, with stunted Chancel, and all the other peculiarities of that style.

———◆◆———

To the Editor of the Ecclesiologist.

SIR,—Although not at present a member of the Camden Society, yet, as hoping when an opportunity offers to become one of them, may I suggest two points upon which their remarks do not quite satisfy me. The first is on the position of Stalls for the Choir. I cannot conceive that the east end of the Nave is at all an allowable position. It seems to me a very unmeaning and awkward arrangement; and I have as an architect had occasion to protest against it. The Chancel is certainly the only proper place. Another point is the Chancel-screen. If we restore this beautiful feature, what need is there of any second fence of rails to the Altar, and why should the congregation go within the screen to receive the Holy Eucharist? The steps upon which the screen stands would, I imagine, be the kneeling-place for communicants, else the screen becomes little more than an ornament. Why does not the Camden Society condemn Altar-rails as unhesitatingly as it does other innovations?

 I am, Sir, your obedient Servant, W. B.

[Were it intended that the Choir should consist of Priests and Deacons, we should cordially agree with our correspondent: as it is, we cannot but think that the old rule—

 " Infra cancellos laicos compelle morari,"

makes the position adopted as good as any other, *under the circumstances.* We could wish that to at least every large church might be attached a college of Priests-Vicars; and they would, of course, occupy the Chancel.

To the remark of our correspondent respecting Rood-screens and Altar-rails, we beg to observe, that we have never recommended Altar-rails; but we have not utterly condemned them, for the following reasons:—

1. They are not innovations, strictly speaking; having been in use before the Reformation, though not commonly employed. For this, we may allege the testimony of three authors, who wrote at the time when the controversy respecting them was at its height: the first, favourable to them; the second, neutral; the third, opposed to them. Dr. Pocklington, in his *Altare Christianum;* Dr. Udall, in his *Communion Comelinesse;* Charles Chancey, in his *Retractations.*

2. We could not but feel some prejudice in favour of an arrangement so warmly advocated by Laud, Montague, Wren, Bridges, and other holy Bishops, who suffered for the Church.

3. Because the plan of kneeling at the Rood-screen would render it extremely inconvenient, if not impossible, for the Priest to administer the Holy Elements to the communicants.

4. Because this plan has never been adopted by our Church, any more than it is on the continent at this day ; where a linen cloth held up before the communicants answers the purpose of rails.—ED.]

SCOTLAND AND SCOTCH ARCHITECTURE.—LETTER I.

To the Editor of the Ecclesiologist.

Mr. EDITOR,— *The* *Ecclesiologist* enables me to bring before the Camden Society, in an unobtrusive but effective manner, a subject which I have for some time wished to press on its attention. I allude to the subject of Church-Architecture in Scotland. Though sad havoc has been made among the Ecclesiastical edifices north of the Tweed, yet there are a greater number of valuable remains than is generally supposed. Of these, however, there has been as yet no systematic examination ; much less has there been any thing approaching to a generalised and scientific description of them. Scotland possesses no *Monasticon.* So far as I know, there is nothing more before the world than a few unsatisfactory notices of individual buildings, scattered here and there over the pages of Rickman and others. It does not seem to be known whether the successive changes of style in Scottish Architecture followed the same laws as in England, or the same as in France, or no laws at all. To me it seems almost certain that the law of sequence was different from that in England, and very probable that it resembled very closely that which is observed in certain parts of France. To mention one or two peculiarities, noticed in the papers read before the Society last meeting on the Antiquities of Argyllshire, I have observed the round-headed doorway lingering to a very late period ; the roll-and-fillet moulding predominating in late buildings ; and square edges appearing in piers and abaci where we should not expect them. Whilst thinking that the Early-Gothic in Scotland closely resembled our own Early-English, I am inclined to conjecture that the Middle-Gothic never worked itself so free from early forms as with us, and that the Late-Gothic was a return upon the Early-Gothic to a greater extent than we have been accustomed to observe.

Here then we have a subject worthy of a careful investigation, and one which well deserves the special attention of the Members of a Cambridge Architectural Society. It must be remembered, that Ecclesiology, like Astronomy and Geology, is an Inductive Science. No sound and truthful generalisations can be hoped for without a careful examination of particulars ; and for this work our Society is peculiarly adapted. A few days of a few long vacations devoted to the study of mutilated abbeys, churches, and tombstones in Scotland, by a few members who might otherwise be losing their time, might contribute materials sufficient for the formation of a scientific Treatise on the Architecture of North Britain. I am desirous (with your permission) to write one or two letters in the *Ecclesiologist,* which may render some humble assistance in furtherance of this work. They will chiefly relate

to the *bibliography* of the subject; some slight acquaintance with which I have had the means of obtaining. Though Scotland has never produced a Dugdale, nor even a Rickman, there are a considerable number of chartularies and manuscript compilations, which are of extreme value in elucidating the art, as well as the history, of the Early Church of Scotland.

I am aware that the *Ecclesiologist* has many contributors; and therefore I will conclude this letter by simply suggesting the importance of each inquirer devoting himself to some one limited and manageable district, and investigating it completely. Thus one person might take the district of Tweedside and Teviotdale, and bring away a detailed account of the noble Abbeys of Melrose, Dryburgh, Kelso, and Jedburgh. Another might reside for a short time in Edinburgh, and examine the numerous antiquities contained in the Lothians—such as Holyrood and Seton, Corstorphin and Linlithgow. A third would find, in and about Fifeshire, abundant subjects of interest at Inch Colm, Dumfermline, Arbroath, and S. Andrew's. The neighbourhood of the Moray Firth—where are Elgin, Pluscardine, and Beauly—would afford an appropriate sphere of occupation for another. So of the north and west. Such information as I have myself been able to obtain respecting Argyllshire is already, in great measure, laid before the Society. And next year I hope to be able to present some notices of Dunkeld and Perthshire, and also of Paisley and Renfrewshire.

Hoping that this unexamined department of art and antiquity will recommend itself to the notice of some of our Members,

I am, Mr. Editor,

Your faithful servant,

J. S. HOWSON.

Trinity College, Feb. 8, 1842.

A CAMDENIAN FIELD-DAY.

MOST of our good friends of the Camden Society, and doubtless every one that is a son of Alma Mater, well know what is meant by a "field-day." They understand by this term a scientifick tour made by some ten or a dozen grave students, very tolerably skilled in natural history, but very little in the equestrian art, who, with large tin cases at their backs, accompany a learned Professor with a still larger tin case at *his* back, and take an interesting ride at the sober rate of three or four miles an hour to some neighbouring gravel-pit or common to look for curiosities. They have, we apprehend, often seen such parties returning home laden with the said tin cases full of pebbles or plants, or heard them afterwards recount with enthusiasm how they discovered a glorious specimen of some weed with a dreadfully scientifick name, or picked up a splendid piece of an equally unpronounceable mineral by the roadside, or right well acquitted themselves at dinner at such-and-such a place; and how the great Professor did thereupon set a marvellously good example in satisfying the demands of a sharpened appetite, and

did afterwards so completely lay aside his professorial dignity, as to become the most affable and facetious and convivial member of the party. Such, we say, are the notions which most persons entertain of a field-day at Cambridge.

But a Camdenian field-day is a thing of so peculiar a character, and attended with so much of kindness and friendship and unanimity—designed, too, as it is, to implant and cherish deeper feelings, and to minister to higher purposes—that we shall endeavour to give a faint sketch of one of these equestrian expeditions, in order that those of our readers who have never joined such a party may form some idea of their nature and objects.

A notice set forth some time before, that a Camden expedition is to take place on a day therein specified in the month of May, brings to the place of rendezvous some ten well-mounted equestrians, each prepared for a hard day's riding—for nothing less, in short, than a *steeple-chase* in its most literal sense. A great deal of greeting and talking, and inquiries for the President, is heard at the trysting-place, which is behind Trinity College ; and there is much preliminary discussion as to the points on which Vandal Churchwardens may be most successfully assailed, and the means of giving the most effectual assistance to our allies in the good cause of Church Restoration. At length, just as the horses are getting rather unmanageable, doleful news is brought that the President is unable to join the party ; and accordingly all start at once on the previously arranged route, not at all in better spirits for this last unwelcome piece of information, but still with light hearts, because they are going with the prospect of having a long day of antiquarian research and recreation.

Proceeding at a rapid rate through Barton, we arrive at Barrington, two of the party having been run away with on the road, and a third having exchanged with a brother equestrian his restive steed for an amimal of more staid and sober habits. At Barrington we go at once to the house of the hospitable Vicar, where we leave our horses and proceed to the church. Here we find much to interest us. The Nave, which is Early Decorated, contains the same oaken seats that held the worshippers of olden time ; the roof is of fine old open timber ; and the whole building, under the judicious care of the Vicar, who has made extensive repairs, looks more like an old church in its arrangements than do nine out of ten as they are built and repaired now. A most beautiful Early-English doorway in the south porch attracts our attention. It has, or rather had, foliated capitals, and the toothed moulding under the label. The Vicar expressing his anxious wish to have it handsomely restored if possible, we consult briefly among ourselves, and the Chairman of Committees officially announces to the Vicar that the party then and there assembled have agreed to undertake the expence of the restoration in as handsome and substantial a manner as he pleases to have it done.* Having carefully surveyed and taken an accurate account in writing of the minutest details of the church, we return to the vicarage, where the good Vicar insists upon our partaking

* This has now been done at the private expense of the members then present. It is engraved in Part V. of the Monumental Brasses.

of a luncheon, after which he accompanies our party, in earnest converse on matters Ecclesiastical and Camdenian, to the next village marked in our route, Foxton. To this place we come with the special invitation of the Squire, who is desirous of having the church repaired, and anxious to obtain our opinion upon the best method of putting the good intention into execution. Here we find a very fine old church, but in a sad state of neglect and dilapidation. The east end has a beautiful triplet of lancets: some curious paintings on oak panels, apparently taken from the rood-screen, are discovered; and a fine Early-English Font, very artistically decorated with lamp-black and whitening, and having the arches upon which it is supported blocked up with rubble, arrests the attention of all. A brick being taken up from the floor contiguous to the Font, it is discovered that a moulded basement is entirely concealed. Application is forthwith made to the Churchwardens for leave to disinter this fine old Font, and to remove the rubbish from under the arches. Permission being granted, and the requisite implements procured, the whole party fall violently to work, chopping and hacking and scraping, some with spades, some with pickaxes, some on their knees, and all with coats off, it proving rather harder work than was expected. Soon it is ascertained that the Font has a beautiful octagonal stem in the centre, which had been quite blocked with masonry; which discovery sets all to work with renewed enthusiasm. In the midst of the work the President enters the church, to the unfeigned joy of all; upon which there is a vast deal of shaking hands and congratulations, as if we had not seen him for a year before; and the President explains how he had followed in our track, and endeavoured to overtake us, but could not do so because we rode rather faster than he was used to do. At length we leave the church, somewhat fatigued with our exertions, but not without a hope that the work, appropriately commenced at the Font, will not be considered by the parishioners as complete until every part of the sacred building has been restored to its original comeliness; and indulging a pardonable satisfaction in the reflection, that our example may excite the legitimate guardians of the fabrick to discharge their duties more religiously and successfully than some of their predecessors. After having drawn up our report, and received every attention from the Churchwarden, and admired the romantic seclusion of his farm-house, which is quite one of the old style, we proceed, accompanied by his son, to the ancient church at Meldreth. This we find to be of three styles—transitional Norman, Decorated, and Perpendicular, and altogether a highly interesting edifice, but in a miserably dilapidated state.* After having filled our Church-schemes with its details, mounted the tower, examined the legends on the bells, remonstrated with an apathetic ex-churchwarden, and given him a copy of our "Few Words," though with little hope of overcoming his puritanick prejudices, we ride forward to visit the ruined chapel at Malden. We here find little more than an Early-English gable, with three lancet lights; and are requested by persons on the spot not to express our admiration of what it once was in the hearing of one who happens to be

* Since this visit the church has been restored.

standing by, because he is a conscientious dissenter, and dislikes to hear any thing said in favour of Jesuits, whom he conceives to have built it. Proceeding to Melbourn, and vainly endeavouring to procure refreshment, some of our party, it being now about five o'clock in the afternoon, leave us and return home, accompanied by the President, who is engaged to dine at Trinity Lodge. The rest ride forward to Royston. While dinner is preparing, we visit the church, and get nearly run over by two persons, who appear to be enacting John Gilpin with great enthusiasm through the heart of that quiet town, but who soon prove to be two renegade members of our party, who had ridden to overtake us, and been (as they declared) run away with by their unconquerable steeds, till stopped by the hill at the other end of the town. Having dismounted they join us in a visit to the very curious and ancient subterranean chapel, well known to exist in this town, and find it to be a deep circular cave, capable of holding about thirty persons, cut in the chalk rock. The entrance is through a long narrow passage; and the chapel, when lighted by several candles, dimly shews all around, on its bare and dank walls, curious sculptures of symboled saints and Scripture personages, carved by the patient hand of some holy eremite in a period of unknown, but probably very remote, antiquity. Returning to our inn, and first seeing our good steeds well provided for, we sit down in high spirits about six o'clock to a substantial dinner, which, though we are still fifteen miles from Cambridge, we are not at all inclined to finish in a hurry. At length, after discussing all we have seen, all the adventures we have met with, all the sketches we have taken, (for drawing materials always form an important part of the equipment of a good Camdenian,) and all the architectural beauties we have seen and examined, we return home at a sober pace, and finish a happy day by joining the whole of the original party at a late but highly social entertainment —a college supper party.

CHURCH RESTORATION.

AMONGST the most interesting restorations now in progress, is that of the well-known church of S. MARY, STAFFORD. Its extent and costliness may be in some degree judged of from the fact that £8000. are to be expended upon it; of which £5000. were given by Jesse Watts Russell, Esq., on condition of the remaining £3000. being raised by subscription. This appeal was so readily answered in the county of Stafford, that in three weeks the required sum was collected. The architects engaged are Messrs. Scott and Moffat, whose general plans for the restoration we have had an opportunity of examining. It would seem, from a careful inspection of these drawings, and from a comparison of the proposed alterations with the present appearance of the church, that the whole restoration has been designed upon the strictest architectural principles, and with equal judgment and good taste.

It is obvious that in the case of any church which was built at different periods, or has been, subsequently to its original erection, enlarged or altered gradually in the successive styles of architecture, two principles offer themselves as guides to such as may wish to effect a restoration. We must, either from existing evidences or from supposition, recover the original scheme of the edifice as conceived by the first builder, or as begun by him and developed by his immediate successors; or, on the other hand, must retain the additions or alterations of subsequent ages, repairing them when needing it, or even perhaps carrying out more fully the idea which dictated them. Now, though no one might wish to adopt either of these opposite theories exclusively, yet with certain modifications it will be found that every church-restorer follows one or the other as his rule. For our own part we decidedly choose the former; always however remembering that it is of great importance to take into account the age and purity of the later work, the occasion for its addition, its adaptation to its uses, and its intrinsic advantages or convenience. To illustrate this by our own church of the Holy Sepulchre. There were some who at first regretted the removal of the superadded belfry stage, with its large windows and embattled parapet; probably because they perceived that the familiar appearance of the building would be destroyed by the change. But even if it had not been absolutely necessary for the safety of the fabrick to remove this story, yet, when an opportunity for a general restoration was offered, who can doubt that it was right to recover the *original* appearance of the church, and to restore to it its own peculiar and interesting character, when this might be done at the sacrifice of no feature of architectural or even picturesque interest? Every one surely will agree that it would have been in the worst taste to keep the disproportionate Tudor work (which had nothing in itself worthy of preservation), instead of regaining the beautiful contour which the church with its conical roof now presents.

We are glad therefore to see, that in S. Mary's, Stafford, the same principle has been acted upon by the architects, though in a case of much greater difficulty than the one we have just described. They found a noble cruciform church, of which the earliest portions (the lantern-arches and nave-piers) were of Transitional Norman character; the south Transept and Chancel of the middle and later varieties of Early-English; the north Transept of rather Early Decorated, and very fine.

Amongst other insertions and additions, a clerestory has been made to the Nave, consisting of five large four-centered windows of late Tudor date. These, evidently wanted, and of tolerably good detail, are judiciously preserved; particularly as the roof, coeval with them, is very fine and in good preservation.

The Chancel also had received a clerestory addition; but of such extremely late and poor workmanship, and of so bad an effect, that with equal judgment it is to be now removed. The Chancel will then, with its north Aisle, be restored to the original pitch, corresponding to the south Aisle, which has never been lowered; and thus the beautiful effect produced of three parallel ridged roofs. But of all parts the

south Transept had suffered perhaps most severely. It presented a flat roof with a heavy embattled parapet, and a very large Tudor window of extremely poor design and execution. However the weather mould-ing on the south side of the central Tower showed the lofty pitch of the original roof, and the mouldings of the window jambs (within which the later window was inserted) enabled the architects to ascertain that the original southern elevation consisted of three fine lancet windows of unequal height, contained probably in the interior under a common arch. It was, of course, immediately determined to restore these fine features ; and, we confess, we view this restoration of the south Transept as one of the most successful of any that we have known. In its old state the Transept's flat roof harmonized neither with the roof of the Nave, which though flat, was considerably higher, nor with the adjoining south Chancel-Aisle, which retained its pitch : but as restored, the higher pitch will group beautifully with the three ridges of the Chancel, and will even suit the Nave better, though it makes one almost regret that the same course was not pursued even with this.

Since the completion, we believe, of the design, the architect's opinions as to the lateness of this part of the additions, and the conse-quent necessity for their removal, have been singularly confirmed by the recollection of the fact, that the fall of the spire, in a storm in the year 1593, destroyed some part of the building. It was evidently in repairing the mischief thus caused, that the insertion of the ugly clerestory in the Chancel, and this mutilation of the south Transept, took place.

The spire is now happily, after an interval of two hundred and fifty years, to be restored ; but the battlement of the octagonal tower does not quite please our eye. The whole of that part appears somewhat too elaborate and crowded.

We have dwelt so long on these greater points, that we can only just notice several other extremely commendable alterations. The pre-sent miserable south Porch will be replaced by one somewhat suitable to the building ; which however we wish might have windows of an earlier form. Again, how much better would the good old-fashioned *Cock* be at the top of the spire, than the modern meaningless *Arrow* represented in the plan !

We shall seldom have occasion to notice any churches which are not of true Christian architecture ; but the stained glass lately adapted to the east window of S. George's, Hanover Square, London, by Mr. Wille-ment, is so well arranged as to appear not only not incongruous with the round-headed windows, but actually suited to them. The glass is of comparatively late date, and represents the Stem of Jesse. Mr. Wille-ment has furnished it with a most appropriate border, in his own unrivalled colours.

NOTICES.

THERE are probably few towns where (as is at present the case in Cambridge) four churches are in the course of repair, restoration, or rebuilding. Of S. Sepulchre's, S. Peter's, and the New Church (or S. Paul's), we have already spoken; and within the last few days, the demolition of S. Andrew's has commenced. In its present state of ruin, the building presents far more of the appearance of a church than ever it did in its days of high pues and intrusive galleries. We think that the restorations which this church experienced in 1660, have been much overstated. The Piers are of excellent Early Decorated character; and there is a good trefoliated Early-English piscina, with two shallow circular orifices, in the north Transept; the western arch is particularly beautiful.

We earnestly hope that the stone-work of the arches will be preserved, and that the piscina will be carefully removed. We could wish to see less of irreverence and thoughtless disrespect to things sacred on the part of the workmen; and we hope that a careful watch will be kept on them by those who have the management of the restoration. It may not be generally known to our members, that a handbill, on the commencement of the restoration of S. Sepulchre's, was printed by the Committee, inculcating on the workmen and visitors the duty of reverent behaviour. It was, we think, useful in that case, as several persons have begged to be supplied with it. The Committee will be happy to furnish copies, on application being made to the Secretaries. It is due to the Rev. W. F. Powell, of Cirencester, to add, that the idea was originally his.

We have not yet seen the plans for the new church. We can only express our hope that the Chancel will be made an object of primary importance, and that we shall not have to lament here, as in so many other cases, the use of stucco and painted deal.

We hear with great pleasure, that the Vicar and his Committee are taking immediate steps for rebuilding the church of S. Peter. We shall not at this early period anticipate their designs; but we are sure, from the spirit and comprehensiveness of their intentions, that a really beautiful and costly church will be erected. Of one thing we are heartily glad—that *competition* will not be allowed. To this subject, a most important one in church-building, we hope shortly to recur. Subscriptions are received at Messrs. Mortlock's Bank, in aid of the fund. The sum proposed is £8000, but we hope that at least £12000 will be collected.

WE have been presented by the author with the two first numbers of an elegantly illustrated work, to which we wish to invite the attention of our readers, on the churches in the district of Holland, in Lincolnshire. It is well known that no part of England contains more magnificent specimens of Ecclesiastical architecture than this; while, from its situation in the so-called Lincolnshire Fens, its fine churches are comparatively but rarely visited. Mr. Morton, of Boston, is now publishing a series of lithographed views, with descriptive letter-press, by Stephen Lewin, Esq., architect, of these churches, issued in pe-

riodical numbers at the very low charge of 1*s.* 6*d.* each part; and
the work is of considerable merit. The general exterior views will
afford some of the best specimens in England of variety and effect
in composition, while the copious extracts from MS. notes made
on all these churches by Gervase Holles, in 1640, are of very great
interest, as shewing how much of stained glass, and how many noble
brasses, armorial bearings, &c. have disappeared since that period.
The churches at present published are Algarkirke, Benington, and
Bicker; and views and details of that noblest and grandest of parish
churches, Boston, are to follow. We have only to wish that less space
were devoted to the transcripts of dull and tasteless modern epitaphs.

Since the above was in type, we have received a lithograph of the
proposed parish church of S. George, Camberwell, of which Messrs.
Scott and Moffat are the architects. The design is, on the whole, a
magnificent one; the style is Geometrical Decorated, and the plan
consists of a Chancel, Nave, two Transepts, two Aisles, north Porch,
and Tower at the west end.

Our principal objection is to the Chancel; it ought to be *at least*
three more bays in length. We do not know why a hexagonal apse
should have been adopted, for scarcely two or three examples in large
churches exist in England. Were the usual plan pursued, it would
give scope for a magnificent east window of seven lights.

In the Transepts, we hope that the doors will stand east and west,
instead of north and south. The north porch should have the side
windows smaller; and the pinnacles are perhaps too ambitious.

The pitch of the roof is very poor; we earnestly hope that it will
be raised to the string-course under the Belfry windows.

The pinnacles at the spring of the spire are too much crowded:
they seem to be copied from Salisbury; but the architect should re-
member the disproportion in size, and that there the arrangement was
necessary to the safety of the Tower; here it is matter of choice.

The second tier of spire-lights should be disposed in the alternate
faces of the spire.

We doubt whether there should be more than single windows under
the Belfry stage; such an arrangement appears to us rather characteristic
of the subsequent styles. The arrangement of the flying-buttresses
seems objectionable; it would be much better if they sprang from the
buttresses above the line of parapets. We believe that the architect has
not finally arranged his plans; and we have therefore inserted the
above hurried remarks in our present number, hoping to recur to the
subject when the amended design shall have appeared. In the mean-
time we must express the gratification we have received from an
inspection of this noble design, and conclude with again protesting
against the curtailed proportions of the Chancel.

[Second Edition.]

Published by T. Stevenson, *Cambridge:* J. H. Parker, *Oxford:*
Rivingtons, *London.—Price* 4*d.*

Metcalfe and Palmer, printers, Cambridge.

THE

ECCLESIOLOGIST

PUBLISHED BY THE CAMBRIDGE CAMDEN SOCIETY.

"𝔇𝔬𝔫𝔢𝔠 𝔱𝔢𝔪𝔭𝔩𝔞 𝔯𝔢𝔣𝔢𝔠𝔢𝔯𝔦𝔰."

No. V. MARCH, 1842.

ON COMPETITION AMONGST ARCHITECTS.

THE first thought which presents itself, now-a-days, to the mind of every one connected either with a vestry, a council for managing a restoration, or a church-building committee, is *Competition*. It is the fashion of the age—the age of shares and tenders and contracts and companies and committees; and to speak against the system is as bold as it is sure, at first, to be distasteful. But whatever may be the merits of this fashion generally, yet, when applied to churches, either new or old, it becomes so dangerous and mischievous, that it is a matter of high importance to show some reasons for rejecting it, and to recommend some less objectionable plan for adoption.

Let us first consider the case of an old church, left to fall into disrepair and dilapidation until immediate steps become necessary to preserve it. If the church be small, the vestry alone decides upon its fate : if it be famous for its size, history, or architecture, a committee consisting of influential people in the county or neighbourhood is very properly formed to conduct the restoration. Now it is the furthest thing in the world from our intention to speak either slightingly or ungratefully of the exertions of any men voluntarily banded in so noble, so holy a cause, as the preservation of one of GOD's Temples. The outlay of time and money by many of late, even if not always commensurate with the demand, deserves our warmest thanks, and constitutes a most cheering sign of our opening prospects ; yet at present we have to regret that members of church-committees are not necessarily conversant with Church Architecture, or qualified to decide upon the weighty matters which often come before their consideration. The gradual formation of local associations, and extending influence of many valuable ecclesiological publications, may soon do much to give a more general correct appreciation of architectural beauties, and knowledge of architectural facts. Yet it may be doubted whether any such body would ever be fully able to undertake a charge of so great importance, any further than the watchful supervision of all proceedings, and the administration of the funds entrusted to their care. But what is the usual conduct of such committees? Is it not to invite the competition of architects, with a plan and estimates for the work, and to offer perhaps a graduated premium to the several best candidates? A moment's

thought will show how differently the churches, which they are submitting to this treatment, were built. An indenture, beginning most probably, "*In honorem* DEI *et Beati M—*" (the Patron Saint), set forth how Master Will. Horwood, freemason, undertook to build for the founder or founders a fair church upon such and such conditions. He was not the preferred competitor, but the selected architect. Probably, could we conceive the modern scheme working in those times, no great harm could have been done. Be the tastes of the committee-men what they may, some freemason *must* be employed; and it would seem that, however the members of this body might differ in grasp of mind and boldness of designing, yet working all in the same style, and trained all in an equal amount of fundamental knowledge, though some might do better than others, none could do wrong. We may well regret the loss of freemasonry, and much more the absence of some source of authority which could alone confer on the strictly worthy permission to exercise this noble art. At present there is nothing to hinder the most ignorant pretender from applying his unhallowed hands to so sacred a thing as church-building. Fresh from his Mechanic's Institute, his Railroad Station, his Socialist Hall, he has the presumption and arrogance to attempt a church. Let it but be remembered what a church is—a building set apart for the holiest purposes, adapted to the administration of solemn rites, symbolical in every part; in a smaller sense, what Coleridge called a cathedral, "the petrifaction of our religion;"— is such a building to be attempted by a " Mr. Compo," a mere builder fresh from a neighbouring meeting-house?

But without the security which would arise from such an authority as we have mentioned, our Committee proceed to deliberate upon the rival plans sent in, by the given day, to their Honorary Secretary. We have seen how unreasonable it is to suppose that they should be really qualified to judge; but even if they should (for argument's sake) be qualified, upon what are they to make their decision? Upon contending plans and estimates for restoring the church! *Contending* plans for doing what can only rightly be done one way? For is it too much to say that there is only one way in which a building can properly be restored? To restore, is to recover the original appearance, which has been lost by decay, accident, or illjudged alteration. The method of the restoration depends on the idea of the original which the architect may form. The sound architect will, from the same data, draw the same conclusions. Yet we are to act, as though from the same given remains to work upon, our competitors had to arrive at different results, between which, equally correct though they be, we were to decide. But it is not difficult to see how the designs *may* be different. The restorations may be as *partial* and as *cheap* as we choose. And a partial restoration may suit one who prefers retaining a particular feature of the modern appearance of the building, from prejudice or association; or another whose taste is for variety, and the ingrafting of modernisms; and a third, who has already expressed an opinion as to his own idea of what the restoration ought to be, which he is now determined to stand by. Nor is this exaggerated : for it is wonderful how soon, even in such a matter as this, sides are chosen, and parties formed, and pre-

judices excited. We may be, for example, as one-sided and unfair, and as violent to remove what we may think an ugly pyramidal head from our church-tower, and substitute a strong embattled parapet, as if discussing politics and working for the next election. To such prejudices, unhappily, competing architects have been found to pander; regardless as well of the real dignity of their profession as of their own reputation. But there may be also a *cheap* restoration: and, alas, such a plan would suit nearly all. How convenient to have only £1500 to raise by rate, instead of £2000! How agreeable to have no more subscriptions to collect; and not even to double our own! And even there may be a surplus, which may be applied to a new organ, or which may save something to the parish. Not that we believe such feelings are *now* always, perhaps not even *often*, entertained; but economy has its charms for nearly all, and he who makes the lowest estimate has *pro tanto* the best chance of success. Can the system which not encourages but creates this appeal to the prejudices of the judges; which distorts the artist's view; which sacrifices *truth* and completeness to the wish for success,—be that which a true son of the Church would make use of in a matter of such high importance?

We propose, on a future occasion, considering competition in the case of new churches.

HIGH-PITCHED ROOFS.

Mr. EDITOR,—Allow me to offer a few remarks upon one of the most important, but at present most neglected, departments of Ecclesiastical Architecture. I allude to the subject of high-pitched roofs. Although much has been recently written which bears very directly upon this point, it is a singular but undeniable fact, that the most approved as well as the poorest of modern designs are uniformly deficient in the pitch or height of the roofing. Of course I am aware that in the Plantagenet and Tudor styles, roofs and gables were built of a much lower pitch than in earlier ages, in accordance with the principles, and to suit the character, of the four-centered arch: and that many high roofs were reduced to a shape more nearly corresponding with a newly inserted Tudor east window, as in the Chancel of Cherryhinton, or for the sake of introducing costly internal ornament in the place of imposing external elevation. Still there was some reason and consistency in this; but I do not think it therefore defensible in modern architects to begin their miscalled restorations of Early-English or Decorated churches, by reducing the pitch of the gables to less than one-half their original height, and by stripping off the old and venerable covering of lead from the roofs, to replace it by cheap blue slates. This is frequently done in cases where the ancient weather-moulding must as it were have stared the architect in the face; so that the only excuse he could possibly have had was the saving of a very few pounds in not making his thin deal timbers a yard or two longer, and covering an area of a few more square feet with this mean and paltry material.* At

* In the former edition, the Chancel of Over church was adduced as an example of a Decorated building, whose roof had been lowered, greatly to the injury of its effect. The writer now desires to state, that this is an error, as he is assured on

Fen Ditton the Chancel (circa 1360) still retains its ancient leaded roof of very high pitch; and patched and mutilated as it now is, it at once arrests the attention as a most beautiful feature. At Bourn, in the same county, we have a magnificent example of a lofty roof, probably little later than the church itself (circa 1200), where not only the original pitch, but the ancient timbers and leaden covering yet remain, though they are in so bad a condition that they cannot be expected to hold together for many years longer. The appearance is majestic and imposing in the extreme. Our good ancestors would have their churches everywhere seen. If the lofty spire did not lift its head high above the surrounding objects, the Nave and Chancel-roofs could still be descried glistering among the green trees. A high roof is a much more striking and conspicuous feature than is generally supposed. Who can behold the superb roofs of Ely and Lincoln cathedrals without admiration; and who does not perceive how important a part they form in the general contour of those divine compositions? But I believe there is hardly a modern church in England, whatever be its style, which has a roof of above half the proper height. Mr. Pugin's beautiful churches are the only exceptions with which I am acquainted. Let any one observe, in passing, the weather-moulding on the tower of Trumpington church. This extends to the belfry window, the height to which, under ordinary circumstances, the ancient Nave-roofs seem almost always to have been carried. And how greatly would the external appearance of this fine church be improved, were the present flat roof raised to its ancient and proper pitch! The same may be said of Chesterton, and indeed of almost all old churches, both in this neighbourhood and elsewhere. In Early-English, and probably also in Decorated churches, the pitch of the roof should be little, if at all, less than an equilateral triangle; in the former, I believe, the ancient architects sometimes even exceeded this standard. But the usual proportion of modern times is that of a triangle whose sides are about two-thirds the length of the base.

The roof of the Chancel at Grantchester, which still retains the original pitch, is very nearly an equilateral triangle, and is contrasted painfully with the perfectly flat roof of the Nave. A church without a lofty roof, or having a high parapet raised on purpose to conceal it, in utter violation of the true genius of Christian architecture, has a most tame and unfinished appearance. It is Grecianized Gothic,—a σηκὸς ἀκαλυφής; and I confess that I have no sympathy with those writers who consider this *unterminated flatness* a beautiful and picturesque feature in church architecture. Imagine the noble Hall of Trinity College destitute of its towering roof and spiry louvre light, or on the other hand conceive King's College Chapel to have been in the Early Decorated style, with very lofty gables; and the contrast must surely, in both cases, be a most striking one.

undoubted authority that that Chancel is Perpendicular, (or possibly Transition), and the roof in all probability the original roof of the *present* Chancel. The passage was written from memory, under a strong impression that the Chancel was of the same date as the rest of the church, which subsequent examination has proved not to be correct. The writer is more anxious to avow his mistake, which he greatly regrets, in consequence of some correspondence on the subject, in the *Cambridge Chronicle*, shortly after the publication of the first edition.

This favourite, because cheap, modern practice of constructing very flat roofs has not only caused the supposed necessity of introducing tie-beams, or what is much worse, brought into general use those frightful flat plaistered cielings; but it is peculiarly liable, by the greater lateral thrust of such roofs, when without tie-beams, to injure walls originally buttressed to bear a high roof, and in their present dilapidated state indifferently qualified to support the depressed trusses of modern work, without requiring in a very few months an iron rod to be thrust right across the east window, or a huge semi-pyramidal mass of red brick to be erected against the walls, intercepting perhaps, in its obtrusive ugliness, more than half of some fine old window or doorway. To conclude these observations, the advantages of high-pitched roofs to churches of the Early-English or Decorated styles are so obvious, the incompleteness of the fabricks without them so manifest, even to an unpractised eye, and the additional expense of them comparatively so unimportant, that I trust you will allow these remarks to have a place in an early number of the *Ecclesiologist*, in the hopes of inviting the attention of Church-builders to this very much neglected subject.

I am, Mr. Editor, your's, &c.
A CAMDENIAN.

REPORT OF THE TWENTY-FIFTH MEETING OF THE CAMBRIDGE CAMDEN SOCIETY.

On MONDAY, February 21, 1842.

THE President took the chair at half-past seven o'clock. The following gentlemen were ballotted for and elected members:—

Barrett, J. Esq., Town-hall Buildings, Manchester.
Belaney, Rev. R., S. Catharine's Hall.
Bostock, Rev. H., M.A., Oxon; Aylesbury, Buckinghamshire.
Fane, W. D. Esq., M.A., S. John's College; Lincoln's Inn, London.
Geldart, G. C. Esq., S. Peter's College.
Kinder, J. Esq., B.A. Trinity College.
Nelson, Earl, Trinity College.
Oakes, H. J. Esq., Emmanuel College.
O'Brien, S. A. Esq., M.P. M.A., Trinity College; Blatherwyck Park, Wandsford, Northamptonshire.
Perry, T. W. Esq., 20, Steward-street, Spitalfields, London.
Walford, Rev. O., M.A., Trinity College; Charter-House School, London.

Several presents having been acknowledged, the following report was read from the Committee:—

"In presenting their ordinary report, the Committee have less to announce than has usually fallen to their lot to communicate.

"By the kind permission of the Venerable the Archdeacon of Chichester, a series of questions, copied, with a few additions, from those formerly issued by the Committee for the Archdeaconry of Bristol, have been forwarded to every clergyman in the Deaneries Rural of Midhurst, Storrington, Boxgrove, Chichester, and Arundel; about one hundred and ten in all.

"The restoration of S. Sepulchre's is proceeding steadily, six out of the eight clerestory windows being now completed. The Committee

beg leave again to remind the Society that more funds are absolutely necessary for an entire restoration.

" The fourth number of *The Ecclesiologist* is on the table; and the fifth is in course of preparation.

" The eleventh edition of the first part of the *Few Words to Church-wardens* has come out; as also the second, with some additions, of the *History of Pews.*

" The *Practical Hints,* which have been entirely re-written, have appeared in an enlarged form, and contain a good deal of fresh information derived from the church schemes.

" An application for assistance has been received from Norbury, Derbyshire.

" The Committee are engaged in correspondence on the subject of the restoration of Hexham Abbey church."

A paper was read by F. A. Paley, Esq., M.A. of S. John's college, on the ceremonies formerly observed in the consecration of bells.

In the absence of the writer, a fourth paper " On the Parochial Chapels of Argyllshire," by J. S. Howson, Esq., M.A. of Trinity college, deferred from last time, was then read.

It was announced that the Reverend the Incumbent of S. Edward's, in this town, had placed £21. at the disposal of the Committee for the removal and restoration of the Font in that church.

The Meeting adjourned at 9 o'clock.

CIRCULAR LETTER TO THE ARCHDEACONRY OF CHICHESTER.

THE following is a copy of the circular-letter referred to in the Report of the last Meeting, as sent, with the kind permission of the Archdeacon of Chichester, to every parish under his jurisdiction. A *Church-scheme* accompanied every packet : and it is hoped that now, as was the case in the Archdeaconry of Bristol, the use of the shorter list may be superseded in many instances by an accurate report of the church in this more comprehensive form. It will be observed that the shorter list of questions comprises points which require no amount of architectural knowledge for their elucidation : while information concerning them, though some of them may at first sight appear unimportant, is not only highly curious in itself, but indispensable for the foundation of some certain rules for church-building, from the investigation of a large number of accredited facts. It is hoped that some other friends may be induced to assist the Society in this way, and to forward their communications to the Secretaries.

And here it may be respectfully suggested to all who propose to describe a church, and particularly its ground-plan, that many advantages would be secured by an uniform way of considering it. As it is, for instance, some talk of a church, and of the relative situation of its parts, and perhaps draw its plan, with the Chancel on their left hand, as if they entered the building from the north ; while others place the east end to their right hand, as viewing the building from the south,

Now, independently on the advantages of uniformity—the necessity for which is easily apparent in the case of *maps*—it will be found that the latter of the two plans above indicated, is the more natural and eligible. For first, almost every one, in considering relative distances, places himself, in imagination, facing north, with the east to his right hand; and again in the majority of instances in this country, we positively do enter the church from the south; owing probably to the disadvantage of a northern door in this climate. With others it may weigh something to remember that the Christian's associations respecting the east, and the greater sanctity of the Chancel, seem to point out a propriety in placing this part on our right.

Cambridge Camden Society, Cambridge, Feb. 15, 1842.

REVEREND SIR,—The Committee of the Cambridge Camden Society (instituted in 1839 for the study of Ecclesiastical Antiquities, and the restoration of mutilated Architectural remains) have long been desirous of obtaining information from authentic sources, on several points of much Ecclesiastical interest, either wholly or in great part hitherto unnoticed; and which can only be thoroughly investigated by means of a careful survey of the details and arrangements which yet remain undescribed in our village churches.

Information, it is evident, on these points, to be valuable, must be well authenticated; and this can be given in the most complete manner by the Clergyman of the parish, the natural guardian of, and the person most interested in, the parish church.

The Committee therefore hope that, in enclosing to you, with the leave of the Venerable the Archdeacon of Chichester, himself a member of the Cambridge Camden Society, the accompanying Church-scheme, you will not consider them to be taking an unwarrantable liberty; and, should you kindly feel disposed at your leisure to return such a description of its several particulars as your church admits of, you will not only lay them under a deep obligation, but, as they humbly trust, will in no small degree forward that spirit of church restoration now so widely spreading through the country.

Should this request occasion you too much trouble, the Committee would feel grateful to you for an answer to any of the underwritten questions; and they need not say how valuable they should consider any, the roughest sketches, in illustration of any particular point.

We remain, Reverend Sir,
Your very obedient Servants,

BENJAMIN WEBB, } *Honorary Secretaries to the*
F. A. PALEY, } *Cambridge Camden Society.*

1. What is the dedication and name of your church?
2. What is the ground-plan of your church?
3. What is the length of the Chancel, and what of the Nave?
4. Is the Chancel higher or lower than the Nave, and by how many steps?
5. How many steps are there to the Altar?
6. Is there any peculiarity in the south-west, or north-west, windows of the Chancel? or the south-east, or north-east windows of the Nave and Aisles?
7. Is there any screen between the Chancel and Nave, or elsewhere?
8. Is there any date on any of the pews, the pulpit, or the reading-pew? or any stand for an hour-glass by the pulpit?
9. Is there any date or legend upon the bells? and how many are there?

10. Is there any stained-glass in the windows, and of what nature and device?

11. Are there any Monumental Brasses in your church? and what is the date and legend?

12. Is there any wake, feast, or holiday in your parish? and on what day?

13. Is there any local custom, or superstition, connected with your church?

14. Is curfew rung? and when?

15. To what point of the compass is the church directed?

A SKETCH.

" HERE is some official letter, my dear," said Mrs. Herbert, as she handed over to her husband an enclosure with the printed address, " *The Reverend the Incumbent, or the officiating Minister of Sedgwell, Wilts.*"

" Let us see what is the seal," said the Rector—" *'Donec templa refeceris,'*—I don't know from whom it can have come."

" What may be the meaning of those words ?" asked Mrs. Herbert.

" Till you have restored the temples," replied her husband. " Why! what can this be ?" he continued, as three enclosures escaped from the envelope. " Cambridge Camden Society—The Society trusts"——

" Why this seems a list of the different parts of a church," said Miss Herbert, unfolding the long strip of paper so well known to us as 'a folio Church-scheme'.

" This letter," said her father, " explains it. It is an application from the Cambridge Camden Society for information with respect to my church, and a list of questions which they wish answered."

" I hope," said Miss Newmarsh, " you will not give them any encouragement. I heard a good deal of that Society when I was in London. It is professedly set on foot for the restoration of ' Fonts, Altars, Crosses, and other rubbish'; but in reality, I fear, with a far worse design."

" Pray, Miss Newmarsh, did you ever read Will Dowsing's Journal ?"

" No, sir."

" Well—he, a Puritan of the rankest character, would hardly, I think, have used terms like those you have just employed with respect to those holy parts of a church you have named. It is language like this which gives such advantage to Papists. But the accounts I have heard of the Camden Society are very different. The Rural Dean was telling me the other day, that at the Rector's request they had given a plan for the restoration of Weston church,—and a very pretty thing it is, I hear. They might do the same for me if they pleased,—I only wish they would."

" They want you to fill up this long paper," observed Mrs. Herbert.

" Which I would do very gladly," answered the Rector, " if I had the knowledge for it. But these questions seem much easier. They want drawings too. Emily, my dear, after service (Mr. Herbert never missed daily service), you shall get your pencil and sketch-book, and we will see what we can do."

"You will want a measuring tape," Mrs. Herbert observed; " I will come too, and see if I can help."

Service over, the party from the Rectory remained with old Master Pensfold, the clerk. Miss Herbert took her seat before what she called a beautiful window, having five divisions, with filagree work at the top, and what we should *call* a Decorated window of five ogee lights, with geometrical tracery, and *write* D. 5 *l's. g.* 3 *f.* 4. 3. 2. 1. *g.* 4 *f's* in head.

"Now," said Mr. Herbert, "let us try what we can make out."

" *What is the dedication and name of your church?* is the first question," observed Mrs. Herbert.

"Easily answered. S. Thomas, Sedgwell."

" S. Thomas Apostle, sir, it used to be called," said the clerk.

" Of course," remarked the Rector, "that does not matter."

Mr. Herbert was mistaken—it *does* matter, in order to distinguish this dedication from S. Thomas of Canterbury.

" *What is the ground-plan of your church?*" continued Mrs. Herbert.

This was entered as Chancel, Nave, and S. Aisle. The Tower and Porch were forgotten. A Camdenian would have written, C. N. S. A. Tower at W. and S. Porch.

" *What is the length of the Chancel, and what of the Nave?*"

" What *does* that matter?" asked Miss Newmarsh. "I never can see any good in a Chancel—it makes a church cold—and one can't hear the commandments. I am sure there was none in Mr. A.'s chapel at B——. Ah! that was something like a church !"

" How was that?"

" Why, there was a pretty east window, with Faith, Hope, and Charity in stained glass; and the pulpit stood just before the rails, so that every one could see the preacher; and there were two tables of commandments, varnished deal, sweetly pretty; and nice galleries all round, as comfortable as possible—not like this great, cold, desolate, barn-like place, without any cieling."

Mr. Herbert took some pains to explain the use of Chancels. As our Society, at no distant period, intends to do the same thing, we w¹ll not enter on his arguments.

" Next comes—*Is your Chancel higher or lower than your Nave, and by how many steps?*—I am sure all Chancels are higher," said Miss Herbert, "and so it is stated in that little book you gave me the other day."

" Not always, my dear. There is a very old author, of great authority in these matters, called Durandus, who says that the Chancel is sometimes lower than the Nave, giving as a reason, that the clergy ought to be humbler than the laity."

" *How many steps are there to the Altar?*" continued Mrs. Herbert.

"Will Dowsing, or some of his fellow-labourers, have taken good care that we should not have many," observed the Rector. " However, there are two; but they probably are of later date than the Restoration. What comes next?"

" *Is there any peculiarity in the S.W. or N.W. windows of the Chancel?*"

" Yes, there certainly is: the S.W. lancet is lower than the others, and has a bar (a Camdenian would have said a *transom*) across it."

" The Camden Society seem to make that a particular subject of enquiry," said Miss Herbert, looking up from her drawing, " for I see that the same enquiry is made at the end of this long list."

Why these *lychnoscopes* are interesting, we need not now stop to explain; the subject having been discussed at p. 26 of our Practical Hints.

" *Is there any screen between the Chancel and Nave, or in any other part of the church ?*"

" There is none between the Chancel and Nave," replied Mr. Herbert. " There are the remains of the holes into which the beams were inserted on each side the Chancel-arch."

" I think," observed Mrs. Herbert, " I have read somewhere that the lower part of the screen is frequently pewed up: and look! here is evidently something boarded over between these two pews."

" Pensfold, just ask Master Jones to bring his tools here for a moment—we'll have a look behind the pew-back."

The obnoxious covering was removed—and six fine panels, each enriched with the painted effigy of an Apostle, brought to light.

" Well, that is a good deed, at all events," observed the Rector. " Now try the other side." A few strokes of the hammer produced the same improvement here.

We have not room to describe the manner in which the eight other questions were answered. Suffice it to say that the packet directed to the Secretaries of the Cambridge Camden Society a few days afterwards, was, with its sketches of the east and west windows, the sedilia, and a fine open seat, considered highly satisfactory and valuable.

ECCLESIALOGIST *v.* ECCLESIOLOGIST.

MR. EDITOR,—I am anxious to be informed of the grounds upon which you call your periodical the *Ecclesiologist*. It appears to me that, according to analogy, the word ought rather to be written *Ecclesialogist*, as we say *genealogy*, not *geneology*; and indeed I cannot see how the change of a in *ἐκκλησία* into o can be defended. Perhaps you will devote a small space in your next number to the explanation of an usage, the correctness of which I have heard questioned by many.

I am, Mr. Editor, your's, &c.

ETYMOLOGUS.

" Etymologus" is informed that the word *Ecclesiologist* or *Ecclesiology* was not invented, but adopted by us; we believe it was first used by a writer in the *British Critic*, to whom therefore any blame on the grounds of its supposed inaccuracy should attach rather than to ourselves. But before " Etymologus" condemns *Ecclesiology*, as a word arbitrarily formed in defiance of analogy, he should show, by producing a parallel example, the correctness of *Ecclesialogy*. For we do not admit that *genealogy* is a precisely similar instance ; since that compound is formed from a substantive ending in εη or εα, the other from

one in ια. And if γενεαλογεῖν should be insisted upon as a case in point, we answer, that even words in η or α sometimes form compounds in ο, as σπερμολόγος, νυμφόληπτος, σκηνοποιός, and many others cited by Lobeck on Phrynichus, p. 641, who discusses this subject, and rightly observes that euphony and other causes seem to have had quite as much influence as strict analogy in many such cases (p. 644). The *Etym. Mag.* (in voc. ὥρα) confirms this opinion: τὰ εἰς ᾱ λήγοντα θηλυκὰ διχῶς συντίθενται· ἢ γὰρ φυλάττει τὸ ᾱ, ὡς τὸ σκιαγραφῶ, ἢ τρέπει αὐτὸ εἰς ō, ὡς τὸ ὥρα ὡρολόγιον. We think however that the word ἱστοριογράφος, which is used by Polybius, is a precisely similar compound to *Ecclesiologist*, and therefore sufficiently defends our use of the latter word. To adduce, as "Etymologus" might have done, ἀγγελιηφόρος from Herodotus, only proves what we do not wish to dispute, that this change of α into ο was not introduced till later ages.

Thus it appears that we might safely rest the orthography of the word in question on classic usage, as decided by the critics. There is, however, another and a totally distinct ground from this, which may be taken with even greater confidence. We have seen that classic usage is not uniform on the point, and that either of the two forms is defensible; and thus, should we claim the *Nicomachean* Ethics as making for us, the Byzantine historian, *Nicephorus*, might be quoted against us; or, were we to appeal to *historiography*, we should be met by a reference to *genealogy*. On this ground, then, it is a drawn battle; we would therefore take another, on which we believe we can come at a decisive result; viz. modern usage in word-making. For lawless and irregular as this science of word-making is in many respects, it nevertheless has some general laws; and one of these appears to be, that in manufacturing a compound out of two Greek words, of which the former is a feminine noun ending in *e* or *a*, pure or impure, its rule is to change this final word into ο, thus adopting the latter of the two classic usages. Thus we have conchology, psychology, sciomancy, &c.; and with the pure vowel, ideology, tracheotomy, eudiometer, goniometer, aetiology, &c.: the last three instances are exactly in point, and abundantly bear out Ecclesiology; but we much doubt if any instances could be found, among words of modern manufacture, in support of Ecclesialogy. But as "Etymologus" has favoured us with one objection to the word Ecclesiology, we will help him to three or four more which have been urged against it, by persons to whose opinion we attach much weight, and which we are glad to have this opportunity of replying to. It is said then—

1. That it *sounds* less correct than Ecclesialogy.
2. That it does not mean what we intend by it.
3. That it means more than we intend by it.
4. That it is a long unpronounceable word.

For the first of these objections no particular reason is given, but it has been frequently made, and by those whose impressions were not likely to be the result of caprice. We think we have detected the particular analogy which, unconsciously perhaps, suggested the preference given to Ecclesialogy on the score of euphony; viz. that the ear, accustomed to the rhythm of Ecclesiástic and -ástical, requires a

similar rhythm in a compound formed from the same root. It is scarcely necessary to observe that such a conformity is not to be looked for, any more than we can expect to find mon*a*poly, mon*a*tony, and mon*a*gamy, because the ear is accustomed to mon*á*stic and mon*á*sticon.

The second objection is directed against the use of the term *ecclesia*, as signifying the material building. On this point, however, will be found full satisfaction in Bishop Pearson's note (*o*) on his Exposition of the Ninth Article of the Creed. Thus he says : " It is certain that in Augustine's time they used the word Ecclesia as we do now the Church, for a place set apart for the worship of God; and it is also certain that those of the Greek Church did use ἐκκλησία in the same sense."

The third objection, again, blames our restricting this compound to a sense which respects the material building only : we reply, that we would fain have used a term which was not ambiguous, but that the Greek language does not furnish one. Nor is such a restriction of use without parallel ; *e. g.* no one objects to the term lithotomy, because it has no reference to engraving in stone.

To the fourth objection we have only to reply by the well-known consolatory saying, that " 'Tis well it's no worse." Let any one who objects—as not unreasonably he may—to such a long word as *ecclesiologically,*—let such an one consider that Isidorus Pelusiota expressly saith (lib. 2, Epist. 246) that the right word for a material church is not ecclesia, but ecclesiasterium ; let him then contemplate the possibility of a man's being said to speak ecclesiasteriologically, and he will be glad to take refuge from so hideous a hendecasyllable, in the comparative brevity and simplicity of such a word as Ecclesiology.

ORTHOGRAPHY OF THE WORD 'PEW.'

Sir,—Will you allow me to make one or two remarks on the orthography of the word *pew*, with reference to the "History of Pews," where the adoption of the spelling *pue* has met with some animadversion.

The oldest forms appear to have been *puye*, *puwe*, and *pue*. *Pew* would not appear to have come into use till the seventeenth century. For, although the parish accounts of S. Margaret's, Westminster, as quoted in p. 8, speak of "Sir Hugh Vaughan's *pew*," it should be remembered that this item is confessedly copied from the *Gentleman's Magazine*, where the original orthography of the extract would appear to have been disregarded.

Since the great mass of early authorities prefer the form *pue*; since the sister term in Dutch is more cognate to it; since the word *pue-fellow* is never, I believe, otherwise spelt ; it seemed allowable, without the charge of pedantry, to adopt this orthography, especially when speaking of the origin of pues ; the rather, since one would, from analogy, conclude that such must have been the original form. For we find that other words now ending in *ew* formerly terminated in

ue: for instance, *crew* is spelt in King James's Bible, *crue*: and to *mew* more than once occurs in our old dramatists under the form to *mue*.

The usual spelling was retained in the title-page and headings, because the other might, without previous explanation, have appeared somewhat unintelligible at a casual glance.

Your obedient servant,
THE WRITER OF THE HISTORY OF PUES.

NEW CHURCHES.

WE have been favoured with an inspection of a sketch of the design for the new church of S. Peter's, Cambridge, by Mr. Salvin, the architect of S. Sepulchre's, and are satisfied that a beautiful and truly Ecclesiastical building will be erected, provided only sufficient funds can be obtained. We shall however defer any remarks that we may have to make upon it for the present.

A DESIGN for a new church to be erected at East Grafton, in the parish of Great Bedwyn, Wilts, has been kindly forwarded to us by the Incumbent, one of our members. It is a small Norman edifice, externally of pleasing effect and correct detail, one which is highly creditable to the architect, Mr. Ferrey. The plan consists of a Chancel, with apsis, a Nave and two Aisles, and a Tower at the north-west corner. The west elevation is good. It appears to us to be modified or rather simplified from Castle Rising church, Norfolk. It is, perhaps, somewhat deficient in breadth for a Norman façade, and the west doorway much wants enrichment. This we think should, as the principal entrance, be at least a triply-recessed arch, with corresponding jamb-shafts and chevron mouldings. The upper stage of the Tower is rather short and crowded with detail, as contrasted with the plain and elongated stage below it. The string under the belfry-windows seems in the engraving to want boldness; and we think that a somewhat larger corbel-table under the capping of the Tower would have a better effect. The windows of the Aisles should have a bold string, perhaps chevronée, carried under them and round the pilasters. This we venture to suggest would be a great improvement at a comparatively trifling expense; in which case the hood-mouldings need not be continued horizontally. The interior is to be groined with stone: but we should much wish to see quadripartite vaulting, instead of single arches thrown across from wall to wall. Upon the whole, we are much pleased with the appearance of this church. The estimate is £2200; but a larger sum should be raised to carry out the plan effectively in all its details.

THE Holy Trinity Chapel, Roehampton, also by Mr. Ferrey, at first a most creditable design, has received, we believe, many important improvements since the view, before mentioned in the *Ecclesiologist,* was first published. Mr. Ferrey has given a very well pitched roof in this, as in other instances. We are confident that in some cases where this gentleman has incurred animadversion, he has been unduly cramped by the many disadvantages under which an architect generally

labours, who endeavours to revive the ancient principles of church-building.

An engraving of Christ's Church, Worthing, has been forwarded to us. This edifice is anything but correct and ecclesiastical in its details. The roof is beyond description : it appears to be a system of tie-beams, with king-posts, and diagonals from the right angles to the principal, or rather only, rafters; for the trusses have no connection whatever with each other, except at the ridge. Each aisle is roofed in the same way, the original design being halved. The whole is of the most lean and hungry description, and much more nearly resembles a railroad-station than a church.—We have again to complain of the unnecessary adoption of a cruciform plan. The Transepts are disproportionate, and badly placed: and the grouping of their roofs with that of the Nave and Aisles singularly unhappy. The south Transept displays a triple lancet, with, as usual, a door below it, and has altogether a more aspiring elevation than the east end, which is very low, with a window somewhat too late for the rest of the building. The lancets are uniformly too short and broad. The Tower, being intended for Early-English, has no right to battlements, and the arrangement of the corbel-string underneath them is altogether incorrect : the gable-moulding over the window in the lower stage of the Tower is particularly objectionable. The roofs of the Aisles, if they reach to that of the Nave, had better be in one continuous surface—for which there is sufficient authority—than be broken by making the eaves of the latter just appear above the ridge of the former, which is only making the want of a Clerestory more evident. We see nothing like a string-course in any part of the exterior ; yet this is almost always a prominent and beautiful feature in the genuine Early-English style; and the buttresses are very poor, both in detail and arrangement. It is this that we have to complain of so frequently in new churches ; that designs are chosen by persons unacquainted with the principles of architecture, when, with more knowledge on the part of the judges, good and unexceptionable churches might, with no additional (very often less) expense, have been produced. We are glad however, in the present instance, to find a Chancel, though a very small one. The first stone of this church was laid October 28, 1840. Why then was not the building dedicated in honour of S. Simon and S. Jude, rather than called "Christ-church," which, as we have elsewhere remarked, is an unsuitable name for a small church ?

Wrotham, Kent.—A south-west view, with plan, of the proposed church at Platt, in this parish, has given us anything but pleasure. It is intended to contain 500 persons ; the distribution of whom is thus amusingly exhibited in the corner of the engraving. " Sittings in pews, 122 ; sittings in free seats, 199 ; children, 170 ; singers' seats, 9 :—500."

The building has the common fault of being of a bad cross shape ; the extreme length being 77-9, and the width of the Transepts twenty-five feet ! The Chancel is disproportionate ; but the pulpit is well-placed at its S.W. angle. Though intended to accommodate so few, it has a western gallery, reached by a staircase in the Tower. To this

unnecessary appendage, the Tower, everything else seems to have been sacrificed. It is the only part upon which even the ornament of a basement moulding has been bestowed. The style is meant to be Early-English; but the position in the view leaves us to doubt of anything but three very plain broad single lancets in the Nave, and a poor window of two lights in the south Transept, surmounted by a trefoiled spherical triangle in the gable. There is a door under this window (in the case of this church a remarkably bad position), and another at the west of the Tower. The Tower is a faulty composition of two very unequal stages, the lowest supported by massive pedimented buttresses, the higher surmounted by a heavy embattled parapet, and furnished with an octagonal turret at the S.E. angle.

CHURCH RESTORATION.

WE have seen Mr. Willement's beautiful design for stained glass, about to be placed in the east window of S. Margaret's church, Leicester. This window is at present blocked with brick, and a huge ugly Altar-screen of the pseudo-Grecian style occupies the greater part of this end of the Chancel, which is crowded with large high pews, and ornamented by a great stove pipe thrust through one of the south windows. The pews must be entirely removed before any stained glass can produce the solemn effect of an ancient church. The estimate for the new window, exclusive, we believe, of the stonework, is £400.

The following is an extract from a circular respecting the repairs of Alwalton church, Huntingdonshire, which we give because we admire its bold and uncompromising condemnation of modernisms. " The repairs had long been neglected, and at various times it had been disfigured by every possible enormity; by pews, or rather cribs, of every shape, size, height, and colour; by, what was called, a singing-loft; by bricking up one most beautiful arch, and by letting others go to decay; by broken floors, broken seats, and broken windows; by crumbling walls, and by a roof scarcely hanging together." All these defects have now been repaired at the expense of above £700, which large sum (considering the smallness of the parish) has been contributed by the parishioners, with a promptness and liberality rarely seen in these times.

A TRANSLATION.

SIR,—From the *Ecclesiologist*, No. III., I find that ladies are becoming proficients in Ecclesiology. If you think these rough lines would give them something like the meaning of the Greek inscription on the ejected Font (No. II. p. 16.) they may be improved for the purpose. C. F. P.

Stop, stranger! stop, and pity me;
Then tell the Bishop what you see.
How chang'd, degraded, is my lot,
A flow'r-vase on a garden-plot!

I once, beneath a Christian dome,
Had flow'rets for a world to come.
My flow'rets drank the Spirit's dew,
In water wash'd, were born anew ;
Were purified from earthly leav'n,
Made sons of GOD, and heirs of heav'n.
O wretched fate! O glory gone!
Earthly my flow'rs—for heav'n I've none.
—— *Rectory, Suffolk.*

NOTICES.

AMONG the presents lately received by the Cambridge Camden Society, may be mentioned one from Mr. G. J. French, of Bolton-le-Moors, Lancashire. This is a handsome crimson woollen Altar-cloth, with the letters I H S and a Cross inwoven in the usual border of diverging rays. Both this and the damask linen cloth and napkin, which were mentioned in the last number, are handsome and appropriate, and we may safely recommend them for general use. As several inquiries have recently been made respecting the price, we shall append them from Mr. French's circular.

Damask linen, 2¼ by 2 yards,......30*s.*
 „ „ 3¼ by 2 yards,......40*s.*
Napkins, 9-8 square,....................7*s.* 6*d.*

The woollen Cloth is of the same size and price as the linen.

We cannot, however, refrain from expressing a hope that the greater frequency of embroidered Altar-cloths by the hands of ladies connected with the parish may confine the use of the woollen cloth to a partial and at most a temporary use. The scope which may herein be given for the exercise of chastened taste and devotional feeling would make us much regret the general adoption of a mere cheap article of manufacture. The same objection applies, but not nearly in an equal degree, to the damask cloths. Might we suggest to Mr. French the introduction of other symbols? On the napkin, for instance, the ancient pattern of corn and grapes, typifying the Holy Elements, would be much preferable to the mitre.

A CORRESPONDENT has directed our attention to an account, given in a recent work, "The History of the Knights Templars, &c." by Mr. Addison, of the subterranean Chapel at Royston. The writer of the article in our last number, in which this curious chapel is mentioned, was not then aware that the history of it had been published by Dr. Stukely, in 4to., in 1742. In a future number we may perhaps extract from this interesting work a brief description of the cell in question.

THE lithographed drawing of the Holy Sepulchre church as restored, will be published in a few days. India paper copies will be sold in aid of the works, and will be procurable through the Society's publishers.

―――――――

[Second Edition.]

Published by T. STEVENSON, *Cambridge:* J. H. PARKER, *Oxford:*
RIVINGTONS, *London.—Price* 4*d.*

METCALFE AND PALMER, PRINTERS, CAMBRIDGE.

THE

ECCLESIOLOGIST

PUBLISHED BY THE CAMBRIDGE CAMDEN SOCIETY.

"Bonæ templa refeceris."

Nos. VI. VII. APRIL, 1842.

ON COMPETITION AMONGST ARCHITECTS.

(*Continued.*)

COMPETITION in the case of the restoration of an old church having been already discussed, we proceed to consider it when applied to new churches: and the arguments advanced against it in the former point of view lose none of their strength when again employed in this. For whereas, in deciding upon the plans for repairing an old building, there is at least something in the present condition and appearance of the fabrick to guide the choice of the judges, here there is nothing. Neither suited for their task by knowledge, practice, nor any intuitive perception of propriety, they proceed to select one out of a heterogeneous collection of competing designs. For the same circumstance which deprives the judges of their last hope of something to controul and direct them, opens an equally wide and trackless field for the exercise of the competitors' abilities. They have nothing to work upon: they may begin where they like; choose what style they like; adopt what plan they like. It is a fact, that many competing architects take little, if any, notice even of the site which is procured for the church. The relative situation of the site, its advantages or disadvantages, we may almost say, are *never* taken into consideration. Ancient churches always appear to have some inherent suitableness to their localities: modern churches for the most part seem excrescences which *might* have grown anywhere, but have by chance grown here.

Now, though we cannot excuse the architect who condescends to tamper thus with church-building; yet in justice it must be owned that the fault is partly that of the system. In the lottery of competition the chances against the selection of a particular plan must be so great, that in truth there is scarcely any inducement for the architect to take great pains with his design. We cannot expect that any one will expend as much energy and devotion on a mere risk, as he would if honourably called upon to exert his whole skill with the certainty of success. So miserable is the system of competition; which drives the

competitors perforce to unworthy and degrading expedients; which entails on the judges almost the certainty of abusing a difficult and uncongenial office; which produces as its result that amount of meagre and faulty deformities presented generally to our mind by the notion of a modern cheap church! Trace the workings of the system still further: see a design, the melancholy first-fruit perhaps of some beginner in cheap church-building, at length laboriously though incongruously completed. It will be sent in at once to scores of competitions; and it would be hard if at some time, in some place or other, it were not selected. Perhaps it received this honour from the paring down of some even of *its* ornaments, from a still greater reduction of estimate, or from the introduction of some feature, or it may be adoption of some arrangement, known to be a favourite with certain of the judges. Alas, then, for the country or district! The design, as amended and improved, is forced with renewed vigour into every competition. What has pleased once may, *and often does*, please again; and so we see the same structure repeated again and again, and every paltry feature in it reproduced *usque ad nauseam*. We have ourselves known an architect confess to having sent in these *ad captandum* designs, and can speak to the effect which such designs have had on those to whose approval they were submitted.

But the most important fact perhaps in connexion with the system of competition, and one which ought to weigh much with church-builders, who must always be supposed to desire most of all the success and excellence of their work, is this—that the *best* architects *never do compete*. Is it to be expected that men at the head of their profession will spend time or thought upon competing, when probably, from the inexperience of those called upon to decide, plans infinitely inferior to their own will be preferred; though, to be sure, they might stand second, and carry off the £5. premium. Should we not on the contrary despise them, if they submitted the work of their own matured experience and of their profound architectural skill to a singularly unqualified tribunal, in comparison with the attempt of one, who, as we hinted before, having as a mere builder succeeded in "running up" a spacious conventicle, now dubs himself architect, and essays a church? Nor let it be argued, that, although we cannot thus obtain the plans of superior architects, yet we may foster rising talent, and help to make superior architects. For experience shows, as we might without it have predicted, that such is not the school of excellence. Success in a good work can be obtained only in a good way. Competition offers scarcely even the advantages of practice; while it degrades even in his own estimation the man who adopts it, cramps his energies, confirms his mannerisms, stamps him second-rate, and makes him for ever answerable for solecisms and absurdities of which perhaps he was not guilty. For how few competing architects can point to a plan which was adopted without restrictions or alterations! No; the judges suggest and "improve," and sometimes even Diocesan Boards and high authorities interfere, and then the contracting builder himself indulges a little according to his own notions of architectural proprieties; and thus, from the combined faults of all, rises the modern structure, called by courtesy a church!

But if it be asked, what plan is to be adopted by those proposing to build a church, if they may not follow the usual one of competition; we answer, that it is their part to choose an architect to whom they can safely entrust the work. Here is full scope for thought and carefulness; they ought well to consider his reputation, and see upon what grounds it rests; they should be satisfied that he is one who will undertake the sacred task in a right and reverent spirit; that he will hold everything subservient to the great object in view. And, lest they should think such an one difficult to be found, let them remember that it is in their power to *make* such, since demand always produces supply; and the more we require artists of high and uncompromising principles, the more such will be encouraged, and will come forward to supply our need. And in this selection there will always be some ready to aid with advice and matured judgment. The Archdeacon, who more peculiarly cares for these things, often Diocesan Church-building Boards, or local Ecclesiological Societies, will be at hand with recommendations, advice, and above all, sympathy.

To architects, on the other hand, we would say—remember the dignity of your profession, and scorn to disgrace it by entering into unworthy contests, and by making mean concessions to popular customs or individual prejudices. If you for your part reject competition, the system soon must fall, since increased architectural knowledge will not much longer tolerate ignorant and faulty designs. Above all, if you intend to build *churches*, dismiss every mercenary or selfish thought, be content to labour as in God's service, without care for your personal fame, without thought of your personal sacrifices: strive in some degree to emulate your predecessors, whose names are perhaps now lost to memory, though their works—works of faith—remain in unapproachable excellence and in imperishable glory.

Thus then we may see a brighter day dawn upon Christian Architecture; sacred works will be again undertaken in a religious, humble spirit; every one will work for the same good end in his own sphere; the founders neither trenching on the prerogatives of the architect, nor he swerving from the line of professional duty for any temptations of fame or interest. Let us all do our part in the effort, and modern cheap church-building will perish with its primal cause, "competition."

HOW TO ATTAIN SOME KNOWLEDGE OF CHURCH ARCHITECTURE.

THE question is very often asked, How am I to begin to acquire some knowledge of churches—their styles, dates, and peculiarities? I am inclined to take an interest in Ecclesiology, but how am I to attain it as a science? How to pursue it successfully? How to ascertain when I am right, and when wrong, in my conjectures on these points? Now we propose to answer these questions as if they had been actually put to some Camdenian friend by a student just entered upon his university career, and desirous to engage himself in some pursuit, that shall be at once instructive, elevating, and useful.

First then, we say, by all means join the Cambridge Camden Society. You will then be at once entitled to the use of a considerable collection of architectural drawings, models, and engravings, and of all the books necessary for commencing your new study. As a member of this body, you will of course attend regularly its general meetings, held twice in every term; there you will be sure to get some information, if not always as elementary as you might wish, still of value and interest, if it be only to satisfy you of the importance and extent of Ecclesiology. Procure and peruse carefully the Society's "Hints on the Practical Study of Ecclesiastical Architecture." It is a very little book, and perhaps you will think that it can therefore only carry you a very little way in advance of your object. Still it will be quite sufficient for you at first to attend to its suggestions; it is designed expressly for beginners, and will shew you how to proceed after you shall have mastered all that it contains. When you have made yourself familiar with the ordinary terms of architecture, which you may readily do by the help of the "Glossary," pay an early visit to Trumpington church with your "Hints," and observe carefully the method there adopted for giving a written account, on a church-scheme, of the minutest details of the church. To learn this thoroughly may perhaps require you to repeat your visit on the next, or even on the third day: if so, your eye, if you are a careful observer, will have become in some degree familiar with the forms and profiles of Decorated mouldings, arches, capitals, bases, &c. Be assured that these are not only of a very peculiar character, but that the forms you see in that church are the same, as far as they go, in *all* churches of the same age. You will now have had a tolerably good first lesson in Decorated architecture. You may then take your next walk, provided with a church-scheme, and sketching apparatus if you can draw, to Grantchester. The Chancel of this church will confirm your knowledge of Decorated architecture; the Nave will afford you an example of the succeeding, or Plantagenet style. The plan and details of this church being very simple, you will have no difficulty in describing it on your church-scheme in the manner used for Trumpington church in the "Hints." You may next in order visit and describe Chesterton, Cherry-Hinton, Fen-Ditton, Teversham, Milton, Histon, and Coton churches. These are all within less than an hour's walk from Cambridge, and will afford you much practice and information. The churches and college chapels in the town itself should also be studied with attention. And do not think that a single visit or cursory inspection of these will be sufficient for you. This is a very common mistake. So long as any pier, or window, or moulding, remain unexamined, you have yet information to derive from them. Were every church, indeed, built in a peculiar style, or were there no definite principles of Gothic architecture, little could perhaps be learnt from any *one* church: but you must ever bear in mind, that what you see in one church you are sure to meet again in hundreds of others, be they ever so distant; so that your actual proficiency may be greater than you suspect. If you are anything of an equestrian, do not fail to accompany the members of your Society on "Field-

days." In these cases a route will be marked out with the special object of comprising as many and as interesting churches as can be seen within the limit of a day; and you will then have the benefit of the advice and suggestions of more experienced persons than yourself. You need not feel any reluctance in obtruding yourself on a strange party; for Camdenians are all friends and brothers, and will feel pleasure in assisting you.

You will thus find it a very easy, as well as a deeply interesting thing, to acquire some little acquaintance with the principles of Church Architecture. Wherever you go, through whatever villages you pass, you are sure of being informed and gratified by a visit to the parish church. You will sometimes, too, be able to instruct others; and thus you may often do much good by speaking a word of advice or suggestion to those who have the management of it. In Ecclesiology there is ever something new to be learnt—something curious to be seen—something interesting to be discovered. And should you be admitted hereafter to Holy Orders, and thus have a church under your own controul, not only will you be much more anxious to see it in a state of good repair, but you will know how to effect this correctly, when without your well-timed interference a fine old building might have been quite spoilt. Then the clergy of the neighbouring parishes will often be glad of your advice; in a word, you may very possibly give an impulse to correct church-restoration throughout a whole district, from having joined the Camdenians when an undergraduate at Cambridge.

SCOTLAND AND SCOTCH ARCHITECTURE.—Letter II.

To the Editor of the Ecclesiologist.

Mr. Editor,—In my last letter I happened to speak of four districts which might afford suitable fields of inquiry for such members of our Society as might be travelling in Scotland, and desirous of examining its architecture. I will begin the present one by mentioning a few books which might be found useful in these localities. As regards the neighbourhood of the Tweed, Morton's Monastic Annals of Teviotdale, a learned and elaborate work, would be found a valuable auxiliary: and assistance might be derived also from Scott's Border Antiquities. In the Lothians, I should think with Arnot's and Maitland's Histories, Scott's Picturesque Antiquities, and the guide-books to Holyrood, the enquirer would be well provided. Sir R. Sibbald's History of Fifeshire (the last edition) is a work of reputation: but for Morayshire, I have not myself seen any publication better than Shaw's History of the county, which in the ecclesiastical part is very imperfect.

To pass from books of local information to those of a more general character. The most important of all is Keith's Catalogue of Scottish Bishops, and, with this, Spotswood's Religious Houses, originally printed at the end of Hope's Minor Practics. They have been edited together in one volume, with additions, by Bishop Russell. There is

considerable imperfection in each of these lists; but they are of inestimable value to the antiquary. Another work, which no one can know without appreciating most highly, is Chalmers' Caledonia. It is a mine of information for almost every part of Scotland, and is very copious in all that relates to its religious history. But we have to lament that the author died before the fourth volume was completed; and thus we are deprived of his guidance through the Northern and Western Highlands, where we most needed it. Some information concerning every parish in Scotland is furnished by the Statistical Account, which consists of reports communicated by the parochial ministers, and published under the direction of Sir John Sinclair, about the beginning of this century. These reports differ very much in value, as would of course be expected; but many of them are copious and accurate. A New Statistical Account, similarly conducted, is now in course of publication; and several counties are already before the world. I may here say that I can, from experience, attest the kindness with which the Scotch pastors are willing to communicate information. The resident minister is usually the best informed person in the parish on antiquarian subjects: and in remote and mountainous districts it often happens that no information gleaned from books is so valuable as that obtained at the "manse."

In the Advocates' Library at Edinburgh are two voluminous manuscript compilations, which contain a large assemblage of documents illustrative of the Monastic and Diocesan Antiquities of Scotland. These are Hay's Scotia Sacra, and Hutton's MSS., each bound in several volumes. Father Hay's notes contain various charters and records, arranged (as I have been told by those who have repeatedly consulted them) with extreme accuracy, with indexes and references. The papers of Lieutenant-General Hutton were not left in a regular form. His object was to contribute towards the formation of a Scotch Monasticon; but he died before his work was finished. The papers consist, in a great degree, of correspondence, interspersed with sketches and copies of original deeds. Here again I cannot but speak of the kind attention which strangers receive at the Advocates' and the Signet Libraries in Edinburgh. For myself, I have especially to express my acknowledgments to the Librarian of the Theological Library at the College, for all I know concerning some of the authors mentioned in this letter.

It would be futile, even were I well acquainted with them, to dwell on the Scotch antiquaries, such as the Dalrymples, Innes, Balfour, Pinkerton, Macpherson; or to do more than mention the old historians, such as Fordun, Wynton, Major, Boece, Leslie, Holinshed. Two or three historical works, however, may be enumerated as likely to be of use to the student of Scotch architecture. Such are the Appendix to the one volume which was published of Bishop Keith's History, containing a list of rentals of Abbeys—a list which, as I am informed, is to be found more correctly printed in the Register-office; Dr. P. Abercrombie's History of Martial Achievements in Scotland, in two volumes; the Appendix to Nisbett's Heraldry, containing some remarks on Ragman Roll; some recent publications by Mr. Dalyell,

from the records of Dumfermline, Abroath, Aberdeen, &c.; and Forbes' Treatise of Teinds, which explains many Scotch terms, and elucidates some historical questions. The more authentic sources of information are the Fœdera, the Scots' Acts, Robertson's Index of Lost Charters, &c.; and finally the Records of Privy Council, and Records of the Great Seal, some portions of which are printed.

Of modern works, Tytler's well-known History may be noted as a source of valuable information. Anderson's Guide to the Highlands is an admirable book of its kind. Of works which relate to various isolated relics of ancient times, three may be mentioned: Cordiner's Antiquities of the North of Scotland, which will afford some valuable engravings and some outrageous theories; Grose's Scotch Antiquities, containing a good deal of information, and many interesting though ill-executed engravings; and Cardonnel's Picturesque Antiquities, which has been well described as a miniature of the last.

It may not be out of place to mention the additional books which have been found useful in elucidating the architectural history of Argyllshire. These were, the Paisley Chartulary, and the Lives of the Bishops of Dunkeld (to be hereafter mentioned); Dean Monro's Visit to the Isles, Martin's Western Islands, Johnson's Tour, Boswell's Tour, part of Sir W. Scott's Diary, as given in Lockhart's Life; some papers in the Scotch Archæologia, Gregory's History of the Western Clans, Skene's Highlanders, M'Culloch's Highlands, Sacheverell's Account of Iona, and the Transactions of the Iona Club. The interesting island of Iona lies so necessarily in the route of steam-boat tourists, that no opportunity should be lost of calling their attention to the antiquarian treasures there contained. With this end in view the last paragraph has been written. I am, Mr. Editor, your faithful servant,

J. S. HOWSON.

Brighton, March 14th, 1842.

REVIEW.

Remarks on Church Architecture. By the Rev. J. L. PETIT, M.A. (Burns, London.)

THIS work has already, we believe, attracted considerable attention from those interested in the revival of Church Architecture. It contains some sound and valuable remarks, but we are sorry to observe that it adopts throughout a merely utilitarian view of the subject; there being no reference whatever to any higher standard than that of mere *taste* in church-building, which is treated quite as a matter of trade, convenience, caprice, or of arbitrary arrangement, instead of one that has ever involved and been influenced by the most unvarying and exalted principles.

It seems a remarkable fact, that most recent works which treat of the principles and theory rather than of the mere mechanical part of Christian Architecture, have been, as is the case with the work before us, chiefly engaged with foreign styles; while not only has little notice been taken, but sometimes a comparatively imperfect acquaintance is

exhibited, of the equally important varieties which characterize ecclesiastical architecture in our native land. We mean that the research of the writers seems to have been almost exclusively confined to foreign examples, to the neglect of the many beauties and peculiarities observable in the parish churches of our own country, which remain to this day but partially explored, although they contain much that is decidedly superior to the most approved German or Italian edifices. For those who profess to write not so much for the furtherance and elucidation of architectural science in general, as for the improvement of modern church-building in this country, such a course does not appear by any means the best adapted for obtaining the object in view; nor does it seem at all necessary, from any poverty of English examples, to have recourse to churches which very few may have an opportunity of visiting, and of which only a general idea of outline, and none whatever of detail, can be obtained by such rude sketches as those which illustrate Mr. Petit's work. These remarks, however, are by no means intended to apply exclusively to the volumes before us, in the second of which are several sketches of, and many remarks upon, English architecture; but to others of the same class, whose *practical* use is much diminished by their having so little reference to the only generally accessible models for imitation or inspection, our national cathedrals and parish churches. We willingly admit the truth of Mr. Petit's remarks on this subject in pp. 14, 15, that foreign examples are useful in "forming our judgment" of Gothic architecture in general; but we do not therefore concede that a correct judgment of English Gothic architecture will be best imparted by bringing forward any rather than English examples to illustrate it.

It may surely also be with reason remarked, that to fill volume after volume with dull theories on the history of Romanesque, or the revived Roman, or Lombardic, or Italian styles, can be of little use to English church-builders, unless it be the wish and intention on the part of the writers, that our own most pure and beautiful models, so admirably adapted to, because reared by, the genius of our Church, our nation, and our climate, should be superseded by the semi-pagan varieties imported from lands and people differing widely from our own. This wish is indeed distinctly avowed by Mr. Petit, whose opinions on this point we therefore think it right to combat, conceiving that no sufficient reasons are adduced by him or others for rejecting a school of art which, from its nationality, beauty, abundance and variety of examples for imitation, its ancient and all-glorious associations, and the advantage to be gained by maintaining a certain degree of uniformity in Christian edifices, may be judged in the highest degree appropriate for modern church-building.

In page 90 of the first volume, Mr. Petit asks, "Might not a style be matured upon the suggestions thrown out to us by these old buildings of Italy, France, and Germany,—a style admitting of great simplicity in point of workmanship [we suppose this means, and therefore conveniently cheap], and at the same time capable of the most varied and beautiful combinations; that could be grounded and advanced upon clear and definite rules, and freed from every sort of

inconsistency; that would harmonize with our modern domestic buildings, and yet be sufficiently distinct from them to mark the high purpose to which the fabrick is dedicated? Might it not enable us to adopt with advantage *forms of great convenience, but ill suited either to Italian or Gothic?*" What, we ask, are we to understand by these "convenient forms" for churches, which the Gothic style is ill adapted to assume? Semicircular or octagonal preaching-rooms?—Mr. Petit then tells us that this new style "*freed from every sort of inconsistency*" may have domes round or polygonal, "turrets and towers of all shapes and dimensions," arches semicircular, elliptical, or *of any other shape;* but Gothic mouldings and Norman details are to be avoided! The writer concludes thus: " I have ventured to throw out a few hints on this subject, without pretending to lay down any general rules; but surely it would be better to attempt maturing a style that might be rendered correct and pleasing, than to continue in the imitation of models, which, though far from deficient in beauty, are yet of a style manifestly imperfect in its nature, and owing its principal value to a charm we cannot impart to our copies—I mean, that of antiquity." We shall only observe that we differ totally from Mr. Petit on every single point here alleged by him. More rational, yet surely somewhat inconsistent, are the following remarks in p. 13.

" I should, indeed, be sorry to see a continental manner generally introduced and established in the building of English churches." [Then why, we ask, so distinctly recommend its adoption?] " The models we have of our own, scattered abundantly through every county, *are the very best we could procure:* our parish churches, taking them in the aggregate, may be pronounced the most venerable, the most truly beautiful, the most durable in appearance, of any of their class; and, still more, they are endeared to us by every association. On this account it is the more painful to see them imperfectly or unworthily imitated; while, at the same time, many circumstances may occur which render it *inexpedient or impossible to follow exactly their proportions or arrangement.*"

Here Mr. Petit's utilitarian views shew themselves without disguise. He voluntarily *asserts* what we should be sorry to find even reluctantly admitted. But these are principles which we believe to be necessarily subversive of correct church-building, and which we therefore will persist in condemning as most pernicious in themselves, and most derogatory to GOD's glory.

Mr. Petit proceeds: " Hence a wider range and a greater variety of examples than is to be found in our own country becomes useful, both by overthrowing such rules of a narrow and restricting character as have been derived from limited observations, and by shewing how exigencies have been met, which would force the architect who is unacquainted with any beside English specimens, to rely too much on his own invention." In this we recognize little real argument. The existence of these "exigencies," which Mr. Petit here leaves undefined, but which should have been specified if his arguments were designed to have any weight, is altogether imaginary; nor is there the smallest reason, except the worst of all motives, the love of cheapness, why we should depart from the custom of antiquity in building new churches.

Very different were the ideas of ancient church-builders from those now advocated by Mr. Petit: very different was the school in which they were educated, to that set forth in the nineteenth century: "If an architect would attack the main difficulties of his art, let him"—what? work in faith, humility, devotion, and with a deep sense of awe and responsibility, as men once worked? No: "let him study to produce a perfect model, with but little reference to any details of style, *and at the least possible expense consistent with durability*: having attained this, he will easily learn *to add as much decoration as he pleases*," and, we suppose, as the money remaining will provide! (vol. i. p. 16.) We do not believe that the ancient architects first formed their conception of a plain building and then enriched it, but that a certain degree of enrichment was a natural and inseparable part of their designs. And certain we are that they did not "run up" cheap walls, and then "practise ornament" upon them by adding detail. How precisely is this the custom of the Messrs. Dabaways, and patent-cement-crocket-and-finial-manufacturers of the day! We do not wish purposely to misunderstand Mr. Petit's words, nor to apply them literally to the external decoration of a "cheap church" *after its erection:* but seriously we think the distinct recommendation to an architect to begin designing on plain cheap walls, and thus to pander to the wretched economy of the age, by no means a very valuable or enlightened suggestion.

Throughout the whole of his work Mr. Petit lays too much stress upon what he denominates "*effect*," and "*the picturesque*." He writes, in fact, as one who, having ascertained the precise nature of the τὸ καλὸν, and established its principles by some fixed laws, proceeds to shew the rest of the world what kinds of form and outline constitute beauty, and what are opposed to it. Now there is nothing in the world so undefinable, and so entirely depending upon individual taste or caprice, as what is called "the picturesque." Mr. Petit has therefore, as we conceive, no right to assert that objects pleasing to his own eye do necessarily contain the elements of beauty, and must be received as such by all. The assertion made in p. 41, "In England there are many situations where the horizontal lines of the Italian would harmonize better with the scenery than the more aspiring forms of Gothic," will probably be absolutely denied by others who claim to themselves an equal taste for, and appreciation of, the beautiful with Mr. Petit.

The attainment of a better knowledge and taste in architectural composition is the principal object for which Mr. Petit professes to have published his work. A great number of sketches, rough indeed, but always remarkably correct in perspective, and therefore not generally displeasing to the eye, are given in illustration of the writer's own views of grace and beauty of proportion: and though we cannot always concur with his opinion in this respect, the examples are well selected, and from their great variety give much value to the work.

We cannot, however, help remarking that this style of drawing is extremely unfair to English architecture, which in detail and finish infinitely surpasses any thing foreign; and we think we detect a general attempt unduly to set off the latter to the depreciation of the former. It is clear indeed that Mr. Petit "foreignises," if we may be allowed

the expression. For instance, in page 6, he prefers saying, "from the plainest village churches, to the magnificent structures of *Amiens* and *Strasburg*," to adducing the really finer churches of Canterbury or Lincoln. So again in page 21, the writer adduces Freyburg, Cologne, Amiens, and Strasburg, as the best examples of what he calls, by an arbitrary term to which we much object, as it tends only to create confusion, "Early complete Gothic;" while Beverley, Ely, Salisbury, Westminster Abbey, &c. are not so much as mentioned.

Aware that paltry and cheap imitations of ancient English churches —that is, imitations of the mere shell without any of the richness of detail—will produce poor and meagre structures, the author, instead of urging a greater outlay and a closer adherence to ancient designs, would unsettle the taste and prejudices (already, alas! wavering and capricious enough) of modern architects by holding out to them the fascinations of his cheap Romanesque, or his plain Italian style. His book seems to say, "If you will not give £10,000 to build an English church, I will show you how to build a foreign one for £5,000. And as an additional reason for the adoption of this Italian style, we are told that churches would thus present an appearance of greater consistency with modern houses! (see p. 44.) Now that churches should be built so as to form consistent street fronts, or give a fine perspective effect to a long range of houses, may be the wish of an artist, but is certainly not that of one who has high views of the *exclusive* sanctity of a church. If men choose to build themselves unsightly abodes, is this a reason why we should make GOD's temples no better? Is it not rather an additional motive for adopting pure Gothic architecture, that churches may stand prominently forth from the grovelling mass of pagan structures, in all the purity and elegance of their vertical lines and aspiring elevations?

The Preface and the first chapter are sound and rational. The author shews that the principles of composition are of greater importance, and certainly much more difficult of attainment, than correctness of detail. It is in these, indeed, that modern buildings generally fail. Ours is but an acquired, that of the ancient architects must have been an intuitive, perception of beauty. The latter is ever essentially correct; whatever be the varieties of style, situation, or proportion, it comprehends and adapts itself to all: the former generally fails in some one of these points, and therefore produces a bad effect. Hence, out of the thousands of ancient churches perhaps none can be justly called faulty, while hardly one out of fifty modern ones is correct.

It is not very easy to comprehend Mr. Petit's meaning, when he asserts in p. 9, that "all buildings, from the rudest Saxon to the most florid Gothic, belong to one family, and have a very decided resemblance from some general and inexplicable law." We imagine that the whole amount of this mysterious, and we think very fanciful, resemblance consists in no more than this, that there is necessarily an association in the mind between the idea of one church and that of another, and that most consist of the same parts, as chancel, nave, tower, &c. More actual resemblance than this we do not believe to exist between Gothic and Romanesque, whose very principles are not

only different, but directly opposed to each other. Were this true, it might also be argued that Grecian and Gothic belong to one family— in a word, that Pagan and Christian architecture are identical. Again, in p. 39, Mr. Petit states, that "the Romanesque of Normandy, and still more of England, is essentially Gothic; not indeed fully developed, but quite sufficiently so to mark its direct and inevitable tendency." If this be true, it must at least be said, that the statement at once overthrows all preconceived ideas of the principles of these styles. But we cannot admit that the pure Norman style contains, strictly speaking, and in any decided degree, the latent elements of Gothic; for we cannot be sure that any of its component parts suggested that feature to which the Gothic is allowed by all to owe its origin, the pointed arch; since this form is found in an eggshell as clearly as in a vault, or an intersecting Norman arcade. The Early-English is the great and hitherto unexplained phenomenon of Christian architecture. Unlike to every other art, which attains perfection by slow degrees, this wonderful style almost instantaneously started into a vigorous existence, and in a very few years assumed principles opposed in such an extreme degree to Romanesque, that subsequent ages may be said to have exercised modifying influences upon it, until it rather returned to than departed further from this style, in the depressed arches, horizontal lines, and surface sculpture of the Tudor period.

Mr. Petit's statement in p. 212, advanced, it would appear, chiefly to prove the expediency of importing a foreign style of church-building into England, by endeavouring to shew the incapacity of our own, must be received with caution. "The early complete Gothic, whether in the form of advanced Early-English or Geometrical Decorated, should be adopted by no architect who has not full command of means, not only as regards expense, but also the choice of form, plan, and even situation. A building of this style, to speak generally, requires vaulting, deep and bold buttresses, and windows and elevations of the nicest design. The adoption of Early-English on the score of economy, I will contend against general practice to be wrong in principle: that it has already given rise to a class of very mean and meagre buildings, it is impossible to deny." Now we think there is little reason in Mr. Petit's recommendation to reject the earlier styles as models for imitation, and to adopt in preference the Perpendicular, or to take up our national architecture at the latest period in which it flourished without debasement. As Mr. Petit does not, we believe, admit that the four-centered arch is a mark of debasement, he in effect recommends us to reject Early-English and Decorated because they are too costly, and to adopt the Tudor style because it is cheap; whereas it is infinitely the most costly and gorgeous of all the styles. The fact is, that Mr. Petit has a great predilection for flat roofs, depressed arches, and horizontal lines; for which reason he would have Italian and Tudor churches built in place of the spiry forms and high-pitched roofs of our purest ages of Christian architecture. And so far from Early-English or Decorated churches requiring vaulting, which the author, in p. 171, pronounces "nearly indispensable," very few of even our

larger parish churches in those styles will be found ever to have had them; and nothing can be plainer or better adapted (since plainness, it seems, is to be the principal object) for modern imitation than many of our Decorated country churches.

Mr. Petit proceeds to shew, p. 214, that every possible characteristic of the early styles may be combined in the Tudor (in *his* Tudor) style. Thus, he says, we may have round or pointed arches, high or low pitched roofs, lancet windows, dog-toothed ornament; nay, "may without fear resort to the flowing lines of the Decorated and Flamboyant, or even to the Geometrical." He adds, "that there is doubtless authority for almost every combination of Perpendicular and Decorated: *but if not* [as of course there never could be], there is no incongruity which prevents them from being admissible into the best designs." If Mr. Petit will study more of English Gothic, and less of Romanesque and Italian architecture, he will probably be soon convinced of the incorrectness of these remarks. And the limitation given in p. 215, appears to us only to increase the inconsistency— "not that we ought to transfer the marks and characteristics of one style to another, but we are at full liberty to appropriate, by such alteration as may be necessary, any feature that pleases us." Only conceive such a suggestion being generally acted upon; and this too at a time when we have begun to learn and discriminate details which were thought to be identical before, and when our ecclesiastical edifices have in consequence begun to assume something like the appearance of their inimitable models!

We regard all attempts to introduce "entirely new styles" for church-building with the greatest suspicion—nay, with entire belief in the certainty of their failure. For first, a new style is *unnecessary;* we are already in possession of models most perfectly adapted to our purposes, if we avoid the indulgence of extravagant caprice and fancy in applying them; secondly, we should naturally prefer the style which the Christian Church in England has made peculiarly its own; thirdly, we ought to follow examples acknowledged by all to be of perfect beauty, and for imitating which we have the greatest possible facilities; fourthly, we must take into consideration the peculiarities of climate;* fifthly, by giving unlimited license to architects and builders of all classes and capacities to vie with each other in "maturing" these new-fangled semi-paganisms, we are sure to introduce every possible solecism and absurdity of which architecture is susceptible, and what is worse than all, to extinguish utterly the reviving love for the ancient forms, appurtenances, and decorations of Christian worship; lastly, both the Italian and Grecian styles have been attempted for the last two centuries in England, yet surely they have ever been found singularly inapplicable to ecclesiastical edifices. For we can by no means agree with Mr. Petit in the praise he bestows (p. 7,) on such non-descript designs as the tower of Warwick church; nor do we think that the much-extolled genius of Sir Christopher Wren ever made, or ever could have made, his spurious compositions attain the perfect

* This alone is a sufficient reason for objecting to the style of the new church at Streatham.

fitness, the consummate grace, of *real* Gothic architecture. Imposing as are not a few of his designs when considered alone, and without reference to any other style, yet when this style comes to be combined, and therefore contrasted, with the latter, as in the western towers of Westminster Abbey, its comparative worthlessness is but too apparent. We have much doubt, too, about the soundness of Mr. Petit's defence (p. 42,) of the semi-pagan style adopted in some of the London churches. These have been altogether condemned by that most eminent and profound architect and antiquary, Mr. Pugin, on grounds which appear not easy to be refuted, and which we should have thought perfectly conclusive to any one who has the least sympathy for what may be called the *catholicity of architecture.* However, great latitude must be allowed for difference of taste in individuals, if what is termed "pleasing effect" is to be the only criterion of excellence. For our own parts, we entirely concur with Mr. Pugin in deprecating the application of Pagan forms to the purposes of the Christian religion. Architecture is a thing that speaks to the soul,—an embodying of religious feeling. Shall we then, while we protest against Pagan doctrines, adopt even modifications of that by which they are most significantly represented and conveyed?

Now Mr. Petit, though he admits (p. 210,) that Grecian "seems improper for a church on many accounts," yet extols the Roman or revived Italian as offering "*advantages* unattainable in other styles," and suggests that a pure round-arched style, "formed from the study of the German Romanesque and the simpler specimens of Italian, might perhaps be made to suit *many kinds of arrangement* to which no other is exactly adapted." Here, as usual, we are left in doubt as to what these new arrangements are to be. How much better would it have been had Mr. Petit employed his time and pains in shewing that, with a right and liberal spirit of church-building, those modern notions about "convenient arrangements," &c., which have done so much mischief to ecclesiastical architecture, are mere restless fancies, instead of pandering to them, and unsettling the established order of things, by his unasked-for importations of Italian novelties!

The second volume of Mr. Petit's work, which is occupied chiefly with the discussion of the various styles, and the deduction from them of rules and authorities for modern church-building and church-restoration, will be found to contain much that demands serious consideration and animadversion. It opens, however, with some judicious remarks upon the mechanical principles of construction, more particularly as connected with vaulting, and the method of pendentives. The second chapter, on "composition, proportion, and arrangements," ably exposes the modern system of exact uniformity in pointed buildings. "Even in domestic or castellated buildings a regular front is rarely seen, except when the extent of the structure in some other direction is quite equal to it." (II. 26.) The bad effect resulting from inattention to this fundamental rule will be easily exemplified by a reference to the meagre uniformity of our University Press, and, though in rather a less degree, the street front of Corpus Christi College. Yet we think Mr. Petit's remarks (p. 38,) on the "designed irregularity in Gothic"

somewhat overstrained. We are inclined to believe that this character in the works of our ancient architects, was the result not so much of aim, as of want of aim: we mean that they carried out their principles of designing without reference to the effect to be produced; they clothed their idea in architectural language, and as that was perfect and harmonious, so also was its expression. Had they studied for effect, as we do now, it is difficult to see why they should not have fallen into the same errors as ourselves, and the more so as the "uniformity" which they avoided would always have been a recommendation of their works to inferior minds.

We come now to Mr. Petit's more immediate suggestions for modern church-building. After noticing the small and simple church of Daix, near Dijon, he proceeds to recommend the adoption of its ground-plan amongst ourselves.

"The plan (he says, p. 33,) appears to be a good one. Let us suppose the transverse arches under the tower to spring directly from the wall, which they might easily have done with the present external abutments), and an excellent area is obtained. The small lateral projections of the chancel [the southern of which by the way, as shown in Mr. Petit's sketch, seems to be merely a sacristy] are in a better position than if they had formed aisles to the nave, as being nearer to the altar. If these be lengthened as far as to the spring of the apse, the altar placed on the line of their eastern walls, and the apse itself cut off for a vestry, the whole of the area allotted to the congregation is in sight of the minister, whether he be in a pulpit or desk, at one of the eastern angles of the tower, or at the Communion-table."

Now, before we can agree to this, we must be convinced that the chief object in church-building is to obtain "an excellent area." If this were all, what should we want more than "a spacious and handsome apartment," as a modern church has even been called? But we have learnt from usage immemorial, that a church must be fitted for certain offices, for which offices the same authority prescribes certain indispensable forms. Now, the recommendation of Chancel Aisles instead of Nave Aisles is directly at variance with this usage, and in a *properly arranged church* would present the inconsistency of the officiating minister turning his back on the majority of the congregation when reading *to* them, and his face to them when he ought to be leading, and therefore turning *from*, them in prayer or in the creed. Upon what principles of reverence we could advise the walling-off of an apse and using it for a vestry, it would be hard to say; and we think on other grounds it would be far from *economical* to build an apse for this special purpose. But here again every thing is to be sacrificed to the external "picturesqueness" of an apisdal church. We must strongly protest against the misappropriation and desecration of an ancient and significant form like the apse: in no age of the Church has it ever been employed but for an Altar, and we are not now to debase it to a vestry. Besides that, after all, the apse is by no means an Anglican form.

Mr. Petit then passes to a consideration of the *cruciform* plan for churches, and strongly urges its more general adoption amongst our-

selves. We have before ("Few Words to Church-builders") shewn several reasons against adopting this plan for small churches, drawn from its less adaptation to our services, since persons in the Transepts must be out of view and hearing of the priest at the Altar. And the same objection is felt by Mr. Petit: but how does he solve the difficulty? It will be scarcely believed that he seriously says as follows:

"It is true the altar will be hid from some of those who are placed in the transepts; but I doubt if many of our modern churches, of any shape, are quite free from this fault: at all events this is not the case with such of the older ones as have side-aisles only to the nave. If, however, the transepts be large, and the eastern limb small, the latter might be cut off by a screen, or be used as a school or vestry; while the altar, placed under the eastern arch, stands in sight of the whole congregation. Or if the transepts be made small, only sufficient for the purpose of abutment, these might be turned into a vestry and a baptistry, and the part occupied by the congregation becomes an unbroken oblong area." (p. 38.)

To all this our former objections to the misapplication of the apse apply with still greater force. Is there then no use in a Chancel, reverence for which has been enjoined even by an œcumenical Council? Are we to unlearn our greater respect for that more hallowed part of a church, taught us as it has been by the authority of our greatest Bishops? Our Church has commanded "that Chancels shall remain as they have done in times past:" but now we are to be absolved from obedience to this rubric, and may make them "schools or vestries!" And to *build* a church of a cross form, with the intention of making the "*eastern* limb" the school or vestry, is the most extraordinary retention of a dead form we ever heard of: not to mention that this is in direct violation of the true principle of church-architecture, *to build nothing for mere look.* Much better build at once in the form of a T: but perhaps this would not be "picturesque." How a cross with "large Transepts" and "small eastern limb," or a cross with "Transepts small, only sufficient for the purpose of abutment," are to be reconciled with "picturesqueness" and "PROPORTION," we leave Mr. Petit to decide.

Mr. Petit labours to show that the resemblance supposed to exist between a small cruciform church and a cathedral is no reason against adopting the cruciform plan; particularly since a cross with a tower at the intersection is *not* the most common plan of cathedrals, at least abroad. But we believe that, so far from such a resemblance being avoided by ancient architects, it was rather studied, or at any rate thought a desirable imitation. Witness the frequent repetition of the Cathedral Tower in the diocese, or in larger districts, as that of Gloucester Tower in the West of England. Mr. Petit does not seem to have noticed instances of parochial churches with two towers (one central and one western), as at Purton in Wiltshire, or with a tower and spire, as at Wanborough in the same county.

But one of the chief objections which we have urged against the common use of the cross form for small and inexpensive churches, is the difficulty of treating the arches at the intersection. Such churches are invariably low, and the transepts disproportionately broad, so that

these arches are rendered far too obtuse for beauty or proportion. And again, (the plan being probably chosen in order to save the expense of nave-piers and pier-arches,) for the like reason the lantern-piers and arch-mouldings are also omitted, and an effect produced too poor to be imagined by those who have not seen a building of this description. As a striking example, we would refer to the new chapelry at Barmouth ; which, however, Mr. Petit, by report and from drawings, proceeds to praise, p. 48.

Another real objection to a central tower for a small cruciform church, or to a tower between the Chancel and Nave of the more common form, is its inconvenience for our service, by narrowing the space between Chancel and Nave. The lately desecrated church (alas, that it should be so) of Upton in Bucks may serve as an example.

We cannot think that the beautiful cross churches sketched and described by Mr. Petit, in connexion with his theory, prove any more than that such forms are allowable, and were not unusual when there did not exist such good reasons against them as there do now. Amongst these churches is that of Mount Bures, Essex, the interior of which Mr. Petit did not see, but for which he proposes the most objectionable arrangement of " open seats down the centre of the Nave, leaving passages along the walls which would place the whole congregation in sight of both pulpit and desk," (erratum, for *desk* read *altar*, p. 43).

With the writer's remarks, however, upon making a central tower open as a lantern we cordially agree. A beautiful instance of this in a parochial church may be found in a church near Bretteville, on the road from Caen to Bayeux. The observations also upon bell-turrets are very sound and reasonable. But we must again condemn the plan proposed by Mr. Petit in closing his list of examples :

"I advert to these, to show how a cruciform church may be arranged so as to keep the whole congregation in sight of the pulpit and altar, with very little loss of room. Let the tower and the two transepts each oc- • cupy an equal square on the ground-plan ; the nave, a rectangle of two similar squares ; and the eastern limb be a semicircle ; then the altar, placed in front of the apse, commands the whole church,&c." (p. 49.)

We hope but few will agree with the following "argument on the score of convenience : that it gives more room for the advantageous arrangement of galleries, as having three fronts instead of one," (p. 50). Again, we can scarcely coincide with the " excellent suggestions to the architect of the present day," of imitating the extreme eastern Transept, as at Durham Cathedral and Fountains' Abbey.

" If an eastern transept be allowed, a large church may be constructed, with the nave of a moderate width, and therefore capable of strength, and convenient for roofing; of a *picturesque and varied outline*, allowing every individual of the congregation to be in sight of both desk, pulpit, and altar; and this without the sacrifice of a square foot of space." (p. 52.)

Here is at once a bold recommendation of the T form: and we confess, we think it more consistent than the plan recommended above.

Mr. Petit continues in page 55, "A Chancel of inadequate width and projection, standing against a large gable, is poor and meagre in the extreme. It is better omitted altogether." We can only hope

H

that the last recommendation may never find its way to modern church-building committees.

The remarks upon Towers will be found generally true and valuable: but with the suggestion of making the Nave roof lower than that of the Chancel *for the sake of effect* we cannot concur, either in point of taste or propriety. Battlements (as a peculiar English feature), belfry turrets, &c., are well treated of. A *gabled* Tower, though to our mind a very beautiful feature, is scarcely English. Mr. Petit only mentions Gillingham, in Norfolk, here by name, besides the ruin of New Abbey, Dumfries, sketched in his first volume. We may add, Coln S. Aldwin, Gloucestershire, and there are several instances, we believe, in the south-western counties. We earnestly recommend to notice Mr. Petit's remarks on the *position* of Towers. In Switzerland he states that they are generally on one side; and his examples of different positions will be found a valuable addition to our own list in the Few Words to Church-Builders. · The summary of English architecture (pp. 80—83) is truly excellent, and it cannot but again excite our astonishment, that the author who can so appreciate our own styles should be found to recommend the introduction of an 'eclectic' Romanesque, and even of all the paltrinesses of the *renaissance*; nay, more, to hold up some specimens, however good in their way, of *cinque cento* as models for our imitation!

The note at the conclusion of this chapter quotes Dr. Möllers' celebrated passage with respect to the incongruity of the pointed form with any flat gable or horizontal roof, and his inference as to the defect in the west front of York Minster. The subject is one of deep importance, and would require more space for full investigation than can now be given to it. Mr. Petit's remarks upon it however are thoughtful, and deserve the attention of ecclesiologists.

.Chapter III. on "Form, Proportion, and Arrangement," gives a
• very useful list of churches accompanied by brief descriptions. We think that *Acton*, near Stafford, should not, in this general disregard of Chancels, be proposed as a model, since it has no external division. In Bocking church, Mr. Petit praises the bad arrangement which leaves no central passage; and takes occasion from a notice of the *exterior* of Eastchurch, Isle of Sheppey, (p. 98) to say—

"A church of a similar external appearance, might have a roof supported by light piers (of any material), without the intervention of arches: this would not be at all contrary to Gothic principles; and a large area might be covered at a small expense." (p. 98.)

What *Gothic* principles such may be, we know not. Again, on page 100, we have the following extraordinary and most objectionable suggestion, in a passage calculated to convey a false impression that the beautiful church alluded to *has no Chancel at all.*

" Northborough, Lincolnshire.—Unless my memory fails me, there is no northern transept corresponding with that represented in the sketch, nor any chancel eastward of it. If this is the case, the form of the building, fanciful as it may appear, is the most convenient that could be devised, since a pulpit facing the end of the transept, and a communion-table facing the west end, will command the whole congregation."

Vitteaux church and S. Thibault, near Dijon, though included in this list, can scarcely be intended for models. The chapter ends with some judicious observations.

The IVth chapter, on "Modern Repairs and Adaptations," contains much to which we are strongly opposed. We have uniformly insisted on attention to the *ancient* forms and arrangements of our churches, and have never listened to any unauthorized though specious proposals for 'adaptation.' But to go regularly through this important chapter: we sympathize with the author's remarks upon restorations by unfit persons, and are glad to bear our own testimony to the excellence of the spirit and execution of the north-west tower of Canterbury. We have, ourselves, before suggested the use of flints in particular districts; but the Essex brickwork can scarcely reconcile us in any way to that poor material, and we consider the recommendation of bricks "for a Romanesque, or simple Italian church," (p. 133) very mischievous. We do not want the styles, and much less the material, however appropriate it may be for *them*. It may be doubted whether Mr. Petit's proposal to add battlements to the mutilated central tower of Bakewell church (p. 134) is in good taste: but we hope that there will be no difference of opinion as to the following recommendation:

" We are now furnished with a suggestion where, and how, the architect should begin upon the enlargement of an old church. Take one of the commonest village churches we can meet with; a moderately sized western tower, a plain nave without aisles, and a chancel of smaller dimensions, both having a high-pitched roof. This is usually enlarged by expanding the nave in either or both directions, or adding an aisle to it,—in short, some alteration is always made *which utterly destroys the proportion of the tower.* Let us begin at the other end. Instead of meddling with the nave, *let us take down the chancel,* and substitute one as much higher and wider than the nave, as the nave exceeds the old chancel, taking care to preserve the original proportions and form, both of the gable and end window......Now this alteration, so far from impairing, *actually improves the outline of the church,* which becomes more varied............And the room for the congregation may be nearly doubled by it, every individual being placed within sight of the altar. If more room be still required, one or two similar chancels might be added as aisles.........Thus we obtain a rule for enlarging a church of the most common form, to almost any extent, without really injuring its proportions or character." (pp. 137—139.)

Now this is most atrocious: generally acted on, what amount of destruction would not this scheme produce! The Chancel, almost always the most beautiful, as most certainly the most hallowed part, unreservedly "taken down;" the Chancel-arch, and every appurtenance, sacrificed, —to be replaced by a large pewed apartment! It is distressing to see this entire ignorance of what the Chancel is, in one of so much zeal and so much observation as this writer. And what is put forth as the main reason for preferring this plan? The *picturesqueness* again, " the proportion of the tower," " the outline of the church." We contend that, however important these may be, they are as nothing to the true form and disposition of a church. We may add, that Mr. Petit seems quite unaware of the provision, not unfrequently left by the first

builders, for subsequently enlarging the church by the addition of
Nave aisles.

Again, what are we to say to the following? "Many country
churches have a large quantity of old wood-work, which might be
turned to account in the rearrangement of *pews* or open-sittings."
(p. 142.) And on the next page, Mayfield church is admired for
being "almost entirely *pewed* with its own wood-work;" probably its
Chancel-screen! The new arrangement of Kingstone-by-sea, Sussex,
is also praised, and with much justice, though we could have wished
a total ejection of pews. But neither Mr. Petit, nor Archdeacon Hare,
who in his primary Charge highly commended the attention bestowed
on this church, seems to be aware of the fact, that a north aisle,
blocked off some fifty years ago, remains in a disgraceful state of dese-
cration, being used, when we last saw it, as a potatoe store!

The remarks on the position of the pulpit are good, as are many of
those about the Font: but the author, while recognizing the propriety
of its position near a door, thinks, in defiance of the Canon, that
"there may often exist sufficient reasons for placing it elsewhere"
(p. 145): and with similar originality and independence, "it appears
to" him that the gilding and painting of cielings "is a point on which
we might venture to differ from the practice of our ancestors:" for
"these gorgeous cielings cannot but take from the simplicity which
ought to prevail in a Protestant church." (p. 146.)

To introduce a suggestion derived from the piety and taste of
"Roman Catholic countries" by the flippant quotation, *Fas est et ab hoste
doceri* (p. 147), is both superfluous and repulsive : and Mr. Petit him-
self is more at home when kindly sympathising with the difficulties and
impediments against which modern architects have to struggle. In the
rest of the chapter, with the exception of the panegyric on railways, we
heartily concur.

The concluding chapters on " Continental Specimens" will not long
detain us. Those who know Grantchester church will by no means
agree with the opinion that the Chancel's being higher than the Nave
" always *improves the outline,*" wherever "a western tower is used."
(p. 161.) The remarks (p. 209) upon *mountain* churches are very
true : less judicious perhaps is the wish (p. 215) that in octagonal
spires the continental fashion of putting gabled spire-lights on *each*
side, should be followed rather than our own, of confining them to the
cardinal sides. In page 224 occurs another hint for the adoption of
the Revived Italian, or the Romanesque, amongst ourselves. We
quote the following excellent remark on pyramidal roofs for towers :

" The pointed roof without parapets, which is a common finish to village
churches, both in England and on the Continent, appears to me very far
from ungraceful, and certainly is in character with the other roofs of the
church. I cannot conceive why modern architects are so anxious to destroy
it whenever they have an opportunity." (p. 250.)

Lucy-le-bois, already mentioned in his book as having a short
apsidal Chancel, is again (p. 254) noticed as " an available plan." "A
church of this form might be built with very little sacrifice of *room*

or convenience, and its outline is remarkably *pleasing and picturesque."* We must again express our dissent from such a suggestion.

Mr. Petit's illustrations, and his remarks on the actual state of churches, both Continental and English, are distinguished, so far as we are able to speak from personal inspection, for correctness and general discrimination. It has not been thought worth while to enter at great length upon the consideration of any of his numerous examples; though an enlargement of his brief notices, and a supply of much that he has omitted, would be a good service to Ecclesiology. In concluding this review, we must again express our earnest regret, that a book containing so much that is good and true, should be defaced by so many mere theories and suggestions, entirely at variance with ancient usage, and opposed in many instances to the authoritative commands of our Church. The other point upon which we are at issue with Mr. Petit is his wish to introduce among us the Revived Italian, and the Romanesque styles: and though this may appear more questionable than the former difference, as depending more upon *taste* and a notion of the *picturesque,* yet we are convinced that most who possess as much appreciation of English architecture as Mr. Petit professes to do, will agree that it is now our duty to confine ourselves to our beautiful national varieties, free as they are from any but Christian elements, and suited as they are to our feelings, our associations, our climate, and, we may add, since even the Reformers of the sixteenth century so decided it, to our services and forms of worship.

A FEW WORDS TO SKETCHERS.

THE number of sketches of various kinds which we have within the last six months received makes us anxious to devote a few remarks to the subject, both by way of thanking such as have already favoured us with drawings, and in hope of inciting others to follow their good example. And the whole substance of what we are about to say may be comprised under two heads—*What* to sketch; and *how* to sketch.

We often, in reply to a request for drawings, receive, more especially from our lady correspondents, the answer—I should be most glad to draw any thing for your Society, did I know what kind of things are most valuable to it.

In the first place, as a general rule, the east window will well deserve the trouble of drawing it: and the same may be said of any *Decorated* windows whatever. These are for the most part so exquisitely beautiful, and so very different from each other, that too large a collection of them cannot be made. Any windows containing more than four lights will be generally valuable. The sedilia and piscina, or any other recesses in the wall of the chancel; all sepulchral recesses, and panelled or canopied altar-tombs, brackets and corbels, if elegantly finished, *benaturæ,* or stoups for holy water, at the entrance or interior

of porches, will be very acceptable. Accurate drawings of woodwork are extremely desirable; such as (and we speak more particularly to our friends in Suffolk and Somersetshire) open wood roofs; open-seats, with their richly carved sides; rood-screens and *parcloses*, or screens to chapels; carved doors; Font covers, *in all cases before* the Reformation; parish chests, if of any antiquity; above all, should the church be so fortunate as to possess it, the rood-loft. Iron-work, as more rare, is still more valuable: here we may mention hinges, ramifying into net tracery all over the door; handles, often worked like serpents; key-plates, and the like. The arrangement of the glass often deserves copying, more especially in France. Village or churchyard crosses, pinnacle crosses, ornamented staircase turrets, (of which there are so many in Norfolk and Somersetshire); niches, canopied buttresses, and groining;—for all these we shall feel much obliged. The rich towers of the west, with their niches, belfry-windows filled with cross stone-work, and pierced battlements; or again, the glorious spires of Lincoln-shire, and Rutlandshire, and Northamptonshire, are excellent subjects; so very frequently are porches and doors, especially Norman doors, and bell-gables may also be mentioned, as likely to be useful as hints for modern churches. Fonts are, of course, more particularly in request. In one thing only would we ask for painting; in copies of tiles, than which few presents can be more valuable.

Next, *how* to sketch. The object which those should bear in mind who attempt ecclesiological drawing is, not to make a pretty picture, but an accurate copy. If a thing is mutilated in the original, mutilated let it be in the copy. We do not of course mean that an obnoxious pew, or pagan monument, may not be removed on paper, if unfortunately it cannot be so in reality: but simply that in cases such as that where the lower part of a rood-screen or of the sedilia is boarded over, they ought to be so represented. Measurements accompanying sketches double their value: in piscinæ, for example, their height, breadth, depth, height above the floor, distance from the east wall. In wood seats, again, the following five particulars are much to be desired: the breadth and height of the standards; their distance from each other; the height of the seat, and of the kneeling-board in front.

Again, any of the details which can only be given generally in a larger drawing may be sketched out with greater minuteness in an additional one: in the same way sections of piers, of window jambs, and mouldings, may be given. Where the different sides of a Font have different panellings, all should be copied.

It is not often that general views of churches are particularly valuable: when they are taken, it should be from such a position, at the south-west, as to combine with the western façade a distinct view of the Chancel.

A FEW REMARKS ON THE ENLARGEMENT OF CHURCHES.

WE wish to call the attention of our readers to a very important subject; the principles, we mean, on which the enlargement and increased accommodation of churches should be provided for. More money is misapplied, and more Ecclesiastical buildings have been ruined, in this than in any other way; and it is more than time that some vigorous steps should be taken to remedy the evil.

When the existing accommodation is found insufficient for the wants of a parish, the first duty of those in authority will be to inquire whether, by the ejection of all pews and the substitution of open-seats, and the subsequent gain of from twenty to fifty per cent *kneelings*, room cannot be obtained. If increased accommodation is still needed, the question becomes a very serious one; and we propose now to endeavour to solve it.

1. We will first take the case where the building consists of Chancel and Nave only. Here an Aisle may well be added on each side of the latter; the windows on the north and south of the Nave being removed into the north and south Aisles, and the Piers being copied from those in the Chancel-arch, or from some specimen in a neighbouring church of the same date. Where the Tower stands at the west end, the west ends of the Aisles might be brought out even with it; each Aisle having its separate gable. The gain of accommodation here will be about cent. per cent.; as, though the Aisles should be somewhat less than half the breadth of the Nave, the passage down them need not be more than 3 ft. 6 in. in breadth, whereas in the Nave it must be five feet at least.

2. Where there are Chancel, Nave, and north *or* south Aisle. Here another Aisle may be thrown out; the increase of accommodation being about 25 per cent., or rather more. It will, in most cases, be advantageous to make the new Aisle like the old; though this is by no means necessary. For example : we received some time ago an application from a clergyman under the following circumstances. His church had Chancel, Nave, and south Aisle, and increased accommodation was wanted. The Piers of the Aisle were Norman, of enormously massy character: was it, he inquired, necessary that in throwing out a north Aisle, the new Piers should correspond with the old; by which a large qaantity of space would be lost? By no means, we replied; and we recommended as a model a plain, slender, octagonal, Decorated Pier occurring in a church near his own. But this by no means palliates the removal of Norman, and the substitution of more modern piers in an old church. It is sad to think to how great an extent this practice prevails. We had mentioned in the second part of our *Few Words* to *Churchwardens* an instance where a fine old Norman Chancel-arch was removed in order to gain some few 'seats.' Since that time we have received two letters from architects—neither of them the one referred to—acknowledging the same fault. The above plan has recently been adopted with success in Ash Prior's, Somersetshire.

3. Another form of church is that which has Chancel, Nave, and two Transepts. Here the case is the same as in the last supposition: and Aisles may be built with great advantage.

4. But where the church has Chancel, Nave, two Aisles, the method of throwing out Transepts is attended with very serious objections; for they must, of necessity, either be taken out of the Chancel or the Nave. If the former, we give in to the miserable practice of modern days, by encroaching upon that part of a church which ought to be held most sacred: if the latter, so much room is necessarily lost, that the gain on the whole is very small. A better plan is to throw out either Chancel-aisles, or double Aisles to the Nave, or both; care being taken to keep them subordinate to the original building.

We cannot sufficiently reprobate the two plans most used by modern builders—the lengthening the Nave westward, as at Godalming, Surrey; or the addition of a large piece to the north or south Aisle, the Piers being removed, and the building reduced to the appearance of a shapeless room, as was the case in the old church of S. Giles, Camberwell.

But no enlargement whatever ought to be thought of, till a calculation has been made how much gain would ensue from the ejection of pews.

As frequent inquiries have been made respecting the length and width of wood-seats, we subjoin the following table, taken from several churches in Somersetshire (the county of wood-seats), which contain beautiful specimens.

	Apart.	Height.	Breadth.	Height of Seat.	Height of Kneeling Board.
	ft. in.	ft. in.	ft. in.	ft. in.	ft. in.
Stogumber	3 0	3 6	1 3	1 10	2 9
Lydiard S. Lawrence	3 10	3 9	1 4	1 6	2 3
Crowcombe	2 10	3 6	1 3	1 6	1 11
Bicknoller	2 11	3 4	1 5	1 5	2 0
Fitzhead	2 5	2 11	1 1	1 4	2 2
Tolland	2 6	2 9	1 2	1 5	2 1
Langford	2 6—2 3	2 9	1 4	1 6	2 0
Kittisford	2 4—2 9	3 0	1 3	1 7	2 0
Hockworthy	2 9	2 10	1 5	1 5	2 0
Nynehead	2 9	3 3	1 6	1 9	2 8
Bradford	2 7	3 3	1 8	1 6	2 6
Norton Fitz Warren	2 8	2 5	1 4	1 6	2 0
Bishops' Hull	2 8	3 1	1 1—1 5	1 5	—
Hill-Farrance	2 4—2 6	2 9	1 4	1 4	2 1

SCOTLAND AND SCOTCH ARCHITECTURE.—Letter III.

To the Editor of the Ecclesiologist.

Mr. Editor,—It has been thought that some of the Ecclesiastical records of Scotland were conveyed to the Scotch Roman Catholic College at Paris, which was, I believe, destroyed in the Revolution. Nor is it impossible that many valuable papers may even now be in the

Vatican, or at Douay, or at the Scotch College at Ratisbon. But it is to be feared that all, or nearly all, which are not to be found in the libraries of Scotland, must have perished in the troubles of the sixteenth and seventeenth centuries.

The collection in the Advocates' Library is very valuable, carefully arranged and well catalogued. I have not sufficient knowledge to venture to speak of what caught my eye in glancing over the general Catalogue of MSS. But I observe in the Catalogue of Chartularies, &c. an enumeration of records relating to the following places: Arbroath, Aberdeen, Balmerino, Cambuskenneth, Coldingham, Coldstream, Dryburgh, Dumblane, Dunfermline, Dunkeld, Glasgow, Holyrood, Inchcolm, Kelso, Lindor, Levenax, Melros, Moray, Newbottle, Paisley, St. Andrew's, St. Anthony's and Newhaven, also the Chapel Royal of Stirling, Soltra, and the Scotch College at Ratisbon.

Many of these have already been printed, and others are in course of preparation, under the care of the Bannatyne, Maitland, and Abbottsford Clubs. The Chartulary of Paisley is published by the Maitland Club, with a preface of extreme value: also by the same Club the Chartulary of Levenax, which however is not an ecclesiastical chartulary; and Abbott Myln's Lives of the Bishops of Dunkeld, whence considerable information may be derived concerning the fabrick of the Cathedral of Dunkeld. By the kindness of a friend I am enabled to complete the list of those which are printed, and of those which are in preparation. The Abbottsford Club has published the Chartularies of Balmerino and Lindores, and the Constitutions of the Nunnery of St. Katherine of Sienna, near Edinburgh; and is preparing the Chartularies of Cambuskenneth and of the Stirling Chapel Royal. The Maitland Club is soon to publish the Glasgow Chartulary. The Bannatyne Club has printed the Chartulary of Melrose, in two volumes, and also that of Moray; and in addition to these, the Chronicon Cœnobii Sanctæ Crucis, and Ferrerius' Lives of the Abbots of Kinloss; and further, has in preparation the Chartularies of Scone and Dumfermline. The Spalding Club, another valuable Society, instituted principally with a view to the east of Scotland, proposes to publish shortly the Chartulary of Aberdeen.

Any of these volumes may, I believe, be consulted at the Advocates' Library, by means of an introduction from an Advocate. It is obvious that they will furnish much of that documentary testimony, without which generalizations drawn from the mere appearance of buildings cannot usually be trustworthy. With this list of authentic sources of information I conclude, for the present, my desultory remarks on this subject; and I remain, Mr. Editor,

Your faithful servant,

Brighton, March 14, 1842. J. S. HOWSON.

MR. EDITOR,—The Nave of the church of S. Saviour, Southwark, has recently been destroyed, and in its place has arisen a structure in the *modern* Lancet style, composed of a Nave and two Aisles of equal height. The great south Porch, although in a mutilated state, was of

great value as an architectural example of Early-English date; this however has been removed, although it does not appear that any inconvenience would have resulted from its preservation. The south side of the new Nave is faced with flint and ashlar; but the north, not being so much exposed to view, consists entirely of brick. The splendid Choir is now merely a vestibule, and the services of the church are conducted in the Nave, the floor of which is now about ten feet *higher* than that of the Choir. The principal entrance into the Nave is through a door lately made in the south wall of the south Transept, from which one flight of stairs leads to the floor of the new building on each side of the new Altar; and another to the east ends of the galleries, which occupy the whole width of the Aisles, as well as the west end. There are other entrances at the west end, under the organ. The roof, which is intended to resemble a stone vault, is supported, or supposed to be supported, by two rows of shafts, of about one-fourth the diameter proportionate to their height. The church is lighted by two rows of lancets; those above the galleries are *all triple*. Internally they have a very poor effect, being without splays or mouldings of any sort whatever. But the most miserable part is that which should have been the most glorious. The east end of the Nave is separated from the Transepts by a slight partition of wood, against which the new Altar is placed. Over the Altar are *perspective paintings* upon the flat wall of four lancet panels, in which are the Decalogue, &c.; and above these five large glazed lancet apertures, through which a glance of the Choir may be obtained; and to complete the whole, a mean pulpit with its modern appurtenances is placed *in front of* this disgraceful Altar. After this it will be unnecessary to say that a very striking contrast exists between the Nave and Choir. The tomb of the poet Gower was removed some years ago into the S. Transept, where it now stands, with the head of the effigy *northward*.

It is lamentable to think that an opportunity should have been lost, which, if improved, would have rendered S. Saviour's church second to none in London, except the venerable minster of S. Peter.

I am, Mr. Editor, your's faithfully, ✠ G.

[The execrable demolition and rebuilding of the Nave of this once noble church have been already exposed by Mr. Pugin in terms of just and severe condemnation.—ED.]

OXFORD ARCHITECTURAL SOCIETY, MARCH 2, 1842.

(Extracted from the Oxford Herald.)

A MEETING was held on Wednesday, at the Society's room; the Rev. the Rector of Exeter College, in the chair. The following new Members were admitted,

E. A. Freeman, Esq., Trinity College.
T. W. Fletcher, Esq., F.R.S., F.S.A.
Rev. E. B. Dean, B.C.L., All Souls.
Charles Cox, Esq., Exeter College.
Henry Champernowne, Esq., Trinity College.

Presents received.—Third edition of Hints on the Study of Ecclesiastical Antiquities, from the Cambridge Camden Society.

A drawing of the entrance doorway and hall of a house at Fyfield, Berks, of the fourteenth century, by W. Grey, Esq., Magdalene Hall.

The designs for the restoration of Steeple Aston Church, Oxon., by John Plowman, Esq., were submitted to the meeting, and met with general approbation, with some slight exceptions of detail. It is proposed to remove the hideous gallery, and fit up the church entirely with open-seats of oak, imitating the beautiful standards which remain; to restore the high-pitched roof of the nave, removing the clerestory, which is a late and clumsy addition; and to rebuild the north wall, preserving the one good window which remains, and imitating it in the other two.

The design for a church at Bedwyn, Wilts, in the Norman style, by Benjamin Ferrey, Esq., was also submitted, and cordially approved.

A paper was read by J. P. Harrison, Esq., of Christ Church, upon the proportions of Chancels. His object was to shew that, apart from other reasons, the principles of Gothic required a well-defined Chancel, and in some cases one of considerable projection; and that the perspective effect of a church mainly depended upon it. He arranged ordinary country churches under six heads, shewing that the length and breadth of the Chancel were guided by the breadth of the Nave, and more especially (a most important point, and not generally noticed) the *ground-plan of the church*, that is, whether it had two Aisles or one only, or none, &c. The maximum and minimum projections were given, and each case illustrated by a good many examples, taken from several counties, and of different styles. Hr. Harrison took the same view as Mr. Petit (whom he quoted), that the ancient architects designed all ecclesiastical buildings upon certain invariable principles of proportion, and that they attended to the position of a church, and the objects surrounding it. The idea was carried out and illustrated by many of the statements in Mr. Harrison's paper. The fact of our finding exactly similar proportions in all churches on the same plan, but of different dates, was adduced to shew that the ancient architects were guided by some fixed rules over and above any taste or skill which they might themselves have possessed. "Intuitive knowledge" was not to be expected in all. A traditional rule of proportions bound, but did not shackle them; without it even *their* knowledge of details would do us but little good. We must recover principles. In the mean time, Gothic should be loved and used as the only pure and perfect style which our own country, or any part of Western Christendom, has produced; there is nothing in it borrowed from Paganism. Mr. Hope was cited to shew that all styles are expressive of the religion of the country in which they arose. It should be enough for us that the *three* orders of Gothic are *English*, and that every day we find something more and more religious in their expression. In this we are more happy than Italy, Lombardy, &c., although the absence of Gothic in these and other Christian lands should make us careful of calling it the one Christian style, to the exclusion of all others.

S. ANDREW'S, CHESTERTON.

THE Chancel of this church is now undergoing complete repair. The whole edifice is in a very dilapidated and dangerous state; the roof of the Nave, the walls of the Aisles, and the top of the spire, being in so bad a condition, that probably a very few years will cause their entire ruin. It were much to be wished that the parish, which is not charged with the repair of the Chancel, would immediately undertake a general restoration. The church has much architectural merit, and the loss of so beautiful a feature as its fine spire within half-a-mile of Cambridge, and in the very midst of our Camdenian operations, would be little creditable to the good taste of the one, or the activity of the other.

The Tower and Nave of this church are of plain Decorated character; the Chancel is Tudor, of good detail and execution, but the jambs and tracery of the windows externally are much decayed; for clunch, of which they are composed, though an excellent material for interior work, is ill calculated to resist the effects of the weather. The Nave-roof is of good ancient oak; the weather-moulding, however, on the Tower shews that it has been much reduced from its original pitch. The Porch is of remarkably good design, and has also an excellent open roof.

In repairing the Chancel, a piscina and three beautiful and elaborate sedilia have been discovered in the south wall. These had been so completely blocked up with bricks and covered with plaister, that not the least vestige of them was visible. The piscina is very perfect, and has a stone shelf and quatrefoil orifice. Both this and the sedilia have cinquefoiled double-feathered heads; the latter are groined internally, and formerly had buttresses between them. We trust they will all be carefully repaired: but should they be consigned to destruction as useless appurtenances, or as too costly in restoration, as has been done elsewhere, accurate drawings of them have already been made and deposited in our archives.* A plain square aumbrye has also been found in the north wall.

NEW CHURCHES.

S. Peter's, Southwark.—This church, though it has been built two or three years, is so striking an instance of the solecisms of modern church architecture, as to deserve the following notice. The building, which consists of a Nave and two Aisles, (the latter not reaching quite to the east wall,) with a half-engaged western Tower, ranges between all the styles of pointed architecture. The material throughout is white brick. The Tower is square, and its features numerically preponderate perhaps in favour of Early-English. Thus the west window consists of three lancets, unequal in height and breadth, with poor labels terminating in huge blank lozenges; and the buttresses, which are diagonal, are pedimented half-way up,—though the pedimental head unfortunately meets a very broad horizontal Tudor tablet, composed of

* Since engraved in Part V. of the Monumental Brasses.

trefoiled lights in arcade! The belfry-windows are large cinquefoiled single lights, of no particular character. The hood-moulding of the west door is continued horizontally, but does not embrace the buttresses. *Detached* corbel-heads are placed *below* the points at which the hood-moulding of the western door is returned horizontally. The Tower is embattled, continuously, of four, and is furnished with four square panelled pinnacles, which have square flat cappings. The Nave has very obtuse Tudor windows of two lights, with no foliations; each has a huge panelled transom of square quatrefoils. In the middle of the south side is an obtuse Tudor door, with mouldings, poor indeed and coarse, but of much pretension : it has a crocketed and finialled canopy. In the east end we again find an attempt at an earlier style, there being on the exterior three blank lancets. Yet above these is a broad tablet of trefoiled triangles, with shields of a very late form attached at intervals to its under side. The depressed gable, which is furnished with a cross, is of an unusual jagged form; and the eastern angles have octagonal turrets panelled in three blank Tudor arches. There are also two small vestries at the east end. We earnestly advise those who have it in their power to visit this edifice, if only that they may see how the characteristics of various styles can, in this age of pure taste, be combined in one building. Of the character and arrangement of the interior we are not able to speak.

Aston Cantelow.—A chapel in this parish was consecrated on the 11th of last November. It is thus described in the *British Magazine* for March, p. 358. " The chapel is a beautiful specimen of the Early-English style, consisting of a Nave and Aisles : there are two ascents up to the Altar, which is of stone carved, and on each side of it are two sedilia." We must again regret the absence of a Chancel ; and must object to the last-mentioned arrangement : the sedilia should never be placed in the east wall, and should never be two and two. Why not put sedilia, as of old, on the south side? If not, perhaps it would be better to keep chairs as at present.

S. Paul's, Finsbury, is we believe one of the fifty new churches, which the truly noble scheme of the present Bishop proposes to add to the metropolis ; and this would have inclined us to omit mentioning it here, since we cannot speak of it with commendation, unless we believed that it is a real benefit to the cause we have at heart to point out errors for the warning of future architects. The church is built entirely of white bricks : its exterior lays claim to be considered a specimen of the Early-English style, but its interior possesses more features of the Tudor period. It is of this strikingly absurd inconsistency of which we have so often to complain. The plan consists of a Chancel, though of *most disproportionate* size, a Nave, a Tower at the south-west angle, and a porch with a parvise towards the southern part of the west front. The sides are divided by mean buttresses of two stages into six compartments, with a corbel-table above each. Each compartment has a tall, but too broad, lancet light, with little attention to the splay. Each window however has a label with flowered corbels. The Chancel has no windows, excepting a circular one of six lights at the east end. The Tower has three stages of very unequal

height: the middle one has a lancet of the same character as those in the Nave on each side; the upper one on each side an empty clock-circle set in a square. There are four angular pinnacles, and a stunted octagonal spire, with two tiers of gabled lights, not alternating, but on the same cardinal sides. Each side is flanked by buttresses reaching to the string-course below the highest stage; each of four stages, the highest and lowest being pedimented.

The interior displays considerable attention to propriety of arrangement; the reading-stand and pulpit being fairly placed, and the Font in its right position at the west end. The latter is octagonal, of Tudor design, but apparently of "composition." The west window has three lancets of unequal height and breadth, below which are two smaller lancets. The east end displays the circular window before mentioned; and below it appear the Creed, &c. in four lancet-compartments, which have a dripstone and corbels. But here ends our Early-English. The Chancel-arch is remarkably obtuse Tudor, continuous, but with drip-stone and corbels. The roof is all but flat; having just sufficient pitch to display five prodigious tie-beams with some pierced work above. Plain galleries surround three sides,—if possible a worse arrangement in a mere Nave like this, than in a church with Aisles,—and are supported by thin cast-iron pillars, circular, with octagonal pseudo-Tudor capitals and imaginary bases.

Within a few minutes' walk of this edifice we had another opportunity of seeing perhaps the most absurd specimen extant of the revived pagan. We refer to the church of S. Luke, Old Street Road, which has for a spire a huge grooved *obelisk*, deprived however of its point, but furnished at the top with a large arrow-vane!

CHURCH RESTORATION.

THE restoration of the church of Sampford Brett, Somersetshire, has given us much pain. The sum expended on it by the Earl of Egre-mont might have built a beautiful church; it *has* spoilt one. The style is probably intended for Early-English; the foliage, carved in Watchet alabaster, is lavishly introduced in the capitals and soffits of the windows, but so totally different from any thing which ever decorated an ancient church, that one is astonished how such a monstrous mis-conception of Christian ornament could have presented itself to the architect's mind. Huge borders of grapes, suggesting the idea of Bac-chanalian merriment, ornament the east end, and seem to hang over the holy Altar. The alabaster corbels represent, we imagine, angels, but the heads far more resemble Cupids. The only part of this barba-rous, yet in some sort magnificent, erection which we can praise, is the adoption of wood seats for pews. The side panels of these are very excellent; they cost six guineas each, and were carved by Rex, of Exeter. We are glad to have an opportunity of mentioning this artist, as well as Webber, of Dunster: they have both formed their style by

a careful study of the magnificent woodwork, of which so much still remains in our western churches, and it would require no common ecclesiologist to distinguish the new work from the old.

The Church of the Holy Sepulchre, Cambridge.—The repairs of this church are proceeding in the most satisfactory manner. The workmen are at present engaged on the groining of the round tower, the eight ribs, supporting a heavy keystone in the centre, being already completed. The whole of this part is of clunch, which is peculiarly adapted for groining, not only from its lightness and the facility with which it can be worked, but from its great firmness and durability. It has now been ascertained beyond all doubt, (what was, upon the first survey of the church previous to commencing the present extensive repairs, considered uncertain) that the tower was *originally* vaulted in precisely the same manner as it is now to be restored; some of the old ribs having been found bonded into the wall at their point of springing from the vaulting-shafts. That the whole of this tower, and probably also the circular aisle, was once adorned internally with fresco-painting, appears from several parts where the original colours yet remain concealed behind the coatings of whitewash and plaister. It is proposed to decorate the semicircular dome or groining in the same manner; to lay down a pavement of encaustic tiles manufactured expressly for this purpose; and, if possible, to fill the clerestory windows with stained glass, of plain and ancient design, but of the richest and most gorgeous colours. The ancient arch into the apse, which we before described as having been in great part recovered, is also to be replaced. Should the Committee for the restoration be enabled to procure sufficient funds to carry their intentions into effect, this ancient church will be one of the most interesting buildings in the kingdom, and present, it is hoped, an example of successful restoration well worthy of being imitated by others.

We take the earliest opportunity of giving our earnest encouragement to those gentlemen who have for some time past been engaged in the most praiseworthy task of clearing off the thick coating of paint and whitewash which has accumulated in many parts of the church of S. Mary, Leicester. Their efforts have been already rewarded by the discovery of a late Norman Piscina, composed of a segmental arch and a projecting basin. The mouldings of the arch however, which were doubtless chevroné, to match those of the extremely beautiful and curious Sedilia, were cut off when the monument which has been lately removed was first erected. The projecting basin was destroyed at the same time. A very elegant lithographic drawing, printed for private distribution, represents the Sedilia, Piscina, and a small portion of the Parclose. Our correspondent adds, "We have brought out many most interesting parts of the church, especially the under side of an arch, which is beautifully painted." We wish these our zealous fellow-labourers good speed in their work; and venture to propose their efforts as an example to many of our readers. How many curious and beautiful architectural ornaments might be brought to light in our parish churches, in this way, by the exertions of persons on the spot!

TRANSLATION

OF THE INSCRIPTION FOR A FONT, REMOVED FROM THE CHURCH, AND USED AS
A VASE FOR FLOWERS IN A GARDEN,
Printed in the Ecclesiologist, No. II. p. 32.

Go, friend, the Church's Ruler tell, that by a doom severe,
To bear the garden's flow'ry store you saw me stationed here;
Me, who in ancient hallow'd house of CHRIST install'd of yore,
Plants of celestial parentage and flow'rs ambrosial bore.
For sons of men, baptized in me and my life-giving flood,
Of water and the HOLY GHOST were born the sons of GOD.
Now all is changed! These flow'rs of earth I soon to earth resign:
Oh, woe is me! O glory once my own—no longer mine!
—Glebe, Ireland.

NOTICES.

A CORRESPONDENT has called our attention to the dilapidated condition of the church of " Sall," Norfolk. We wish we could do any thing in this and in many similar cases continually brought under our notice : all we can do at present is to publish the fact, in the hope that some one interested may step forward. The living, we believe, is in the patronage of Pembroke College in this University.

Another correspondent has inquired, what is usually done with monumental brasses in case of an old church being pulled down? and he mentions an instance in which a brass has recently been *stolen* under these circumstances, in the neighbourhood of Colchester. That no monumental brass is really safe from sacrilegious hands while *loose*, is, we are sorry to say, a fact but too easy to prove by numerous recent examples of this wicked peculation. We cannot too strongly urge all churchwardens to see that every brass in their churches is *firmly infixed in its slab, and the slab itself securely laid down in the pavement.* We hope to hear no more of ancient brasses lying loose and neglected in the church chest, or the Sunday school-room (often the chantry of the church), or the sexton's house. We can mention a case in which (not three years ago) some glaziers, who were employed in the church, were allowed to tear up and sell *every monumental brass* in the church, which contained, it is said, some very fine ones!

A lithographic engraving of the Church of the Holy Sepulchre, as restored, is now ready, and may be procured from our Publishers. The price of the India proofs is 2*s.* 6*d.* each.

[Second Edition.]
Published by T. STEVENSON, *Cambridge:* J. H. PARKER, *Oxford:*
RIVINGTONS, *London.—Price* 8*d.*

METCALFE AND PALMER, PRINTERS, CAMBRIDGE.

THE

ECCLESIOLOGIST

PUBLISHED BY THE CAMBRIDGE CAMDEN SOCIETY.

"Donec templa refeceris."

No. VIII. MAY, 1842.

S. STEPHEN'S CHAPEL.

IT is well known that the attention of antiquaries and architects has lately been much directed to the condition of this beautiful and deeply interesting monument of national and ecclesiastical architecture. When the fatal fire of the Houses of Parliament had more fully revealed what remained of its structure and decorations, it was generally hoped that in any subsequent erections the venerable Chapel might be preserved: and it was the belief, it seems an erroneous one, of many, that the distinguished architect selected to design the New Houses had intended to include in his plan a complete restoration of S. Stephen's Chapel. When therefore statements in the publick papers, and the observations of such as had visited the works at Westminster, had given an alarm to all who took an interest in the subject; and when it appeared impossible to obtain accurate information as to what was intended, while at the same time still greater changes, and even mutilations of Westminster Hall itself, were not obscurely hinted at, applications were made to the Cambridge Camden and, as it now appears, to other similar Societies, by some of their respective members, urging the Committees to take some steps at least to ascertain whether there were any real grounds for the fears thus generally entertained. Many reasons however combined to make any decided step on their parts impossible : they felt the impropriety of committing themselves upon mere rumour to a proceeding which, besides its obtrusiveness, might seem to imply a want of confidence in the skill and taste of the architect whose judgement was disputed. It was therefore determined by the Committee of the Cambridge Camden Society to request their President to communicate with Mr. Barry, expressing the fears that were entertained in many quarters, and respectfully begging to be made acquainted with the real circumstances of the case. Mr. Barry's letter in reply, which is inserted here by his obliging permission, will inform our readers of the present posture of things, and will put them in possession of the reasons which exist in the mind of the architect against a restoration of S. Stephen's Chapel.

To the Venerable Archdeacon Thorp.

REV. SIR,—On my return to town after a few days' absence, I am favoured with your letter of the 22nd inst.

No apology is necessary on your part for the praiseworthy duty

which you have undertaken on behalf of the Camden Society, of applying to me for information on a subject of so much antiquarian and religious interest as S. Stephen's Chapel, respecting which I have much pleasure in forwarding to you the following particulars.

In consequence of the dangerous state of the ruins of the Chapel, subsequent to the fire which destroyed the late Houses of Parliament, it was deemed absolutely necessary to remove them entirely; in doing which all such parts of the moulded and carved details as were not entirely obliterated by the action of the fire were carefully preserved. These relics may be seen by members of the Camden Society, if it should at any time suit their convenience to favour me with a visit for the purpose, at the New Houses of Parliament.

The Society is in error in supposing that a restoration of the Chapel has ever formed part of my design for the New Houses: the only portions of the ancient Palace of Westminster which I proposed to retain and restore were the Crypt of the Chapel, the adjoining Cloisters, and Westminster Hall; and upon that understanding my design was sanctioned and adopted by Parliament.

The Society is perhaps not aware that many and most important data are, and even before the fire were, wanting for a perfect and faithful restoration of the Chapel: any attempt therefore to effect that object would, to a considerable extent, be purely speculative, and consequently unsatisfactory. But even if *all* the requisite data were at command, a perfect restoration would be impracticable, owing to the proposed use of the Hall, which will occupy the site of the Chapel, as the public approach to the two Houses, the committee-rooms, libraries, &c., by which the east window and the Altar, as well as many other ecclesiastical features and arrangements upon which the effect of the ancient Chapel mainly depended, must necessarily be dispensed with.

If the Chapel *could* be restored to its pristine state upon its original site, and *could* be exclusively set apart for sacred purposes, then indeed it might be desirable to effect a restoration of it; but according to the arrangement of the plan adopted, or any modification of it that I can devise, this would in my opinion be impossible.

With reference to the regret that the Camden Society expresses as to the opportunity which would be lost of restoring or returning to the ancient fresco decorations of the walls by the non-restoration of the Chapel, I am happy to say that no apprehensions need be entertained upon that account; for by the design proposed a much wider scope for fresco-painting will be provided than was or could have been set apart for that purpose in the ancient Chapel.

I trust I have said enough to relieve the minds of the members of the Camden Society from some errors and misconceptions which have been entertained relative to the supposed intended restoration of S. Stephen's Chapel, and to induce the Society to agree with me that under all the circumstances it would be unwise, even if it were practicable, to attempt a restoration of that sacred edifice.

I have the honor to be, Rev. Sir,
Your obedient Servant,
Westminster, 26th March, 1842. CHARLES BARRY.

REPORT OF THE TWENTY-SIXTH MEETING OF THE CAMBRIDGE CAMDEN SOCIETY.

On MONDAY, April 18, 1842.

THE President having taken the chair, the following candidates were balloted for and elected :—

Brown, Mr. C. E. Cambridge.
Colville, J. W. Esq. M.A. Trinity College; 32, Curzon-street, May Fair, London.
Curzon, the Hon. Edward Cecil, M.A. Christ Church, Oxford; 17, Connaught Terrace, London.
Fowler, Rev. Hugh, M.A. Sidney Sussex College; Lamerton, near Tavistock.
Ingram, Rev. G. B.D. Queens' College; Chedburgh Rectory, Suffolk.
Lockwood, H. F. Esq. Architect, Kingston-upon-Hull.
Manners-Sutton, Rev. T. M.A. Trinity College; Subdean of Lincoln.
Moore, Rev. E. M.A. S. John's College; Whaplode Drove, Spalding.
Parker, Rev. John, M.A. Oriel College, Oxford; Sweeny, Oswestry, Salop.
Sandys, H. B. Esq. Trinity College.
Trevelyan, Rev. E. Otto, M.A. Corpus Christi College, Oxford; Stogumber Vicarage, Taunton, Somersetshire.
Witts, W. F. Esq. Fellow of King's College.

A list of nearly one hundred presents was then read by the Secretary. This list comprised several books; impressions of many rare and valuable brasses; eight beautifully coloured drawings of Decorated windows from Carlisle, Heckington, and Sleaford, made to a scale, and presented by E. Sharpe, Esq. architect; and a large collection of Gothick mouldings, by F. A. Paley, Esq.

The following changes in the Laws, recommended by the Committee, were then proposed successively, and adopted unanimously by the meeting :—

" That to Law II. the following words be added—" or who, not being, or not having been, Members of the University, shall be approved of by the Committee."
That in Law IV. the words " other ordinary members, as also," be omitted.
That to Law VII. be added—" No member shall be considered entitled to his privileges as a member, whose subscription is in arrear."
That to Law XVI. be added the words—" No alteration shall be made in any law of the Society without notice having been given at a previous meeting."

The following Report was then read from the Committee :—

" On again meeting the Society the Committee beg leave to report the places whence applications have been received since the last meeting :

ALVERTON, Truro, Cornwall
AYLESBURY, S. Mary, Bucks.
BAKEWELL, Derbyshire.
BEESTON, Nottingham.
BRIDGERULE, Devon.
CONGLETON, Cheshire.
DEVIZES, Wilts.
FAIRBURN, Ferrybridge, York.
LICHFIELD, S. Michael.
MADRON, Penzance, Cornwall.
MIRFIELD, Dewsbury, Yorkshire.
PAUNTLEY, Newent, Gloucestershire.
STONNALL, Shenstone, Stafford.

" The second edition of the *Few Words to Church-Builders* is in the press, and will probably appear in the course of next week. The Appendix is carefully corrected and greatly enlarged.

I 2

" The 6th and 7th numbers of the *Ecclesiologist* have appeared, and the 8th will be ready before the next meeting.

" The Committee for the Restoration of S. Sepulchre's are about to issue a list of additional subscriptions received since the last report, accompanied by a lithographic drawing of the church, and trust to the active exertions of the members of this Society in aid of a work in which its credit is so intimately concerned. A very large sum will still be wanting to carry out the repairs in the same church-like and durable manner in which they have so far been conducted. A Faculty has been granted for the proposed alterations: the original Chancel-arch has been discovered, and will be restored; and rapid progress is making towards the erection of the new Aisle.

" The Committee have undertaken to receive subscriptions for a new church at Alexandria, (for which a grant has been made by the Society for Promoting Christian Knowledge,) for which they have also promised to furnish designs.

" The restoration of the Font of S. Edward's, under the able superintendence of Mr. Lawrence, clerk-of-the-works at S. Sepulchre's, is highly satisfactory.

" The Fifth Part of the *Illustrations of Monumental Brasses* will contain—

> THOMAS DE CREWE, Esq. and LADY—from Wixford, Warwickshire.
> LORD BEAUMONT—from Wivenhoe, Essex.
> The COUNTESS of OXFORD—from Wivenhoe, Essex.
> BRITELLUS AVENEL, Priest—from Buxted, Sussex.

" A Second Part of the *Transactions* is in course of preparation."

A paper was then read from the Reverend W. Airy, M.A. Trinity College, Vicar of Keysoe near Kimbolton, and Rural Dean, describing an inscription lately discovered on the curious Font in his church. A model of the Font, executed by Mr. Airy, and a full-sized copy of the inscription, were exhibited. [The paper is printed in the present number of the *Ecclesiologist*.]

Edmund Sharpe, Esq. M.A. of S. John's College, Architect, then proceeded to read a first paper on the Early History of Christian Architecture. He commenced by classing the whole architecture of Europe under the two heads of Pagan and Christian; the former being subdivided into orders, the latter into styles. The origin of Christian Architecture he derived historically from the debased Pagan of the lower Emperors; defending however the anomalous appearance of the theory by comparing with it the somewhat analogous process by which, from the corruption of the seedling plant, springs a new production of far greater beauty and luxuriance. The *essential* differences between the principles of Pagan and Christian art were next briefly pointed out and illustrated; first as regards construction, and secondly decoration. Having then traced the history of the arch, through the progress of its struggle with the older forms of construction till its triumph as exhibited in the palace of Diocletian at Spalatro, Mr. Sharpe proceeded to describe the earliest form of Christian churches, pointing out the arrangements of the Basilicæ, and briefly referring to the typical additions gradually made to the original plan. Christian Architecture may be classified in

two great divisions, the twelfth century being the period of transition, as marking the general substitution of the pointed for the circular arch. The latter division is called almost universally, however unmeaningly, Gothick : the former is yet without any name of general acceptation. The first period of Christian Architecture was then considered as divided into two great contemporaneous styles, prevailing according to the in- fluence of Byzantium and Rome in the Greek and Latin Churches respectively ; the Greek cross and domical vaulting marking the one, as the Latin cross and cylindrical vaulting mark the other ; the former having its archetype in Santa Sophia, the latter in S. John, Lateran.

" After proposing Byzantine and Romanesque as the distinctive names for these two classes, Mr. Sharpe proceeded to review the differ- ent nomenclature adopted by late architectural writers. Mr. Gunn called *all* Christian Architecture previous to the rise of the Gothick, Romanesque : German writers to this day call it with equal generality Byzantinisch. Professor Whewell, the reviver of the term Romanesque, does not appear to recognize a distinct Byzantine style. M. de Caumont designates the whole period as *Romane*. Mr. Hope used *Byzantine* without sufficient definition ; and when contrasting it with *Lombardic*, must be supposed to use the latter term as equivalent to *Romanesque*. Wiebeking proposes to use *Neu Griekisch* instead of *Byzantinisch*. De Lassaulx adopts *Romanisch* as equivalent to the English *Romanesque* and French *Romane*.

" In considering Byzantine architecture, Mr. Sharpe regretted the great scarcity of information as to the eastern churches ; but, after pointing out the characteristics of the style, mentioned some extra- ordinary and hitherto undescribed churches in the west of France, which are clearly Byzantine. In illustrating the chief of these, the Cathedral church of S. Front at Perigueux, from his own drawings and admea- surements, he explained all the peculiarities of a Byzantine church ; and accounted for the striking absence of sculptured decoration in the style from the iconoclastic principles of the Greek Church. The Cathedral of S. Mark at Venice he also adduced as an instance of the Byzantine. The Cathedrals of Cahors and Angoulême, and the church of Souillac, are the other French buildings in imitation of S. Front.

" The *Romanesque*, including all within the above-mentioned period that is not Byzantine, is to be subdivided according to particular loca- lities. In England, Mr. Sharpe proposed to call it by the old terms, Saxon and Norman; in France he distinguished the Norman, Poictevin, Auvergnese, Languedocian, Provençale, and Burgundian Romanesque. Germany has the higher Rhenish and lower Rhenish Romanesque ; while there are peculiar characteristics in that of Bavaria, Saxony, Franconia, Brunswick, Hanover, and Westphalia. In Italy may be distinguished *Basilican* and *Lombardic* Romanesque, besides examples of Baptismal and Sepulchral Romanesque. Sicily exhibits, as well as our own country, all the peculiarities of the Norman variety. The style was illustrated by descriptions and drawings of S. Saturnin, Toulouse. perhaps the finest existing specimen of Romanesque ; which was conse- crated by Pope Adrian II. in 1051. Having now come to the Tran- sition period, Mr. Sharpe referred to the many theories on the origin

of the pointed arch, the earliest Transitional feature; and while acknowledging the propriety of attributing the introduction of the pointed arch in the architecture of the Rhine to the facilities it afforded in the construction of cylindrical cross-vaulting, he did not consider this the earliest or most important cause of its *general* adoption. From documentary as well as internal evidence he had traced the existence of the pointed arch in buildings earlier than those adduced by Professor Whewell in support of his theory. He had found, almost without an exception, in buildings of the Transitional period, that the pointed arch was used in vaulting in pier-arches, and over large openings; while the circular one was retained for doors, windows, arcades, and all the smaller apertures. The former therefore he designated arches of *Construction,* the latter of *Decoration.* It appeared then that the pointed arch was first used in construction, and afterwards adopted in decoration; just as the form of the arch itself supplanted the entablature by becoming useful, and then being made ornamental. He further referred to the liability of the circular arch of large span to lose its form at the crown, and mentioned the curious fact, that he had proved (from accurate investigation) many of the very obtusely pointed arches of the Transitional period to have been constructed *from one centre only,* the arch stones at the crown having been slightly raised so as to form an apex. This weakness of the circular arch being known to the architects of the twelfth century will account for the rapid adoption of the improved form in every position. The writer then shewed from the principles of construction how this tendency to sink in the circular arch, arising from the great *lateral* pressure at the crown, was obviated by the adoption of the pointed form, in which the pressure at the apex was very much more *vertical.* This is the theory on the origin of the pointed arch put forth by Mr. Ware in 1822, and this the writer proposed to support and illustrate in a subsequent paper."

After some discussion of the various subjects involved in this paper, and due acknowledgements made to Mr. Sharpe and Mr. Airy for their interesting communications, the meeting adjourned.

OXFORD ARCHITECTURAL SOCIETY.

A MEETING was held on Wednesday last at the Society's room, the Rev. the Rector of Exeter College in the chair.

NEW MEMBERS ADMITTED.

The Lord Bishop of Salisbury (by acclamation).
James Orr, Esq., Oriel College.
The Hon. H. R. Skeffington, Worcester College.
John W. Knott, Esq., Wadham College.

PRESENTS RECEIVED.

An impression of the fine Brass of Bishop Wyvil, from Salisbury Cathedral; presented by W. J. Jenkins, Esq., Balliol College.

Lithographic Views of Hereford Cathedral, shewing the proposed restorations; presented by the Dean of Hereford.

Lithographic Views of Stamford church, interior and exterior, and of the proposed New church at Camberwell; presented by Messrs. Scott and Moffat.

A Model of the very elegant Early-English Font at Wellow, Somersetshire; presented by the Rev. John Ward, of Great Bedwin, Wilts, modelled at his own expense.

Specimens of Altar, Communion, and Corporal Cloths, of crimson damask and white linen, with appropriate designs, manufactured by Mr. French, of Bolton-le-Moors, with Lithographs of the designs, and prices, which are very moderate; presented by Mr. French.

The Chairman informed the meeting that the Society has purchased the entire collection of architectural drawings left by the late Mr. Rickman. The value of these drawings does not consist in their merit as works of art, for they are merely outlines in pen-and-ink, some of them mere scratches, though generally drawn with great care and accuracy; but in the immense variety of examples here brought together during a long number of years devoted to the study of Gothic Architecture. There are altogether upwards of *two thousand* examples, of which the greater part are English, a few Scotch, and about three hundred are foreign, chiefly French, but some from Rotterdam and other places. The whole of this large collection are drawn from sketches made on the spot, and the greater part are unpublished. Collected by so careful an observer as Mr. Rickman, their value as examples may be relied on, and can hardly be estimated too highly for the use of such a Society as this. Mr. Rickman unfortunately died before he had at all completed his design, which evidently was to form a chronological series; and many parts of it are left in a very imperfect state, but other branches of the subject, particularly the variety of the forms of tracery of windows, and of those more especially during the Decorated period, will be found particularly copious and complete. He took this opportunity of urging upon the attention of the members the importance of collecting sketches and transmitting copies of them to the Society, with a view to carrying out the design of which so noble a foundation is here laid. Let them not be discouraged by the rudeness of their early attempts, but take encouragement from the rudeness of many of Mr. Rickman's drawings; and remember that a rude sketch, if accurate, and accompanied by *measurements*, is more really valuable than a highly finished artist's drawing without them.

A paper on the Military Architecture of the Middle Ages, communicated by G. T. Clark, Esq., was read by the Rev. J. D. Collis, of Worcester College. The object of the paper was to point out the distinctions between the several styles of castles found in England, and to enable parties to ascertain to which class they belonged, by the existing remains. He divided them into two principal classes—the Norman keep, as Newcastle, London, &c., and the Edwardian castle, with its walls of enceinte, inner, outer, and middle baileys, posterns, and ditch, as Caerphilly, Caernarvon, &c. At a later period, though houses continued to be castellated in appearance, it was more for ornament than actual use, the windows became larger, and the whole building has more of a domestic character. It is remarkable that during the 13th century, when we have so many churches, we have very few castles

The number of castles, of which there are known to be existing remains, is in

England	461
Wales	107
Scotland	155
Ireland	120

843

And it is probable that if more accurate search were made, it would be found near a thousand. This paper was illustrated by drawings of the keep at Newcastle; the Tower of London, freed from its modern incumbrances; and Caerphilly, with its moat, carefully restored.

INSCRIPTION ON KEYSOE FONT.

[*By the Rev.* W. AIRY, *Vicar of Keysoe. Read before the C.C.S. on April* 18, 1842.]

IN offering to the acceptance of the Camden Society a small model of the Font in the church of Keysoe, which gave employment to my fingers during a few of the past winter evenings, I would venture on calling the attention of members to its principal feature, the inscription which surrounds it, more by way of asking than of communicating information respecting it. Whether inscriptions frequently occur upon Fonts is probably better known to many members of the Society than to myself; my own experience, as far it goes, would lead me to suppose them uncommon. In the present instance, thanks to some barbarous church-warden, the inscription is in tolerable preservation; for when I first came to this parish I found the Font wedged into the end of a narrow pew abutting upon one of the pillars; so that, being octagonal, five of its sides were effectually protected from injury, while a good coat of mortar and white-washings innumerable had almost done as much for the remaining ones. Fortunately, however, the mortar had given way on one side, and the lime-wash, though thick, still allowed the letters GRACE to be traced: so that having this indication that something yet remained behind, I at once removed the Font from its confined position, and by dint of scraping and scrubbing, at last laid bare the inscription on the eight sides. There was a little difficulty at first as to where the legend commenced, one line being headed by a cross, and another by a kind of colon, or three dots in a vertical position. However, having decided that the cross was the beginning, the legend ran thus :

> Trestui : ke par hici passerui
> Pur le alme Warel prieui :
> Ke Deu par sa grace ‒
> Verrey merci li face. Am.

or, in modern French,

> Restez ; qui par ici passerez
> Pour l'âme de Warel priez :
> Que Dieu par sa grace
> Vraie merci lui fasse, Amen.

Now I do not know that there is any difficulty about this inscription, unless it be in the very first letter. What has the T to do there? It seems plain, from the general sense of the inscription, that the meaning of the word, whatever its form, is *Restez.* An ingenious friend has indeed suggested that the word is *Tristez*, a monkish formation from 'tristis', 'to be sad for', or 'lament'; and then the word 'prieu' he would take to be 'Prieur'—' Lament for the soul of Prior Warel;' and this is in some measure more plausible from the circumstance of this benefice having formed part of the possessions of the Priory of Chicksands, whence it was transferred at the Reformation to Trinity College: but the remainder of the sentence—not to mention the colon after ' trestui'—would hardly allow of that meaning. My own opinion is that 'trestui' is a corruption, or rather a vulgarism, of 'restez', and not improbably is the origin of the old word ' tryste', a resting-place where one person waits for another,—the derivation of which has not, I believe, been ascertained by any of our etymologists. With regard to the date of the Font, my own impression is that it is Norman; but on this point, as well as the other, I speak under correction; and having thrown out these remarks, as I before said, more with the hope of receiving than of imparting information, I should really feel thankful to any more experienced member for a better opinion upon the subject than I am myself able to form.

[The date of the Font is Early-English; so at least we conclude from the appearance of the moulding which runs round the top of the eight faces of the stone, and is carried over the edges of the pedimental buttresses which divide them. We believe, however, Mr. Airy's conjecture on the word 'trestui' to be perfectly correct. It occurs in Geoffrey de Ville Hardouin, who wrote about 1207, in a similar sense. This author also occasionally employs the unusual form ' ui' for the second person plural. 'Verrey' we believe to be the third person singular conditional of the verb *vouloir ;* and 'face' the infinitive mood, as indeed Joinville, in his *Vie de S. Louis,* writes it. So that the sense of the two last lines would be, ' That GOD, of His compassion, would please to have mercy on him.'—ED.]

REVIEW.

The Appropriate Character of Church Architecture. By the Rev. G. A. POOLE, M.A. 12mo. pp. 182.

WE had already recommended Mr. Poole's ' Two Lectures on the structure and decorations of churches,' in our *Few Words to Church-wardens.* The present work has grown out of the former : " At the publisher's request the lectures have been cast into another form, and the author has taken advantage of the opportunity thus afforded him to make many additions to the matter which they comprised, and to give a more orderly arrangement to the whole." In its present improved state this little volume will be found well deserving the attention of the ecclesiologist, and we heartily recommend it as containing the best exposition of symbolism that has hitherto appeared ; in the illustration of which the author has availed himself of

Mr. Lewis's researches, "without wholly adopting his interpretation." The section on Fonts (pp. 61–81) is extremely valuable. Mr. Poole doubts, from the different descriptions which have been written of it, whether the Baptistery at Luton is hexagonal or octagonal. It is octagonal, but not, as he imagines, unique: there is a similar erection, though in wood and hexagonal, in Trunch, Norfolk. Something might have been said on the ancient painting and gilding of Fonts: that in Cothelstone, Somersetshire, is a fine example. Several instances are given of the desecration to which these beautiful church ornaments are subject; we could add two more from the diocese of Chichester; in one of which the Font was, no long time since, moved into the Chancel; and there the top of the bason was cut off, because it intercepted the view from the Altar: in the other instance, the Font is used as the tressel for coffins!

We are glad to see (p. 148) that Mr. Poole has modified his censure of all stone Altars, to which we referred in our third number. In speaking of piscinæ, and mentioning the rarity of those of Norman date, he might have added to the two examples from Ramsay one lately discovered in the restoration of Old Shoreham, Sussex: a projecting basin, in the shape of a monster's head. We are sorry, however, to meet with the sentence—"for the waterdrain (of the piscina) there is and can be no use consistent with our modern Liturgy." We think otherwise; and have given our reasons in the *Few Words to Church-Builders.* The "Anglo-Catholic use of two lights on the Altar," the subject, as most of our readers are aware, of a very excellent little tract by Mr. Poole, is dwelt upon in the Appendix, and some of the common objections satisfactorily answered.

TEMPLE CHURCH.

MR. Williment has just completed the central East Window of the Temple Church. The design, in accordance with the works of the period when the Choir was completed, is composed of a series of historical subjects in compartments, set in a rich mosaic, and borders of vivid colours. The subjects comprise the principal events in the history of our Lord, from the Annunciation to the Ascension. Those in the side-lights are contained in lozenge-shaped compartments, and in the centre are circles: the Crucifixion is one of the latter, and very properly holds a prominent situation. The colours of the glass are rich and vivid; the rich ruby and deep blue appear quite equal in depth of tint to the works of antiquity: the costume is in strict accordance with the period of the architecture. Beautiful as this window is, we regard it as only a sample of what may in time be expected to be seen in this church. The general effect is so good, and in such strict harmony with the building, that we cannot suppose any of the other windows will be allowed to remain destitute of the accompaniment of stained glass; and the more so, as the nakedness of plain glass will be rendered the more striking when the windows are partially occupied with this resplendent material. E. J. C.

"ARTIFICIAL-STONE" FONTS.

WE have received the subjoined Circular, which we give entire. It is in the original illustrated by engravings of three Fonts—one from Springfield, Essex, one from Evesham, Worcestershire, and one *from a Pedestal in Henry VII.'s Chapel.*

An idea having lately prevailed, that the Canons of the Church are opposed to the use of any Fonts but those made of stone, in its original condition, Austin and Seeley feel themselves warranted in asserting the contrary, and in stating that, as "artificial stone" was, until recently, unknown, it could not have been intended to prohibit it, but only the use of lead, which, in the earlier ages, was common. According to the interpretation of Lyndwood, the only requisitions are, that a Font should be "competens, durabilis, fortis, ac aquæ infusæ retentiva." In all these respects, A. & S. are prepared to answer the demands of the most scrupulous, having about twenty different patterns, made of the same material as that which they have so long used as Fountains, several of them being, also, exact copies of the originals.

Having drawings or prints of more than two hundred ancient Fonts, A. & S. are enabled to model correctly any that may be required of a particular style, and free from the blame which has been attached to some other " composition Fonts."

Austin and Seeley beg to add that their work is executed without the application of heat, and is more proof against the changes of the weather than any stone in common use, excepting granite. They are induced to state this plainly, in consequence of the ignorant prejudice which exists against " artificial stone," and the preference consequently given to Bath, Caen, and other soft and perishable stones. As, however, their business is not confined to "artificial stone," they will be happy to execute orders in Marble, or Portland, if desired.

New Road, London, (corner of Cleveland Street).

" For the resolution of all doubts," says the Preface to the Prayer-Book, referring to the Rubrick, " the parties that so doubt shall alway resort unto the Bishop of the diocese, who by his discretion shall take order for the quieting and appeasing of the same." Messrs. Austin and Seeley seem, however, to imagine that this office belongs to themselves; and accordingly pronounce, ex cathedrâ, that artificial stone is not contrary to the Canons.

The authority of Lyndwode as a collector and commentator is undoubtedly very high ; though how it can be set up against the literal injunction of a Canon made one hundred and sixty years after his death, we cannot see. But a word, very germane to the present question, has been omitted in the above quotation. The constitution of Archbishop Edmund runs thus:—" Baptisterium habeatur in qualibet Ecclesia Baptismali lapideum, vel aliud competens, quod decenter cooperiatur, et reverenter observetur, et in alios usus non convertatur." Lyndwode's interpretation of the word ' aliud' is " Sc. de alia materia congrua et honesta, tali viz. quæ sit SOLIDA, durabilis, et fortis, ac aquæ infusæ retentiva." ' Competens' is " sic quod baptizandus possit in eo mergi." That artificial stone was unknown, and therefore not expressly forbidden in the Canon of 1603, does not prove that it may be employed now ; else plaister-of-Paris or Wedgwood's ware might be used

well : but the truth* which the Canon signifies, renders artificial stone of any kind most unbecoming.

We were not previously aware that Caen stone was soft and perishable ; Westminster Abbey and Rouen Cathedral abundantly prove the contrary. Nor have we ever seen a Font affected by the weather, though indeed the experiment is being now tried at Scraptoft, Leicestershire, and S. Cuthbert's, York, where the Fonts are used to catch the water that runs from the roof.

<hr/>

WOOD-SEATS AND CHAIRS.

SIR,—I have often regretted that the use of chairs instead of open benches has not been more strenuously advocated. I certainly have no desire (in spite of the insinuations of the advocates of benches) for the revival of Processions ; yet the adoption of chairs, in certain cases, does seem to me to have some real advantages, which with your permission I will proceed to state.

Two objections are urged against the practice—1. The ugliness of chairs ; 2. The impropriety of adopting foreign arrangements in English churches.

With respect to the first objection, it has no force with those who have seen how little the hundreds of chairs which they contain disfigure the French Cathedrals : to whom the feeling how easily they could be removed, if necessary, reconciles the eye to their appearance ; and to whom they seem no more in the way than would an equal number of stationary figures.

In answer to the second, it is maintained, that chairs are not only an English arrangement, but that they were employed long before woodseats came into use. Early illuminations, while they never represent the latter, often exhibit low stools ; and these, the express testimony of Dr. Udall, in his *Communion Comeliness,* would prove to have preceded open seats. Nor is there any force in the objection, why then do we never find ancient chairs now ? for neither are they found in France. Again, we find in many village churches evident traces that the Nave never had open seats ; yet we cannot imagine the parishioners in these cases to have stood during the time of Divine service. Indeed, the whole tendency of wood-seats, of which we rarely find any specimens before 1400, was, through the various stages of poppy-heads, broad panelled sides, transverse bars, and finally low doors, to the pews which have been the ruin of so many churches.

The adoption of chairs hinders a great difficulty in the arrangement of the Transepts. If the open-seats face eastward, the passage for access must be close to the eastern walls ; otherwise some of the worshippers would sit and stand with their faces almost touching them. The appearance thus occasioned is in the highest degree awkward. And again—though hearing is not the first object to be attended to—it is as well, by having moveable seats, to enable the

* See Wheatley, chap. vii. sect. i. n. 3.

·people to alter their position as the Priest alters his, and thereby to receive his words with the greater ease. Again, suppose a parish to have just escaped from the misery of pews, by ejecting the whole of these wooden boxes together. If they have open seats, in these days of parsimony they will probably be of deal; and how unspeakably mean is the appearance which such present! Whereas chairs, which would not cost more, if they add no beauty to, at least detract none from, the church. And then, in due time, if seats were in the end preferred, carved oak might be provided, and the requisite number of seats, little by little, be obtained.

Yours obediently,

CATHEDRALIS.

[We refer 'Cathedralis' to the new edition of the *Few Words to Church-Builders*, for our own opinion on this subject: we have willingly inserted his letter, though we do not think the eye is reconciled to any thing really ugly by the knowledge that it might easily be removed, nor are we aware that there is any reason to believe that chairs, rather than benches, succeeded to the low stools of the old illuminations.—ED.]

A DESECRATED CHURCH.

MR. EDITOR,—I wish to call the attention of the Society to one of those melancholy spectacles which are now happily of rare occurrence, yet surely indicative of a very perverse state of feeling in places where they do exist—a disused and desecrated church. Such, I regret to inform you, is at present the case in the parish of Witton, Hunts., where the church, which is in a sadly dilapidated, yet by no means irreparable condition, has not been used for divine service for above a year, in consequence of the opposition of some factious individuals, I believe of the quaker persuasion, to levying a rate. The building, though very small, is quite a gem of Early-English architecture, and on this account alone is well deserving of a careful restoration. The plan consists of a Chancel, Nave, north Aisle, and low Tower at the west end; which latter structure, with the south Porch, is of wood. The rest of the edifice, with the exception of some late Decorated and Perpendicular windows, is Early-English throughout, and is a very curious and valuable specimen of that style. The Nave-arches are richly and deeply moulded, and the capitals of the beautiful clustered piers finely foliated, though clogged with seven-fold coatings of whitewash. At the west end is, or rather was, a single lancet, the foliated capitals of which shew that it was once furnished with jamb-shafts. There are two other lancets in the Chancel, the only ones now remaining in the church, and several corbels of rich and delicate execution. There is a south Chancel door, with the toothed moulding on the imposts. But I was particularly pleased with the north door of the Aisle, which presents a fine specimen of that now rare but most beautiful device, hinges ramifying in wrought-iron scroll-work over the whole surface of the door. The

arch of this doorway is finely moulded. The north wall is badly propped by clumsy brick buttresses—themselves more tottering by far than the old walls they are intended to support—and must in a very short time fall to the ground. The lead is hanging loose from the roof; the bells, of which there are three, have only to be rung to bring them, and perhaps the Tower along with them, to the ground. It is quite astonishing how a parish of professedly Christian people should remain in utter apathy, while their very beautiful and ancient church has not been opened for their reception for more than a year, and while the sum of £500, if judiciously applied, would effect a very complete and substantial restoration. I advise the members of the Society to visit this curious little church while it yet remains standing, which may not be for long; and I trust they will take some active measures in a case which comes strictly within their province, and which I can assure them is well worthy of their immediate attention. Witton is less than three miles from S. Ives, and the neighbouring church of Houghton is also an interesting edifice, and deserving of a visit. To the parishioners I beg to suggest the noble example of the good people of Alwalton, in the same county, in their recent repairs of their venerable church.　　　I am, Mr. Editor, yours, &c.

<div align="right">A MEMBER.</div>

[We need hardly remind our correspondent, that there are ecclesiastical authorities within whose province such cases as this most strictly come: but if any uncertainty in the present law respecting church-rates prevents the Incumbent and Churchwardens from taking the requisite steps to procure funds for the immediate restoration of their church, we earnestly hope that among those inhabiting, or connected with, the parish, there will be found persons of sufficient zeal and liberality to wipe off the disgrace which will otherwise attach to their parish, and to restore the House of GOD to its proper use and honour.—ED.]

ILLUSTRATIONS OF MONUMENTAL BRASSES.

THE Fifth number of this series is advertised in the report of the Committee, given on page 120. The Committee feel themselves bound to their subscribers to complete a fair-sized volume, and at the present price; although the increased costliness of the plates, and more particularly of the vignette illustrations, have entailed on them an expense which is scarcely to be met even by the augmented sale of the work. The early numbers of the series have been for some time out of print on India paper; and but very few of the plain copies now remain. To the applicants for these numbers, most of whom have been prevented from subscribing to the series, the Committee will engage to republish the earlier parts with very much improved illustrations, so soon as sufficient names are enrolled as subscribers. They therefore request all who desire to take in the series, who wish to complete their sets, or who, of the original subscribers, would wish to obtain the *improved* issue, to forward their names to the Secretaries or Publishers.

TRANSLATION OF AN INSCRIPTION

ON A RED-CROSS SHIELD,

Supposed to be dedicated in the Church of the Holy Sepulchre, Cambridge.

(From the Ecclesiologist, No. III. p. 50.)

BY THE LORD BISHOP OF DOWN, CONNOR, AND DROMORE.

OF old I saw the mailed band advance
With haughty step, and hurl the flaming lance;
Not mean my prowess then: compell'd to flight,
The Mooned hosts confess'd the Cross's might.
Now the meek voice of pray'r I hear, and see
The childlike homage of the bended knee.
My prowess now how great! Hell's host o'erthrown,
By flight salvation's heavenly Symbols own.

S. MARY THE GREATER, CAMBRIDGE.

[The following letter has been received by the President; and heartily do we agree with the writer in wishing for the removal of the gallery which occupies so objectionable a position in the University church. Had we inherited any portion of the authority which the High Commission once exercised, we should certainly have ordered its destruction at the same time that the balls were removed from the Tower: but we trust that 'faire means' may avail to 'redresse' these most unfitting seats, and that the Chancel of S. Mary's will at length benefit by the increased attention to ecclesiastical usage and propriety.—ED.]

April 26, 1842.

MY DEAR ARCHDEACON,—Perhaps, at the coming Installation, there may be some attention paid to the question of the propriety of restoring the interior of the University church to a condition less at variance than the present is with ecclesiastical usage; and if so, perhaps the authority of Archbishop Laud, backed by that of King Charles I., may not be without its use in supporting the exertions of those who may endeavour to bring about such a restoration.

It is singular that the present anomalies in S. Mary's should have been introduced *after* the following Remonstrance:—

"I find," says Laud, p. 561 of his History, (ed. H. Wharton, 1695), "by my Lord* the Bishop's account, that there are divers particulars of moment, and very fit for redress, presented to him in his late [yet (*sic* Qu. 'it,' *i. e.* 'y',) being his first] visitation, and most of them in the University and Town of Cambridge. * * *

That in some of the *Chancels* of the Churches in Cambridge, there are *common seats, over-high, and unfitting that place in divers respects.* * * *

For the *profanations* and disorderly seats, I think, if an admonition would amend them, it were well given. But if that prevail not, the High Commission may order it, if your Majesty so please."

To which King Charles thus assents in the margin:

* Bishop Wren.

"It must not bee—C. R. You are in the right; for if faire means will not, power must redresse it."

As the High Commission no longer exists, perhaps the Camden Society may be able to do something tówards carrying Archbishop Laud's and King Charles's wishes into effect.

I am always, my dear Archdeacon,
Yours affectionately,
Τὰ ἀρχαῖα ἔθη κρατείτω.

THE repairs at Chesterton church are proceeding rapidly, and in some respects deserve commendation. But we regret to see that the south-eastern window has been entirely blocked up with brick, and that the tracery of the windows on the north and south sides has been only faced externally with stone, instead of being entirely replaced. The old roof of oak, which is entirely decayed, is to be replaced with one of Memel timber, of precisely the same design. To the material, if it must be used, we have not so much objection to make, as to its being subsequently painted to represent oak. A very perfect rood staircase has been discovered at the north-west angle of the Chancel. We regret to see the want of reverence which seems to prevail. The east walls being pulled down, the Chancel is left without any protection; and the Altar was, when we last saw it, used as a drawing-board.

NOTICES TO CORRESPONDENTS.

WE are greatly obliged to "Anglicanus" for a paper on the introduction of foreign styles into this country: we quite agree that the growing adoption of a variety of styles, so unsuited to our climate, habits of worship, and even ritual, with the sanction and encouragement of the highest authorities, is a subject which demands earnest notice from any voice that has a chance of being heard; calculated as it is to obstruct the progress of that improvement in our national religious architecture, which is beginning to flow from a more careful observation of the multitude of examples we happily possess in a style truly religious and truly national. If "Anglicanus" will favour us with his address, we will point out some very trifling alterations in his letter, which he will probably, with us, be glad to adopt; and we shall then be able to exhibit in our next Number, free from the objection to which it appears to us now liable, an article which we consider very valuable and sure to do good.

Orientation.—The principal point to be noticed under this head in the Church Schemes (besides any remarkable deviation from the usual direction of E. and W.) will be a difference in the directions of the Chancel and Nave. The meridian line may be determined by observing the Sun's position at mid-day, or by the compass: of course the Society will not expect very great accuracy in this part of the Schemes.

A Camdenian.—£2. have been received; and as it was thought that under the circumstances they ought not to be applied to the general purposes of the Society, they will be given towards the cover (which will probably be a copy of the excellent one at Littlebury) of the beautiful Font of S. Edward's.

The Ecclesiologist.—Twelve sheets are published yearly, and sent post-free on remitting *five shillings* (by post-office order or otherwise) to the publisher, Mr. Stevenson.

[Second Edition.]

Published by T. STEVENSON, *Cambridge*; J. H. PARKER, *Oxford*; RIVINGTONS, *London—Price* 4d.

METCALFE AND PALMER, PRINTERS CAMBRIDGE.

THE

ECCLESIOLOGIST

PUBLISHED BY THE CAMBRIDGE CAMDEN SOCIETY.

"Bonæc templa refeceris."

No. IX. JUNE, 1842.

A HINT ON MODERN CHURCH ARCHITECTURE.

IT has often appeared to us a surprising fact, that modern church-architects should never have recourse to a method which would, if adopted, not only place their works beyond the reach of criticism, but enable them to produce buildings at once the most beautiful, commodious, and correct, at an outlay considerably less than is now too often devoted to the erection of the unsightly piles known by the generic name of "new churches." In saying this, we do not of course mean to imply that any superfluous sums are in these days contributed for the purposes of church-building, but simply to state our opinion, that a particular sum collected for building a new church might, by the adoption of the system we would propose, be expended to much greater advantage than under the present practice of architects it will generally be found to be. We would suggest then that instead of new designs, or "original conceptions," as they are very properly called, formed by the adaptation of a buttress from this church to a window or a parapet from that, *real ancient designs*, of acknowledged symmetry of proportions or beauty of detail should be selected for exact imitation in all their parts, arrangements, and decorations. How often do we see a simple village church, consisting, it may be, of low and rough stone walls, surmounted, and almost overwhelmed, by an immense roof, and pierced with some two or three plain windows between as many bold irregular buttresses on each side, or having a short massive Tower placed at one corner or in some seemingly accidental position, which nevertheless every one confesses to be as picturesque and beautiful and church-like an edifice as the most critical eye or the most refined taste could wish to behold. And just such another church could be built perhaps for seven or eight hundred pounds; while a modern Early-English design, with all its would-be elegances of trim regular buttress, triple lancet, and curtailed Chancel, would contain no more kneelings, cost more than twice the money, and look like a "Gothic factory" after all. And why is this? Because a lofty Tower must be built instead of a simple unpretending Chancel; or because one-half of the money is expended first in procuring, and then

in smoothing and squaring, great masses of stone, or in working some extravagant and incongruous ornament, so that cast-iron pillars must be placed in the interior instead of piers and arches; whereas the small rude hammer-dressed ashlar or rubble work of the ancient model has a far better appearance, and allows a larger expenditure where it is most wanted, in procuring solid, handsome, and substantial arrangements for the interior.

Now we cannot help thinking that architects would act more wisely if they would carry away with them on their journeys of research, not only mere sketches of details and partial measurements, but entire churches: we do not mean take them bodily away in their trunks or portmanteaus, but make plans, sections, and measurements of the whole, wherever they meet with an old church of peculiarly beautiful or appropriate design, so as to be able to build it elsewhere in precisely the same manner, or with the additional improvement of substituting, as far as can be ascertained, the original forms for the altered and mutilated portions of later ages. Any architect who would set the example of building new churches after the exact models of good ancient ones, would, we think, have the glory of commencing a new and happy era in the history of modern church-building. And why should not this be generally done? Are not ancient churches allowed by all to be most beautiful, and modern ones (at least by many) to be most faulty? Since church architecture in the present day is strictly imitative, why may we not copy whole and perfect edifices as well as detached and unconnected parts? And what would be the result of the general adoption of such a system? The gradual return to ancient propriety in ecclesiastical architecture, instead of the extensive introduction of a series of nondescript designs which appear painful to us, and may possibly appear even ridiculous to posterity. We should thus replace by new and perfect buildings the worn-out and mutilated edifices of our pious ancestors;* and England might once again become the country, if not of glorious Cathedrals, at least of refined and chastened Christian art.

Nor let it be thought that servile imitation implies a poverty of invention reproachful to our times. It is no sign of weakness to be content to copy acknowledged perfection; it is rather a sign of presumption to expect to rival it in any other way. We are indeed aware that it is a great pleasure, and therefore a great temptation, to exercise genius in producing new combinations, and endeavouring to surpass ancient examples. Yet surely there is still greater pleasure (as certainly we think there would be greater good) in producing an exact copy of a church whose excellence has been proved by the admiration bestowed upon it by all for centuries past, than in trying experiments which, should they happen to fail, entail lasting discredit on the authors and promoters of the design.

Much has been written upon the causes of the acknowledged failure of modern works executed in imitation of the ancient ecclesiastical

* We may ask in illustration of the principle we have ventured to suggest, whether it would not have been better to rebuild, precisely after the ancient design, that beautiful and perhaps unsurpassed edifice, the old Gateway of King's College, instead of the modern unmeaning screen and gateway at present fronting the street.

styles: and it is very generally held that the sudden discovery of some unknown principle may at once enable us to regain all the lost graces and beauties of ancient architectural compositions. We think that this opinion will prove fallacious. There is surely something inherent in the very nature of mere imitative art, which renders the attainment of equal excellence with the originals we profess to copy a mere contingency, dependent solely upon individual skill or the circumstances of the case. We speak of course of affecting to copy, not of literally copying, ancient design. It has been said that no political constitution has ever prospered which has been borrowed from another nation, and has not been gradually altered and improved from its earliest formation, according to its own wants and emergencies, until it has attained its highest point of perfection. Similarly, it is characteristic of progressive art to arrive gradually by its own impulses, its animating and unexhausted powers, at consummate excellence; of retrospective or imitative art, destitute of this life-giving principle, to fail or partially succeed according to the skill of individual copyists. The latter is not a natural production; it is not the free exercise of genius inspired by a consciousness of present defects and yet untried capabilities, ever looking forward and improving upon the past; but it is the fettered effort of a mind, aware indeed of the beauty of the thing produced, yet unacquainted with the feelings and impulses that produced it. For this reason it appears to us probable that Christian architecture, having ceased to be progressive, and being no longer animated by the hidden power that gave it birth and reared it into mature excellence, will not thrive in its second birth under the present process of what we may call *inventive imitation;* and that it will be the safest and best course to adhere, for the present at least, to close or mechanical imitation, as the only sure way of attaining that excellence which we admire, but have hitherto striven to reach in vain.

REPORT OF THE TWENTY-SEVENTH ORDINARY, AND THIRD ANNIVERSARY MEETING OF THE CAMBRIDGE CAMDEN SOCIETY.

On WEDNESDAY, May 11, 1842.

THE President took the chair, at a very crowded meeting, at half-past seven o'clock: and the election of the following members commenced immediately :—

Beresford, Field Marshal the Viscount.
Birtle, Rev. J. Oake, Milverton, Somersetshire.
Chandler, the Very Rev. G. D.C.L. New College, Oxford; Dean of Chichester.
Dupuis, H. Esq. M.A. Fellow of King's College.
Forbes, Sir Charles, Bart.; Fitzroy Square, London.
Francklin, W. Esq. B.A. Balliol College, Oxford; North Petherton, Somersetshire.
Harrison, Rev. T. M.A. S. John's College.
Horne, Rev. E. M.A. Queen's College; S. Lawrence, Southampton.
Miniken, W. Esq. B.A. S. Catherine's Hall.
Murray, C. R. Scott, Esq. M.P. B.A. Christ Church, Oxford.
Percival, Captain; Langford, Somersetshire.

Pratt, Rev. Jermyn, M.A. Trinity College; Campsey Ashe, Woodbridge,
 Suffolk.
Randall, Alexander, Esq. Maidstone.
Rudge, E. Esq. S. Catharine's Hall.
Wilkins, the Ven. G. Archdeacon of Nottingham.

The Rev. Dr. Routh, President of Magdalene College, Oxford,
and President of the Oxford Society for promoting the study of
Gothic Architecture, was then elected an Honorary member by accla-
mation.

A list of presents received since the last meeting was read by one
of the Secretaries; among them was a view of the restoration of Here-
ford Cathedral, presented by the Very Reverend the Dean, and a view
of the Chapel of S. Mary now building at Arley Park, Cheshire, with a
copy of the inscription on the foundation-stone, presented by R. E. E.
Warburton, Esq., the sole founder.

On the recommendation of the Committee it was next unanimously
resolved,

" That the Members of the Durham Architectural Society be admitted,
 in compliance with Law XVIII. to the same privileges as have
 been granted to the Members of the Oxford, Exeter, and Lich-
 field Associations."

The Annual Report of the retiring Committee was then read, toge-
ther with an audited statement of the accounts of the Society. On the
motion of R. E. E. Warburton, Esq., M.A., Corpus Christi College,
Oxford, seconded by the Rev. J. C. Franks, M.A., Trinity College,
Cambridge, the Report was unanimously accepted and approved. [This
Report, which is too long for insertion in the present number of the
Ecclesiologist, is printed at length in the Society's Report for 1842, just
published.]

The President then rose and delivered an eloquent address upon the
history and prospects of the Society, explaining at length the position
it occupied, and pointing out the general principles upon which its
operations had been conducted.

It was unanimously resolved, on the motion of the Rev. J. J. Smith,
M.A., Fellow and Tutor of Caius College, seconded by Dr. F. Thackeray,
that the President should be requested to allow his Address to be
printed in the forthcoming Annual Report.

The election of the six members, who by Law VIII. were to form
the original Committee, then commenced.

The following gentlemen, all members of the late Committee, were
successively proposed, and, there being no opposition, were declared
severally elected by acclamation :

 F. A. Paley, Esq. M.A. S. John's College.
 Proposed by Dr. F. Thackeray, Emmanuel College.
 Rev. F. W. Collison, M.A. Fellow of S. John's College.
 Proposed by Rev. W. Keeling, M.A. Fellow of S. John's College.
 Benj. Webb, Esq. B.A. Trinity College.
 Proposed by Rev. J. F. Russell, B.C.L. S. Peter's College.
 Rev. J. M. Neale, B.A. Trinity College.
 Proposed by Rev. T. L. Fulford, M.A. Trinity College, a (member
 of the Exeter Architectural Society).

Rev. E. T. CODD, M.A. S. John's College.
Proposed by J. Atlay, Esq. B.A. Fellow of S. John's College.
P. FREEMAN, Esq. M.A. Fellow and Tutor of S. Peter's College.
Proposed by R. A. Suckling, Esq. Caius College.
The Auditors for the ensuing year were then unanimously elected:

The Rev. Prof. SEDGWICK, M.A. a Senior Fellow of Trinity College.
Proposed by A. S. Eddis, Esq. M.A. Fellow of Trinity College.
The Rev. S. W. WAUD, M.A. Fellow and Tutor of Magdalene College, and Rural Dean.
Proposed by the Rev. C. U. Barry, B.A. Trinity Hall, Incumbent of S. Edward's.

[The Committee have subsequently elected the following Officers:—

ChairmanRev. J. M. Neale, B.A. Trinity College.
TreasurerRev. F. W. Collison, M.A. Fellow of St. John's College.
HonorarySecretaries.. B. Webb, Esq. B.A. Trinity College.
F. A. Paley, Esq. M.A. S. John's College.

And have added to their number,

R. W. Bacon, Esq. M.A. Fellow of King's College.
A. S. Eddis, Esq. M.A. Fellow and Assistant Tutor of Trinity College.
Rev. W. N. Griffin, M.A. Fellow of S. John's College ; and
E. Venables, Esq. B.A. Pembroke Hall.]

An unanimous vote of thanks was passed to A. S. Eddis, Esq. M.A. Fellow of Trinity College, the retiring Treasurer.

The business of the evening being concluded, Mr. A. S. Braithwaite, one of the patentees of the newly-invented method of imitating ancient carved wood-work, was introduced to the meeting, and exhibited a collection of his specimens and designs. The carvings were generally admired for their delicacy and boldness, and it would take a practised eye and hand to distinguish between these casts and original work. The process was described to be very simple ; the wood being merely impressed by an iron mould, heated very intensely, and acted upon by a press. It appeared to be the prevailing opinion among the members present, that however desirable might be the great saving of expense which Mr. Braithwaite's invention secured, and however faithful the copy of ancient work which his process supplied, yet these scarcely counterbalanced those disadvantages which must attach to this pressed wood in common with cast-iron; while there was much reason for apprehension with respect to the general introduction of any process so entirely mechanical, lest it should repress, if not destroy, all the variety, originality, and delicacy which inventive art in this department used formerly to display.

An elaborate paper prepared by H. Goodwin, Esq. B.A. Fellow of Caius College, was deferred for want of time; the remainder of the evening being occupied by remarks from P. Freeman, Esq. M.A. Fellow of S. Peter's College, in illustration of some large drawings of wooden roofs, which were exhibited to the members.

After an unanimous vote of thanks to the President, the meeting adjourned.

ANCIENT HERALDRY.

Of the many uses of Monumental Brasses, not the least important is their direct application to the study of Heraldry. In modern times, when the practice of this noble science has confessedly become very degenerate, and when, from accidental causes, or from the carelessness with which we are apt to regard whatever ceases to be a subject of pride and a privilege to a few, the true bearings of ancient families, whether surviving or extinct, have in some instances been lost, in others extensively altered or corrupted; it is highly interesting to find sculptured upon unchanged and unchanging brass the exact copies of the original escutcheons, by which we may test, and if necessary amend, inaccuracies that have become inveterate by the lapse of many centuries. And we think it will be allowed that this is a matter of no small importance (as far as the pride of family distinction can be called important) at a time when, from the immense demand for new coat armour, and the frequent announcements of " arms found at the lowest charges," all the ancient bearings are so hackneyed, and have been made to assume such endless variety by change of tinctures, number, and disposition, that frequently the merest trifle alone distinguishes the proud escutcheon of six hundred years from that of the rich retired tradesman who had his coat "found" at the herald's office not six months ago. And heraldry is extremely liable to corruption by time. We need only instance the modern three instead of the ancient four pallets in the arms of S. Peter's College; the field of France semée of fleurs-de-lys changed into three fleurs-de-lys ; the lion and leopards of England converted into three lions passant ; the countless variations in the number of charges in bordures, ordinaries, orles, &c., which those who are in the habit of comparing ancient with modern shields cannot fail to observe. We say, therefore, that these monuments are a standing testimony to the purity and antiquity of coat armour, which is highly to be prized in times when all may bear arms, and when antiquity therefore constitutes their only value. Again, the numerous quarterings sometimes exhibited in ancient shields afford evidence of the most certain kind of intermarriages, of which all written or even traditional record has now perished. They furnish us with hieroglyphical pedigrees, φωνᾶντα συνετοῖσι, often of the greatest importance in ascertaining the rank and influence, fortunes and alliances, of old families. In a late assignment of a peerage long held in abeyance, an almost defaced shield cut in stone on the porch of an Early-English church in Lincolnshire furnished evidence, in default of which the decision would in all probability have been very different from that which was given by a Committee of the House of Lords.

In respect of unchanging accuracy, monumental brasses naturally afford much more certain testimony than stained glass, in which ignorant and remorseless glaziers can at any time omit or add a bordure (sometimes, as may be seen in Milton church, compony of half-a-dozen tinctures) at will, or collect into a heap which may readily be mistaken for the quarterings of some goodly escutcheon, a variety of integral coats, taken at random from different windows, which never had the

remotest connexion with each other. A glazier's workman may thus make more intermarriages in half-an-hour than have taken place in the old parish church for the last fifty years. He may compose a pedigree which will lead some worthy antiquary a wild-goose chase for months to come. He will fraternise the arms of a See with the escutcheon of the parish Squire, or the plain ancient Ordinary of the founder or benefactor of the church with the multiplex modernisms of the occupant of the great pew in the Chancel. But nothing of this kind can possibly be done with Brasses. It is true that the tinctures are never expressed on the more ancient examples; as the colours with which they were in many cases originally inlaid have long since perished. Yet the absence of these will seldom afford much difficulty to a good herald; and the very deficiency furnishes a field for research and conjecture by no means displeasing to the true lover of the science.

Even after the time of the Commonwealth church-windows seem to have contained considerable quantities of stained glass, and especially of heraldry of high value and antiquity, which has since disappeared: as we know from local histories, MS. notes, and various antiquarian works published shortly after that period. Perhaps coats-of-arms were generally spared, when the " glassy bones" of Saints were dashed indignantly from the position which they occupied so greatly to the glory and solemnity and devotional appearance of ancient churches, though so much to the scandal of fanatic Puritans. Yet now it is quite a rare occurrence to find an old escutcheon remaining in stained glass even in a country church, and it is hopeless to look for such a thing in the modernised churches of large towns and cities. It made the windows dim, so that the people could not see the preacher; or the late churchwarden was a glazier; or there was a maker of kaleidoscopes (a particular friend of the clerk) who resided in the place. The neglect and apathy of centuries is hardly more to be dreaded by the antiquary than the rage for modern improvement: either will destroy as surely and effectually the precious relics of bygone days, as did ever the most violent outbreaks of popular fury, zealous to demolish and loath to spare a fragment of hated magnificence. Yet even now enough ancient stained glass will be found to remain to repay a diligent search: and a word spoken for its preservation before it be too late may often have a good effect. Not long ago we were visiting a country church in Rutlandshire, and conjectured from certain ruby and sapphire twinklings glittering amidst a mass of mortar which almost blocked the tracery of a fine Perpendicular window, that some heraldic treasure was concealed behind this unsightly covering. Accordingly, with the aid of the clerk, and by endangering our lives on a tottering ladder, we laid bare and partially cleared five or six escutcheons, which proved to be as perfect and almost as brilliant as when they were first placed there in the fifteenth century. In the little church of S. Mary, Wiggenhall, near Lynn, a good deal of ancient heraldry yet remains in the windows.* But where we find one coat tolerably perfect, we shall probably find

* We advise the lovers of ancient heraldry to examine the windows in Gilling Castle, Yorkshire, and particularly the extraordinary and unique cornice in one of the rooms, containing many hundreds of coats of arms in ancient painting.

two or three that are broken, mutilated, falling from their places, or even lying about the church (as we have often seen them), in the piscina, or the parish chest. A writer in a late number of the *Archæ-ologist* (vol. i. p. 90.), states, that on going to examine some coat armour reported to exist in the windows of Raskelf church in York-shire, he found, after much search, about half-a-bushel * of old stained glass lying under the gallery, and learnt that within the memory of the oldest parishioners the church windows were "quite dark with stained glass." It is truly lamentable to hear constantly of so much destruction both of stained glass and monumental brasses in what ought to be better days. We would have every Camdenian possess a sufficient skill in heraldry to be able to carry off in his note-book the correct blazon of all ancient arms he may meet with in his ecclesiological researches; for certain it is, in the present state of things, they are not likely to remain long.

In many places, however, the old custom of adorning windows with heraldic cognizances is being revived with the best success and the happiest results. Among the most recent instances we may mention the shields, by Mr. Williment, in the new University Library, which are beautifully executed, though they can never look well in the unsightly windows in which they have the misfortune to be placed; and those lately made for S. John's College Chapel, under the direction of the present Dean, to whose knowledge and correct taste so much of the adornment recently bestowed upon this Chapel owes its origin and successful execution.

It is curious to observe how differently bearings in modern heraldry are represented from the quaint forms they anciently assumed. We deem the present more refined and life-like figures anything but an improvement upon the latter. A modern lion ramp is no more like the grim long-backed creature of old, with open mouth and 'arbores-cent tail,' than a tame spaniel is like the wolf of the forest. All the glories of his shaggy gambs and fiery serpent-like tongue are gone. Modern heralds paint animals from nature, which is just what ancient heralds took care never to do. They even went so far that some creatures, having been traditionally and conventionally aggravated into the furthest possible point from resemblance to reality, so that it was quite impossible to say what they were originally intended for, remained fixed, as it were, in all the dignity of their nonentity, and herded into the varieties of the wyvern, cockatrice, heraldic tiger, and griffin tribes. The ancient forms may be seen in perfection in monumental brasses; and it is not a little to be wished that, as the demand for stained glass increases, artists will take a hint from these sources in attaining a more correct style of painting heraldry than their works usually exhibit.

We propose in an early number to illustrate the above remarks by giving the blazon of some ancient arms, taken from monumental brasses and stained glass of an early date.

* Since writing the above we have visited this church. The "half bushel" then did not amount to two handfuls!

NEW CHURCHES.

S. Thomas, Arbour Square, Stepney.—This church contains 1,100 kneelings, and cost between £4,600 and £4,700. We have only seen a south-western view; and it appears to us, from this, a most wretched specimen of modern church-building. The style, *of course*, is Early-English; the plan, a Nave and two Aisles, with a square porch or vestibule at the west end of each. The west window is a triplet: this, as we have often said before, is wrong; and the west door forms a kind of triplet also, and is anything but good. The porch or vestibule is lighted by one lancet at the west. There are six buttresses to each Aisle, and between every two is a couplet. But the most extraordinary part of the building is the Tower, if it may be so called; it is a tall thin octagonal column at the north-west of the Nave, with a kind of projection near the top, strongly reminding us of the Monument in its general contour. On the whole, this building appears to us to be, even when compared with other modern churches, peculiarly miserable.

The Hook, near Kingston.—No one, unless they were told, could imagine that it was a church. Its plan is a Nave, with vestry at the west end. In the *middle* of the south side is a porch between two buttresses; and on each side of these is an Early-English couplet. The west window is a triplet. There are 202 kneelings: the cost was £820.

Holy Trinity, Blackheath Hill.—This is a church of far higher pretensions than the two last, and proportionally a failure. The style is Early-English: the plan a Nave, with semi-hexagonal Apse, Aisles, a southern Porch or Transept (we really know not which), and *two Towers at the east end!* The number of kneelings is 1,200; the cost £4,400. It would be absolutely ludicrous, were it not painful to think of, that two Towers should have been undertaken for a sum which would not properly suffice for one; and they are placed at the *east* end, because *the entrances are there*. The Towers themselves are beneath criticism. The only thing in the building which we can praise is the well-developed Clerestory.—The above three churches are engraved and described in the *Christian Guardian*.

A NEW church about to be erected at *Westminster* (we believe in the parish of S. Margaret) has little we can praise: it consists of Nave, Aisles, and polygonal Apse. The style is singular; as uniting details of one, or perhaps two dates, and arrangements of another. The Aisles are furnished with eight windows of two lights without foils, which are intended for Early-English, and a spherical triangle in the head which may be intended for, but certainly is not here a feature of, that style. The Clerestory consists of sixteen lancets: the windows here are Early-English; their arrangement Perpendicular. The Apse has windows of two lights, with foliated circles in the head. The view we have seen does not exhibit any receptacle for even one bell, nor any porch or door.

S. Mary's, Arley Park, Cheshire.—We have been favoured by the Patron with a lithographed view of this Chapel; and we hasten to offer our congratulations to Mr. Salvin, the architect, on his success

in the design. The Chapel is in the Decorated style, and consists of a spacious Chancel and Nave, the latter communicating with the mansion by means of a cloistral gallery. The general view of the whole is truly excellent: the architect would seem to have caught the spirit of ancient models. We particularly admire the general arrangement of the string-courses, basement moulding, and buttresses, of which those at the angles are niched with pedimental cappings, and those to the Chancel are richly pinnacled. There is a flowing battlement to both Chancel and Nave; this, though it is very elegant, appears to us to conceal too much of the roof, which we think might advantageously be of somewhat higher pitch. At the eastern angle between the Nave and southern cloister, is an extremely beautiful engaged octagonal belfry turret, surmounted by a high pyramidal head which terminates in a finial. This we believe and hope the architect intends to continue to the ground, though at present it is blocked off with a corbel midway; we must further recommend a good cross for the gables of the Nave, instead of a *cruciform-finial*, which without crockets leading to it can scarcely be correct. We defer any notice of the interior, which however will be singularly costly, correct, and beautiful, till another occasion. After all, the most cheering part is the good spirit in which the chapel was founded and is erecting, and we cannot refrain from gratifying our readers with the beautiful inscription which was engraved on the foundation-stone—

✠ In . nomine . Dei . ✠ . Amen . Qui . super .
fundamentum . Apostolorum . et . Prophetarum .
ipso . summo . angulari . lapide . Christo ✠ Jesu .
ædificabit . ecclesiam . et . in . honorem . Beatæ .
Mariæ . Virginis . primum . lapidem . hujus .
oratorii . posuit . Rolandus . Warburton . armgr
quo . verbum . Dei . quotidie . sonet . precesque .
fidelium.ascendant.Anno.Salutis.MDCCCXLII.

CHURCH RESTORATION.

WE have it in our power to announce several instances of restoration, which though on a small scale are not the less valuable, as evidences of the growing zeal for such matters, and as patterns for others. In the beautiful church of MEYSEYHAMPTON, Gloucestershire, three windows have lately been opened in the south Transept, and it is now proposed by the Rector to aid a fund for future improvements by the sale of some additional copies of the plate of the magnificent sedilia in his church as restored by his family, given in No. IV. of the "Monumental Brasses."

While we write, a circular has been issued announcing the contemplated restoration of S. BOTOLPH's church, Cambridge, if the sum of about £400 can be raised in the parish or elsewhere for the purpose.

It is proposed we believe to remove the coating of rough-cast from the exterior; although, as the masonry appears to be composed of rubble mixed with flint and clunch, there is little doubt that this is the original covering, which is perhaps not more unsightly than the bare rude stone-work is likely to prove. The Tower is Perpendicular, of late and rather singular character. The western door and the Nave piers are Decorated; but we are unable to discover traces of any work earlier than the fourteenth century. The church contains a good and perfect rood-screen, but is not remarkable for any peculiar beauty or architectural interest in other respects. There is however much room for improvement both in external appearance and interior arrangement; and we heartily wish well to this as to every new evidence of the spirit of church-building and church-restoration at present so prevalent in Cambridge.

The church of SWAFFHAM BULBECK, in this county, is under repair, and the works are said to be conducted with much taste and propriety of feeling.

A very beautiful eagle-desk has just been put up in the Chapel of S. JOHN'S COLLEGE, the gift of one of the Fellows of that society, and a valued member of ours, now far distant. The pedestal is copied from that of the lectern in Ramsey church, Hunts; the finials, which are there wanting, being restored, (see Glossary of Architecture). The plumage of the eagle is particularly deserving of commendation, and the execution of the whole does great credit to Mr. Sidey, of London, the founder. It bears the simple expression—

> In usum Sacelli Coll. Div. Johann. ap.
> Cant. dicavit unus e Sociis. A.S. MDCCXL.

The ancient and very curious church at GREENSTED, Essex, well known as having its Nave built of logs of wood, is also in course of restoration. The pews are to be entirely removed, and a better porch to be substituted for the present mean erection. The Cambridge Camden Society has given a grant in encouragement of so interesting a work, and would willingly press this object on the attention of Ecclesiologists.

S. Sepulchre's Church.—A small doorway has been discovered in the wall on the north side of the Altar. Though at present in the inside, it appears originally to have been an entrance from the outside of the church, as far as we can judge from the fact of its having had a bold square hood moulding, and from the clunch of which it is composed and the masonry of the wall on each side of it, being much more decayed and discoloured than is usual in interior work executed in this material. This door appears to have been the entrance to a descent, of how great a depth it cannot at present be ascertained, as the floor, cieling, and back are blocked with brickwork of not very ancient date, so that at present there is only room for two persons to stand within.

The lid of an ancient coped coffin, with a floriated cross sculptured on the surface, has been removed from this brickwork: and the end of what appears to be another is visible. In opening the doorway several fragments of Norman mouldings, capitals, &c. were found.

From this circumstance, and from the very curious Chancel-arch, which we have mentioned in a former number, having been recovered from a part of the Tudor structure, it seems fair to infer that when the latter was erected, probably about the time of Henry VII., a much larger portion of the old Norman edifice then existed, and was removed to make room for the new Chancel and north Aisle. The present north wall of the Chancel, which opens by a large Tudor arch into the north Aisle, exhibits portions of three different dates; part of the wall being Norman, as is evident by a portion of a string-course precisely similar to that which runs under the windows of the circular Aisle; part Early-English, as appears by the base mouldings of an engaged octagonal shaft, upon which the western shaft of the last-mentioned Tudor arch rests; and part, including the newly discovered doorway toward the east, of Tudor date. It is extremely difficult even to conjecture the original form of the Chancel or Apse which extended to the east of the circular portion of the church. The bearing however of the building appears to have been to the north-east, not only from the fact already mentioned of the southern face of the present north wall of the Chancel having been apparently *external*, but from no remains whatever having been discovered in digging to the depth of eight feet on the south side for the foundation of the new Aisle, and from a considerable quantity of moulded fragments having been found, on clearing away the earth, built into the north wall of the north Aisle below the earth-line, which must have belonged to a former building not, apparently, to the south, and therefore probably to the north side. To this may be added the fact that, in the cellar of a house standing not thirty yards to the north-east of the church, there are traces of ancient walls and arches, now blocked and much altered in form and appearance, but connected, according to a local tradition, with a passage or crypt belonging to the church. Hence we are inclined to surmise that the descent by the newly discovered doorway *may* have communicated with some such subterranean apartment; and it would be extremely interesting, were it practicable, to prosecute discoveries in this direction.

With respect to the progress of the works, the whole interior of the circular Tower from the crown of the vault to the pier-arches, has been entirely restored. The coatings of whitewash and paint have been removed, the joints carefully pointed with the hardest cement, the surface of the original stone-work smoothed and dressed, and the much mutilated capitals and arches of the unique and beautiful triforia very skilfully repaired. Much of the same work yet remains to be done to the main piers and arches; the former having been mercilessly cut and broken for the insertion of pews, which will henceforth be for ever banished from this fine old church. A beautiful stained window, the munificent gift of Mr. Williment, has arrived, and been placed in the east clerestory window. May it not be hoped that the remaining seven will be similarly adorned by the devotion of persons interested in the restoration, and zealous for the honour of the Church?

CORRESPONDENCE.

OPEN SEATS *versus* PEWS.

To the Editor of the Ecclesiologist.

MR. EDITOR,—I never was so fully convinced of the justice and reasonableness of the irreconcileable war waged by the Cambridge Camden Society against pews as I was a few Sundays ago, when it was my lot to do duty in a certain village church. Upon turning round, at the Altar, to pronounce the offertory sentences, I could not see a single person, except the clerk, who was standing close by. The thought occurred to me that I was about to officiate to "a beggarly account of empty boxes." The fact was that the pews on each side of the Chancel-arch were so high as effectually to conceal, not only those who were impounded in them, but also every individual in the open seats beyond: and I afterwards found that there were about thirty persons thus lost to sight. Had all the seats been open ones, this could not have happened. Other advantages of open seats are these: they exhibit the piers in their whole length, and therefore in their proper proportions, as they also do the arches, and indeed the whole height of the edifice: they bring the whole congregation within the sight of the minister: and they moreover induce a more devotional posture of the body, and greater activity of mind in the service; they substitute kneeling for sitting, sitting for lolling, wakefulness for sleepiness. It is remarkable that even ladies will sit at a concert or a play for a much longer time than is taken up in the longest church service, upon benches without cushions and without backs, and yet complain neither of fatigue nor inconvenience. Why cannot the spine perform its natural office of support as well in a place of worship as in a place of amusement?

In the open seats of the poor a length of stuffed matting should be provided for the convenience and comfort of kneeling. Pews are the ugly offspring of two ugly parents, Pride and Luxury; and both parents and offspring, in a place dedicated to the worship of GOD, are insufferable. Your obedient Servant,

CLERICUS.

To the Editor of the Ecclesiologist.

MR. EDITOR,—A mistake has been pointed out to me in the *History of Pews*, which I am anxious to correct. I had said (p. 50) that the Abbey church at Bath was pewed and galleried in 1840 : and the sentence implied (which was indeed my own impression) that it was not so before. On both these points it appears that I was mistaken. The present pews and galleries were erected in 1834; and their previous arrangement is said to have been much worse than the present.

My statement as to the date was founded on inquiries made for me by friends living on the spot; and it seems that some importance has been attached to the difference of six years between the real and the asserted re-arrangement, because the church has, during that period,

changed its patronage. The statement therefore looked like a design to impute the supposed deterioration of its arrangements to its present management. This was not in my thoughts: I only complained, as I do still, that in our own day (whether in 1840 or 1834 made no difference in the argument) this act of barbarism was committed.

I have no doubt those who so altered the church thought it an *improvement;* and as little doubt that they would now, if they could, undo their own work. Three parts of that noble church, the Nave and Transepts, are not used : the Choir has very high pews, (with, I believe, locks,) and galleries; the pulpit and reading-pew stand with their backs to, though not immediately in front of, the Altar; the old Jacobean Font, in the south Transept, is not used, except, as when I saw it, to hold rubbish. That which now serves for the Font (contrary to the Canon) is a wooden stem, which I take for granted, when used, supports a Wedgewood basin. When not wanted, it is put away between the reading-pew and the pulpit : and when wanted it is set in front (again contrary to the Canon) of the Altar-rails. This is what induced me to say that the church had become like a conventicle.

I am credibly informed that many of the congregation, on passing from the Choir into the Nave,* put on their hats.

It is but fair to state that the pews and galleries are of oak, and some of the details not bad. But the panelling of a gallery front or *Bishop's pue* (so it is called) with Gothick tracery, I think you will agree with me in pronouncing intolerable.

I remain, Sir, your obedient Servant,

THE WRITER OF THE HISTORY OF PEWS.

* That this is not a solitary instance of such irreverence, the following letter on S. Saviour's, Southwark, will tend to prove.—ED.

To the Editor of the Ecclesiologist.

SIR,—The account given in one of your late numbers of the barbarisms which have been perpetrated in the church of S. Saviour's, Southwark, falls I fear short of the truth. But it is to the consequences of such remorseless proceedings that I wish to call your attention. The Nave has, as you are aware, been blocked off from the Choir, and the latter is not used for service. On paying it a visit a few days ago, judge of my surprise on finding that of several visitors who were admiring the wonderful Reredos, none thought of uncovering their heads, although standing in the Choir; that token of reverence was reserved till they entered by the cheap wooden staircase into the miserable modern Nave. Surely this profanity cannot be known to the guardians of the fabrick.

I am, yours, &c. VIATOR.

May 17, 1842.

INSCRIPTIONS ON BELLS.

To the Editor of the Ecclesiologist.

SIR,—Attention has been directed to inscriptions on bells, and they are so far useful that where the oldest remains it will often be found to give the dedication of the church. In two adjoining parishes, as well as in all I have examined, I have found it so. In one the church was known to be dedicated to S. Mary, and on the bell was *Sancta Maria ora pro nobis.* In another to S. Mary Magdalene, and there was *Sancta Maria Magdalene, &c.*

Whilst restoring a Decorated east window of considerable beauty in the Chancel of Ringshall, Suffolk, it struck me that I had before seen one of the small heads at the termination of the dripstone. I supposed that the Decorated style commenced in the early part of the reign of Edward II., and was aware that the tithes of the parish were given to Thetford Priory by a lord of the manor, whose family first presented a rector in 1318. I have since found the head to which I saw the resemblance on the dripstone, Edward II. The features and the peculiar waving of the hair, extending below the chin, are precisely the same as represented on Edward's tomb in Gloucester Cathedral. On the north end of the dripstone is a head with a cap. I find that John Salmon was Bishop of Norwich from 1299 to 1325, and Lord Chancellor from 1319; but here there are no means of comparison.

Your obedient servant,

C. F. P.

April 14, 1842.

INSTRUCTIONS OF THE INCORPORATED SOCIETY FOR PROMOTING THE ENLARGEMENT, BUILDING, AND REPAIRING OF CHURCHES AND CHAPELS.

WE had been furnished with some remarks on the "Suggestions and Instructions," &c. as lately revised; but we feel it to be the most proper and respectful course to confine ourselves to printing the Instructions at length in our next number; both as containing an almost unexceptionable guide to church-builders, who may desire to erect new churches in conformity with ancient usage as to materials, construction, and arrangement; and as throwing light on the views which have been advocated in the *Ecclesiologist* and other publications of our Society.

A correspondent, "Πρεσβύτερος," has requested our opinion upon the propriety of allowing ivy to grow upon churches. We certainly hold that ivy mantling the grey walls of an ancient church much enhances its picturesque and venerable appearance; and we think we could name more than one new church, which would look none the worse for being completely hid by a bushy covering of this convenient evergreen. There is no doubt however that ivy, if allowed to grow old without being duly trimmed and attended to, will eventually cause much mischief by insinuating itself between the stones and dislodging them; for though in old ruins the loose masonry often

appears to be cramped and bound together by this plant, it was probably the very same cause that originally loosened them. We recommend those who wish to plant ivy against church walls, to take care that every part which it is intended to cover be previously pointed up with hard cement; for by this means the plant, unable to penetrate, will climb harmlessly up the surface of the walls, from which it can readily be detached if necessary. We believe that the common prejudice against ivy on the ground of its making churches damp is quite unfounded, and that it has in reality rather a contrary effect. This however is not the case when it begins to climb the roof, at which point its progress should always be stopped, as it not only prevents the rain from running clear off, but is sure to penetrate tiles or slates, however closely they may be laid, and find its way into the interior of the church. At Castle Bytham, Lincolnshire, we have seen ivy hanging down in festoons from the cieling nearly to the floor of the Chancel. But if the progress of ivy be carefully watched, and any appearance of its penetrating the walls or roof be promptly met with the proper preventive measures, namely, cutting the plant and securely stopping the crevices, we do not think that there is any strong objection against allowing it to grow upon churches, especially upon towers, where it is at once more beautiful and less liable to do harm than in any other position.

TO CORRESPONDENTS.

WE have received a letter from Mr. Elliott, the architect of Christ Church, Worthing, containing some strictures upon our review of his design in our fifth Number. We are certainly not disposed to alter our opinion upon the singularly unsightly arrangement of the timbers which compose the open roof: nor can we admit (if the engraving be correct) that the trusses are legitimately connected by a series of thin horizontal timbers in place of purlins. "Common rafters" we had always thought were timbers laid in a vertical, and not a horizontal, direction. The Transepts certainly appear better proportioned in the ground-plan than in the engraving; but the shortness of the Chancel much injures their effect. As to the roofs of the Transepts, the ridges should have ranged with that of the Nave; indeed the general arrangement of the Transepts is altogether wrong. The lancets certainly *appear* in the engraving to be too short and wide, whatever their real size may be; and we think that a string should have run beneath them even in a flint church, especially as quoins and dressings are abundantly used. With respect to the battlements on the Tower, we beg to state our belief that battlements are always later additions on Early-English Towers; and we do not believe that there is a Tower of this date existing that has not, or had not, or at least was not designed to have, a spire. The Tower in this design is of Perpendicular character with Early-English details. And the string-course under the battlements is decidedly wrong, as a closer inspection of the Tower of Chichester Cathedral will, we think, convince Mr. Elliott. Lastly, the clerestory, if 2ft. 6in. high, is wrongly represented in the lithographed view: though a clerestory of such scanty size, without windows of any kind, and propped upon iron pillars, is altogether inconsistent with the principles of correct church-building.

The Ecclesiologist.—Twelve sheets are published yearly, and sent post-free on remitting *five shillings* (by post-office order or otherwise) to the publisher, Mr. Stevenson.

[Second Edition.]

Published by T. STEVENSON, *Cambridge;* J. H. PARKER, *Oxford;* RIVINGTONS, *London.*—*Price* 4d.

METCALFE AND PALMER, PRINTERS, CAMBRIDGE.

THE

ECCLESIOLOGIST

PUBLISHED BY THE CAMBRIDGE CAMDEN SOCIETY.

"Bonec templa refeceris"

Nos. X. XI. JULY, 1842.

NOTICE.

THE Secretaries of the Cambridge Camden Society take this opportunity of announcing to the Members that the Report for 1842 is now published. Each Member is entitled to one copy gratuitously, which may be obtained upon application to any of the Society's Publishers.

They are instructed also to invite such Members as have not already done so to forward their names to Mr. Stevenson as subscribers to the *Ecclesiologist*; it being only by means of this periodical that the Committee can keep up a continual communication with the distant members of the Society. Persons subscribing for the present year will receive, by post, the back numbers immediately, and the future numbers as they appear. The subscriptions of some of the present Subscribers have not yet been received by the Publisher.

Notice has already been given that the First Number of the *Illustrations of Monumental Brasses* is out of print. Many applications having been made for complete sets, and many of the present Subscribers having expressed a wish that the First Number should be republished in a style more suitable to the later parts, it is intended to reprint the Number with new plates, so soon as a sufficient number of Subscribers is obtained. Names are received at the Publisher's.

THE PRACTICAL STUDY OF ANCIENT MODELS.

IN reply to several applications for advice upon the best method of obtaining an accurate acquaintance with architectural details, and more particularly to some very gratifying communications from persons actually employed in the execution of church-work, we beg to recommend with great urgency a careful observation of existing models. So soon as a student has obtained, from any of the many

useful elementary works on Architecture, a general idea of the distinction of styles and periods, let him at once test his knowledge by practical observation. Practice in this, as in every science, is the surest method of advancement: and happily in this no bad effects can follow from the inexperienced attempts of the beginner. Our first Church-scheme may contain many faults and imperfections; but no mischief can ensue unless we think overmuch of ourselves, and presume at once to assign new dates and to dispute authorities. But every succeeding trial finds the eye of the Ecclesiologist more versed and critical, his judgement more confirmed and accurate, and his description more terse, yet far more circumstantial. It is in the facility afforded for a methodized and minute examination that the great value of our Church-schemes has been practically found to consist. There is probably not any locality, except the metropolis, which does not afford ready opportunities for following this plan. Indeed any one church will be enough to occupy many days' careful investigation, in the way pointed out in an article in our sixth Number. But to the builder, or mason, or carver, whom we are now chiefly addressing, the study of ancient models is yet more valuable than to unpractical men. As the sculptor and painter devote themselves with the utmost diligence to examine and copy the works of their predecessors, so let our own workmen. The advantages thus gained by the former will also be, and indeed have been, the reward of the latter. We could specify several artists who have arrived at great excellence and purity of workmanship, solely by a careful attention to the models by which they are surrounded. The success which has been obtained of late in several departments of church-decoration, and, as a remarkable illustration, in the art of engraving on brass, revived by Mr. Pugin at Birmingham, proves satisfactorily that there need be no want of skill amongst our workmen to imitate the decorative work of our ancestors. In the art of wood-carving, and the traditional excellence of certain Cathedral cities in this particular, most of our readers will see an exemplification of what we mean. These schools have been formed by the habit of studying ancient remains which an experienced architect has rendered compulsory on his workmen. An individual may to a certain extent secure this advantage by carefully examining, in the way we recommend, the churches in his neighbourhood; but we must see a kind of Freemasonry revived, before we can recover the amount of skill which distinguished the church-builders of former days. Why should not every Cathedral be made a school of art in these and other departments? There must always be in each of them, besides excellent examples to copy, a superintending architect, a clerk of the works, and a body of workmen; the very germs for such a system as we should wish to see established. However, to such of our fellow-labourers as we are now addressing we offer, if not the advantages of such combined action as these schools might afford, yet every encouragement to individual study of the same rudiments. By examining, drawing, measuring mouldings and details, by comparing the obvious excellence of ancient work with the equally obvious defects of modern, their taste will be

corrected, and both their eye and hand improved. The minute points of contrast are too varied and technical for notice here: let one instance suffice. In a restoration lately effected by the Cambridge Camden Society, a beautiful piece of decayed stone-carving was to be restored. The managing workman was complimented by the writer upon the boldness and freshness which he had given to a delicate piece of foliage. "Why, sir," he replied, "I don't like the flower to look as if it had been *ironed out.*" Now does not this answer give a clue to the reason of much that we deplore in the lifeless, hungry, mean appearance of modern church-work? Not content with casting ornaments at once in iron, or cement-stone, or even wood, we make even our real work in each material like the wretched mechanical imitation.

An incidental but great advantage which would be gained by the direction of our workmen's attention to the ancient examples in their neighbourhood would be the retention and perpetuation of those local peculiarities observable in particular districts, which give so much *character* to the churches in which they are found; and which it is right to preserve, as well for the value of all those material developments in which the deep and clearsighted wisdom of our thoughtful ancestors was wont to express itself, as for their inherent beauty and the endless variety they afford in the details of architecture.

It is the more necessary to insist on this *practical* course, because so few think of it. We are a reading age, and people expect to learn every thing at home from books. We do not undervalue books : there are many of extreme value to the ecclesiologist; and amongst those architectural works which exhibit elevations and details scientifically drawn with accurate sections and admeasurements, perhaps none are more valuable than the views of Stanton Harcourt and Littlemore churches, published by our sister Society of Oxford. But we must first learn by sight : afterwards we may extend our researches and begin to classify our knowledge by means of books. To the workman books will be of less value than to others. His own collection of working-drawings selected from his neighbourhood must be at least his first book. His part in the great work of church-building is to follow rather than to lead; and his labour should be directed accordingly. What he wants for this will be a perfect knowledge of his art, with an anxious endeavour to execute his prescribed task with all the skill and taste that careful study will give him; but above all the consciousness that he is engaged in a good work, a sense that he is working for GOD'S honour and not only for man, together with that holiness of life and thought which, while it is necessary for all their fellow-workers in their several degrees, is to none more becoming than to those in whose occupation HE, Whose House they are adorning, did not disdain while on earth to employ His Sacred Hands.

INCORPORATED SOCIETY FOR PROMOTING THE ENLARGEMENT, BUILDING, AND REPAIRING OF CHURCHES AND CHAPELS.

SUGGESTIONS AND INSTRUCTIONS.

(As amended, May 1842.)

1. *Site.*—Central, with regard to the population to be provided for; dry; if possible, rather elevated, but not on a high or a steep hill;—not near nuisances, such as steam-engines, shafts of mines, noisy trades, or offensive manufactories:—accessible by foot and carriage-ways, but not so near to principal thoroughfares, as to subject the service of the Church to the danger of being incommoded by noise. The building to stand east and west as nearly as possible.

2. *Style and Form.*—No style seems more generally suitable for an English Church than the Gothic of our own country, as developed in its successive periods. The Norman (or Romanesque) style is also suitable, and offers peculiar advantages under certain circumstances, especially when the material is brick. The Society earnestly recommend that, in the proportions and great features, as well as in the details, good ancient examples should be closely followed.

For Gothic *Churches*, the best form is either the cross, consisting of a nave, transepts, and chancel, or the double rectangle, composed of a nave, with or without side aisles, and of a chancel. In a *Chapel*, the single rectangle is also suitable; the length being *at least* twice as great as the breadth. If the funds do not suffice to complete satisfactorily a design, otherwise eligible; or if the circumstances of the neighbourhood render it probable that, at no great distance of time, the building may be enlarged; it is better to leave a part of the original design, as, for example, side aisles or transepts, to a future period, than to attempt the completion of the whole design at once in an inferior manner. In such a case the temporary walls and fillings up of arches should be so built, as clearly to show that they are temporary, and that the building is incomplete, but at the same time not without due regard to ecclesiastical propriety.

3. *Foundation.*—To be surrounded, if requisite, by good covered drains. If the soil wants firmness, the walls may often be better secured from partial settlements by spreading the footing on each side, than by deepening the foundation, or resorting to more expensive works.

In all irregular or doubtful soils, concrete is recommended for the foundations, in preference to any other material.

No interment should be permitted under a Church, except in arched vaults properly constructed at the time of building the Church, with entrances from the outside only; nor should any graves be made within twenty feet of the external wall.

4. *Area.*—It would tend much to the preservation of Churches, and render them more dry, if a paved open area, not less than eighteen inches wide, were made round them, and sunk six or eight inches below the level of the ground about the Church, with a drain from the area to carry off the water.—Or the same objects might be

attained either by turning a segmental arch from the wall outside the footing, or by bedding in the wall a course of slate in cement.

5. *Basement.*—The inequalities of the ground, the dampness of the soil, &c. often render it desirable to have crypts under a Church. They should be of a massive construction, turned upon semicircular or segmental arches, resembling the early examples, entered only from without.

6. *Floor.*—To *sittings*, wood: to open spaces, or chancel, stone or encaustic tiles.—If not undervaulted, it may be freed from damp by brick rubble, flints, ashes, or furnace slack, laid to the depth of twelve or eighteen inches under the floor.—Allowance should also be made for the future rise of the surrounding burial ground; the floors of many Churches, originally above ground, are at this day many feet below the surface, and have thereby become damp and unwholesome. It is desirable that the Church floor should be raised at least three steps above the ground line.

The distance between the joists of the floor should never exceed twelve inches.

All wood floors should be supported on walls, with a clear space of eighteen inches in depth, well ventilated beneath.

No American timber to be used either in the floors or any other part of the building.

Flagged floors should be laid on cross walls eighteen inches high.

7. *Walls.*—To be solidly constructed of stone, either squared, or rubble, or flint; or of brick, where no good stone can be procured without great additional expense. If the walls are of brick, cased with stone or flint, the stone or flint to be *well bonded* into the brick. As a general rule the thickness must *not be less than* as follows:—

	Square Stone of the best quality, or Brick.	Brick, faced with Flint or Stone.	Inferior Stone, Flint, or Rubble.
	ft. in.	ft. in.	ft. in.
If less than twenty feet high, and carrying a roof not exceeding twenty feet span.	1 10½	2 0	2 3
If twenty feet or more high, or carrying a roof exceeding twenty feet span.	2 3	2 5	2 6
If more than thirty feet high	2 7½	2 9	3 0

The above dimensions are given on the supposition, that there are buttresses, of solidity and form suitable to the style adopted, placed opposite the trusses or principals of the roof: where there are no buttresses the thickness of the walls must be considerably greater.

No cement or plastering of any kind to be used as a facing of the walls, or of any external part of a Church or Chapel.

If a wall be built with two faces of stone, filled between with rubble, great care must be taken that they be properly *bonded together*, as the wall will otherwise not stand a partial settlement. Where good stone is scarce, a thickness, otherwise perhaps unattainable, may be secured by this method of construction.

Walls built of flint or rubble should have bonding courses of stone or brick, and stone or brick piers at intervals, approaching at least within four inches of the external face.

Whatever be the material of which the substance of the walls is made, the dressings should, if possible, be invariably of stone. The greatest attention should be paid to the quality of the mortar used.

8. *Roof.*—The best external covering is lead, which should be not less than *seven* pounds to the foot;—or copper of not less than *twenty-two* ounces to the foot. Blue tiles, commonly called Newcastle tiles, or stone tiles, are perhaps the next best covering.—Westmoreland slates are better in colour than those commonly used, but are, in most cases, expensive. All slates to be fixed with *copper nails.*

Flat *ceilings* are inconsistent with Gothic architecture. Next to a stone vaulted roof none has so good an effect internally as an open roof, exhibiting the timbers. It is desirable that this should be of high pitch, the transverse section forming or approaching to the figure of an equilateral triangle.

If a wooden panelled roof be preferred, the panelling should not be made to imitate stone.

In roofs of low pitch and wide span, horizontal tie-beams are necessary; but in other cases, where the Society is satisfied that *due* provision has been made for the safety of the construction without them, they may be dispensed with.

If the distance between the principal trusses exceed ten feet, intermediate trusses must be introduced. The distance between the common rafters should never exceed twelve inches.

Wherever the ends of timbers are lodged in the walls, they should rest in cast-iron shoes or on stone corbels.

9. *Windows.*—In Gothic Churches, where stained glass is not used, the glass should be in small panes, those of a diamond shape being generally preferable.

Hopper casements are recommended, and they should be inserted in almost all the windows, in order to secure due ventilation.

Where lead lights are adopted, copper bands to tie them to the saddle bars are preferable to lead, being less liable to stretch and become loose by the action of the wind.

The very unsightly appearance often occasioned by the wet streaming down the window backs can be prevented by fixing a small copper gutter at the bottom of each lead-light, to receive the moisture produced by condensation, with copper tubes to convey the same to the outside of the building. This has also a tendency to keep the building dry, and to preserve it from decay; or the inside of the sills may be raised an inch an a half.

A good effect will be produced by keeping the sills of windows raised as much as practicable above the line of the tops of the seats.

10. *Tower and Spire.*—The usual place of the Tower, in a Church without transepts, is at the west end; or it may be placed about the middle of the side.—If funds are scanty, it is better to leave this part of the Church to a future period, than to attempt its immediate completion in an inferior manner.

When the Tower contains more bells than one, the timbers of the bell framing or floor should not be inserted into the main walls; but should be supported either on set-offs or on corbels.

11. *Gutters.*—Where necessary, to be *most carefully* constructed to carry off the rain and snow into the perpendicular pipes, which are best of cast iron, cylindrical, and placed an inch or two at least from the wall, so as to admit air and keep it dry.

Dripping eaves projecting very far do not in all cases supersede the necessity of gutters and pipes, even in very sheltered situations ; but in exposed places, eaves-gutters, and rain-water pipes will be absolutely necessary to prevent the wet being driven against the walls, and thus rendering the building damp.

Eaves-gutters may be made of cast-iron ; but, unless very skilfully cast, they will not preserve their level.

The lead for gutters must not be less than eight pounds to the foot.

Lead gutters must not be less than twelve inches wide in the *narrowest* part, with drips at proper intervals; each drip two inches deep at the least, and the fall between the drips not less than one inch and a half in every ten feet.

Outlets to be provided in parapets to carry off the overflowing occasioned by rapid thaws or otherwise.

Drains on the roof should be protected by coverings, as it prevents the melting snow from congealing in the gutter, and thus obstructing the water-course.

Drains should be formed at the feet of all the rain-water pipes.

12. *Ventilation.*—Ventilation cannot be always completely effected by windows alone, without incommoding the congregation. In such cases foul air may be expelled at or near the roof, either by horizontal or perpendicular channels or tubes.

Where there is a ceiling, apertures should be made in it for the proper ventilation of the roof.

All the original provisions for the ventilation of the building must be carefully looked after, and the apertures kept open.

13. *Chimneys.*—If any be required, the utmost care must be taken to render them safe from fire. They should never be brought within eighteen inches of any timber. They should be as unobtrusive as possible, but not disguised under the form of any ornamental feature of the building.

14. *The Lord's Table.*—Should be raised two or more steps above the floor of the chancel, which should be raised a step or two above the floor of the nave. Where the rails do not extend across the chancel, no seats should be allowed between the rails and the north and south walls ; and as much room as possible should be left about the rails for the access of communicants.

15. *Font.*—To be fixed at the west end of the building, or as near as convenient to the principal entrance, but not so as to be under a gallery. Care to be taken that sufficient space is allowed for the sponsors to kneel. The font to be of stone, as directed by the Canon, and large enough to admit of the immersion of infants. To be provided with a water-drain.

16. *Reading-Pew and Pulpit.*—The reading-pew should not be so elevated as to resemble a second pulpit ; and both reading-pew and

pulpit should be so placed as to intercept the view of the east end as little as possible from the body of the Church.

17. *Seats.*—The seats must be so placed as that no part of the congregation may turn their backs upon the altar. There must invariably be an open central passage up the whole length of the Church, from west to east. No square, or round, or double pews can be allowed, and as few pews as may be. Much accommodation is gained by the adoption, instead of pews, of open seats with backs.

The distance from the back of one seat to that of the next must depend in great measure on the height of the backs and the arrangements for kneeling. Where the funds and space admit, convenience will be consulted by adopting a clear width of *three feet*, or even *three feet four inches*; but the width of *two feet six inches* in the clear may be allowed if the back of the seat be not more than *two feet eight inches* in height. This height is in all cases to be preferred, both for convenience and for appearance. If a greater height be adopted, the distance from back to back must not be less than *two feet eleven inches* in the clear. There should not be any projecting capping on the top of the backs. Means for kneeling must in all cases be provided. Hassocks are to be preferred to kneeling boards, especially where the space is narrow.

Twenty inches in length must be allowed for each adult, and *fourteen* for a child. Seats intended exclusively for children may be *twenty-four* inches from back to front.

18. *Galleries.*— None can be permitted in any part of the chancel. Where necessary, they should not enclose the columns against which they rest, so as to break the upright lines of the shafts from the floor to the roof. Wherever placed, they should, as much as possible, be made to appear as adjuncts and appendages to the architectural design of the interior, rather than as essential parts or features of it. The Society will not sanction any plan involving the erection of a gallery, unless in cases where it is distinctly shown that no room is unnecessarily sacrificed, by inconvenient arrangements, on the floor.

19. *Vestry.*—The Vestry should have access to it from without.

20. *Finishings.*—Wall wainscoting, or wood linings to walls, to be avoided wherever convenient. Wood linings to walls confine the damp, and frequently occasion dry-rot. For the same reason cement skirtings are to be preferred to wood; particularly on the ground-floor. Where the linings to the walls are of wood, holes should be perforated under the seats to allow the circulation of air. As it is scarcely possible to prevent rot if any wood is in contact with the walls, the ends of seats next the walls should be omitted, and cement painted, be substituted.

21. *Exciseable and customable Articles.*—Architects are particularly desired to take care that an *accurate account* be kept of the quantities of customable and exciseable articles used, where the expense of enlarging or building a Church or Chapel will amount to £500, or upwards, such as may be duly certified or verified by affidavit.

PETITION TO THE INCORPORATED CHURCH-
BUILDING SOCIETY.

[We have much pleasure in inserting the following document, which our correspondent states to have been forwarded from a parish in this county. We are unwilling for it to be supposed that we object to the assignment of places to regular church-goers. The reasons adduced in the Petition hold against the improper appropriation of seats: the right arrangement is, as the last clause says, the duty of the Church-wardens.—ED.]

" We, the undersigned, being Communicants and other members of the Church at ———, hearing that it is in agitation to petition the Incorporated Society for the Rebuilding and Repairing Churches or Chapels to agree to the appropriation of a certain number of seats in the church, beg, without dictating to the Society, to express a hope that it may not take place; for which we give the following reasons:

1. It appears from late Charges of three Bishops at least, that appropriations of places in churches are illegal.

2. They are inconsistent with the character of the church as a place of *common* worship, and as the House of GOD.

3. They tend to dispossess Christians of their common spiritual privileges.

4. They foster pride and earthly-mindedness in the presence of GOD, and give rise to many bad feelings and consequences.

5. They tend to drive persons from the church, and thereby to promote schism; and to provide for the wealthy at the expense of the poor members of CHRIST's Body.

We further request that the Incorporated Society will take into consideration that we are the whole of the regular Communicants, and all the other regular attendants, except two or three persons, at the church in this parish: and that we are as strongly averse to any appropriation for ourselves, as for others.

That the only persons who desire any appropriation for themselves, are non-Communicants, irregular attendants, or dissenters.

That it would be impossible, from the limited extent of the church, to make appropriations for all who might put in their claim.

That the Churchwardens, in this as in all other cases, have it in their power by virtue of their office to arrange the manner according to which Parishioners shall be placed at church."

REVIEW.

A Handbook for Westminster Abbey. London: G. BELL.

A GUIDEBOOK might be made the instrument of instilling good principles, and affording useful and improving information, less objectionably than any other class of writings. It finds its reader for the most part in the happiest temper, determined to enjoy himself, ready to believe every thing, and unwilling to criticise any thing with even the

least severity. It is therefore with great satisfaction that we hail the appearance of the present volume, as a token of great improvement in this particular. Its pages are not disfigured by the usual " guide-book" sentimentality, rambling on without method, and mixing in-accurate, if not false, information with indiscriminate and nauseating praise: but it gives a well-arranged and correct description, neither too popular nor too pedantic, of the sacred edifice, pointing out very judiciously the more remarkable portions, and leading the reader to appreciate for himself the extreme beauty and harmony of the whole. The style also breathes a degree of good humour attempered by a feel-ing of reverence, which seems much what we should desire, and which suits well the assumed name of the Editor, *Felix Summerly.*

We are sorry however to be compelled to notice some points in the work before us with animadversion. One of the most prominent of these is the flippant tone adopted throughout, and particularly in the prefatory matter, with reference to our Church before the Reformation. The builders of these glorious fanes, our own ancestors, deserve from us at least gratitude for what they have left us, at least admiration for their zeal and skill so much superior to our own, at least pity for the fewer advantages which it was given them to enjoy as compared with ourselves. We will not particularize instances; but we must protest strongly against the scoffing language used generally (*ex. gr.* pp. 7 and 111) about reliques. To introduce irrelevantly a painful catalogue of reliques once venerated, is in as bad taste as it is wrong. There is more offence to piety in our holding up such things, however extra-vagant and false some of them may have been, to the hollow ridicule of the ignorant and indiscriminating, than there was excess of it in the simple and earnest (though sadly misdirected) faith with which they were formerly regarded. We hope also that few will sympathise with the writer in his jokes upon the reputed miracles of S. Edward the Confessor; no right-minded person would consider such matters a fit subject of *ridicule.*

On page 11 are some very just remarks on the exterior appearance of the Abbey, showing how little a great open space is required for the full effect of a pointed building, and explaining the beauty and value of the proximity of S. Margaret's church, " long in danger of being removed" on this very score. We are glad that the writer calls atten-tion to the ludicrous incongruity of Sir Christopher Wren's western Towers, and their clock-holes; and cannot refrain from quoting the same architect's opinion of the six buttresses which span the north side of the cloister and abut on the south Aisle of the Abbey; " a dangerous attempt," he says, " to flatter the humour of the monks who would have a cloister,—the work of a bold but ignorant architect."

We should have hoped that this writer would not have fallen into the custom of speaking of 'middle aisle' and ' side aisle;' and he is perhaps writing above himself when discussing *ideal* and *material* art in p. 61. The remarks upon stained glass however are good, and those upon modern monuments extremely judicious. The latter must have, we think, an excellent effect on the readers of the Handbook,

in teaching them to qualify their admiration of those strange assemblages of Pagan costume and heathen symbolism which now disgrace the Abbey. We hope Mr. Markland's book on this subject may obtain a very wide circulation. We must here add our commendation of Sir R. Westmacott's recumbent effigy of the Duc de Montpensier, though it still falls very short of those monuments which ought to be his patterns.* The writer expresses a wish, with which we cordially agree, that the triforia might be made accessible to visitors "even though another threepenny fee should be necessary." It is indeed a sad privation to the lovers of architecture. We cannot, however, join in the recommendation of musical festivals. "The crowd collected, without a single advertisement, at the last thrilling performance of Tallis's Service," rather makes us reflect on the sad cause that the ordinary services are so unworthily performed and so scantily attended. The present pewed state of the Choir receives, as it deserves, the author's execration. Indeed to our own minds there is nothing so saddening as a visit to Westminster Abbey. There is an incubus over every thing: the fees, the incivility of vergers, the hurrying round in a mixed and incongruous party, the longing after a moment's glance at beauties, which are either entirely concealed from one, or from which one is heartlessly driven; the scoffs and jests which one is compelled to hear from the party to which, like the victims of the Italian tyrant, one is bound; the impossibility of seeing or conceiving the pile as a whole; the ever-present feeling of iron gates and threepenny fees; all these, together with the barbarisms of the modern monuments and the paltriness of the modern ornaments, make a whole of extreme wretchedness. The author is particular on the subject of fees. "Thanks to the liberality of the present Dean and Chapter, *the tribute* for seeing the other parts is reduced to sixpence," &c. (p. 2.) Again: "A sum of threepence, paid at the *iron gates* of the south Aisle of the Nave, gives admission to the Nave and north Transepts. Another payment of threepence, made at the southern ambulatory, provided you have been in the Nave (if not, sixpence) passes you to the Chapels. Take care that the first sum be paid at the south Aisle of the Nave"! (p. 49.) Again: "Passing through iron gates of an unsuitable character, which part off the south ambulatory from the south Transept, you pay down, *on the tomb of Henry the Third's children*, the entrance fee to the Chapels"! This is most painful. The author mentions (p. 79) that the canopy of the tomb of John of Eltham was in the collection of Strawberry-Hill. We know not whether it has come back to its rightful place. Were we to give a list of ornaments and brasses thus sacrilegiously stolen, often by distinguished persons, we should scarcely be credited. There was in the same incongruous collection a shrine of the same style, and probably executed by the same artist, as that of S. Edward the Con-

* We are glad to see the testimony of Flaxman to the excellence of the ancient high-tombs quoted at page 72, and Washington Irving's opinion at page 80. We could easily be more severe than the text on the startling absurdity of the colossal statue of Watt in S. Paul's Chapel, p. 94.

fessor. It might well have served as a pattern for the restoration of the latter.

There are other points in the book before us which might have been mentioned: but we conclude with noticing the careful and valuable Indexes, and the extreme beauty of the wood-cuts, all executed by female artists. Those at pp. 19, 87, 93, and particularly at pp. 59, 75, 96, 97, and 109, are truly excellent. We earnestly hope to see a second, *and improved,* edition of this little Handbook.

OXFORD ARCHITECTURAL SOCIETY.

A MEETING was held on Wednesday, May 25, at the Society's Room; the Rev. the Master of University College in the chair. The following members were admitted:—

Rev. F. S. Gawthern, M.A., Exeter College.
T. L. Knowles, Esq., Pembroke College.
Rev. I. Chandler, Corpus Christi College.
Rev. F. Goddard, Brasenose College.
Henry Jessard Hannam, Esq., Buscot, Dorchester, Oxon.
Joseph Neeld, Esq., M.P., Grittleton House, near Chippenham, Wilts.
G. H. Vansittart, Esq., Balliol College.
Rev. E. B. Pusey, D.D., Canon of Christ Church.
Rev. W. Jelf, D.D., Canon of Christ Church.
Rev. John Parker, M.A., Oriel College; Sweeny Hall, Oswestry.

Presents received.—A short account of Studley Priory, Oxfordshire, with Etchings of the Remains of the Monastic Buildings discovered at Studley, by Sir Alexander Croke, etched by himself; also a few other etchings of churches, &c.; presented by Sir Alexander Croke.

Design for the restoration of the Gatehouse at Rye, the intended scene of the Rye House Plot, by Joseph Clarke, Esq., architect.

Engraving of the Chapel now building at Arley, in the Decorated Gothick style, with a copy of the inscription on the first stone, by A. Salvin, Esq., architect.

A rubbing of a Brass in S. Peter's church, Bristol, by H. N. Ellacombe, Esq., Oriel College.

A collection of rubbings of Brasses, by Henry Addington, Esq., Lincoln College.

A paper was read by Mr. Addington on the History of Monumental Brasses, with a description of the principal characteristics of each successive period. This paper was illustrated by a chronological series of the impressions of Brasses, from the earliest known example in England, Sir Roger de Trumpington, in Trumpington church, near Cambridge, A.D. 1289, down to the time of the Commonwealth. The series included a very interesting variety of the costumes of each period, Bishops, Priests, Merchants, Warriors, and Ladies, each as they appeared in life in the dress peculiar to their age, represented with a fidelity which perhaps no other mode of illustration possesses in an equal degree. After the conclusion of the paper, some observations were made by Dr. Buckland on the best mode of perpetuating inscriptions by cutting them deep in stone, instead of raising the letter or trusting to any metal inserted. The Chairman men-

tioned a very fine Brass at Newark, and other members mentioned various circumstances relating to Brasses and other sepulchral memorials.

CORRESPONDENCE.

MODERN ROMANESQUE.
To the Editor of the Ecclesiologist.

MR. EDITOR,—Your remarks on Mr. Petit's recommendation of Foreign Church Architecture, have led me to trouble you with a paper I was induced to write some months since, but which at that time I had no means of making publick, on hearing that the new church at Streatham had been spoken of with approbation by high authority. The subject is daily becoming more serious. Streatham church does not now stand alone: a highly ornamented church in a similar style (with the Altar at the west end) is now erecting at Wilton; and I have heard only to-day that the parish church of Hampstead is to be rebuilt, or nearly so, with a lofty Venetian Campanile, and with the domes and minarets of the Grecian Basilica or the Turkish Mosque.

I am, Mr. Editor, your constant reader,
April 12th, 1842. ANGLICANUS.

ONE who takes a deep interest in the revival of our national Christian Architecture cannot refrain from expressing his regret at hearing that the sanction of high Ecclesiastical authority should have been given to the introduction of foreign styles of Church Architecture, essentially discordant with our national feelings and associations, and which were designed for a totally different country and climate.

To liberate our Architecture from its present state of degradation and confusion, some grand and reasonable principle ought to be laid down and adhered to: and as regards *Church* Architecture, what principle can be so reasonable, as that the styles which have emanated directly from the Christian religion, and every feature of which is pregnant with faith, should be invariably adopted for ecclesiastical design, when we find that these styles have, in different countries, been selected by their original inventors, so as to suit the climate, scenery, manners, and national feelings of every part of the Christian world? What principle can be so reasonable as the adoption in each country of its own peculiar and national variety of architecture?

Next to the revival of Pagan Architecture for ecclesiastical purposes, which has disgraced every Christian nation for the last three centuries, the greatest anomaly of modern art is its adoption of those so-called liberal principles, which, repudiating every patriotic and national feeling, view man as a citizen of the world, and consider the architecture of every nation, climate, and religion, as equally deserving of his imitation. It is this principle which has produced the inextricable medley into which our arts have fallen; and hence it arises that our age, unlike any preceding one, possesses no characteristic or vernacular style of architecture.

The writer who, in hopes of doing some service to the publick, now ventures to state his opinions, has long been impressed with the fact, that one great cause of the confusion of modern architecture is the custom of sending students to follow their studies on the Continent before they have had the means of impressing upon their minds any of the great and leading principles of the art which they pursue. The consequence is that they naturally run wild among the varied shades of national style; and not knowing what to imitate, or what to reject, they bring home a medley of heterogeneous ideas, all of which, however unsuitable to their own country, they think superior to the specimens of native architecture which they have neglected. If instead of this they would devote the same time to the careful examination of those buildings which are to be found in every town and village in our own island, and in studying the real principles by which their builders were actuated, and defer their continental tours to some future opportunity when their ideas are more established, they would be enabled to select from foreign specimens just such information as would be of real service, and which would assist them in carrying out the principles of our own architecture. No book, which has for many years been published, has done so much injury as Mr. Hope's work on Architecture, replete as it is with interesting and instructive information. By following out the history of the early Italian, Lombardic, and Byzantine styles, it has given a terrific spur to that love of novelty and eccentricity, which is natural to an enquiring mind when devoid of a true principle on which to base its ideas, and has led to the introduction into England of architectural exotics of every imaginable variety. Every young architect has now his pet style of foreign architecture: one goes to Constantinople, and imports the domes and minarets of the Greek Church and the Turkish Mosque; another introduces the Arabesques of Morocco and Grenada ; a third, the Classico-Gothick style of the Roman Basilica; and a fourth, the early architecture of Lombardy and Venice: all of which are alike unsuited to our climate, and unconnected with our traditions. The two latter styles (from which we have most to fear) are but the crude and undeveloped ideas from which Christian Architecture arose ; and, apart from their unsuitableness to our national feelings, they do not on the ground of their intrinsic merits claim our imitation. They are most valuable as links in the history of art; but even in their own country could hardly be selected as perfect models. In the best times the Gothick Architecture of Italy, though unrivalled in splendour and in execution, has been too much intermixed with classic feeling to be ranked for purity and intrinsic value with the works of more northern countries; and for this reason, though the English Ecclesiastics were in constant communication with Italy, and must have been far better acquainted with its architecture than any modern student can be, we never find that they imitated it, and but seldom that they employed Italian artists: and if those who were deeply imbued with all the true principles of Catholick Architecture, and who saw it as practised in other countries when in the zenith of its beauty, were never led by it to a departure from their own school of design,

why should we, who are surrounded by the noble and truly national works of our own countrymen, neglect them for the study of foreign designs, which the greatest of our native artists knew and deliberately rejected? Several of the architects who have fallen into this error have a good general knowledge of our own national monuments, but appear to be under the impression that a preference for this or that style is the result of individual feeling or caprice, rather than of principle; and are thus led away by every new style which is brought under their notice. The object of the writer is not to throw discredit upon their works, but to point out mistakes, and to invite them to exercise their talents on more legitimate objects. The restoration of our ancient architecture is only in an incipient state; and if the failure of most of the attempts at it has given a distaste for the style, it is owing to the want of energy with which it has been studied: but if those who now waste their time in importing foreign notions would expend their whole strength and attention upon thoroughly working out the principles of our own buildings, even to their materials and mechanical construction, and would only consult foreign specimens by way of elucidation, to fill up those blanks which have been caused by the destruction of the internal decorations, fittings, and moveable ornaments in our own buildings, we might entertain some hopes of regaining the architectural consistencies which we have so long lost. The writer cannot but conclude his remarks in the words of an eminent reviver of Christian Architecture, whose foreign parentage, and whose perfect knowledge of European art, place him beyond the suspicion of prejudice: " Alas, England! how art thou fallen, when thine own " children forget the land of their fathers, and leave thy most beau- " teous works unnoticed and despised, to catch at foreign ideas, " unsuited to their country, and jarring with its national traditions."

GREAT S. MARY'S, CAMBRIDGE.

To the Editor of the Ecclesiologist.

SIR,—It seems reasonable to expect that, as *every* church ought to present such an appearance as may be agreeable to, and as far as possible an exponent of, the doctrines preached within its walls, so an University church will be of such a character as to serve as a model for other churches in this respect.

It has been always held that the principal object in a church is the Altar. This, if we may so speak, is the cynosure of that spiritual heaven represented on earth in the Church. It is also enjoined by the laws of our own Church, that the Lord's Table should be seen by the people, and that the Ten Commandments should be placed at the east end of the church in such a manner as that the congregation may best see and read the same.

What now is the condition of the University church in this respect? Not only can the Altar not be seen, nor the Commandments read, by any who assemble within its walls, but the fact also is that the view of both is intercepted by the gallery which is set apart for the use of the most dignified members of the University.

Further, it may be observed, that the Altar being thus excluded and forgotten, the pulpit, by a natural consequence, finds itself in a position inconsistent with a due reverence to the principal object in the church. It is placed in such a manner that the greater part of the congregation, instead of looking towards the Altar, turn their eyes from it to the pulpit, and the church thus ceases to be a house of prayer in order to become a house of preaching.

It would be difficult to find another church in which the pulpit occupies such a position as this, except one or two where it was either dictated by necessity, or selected for schismatical reasons.

The evils above mentioned would be removed, and much additional beauty given to the building, if the Altar of the church were restored to the view of the congregation, the gallery which intercepts it being removed, and the western gallery being reserved for those who now occupy the one so removed, and their access from the vestry being by the south aisle, the lateral galleries being prolonged, and the pulpit placed towards the north-east or to the south-east of the church.

It may be well to add that the opinions here expressed are entertained by many persons within and without the University. Let it suffice to mention one, a Select Preacher and an Archdeacon, who has thus publickly expressed himself on the subject:

" Unfortunately a Cambridge man may deem himself sanctioned in any license he may choose to indulge in by the strangely anomalous arrangement in S. Mary's, where the Chancel is excluded from view by the seat in which the Heads of Houses and Professors turn their backs on the Lord's Table, where the pulpit stands the central object on which every eye is to be fixt and where every thing betokens, what is in fact the case, that the whole congregation are assembled solely to hear the preacher."— *Archdeacon Hare's Charge*, 1840, p. 55.

I am, Sir, your's, &c.

Τὰ ἀρχαῖα ἔθη κρατείτω.

[We have inserted the above letter from our correspondent, not as approving of all its suggestions, but simply as wishing by every means in our power to call attention to this important subject. Our own impression is, that nothing effectual will be done while any galleries (except one for the organ) are permitted to remain.

Our own plan would be the following: the Chancel to be rebuilt, and fitted up with stalls for the Heads, Doctors, and Professors.

The pulpit to be removed to the north side of the Chancel-arch.

The galleries being removed, the lost space to be made up by throwing out a second north and south Aisle, as at Chichester Cathedral, and (on a smaller scale) in Trumpington church.

The pues to be entirely removed.

But it appears very desirable that accurate information should be obtained as to the position occupied by the Heads of Houses before the present arrangement. We learn from a letter addressed by Mede to Dr. Twisse, (folio edition, lib. IV. page 860,) that in his time it was the custom for the University preachers, on leaving S. Mary's pulpit, to bow towards the Altar, so that the church must have been then very differently arranged.—ED.]

SUPPOSED ANGLO-SAXON REMAINS NEAR BUNGAY, SUFFOLK.

To the Editor of the Ecclesiologist.

SIR,—Whoever has paid the slightest attention to our great national record, the Domesday Book, must be struck with the vast enumeration of churches which at that period existed in the eastern portion of this kingdom. In the county of Norfolk 243 churches are mentioned; and in the returns for Suffolk they amount to 364; while in many other provinces, including even Middlesex, one only is noticed in each. Now, although there are satisfactory grounds for believing that very many churches are omitted by the compilers of Domesday, it cannot be doubted that East-Anglia was, in this particular, remarkably abundant. If I add to this statement, that it is at the present day almost as unusual to meet with a church in these eastern counties unmarked by some feature of the circular architecture, as it is in other districts to find it, it becomes a matter of interest to inquire how far much of this architecture is or is not genuine Saxon. For my own part I entertain no doubt but that very many of our Suffolk churches are, in part at least, of Saxon construction. The coarse masonry, the semi-circular chancels, the round-headed portals, the thick, yet low walls, the narrow loop-holes, like windows placed high in the wall, indicative of the most jealous precaution, and the circular apertures in the towers, splayed both externally and internally—leave ample grounds for believing such to be the fact. But there is one remain to which I would especially draw your attention, and that is the ruinated edifice in the parish of S. Margaret's, South Elmham, locally termed the " Minster." The parish lies about five miles south of the market-town of Bungay, and forms the nucleus of a property originally granted by Sigebert, King of the East Angles, to Felix the Burgundian, his first Christian Bishop, who fixed his See at Dunwich in the year 630. The estate, comprising several parishes, continued to augment the revenues of his successors till the reign of Henry VIII., when it was compulsorily surrendered to that monarch for property of inferior value. The Bishops had early a palace in the parish of S. Margaret's, some ruins of which yet remain: and the "Minster" stands a short quarter-of-a-mile distant, in a square plot of level ground, which measures about an acre and a half. The site is encompassed by a moat, evidently once broad and deep, strengthened by a mound or rampart of earth on the inner side. The ground-plan of the building exhibits a Nave about 72 feet in length by 27 feet in width, to which is attached a Chancel 24 feet in length, terminating in a semicircular Apse. The width of the Chancel is about 2 feet less than that of the Nave. The entire Chancel can be traced most distinctly, though its foundations rise very little above the present level of the earth: but the Nave presents more decided features, the walls springing in every part to a height of nearly 20 feet. Cracks and narrow apertures indicate the original position of the small windows, which were few in number, and placed high in the walls. The only entrance, to the body of the church at least, must have been in the

western front, where a fractured aperture presents itself of considerable width: there were no doorways in the north or south walls. The masonry of the whole structure is of rubble and coarse mortar, rudely but strongly united; and from the appearance of a small portion of the original facing, which may be discerned on the south wall, I should say had never been covered with a coating of cement. But the most remarkable feature of the edifice, and one which unquestionably refers it to a period of very high antiquity, is a partition-wall crossing the Nave from north to south at the distance of 27 feet from the western wall; thus dividing, by two narrow arches and a thick intermediate pier, this portion of the church into two unequal divisions. There are no buttresses, nor any indication of the slightest protuberance in the surface of the walls. There are no dressings or fractured ornaments of wrought stone to be traced;—I believe not a single fragment is discernible.

Such is the "Minster" at South Elmham; and I confess myself visionary enough to ascribe it, from its ecclesiastical locality, its rude architecture, and its Saxon appellation of the Minster, to the piety and munificence of Felix, whose name yet lives in that of the adjoining village of Flixton, once part of his property, and where are to be traced, in the Tower of the church, undoubted Saxon remains. I must add, in corroboration of this opinion, that tradition, whose voice, when consonant to probability and the general tenor of history, is entitled to be heard, asserts that the "Minster" occupies the site of a Pagan temple, which the frequent discovery by the plough of urns filled with burnt bones and ashes seems to confirm. There is no absurdity in supposing that a site dedicated to Wodin or to Thor was purposely selected in early days for the situation of a Christian church; for among the prudential admonitions of S. Gregory to his missionary S. Augustine he especially advises him, as we learn from Venerable Bede, " not to destroy the heathen Temples of the English; but only to remove the images of their gods; to wash the walls with holy water; to erect Altars, and deposit relics in them, and so to convert them into Christian churches, not only to save the expense of building new ones, but that the people might be more easily prevailed on to frequent those places of worship to which they had been accustomed."

How long the "Minster" has been disused as a place of divine worship is unknown; but it must have been desecrated for a very considerable period, as a large oak tree grows from the foundations of the south wall, in size and apparent age rivalling those in the adjacent avenue at the Hall, which were planted there by Bishop Nix in the year 1520.

I am, Sir, your obedient Servant.

ALFRED SUCKLING.

Barsham Rectory, June 7th, 1842.

[As the church of Flixton has been visited by members of our Society, we give here a short extract from the report which they have sent in to us :—

" The Tower is probably Anglo-Saxon. It is built of uncut flints, no quoinings or ashlar dressings being employed in any part. The flints are

laid in horizontal courses, though rudely. The whole appearance of the Tower is extremely rude.

" On each side of the lower part of the Tower is a circular aperture equally splayed inside and out. A stage higher we have on the west a circular-headed window, splayed at the sill, but not in the jambs or arch. In the next stage, on each side, is a circular-headed window, deeply splayed within so as to leave but a small narrow aperture in the external face of the wall. The jambs of these windows are very far from the vertical, inclining towards the arch, and being wider at the bottom. On each side of the belfry is a balustre window. The balustre is a cylinder of equal thickness throughout, and is surmounted by the ordinary Norman cushion capital. The arches and jambs of the windows are made up of rag, flint, and here and there a large smooth pebble. And the outside face of the arch with the part of the soffit adjoining, is coated with rough-cast.

" The actual date of this Tower is uncertain, but the absence of all stone dressings, contrary to the usual way of using flint in the neighourhood, and the circular apertures in the lower stage equally splayed internally and externally, seem to carry us back to a very early period.

" The Chancel of this church is in ruins."

The tripartite division which Mr. Suckling describes in the " Minster," and which Mr. Salvin also finds in the ruined church that he has discovered at Castle-Rising, appears to be quite a note of great earliness of date. The Nave of Daglingworth church in Gloucestershire, where long-and-short masonry is observable at every corner of the building and in a curious north door, is thus divided by an arch thrown across it. So also the well-known church of Brixworth in Northamptonshire, Kilpeck in Herefordshire, Bishopstone in Sussex, and the desecrated church of Yainville, near Jumieges, in Normandy, have also Sanctum Sanctorum, Chancel, and Nave.—Ed.]

ANGLO-SAXON DISCOVERY.

To the Editor of the Ecclesiologist.

Sir,—During a visit to Castle-Rising last week, I discovered in the north embankment of the castle the ruins of a church, which I have reason to believe has not before been recognized, and I therefore trust you will allow me to draw the attention of your readers to so interesting a subject.

These ruins, of which the walls are in some places 10 and 12 feet high and in others only level with the present surface of the earth, consist of a Nave 41 ft. 3 in. long, by 19 ft. 2 in. wide, and the square imposts of an Arch, 9 ft. 1 in. wide, leading to a Chancel 13 ft. 3 in. wide, by 12 ft. 10 in. long, with part of a deeply splayed window on the south side. Another Arch, similar to the former, 9 ft. 10 in. wide, divides the Chancel from an east end of semicircular form, 15 ft. long by 12 ft. 9 in. wide. On the north side of this division is a small window, 5 in. wide splayed back, to 2 ft. 8 in. wide on the inside. The wall on the south side is too much ruined to shew any window, but the east end has a window of the same dimensions filled in with masonry, as are also the arches already described, dividing the edifice into portions probably for the uses of the garrison.

Twelve months since these ruins were covered with earth, forming an

M 2

addition to the internal slope of the embankment: and in further exca-
vations, which Colonel Howard intends having made under his own eye,
it is hoped more of the plan and architectural features may be elucidated.
In the mean time there is good reason to believe these remains are
those of a building of very high antiquity. For it has been founded
within a Roman encampment before the Norman era, as is shewn by
the materials of which the walls are composed, being the stone of the
immediate neighbourhood mixed with Roman bricks, and not those
used by the Normans in the castle and the church of the village; also
by the mound, added to the Roman encampment by the Normans,
having blocked up the windows of the north side and east end; for it
is exceedingly improbable that the church was built against a bank of
earth, and windows made in those parts where they could neither admit
light nor air; and we have further evidence of its antiquity in the great
simplicity of its forms, and in its plan being in three parts, as at the
Minster in Suffolk, (which is also surrounded by an embankment and
ditch,) and others of the very early churches.

<div style="text-align:right">I remain, Sir, yours, &c.,</div>

London, June 20th, 1842. A. SALVIN.

<div style="text-align:center">To the Editor of the Ecclesiologist.</div>

SIR,—I remember to have seen, either in a number of the *Ecclesi-
ologist* or in one of the Society's Tracts, a proposal for giving the name
of the "Plantagenet" style to the Early Perpendicular. The objection
that many Plantagenet sovereigns reigned before its introduction
was overruled by instancing the name "Tudor," to which no one
objects, although it was not used throughout the Tudor period. But
the two cases do not seem quite analogous, for the Tudor style is the
exclusive* style of the Tudor period as far as Gothick was employed;
whereas three previous styles might with equal propriety be denomi-
nated Plantagenet. To say "Plantagenet Perpendicular," as opposed
to "Tudor Perpendicular," would be correct; but to say simply
"Plantagenet style" seems to be very inappropriate. If it is to be
named from a dynasty, would not "Lancastrian" be more correct?
But, to speak the truth, I do not see the force of the objections which
have been made to the use of the term "Perpendicular" as including
the whole period from the close of Decorated to the total extinction of
Architecture at the great Rebellion. From the glorious works of
Wykeham to the barbarous openings which light our Hall the same
character of *Perpendicularity,* if I may use such a word, prevails, and
the gradual declension of beauty is only paralleled to the gradual in-
crease during the Early-English and Decorated styles. At the same
time, as I have seen it remarked, the names of the Gothick styles are
singularly incongruous, and it would be well if some terms could be
adopted which would express the character of Rise, Perfection, and
Decline, which severally characterize them.

<div style="text-align:center">Yours obediently,</div>

Trinity College, Oxford, May, 20, 1842. E. A. F.

* Debased can hardly aspire to the name of Gothick, but so far as it is Gothick
it is a degenerate Tudor.

FREEMASONRY REVIVED; OR, WORKING MODELS.

[WE thankfully avail ourselves of permission to publish the following letter which has been received by the President. The suggestion it contains is very valuable; and we have long desired such an opportunity of creating among our resident members a practical acquaintance with details, which they would thus be in a condition to follow out and to superintend in their several localities after quitting the University; than which we can conceive nothing more likely to give a permanent and progressive impulse to church-restoration through the country. But we have no adequate funds: any one who takes the trouble to compare our income with our publications, will perceive that the former is barely sufficient to carry on that department of our office, independently of any undertaking in aid of individual restorations, or of such a school of practical architecture as is here recommended. We are however encouraged by this communication to renew our endeavours to carry into effect a design so likely to be of lasting benefit to Ecclesiastical Architecture.]

MY DEAR ARCHDEACON,—I was occupied last week in visiting a portion of my Archdeaconry; and so many cases came under my notice, in which it would appear that, by the expenditure of very small sums under proper superintendence, great beauty in the way of decoration might be preserved in various parts of the churches, that I determined at once to suggest to you what occurred to me. Your Camden Society, notwithstanding its frailties, has done much good: might it not become highly useful by undertaking the establishment of a mason's yard, in which the work necessary for the restoration of windows, doors, fonts, &c. might be carried on under the superintendence of a master-mason directed by the Society, whose business it would be to inspect the old work in any church, and to insert the restored parts, conveying them from Cambridge ready wrought? The Society might keep, ready made, windows of various sizes of the different styles, in the same manner as chimney-pieces are usually kept in warehouses, and thus tempt persons to the work of restoration by shewing at what cost the materials might be provided, independent of the cost of carriage and fixing. A very short time would prove what ought to be the price at Cambridge. And I think the establishment of such a yard would afford the best opportunity for raising up by means of apprentices a very superior class of workmen. Carpenter's work for pews, pulpits, and screens, might also form part of the works completed under the care of the Society, and a clever smith or two would preserve many a valuable relic from ruin. I do not calculate upon any opposition from the various trades, because there seem to me to be no tradesmen in the rural districts who are at all engaged in this sort of work; in all my round I did not see a single piece of mason's work amidst all the repairs which had of late years been effected. Plenty of plaister, but no stone. A fraternity of masons would do wonders in many a church by a few days' labour.

Believe me to remain, yours faithfully,

OPEN SEATS VERSUS PEWS.

To the Editor of the Ecclesiologist.

MR. EDITOR,—I shall be glad, if you will allow me, to make an observation on a letter signed Clericus, which appeared in your number for June. In that letter it seems to be taken for granted that open seats are to have no *backs* at all, in fact that there is no medium between a form and a full-grown pew. Now (so far as my experience goes) I never remember to have seen old open seats without backs in any church, with the exception of Great S. Mary's, Cambridge, which of course can afford no precedent on account of its peculiar use and character. The true ecclesiastical open seat is as far removed from a backless form as from a high pew, and even in point of comfort is superior to either; for its low back is a perfect support to the spine, which it ceases to be when too high, as in this case it presses against the shoulders, and gives hardly any support at all. I venture, Sir, to trouble you with these observations, because I think that the Cambridge Camden Society will be crippled in its efforts if the notion goes abroad that it wishes to allow of nothing but mere forms in churches. For my own part, so necessary does a back appear to be, that I think it a token of no little want of feeling, that in many churches, though pewed up to the very teeth, the children of the Sunday School are made to sit erect on backless forms; the only distinction between them and the rest of the congregation being that they are not able to remonstrate.

Your obedient servant,

γ.

UPON WESTERN TRIPLETS OF LANCETS.

To the Editor of the Ecclesiologist.

SIR,—Although it must appear presumptuous in an individual to express a doubt upon an architectural point already ruled by the Cambridge Camden Society, still it may be as well to state it, in order to secure the advantage of a solution from some member of that Society in one of your future numbers. Besides, as the synthetical process by which a perfect knowledge of Gothick architecture can alone be ultimately attained is still going on, it may be fairly allowed us to consider many questions as still open to the correction of the larger experience of some future day, however conclusive the evidence hitherto collected may at present appear to be. The point upon which I feel a doubt is, the rule more than once laid down in your publication, that triple windows are inadmissible in the western ends of small churches. Is this rule founded upon the mere fact of want of precedent, or upon any principle involved in the genius of the Early-English style? It is obvious that no *general* principle of that style forbids the admission of triplets at the west end, since in large churches they are of frequent occurrence in that part of the building. The size of the church then, it would appear, influences the rule. Now, though fully concurring in the opinion expressed in your number for the present month, as to the impropriety of inventing novel combina-

tions in Gothick architecture, of attempting, in our present half-informed state, to form the style before a fluent and familiar knowledge of the language has been obtained; I must yet express a doubt whether the practice condemned by your Society deserves to be considered as an improper license or incongruous feature. Certain details, legitimate in larger churches, are inadmissible in smaller ones of the same style, on the obvious ground of being disproportionate to the size of the latter. But the objection of disproportion cannot apply to the present case; unless indeed the insertion be in a western tower. The general principle of Gothick architecture does not forbid the assimilation of the eastern and western ends of churches: as a familiar instance, take the uniformity in this respect of King's College Chapel. And though perhaps it may be answered (what I for one can never admit) that the Tudor style is too debased to be cited for the establishment of any general principle, still I apprehend that both the Perpendicular and Decorated styles allow their assimilation. Is it, then, a peculiarity of the Early-English style, that in small churches the west end is forbidden to resemble the east, if the latter should happen to have a triple window?

The limitation intended by the term 'small churches' is not very clear. I presume small churches of the cathedral form are not included under the restriction; since there are many instances of such in Ireland, which have the triple western window. There are some in that part of the kingdom without side aisles, which have the same feature; whether any of these are also without transepts, I do not recollect. It is to be hoped the Camden Society does not reject Irish precedents in the formation of their architectural rules. If so, consistency ought to urge them to disallow in the province of York the Gothick peculiarities which may be formed in that of Canterbury; and even the dioceses of Sarum and Hereford ought now to be guided by different rules in the structure of their churches, as they were in old times in their liturgical offices.

In all fairness I must acknowledge having recommended this architectural heresy (if it be one) in the planning of a new church, although with sincerely orthodox intentions, before I was aware of the objection made to it by the high authority of the Camden Society. I beg however to be understood as stating my doubts, not in a cavilling spirit, but as really desirous of eliciting learned information from a body to which all churchmen owe a debt of respect and gratitude.

Allow me to take the present opportunity of making another remark connected with your publication. In a former number, strictures were made upon Mr. Petit's commendation of Sir Christopher Wren's towers at Westminster and Warwick, in such terms as might lead the uninformed to suppose that those commendations were unqualified. Now Mr. Petit expressly condemns their details, while he praises their proportions: and the remarks are curious and instructive, as calling attention to the great desideratum in the Gothick architects of the present day,—namely, a correct apprehension of general effect. I hope it was not the intention of the reviewer to condemn the proportions of Sir Christopher's additions. Unless my eye is altogether defective,

these have ever struck me as so beautiful and true, as to induce an
earnest wish that, while the graceful outlines of those towers may be
religiously preserved, they may be made perfect by the removal of the
barbarous details; an enterprize worthy of the strenuous remonstrances
and active superintendence of either or both of the sister associations at
Oxford and Cambridge.

I have the honour to be, Sir, your faithful servant,

JOHN JEBB.

Woodlawn, Maidstone, June 13, 1842.

[We are much obliged to Mr. Jebb for his remarks; and will
proceed to state the reason of the recommendations we have given
with respect to the subject which he mentions.

In the present state of symbolical knowledge, we hardly venture to
defend that recommendation by a mystical reason; though we firmly
believe that the arrangement we prefer has such a meaning, and that
(as we think) not a recondite one.

By a small church we mean a building neither Cathedral, Con-
ventual, nor Collegiate; and we include cross churches. To the
difference between the style of building in the two classes we hope
shortly to refer. We have so often had occasion to vindicate a
strictly English style, that we cannot allow Irish or Scotch examples
to interfere with our own practice. Between these and our own
arrangements there are often very wide differences; and a very
interesting volume might be employed in pointing these out.

But we wish to base this recommendation on the strongest of all
grounds, precedent. Our own researches have as yet discovered but
one instance where it is violated, in the church of Great Abington,
near this place.

Let us look at Sussex, the county of Early-English churches: and
from it we will select twenty buildings, taken at random, for the pur-
pose of shewing the arrangement of the windows.

1. BIGNOR, E. an unequal triplet; W. a single lancet.

2. W. CHILTINGTON, E. an unequal triplet; W. a Perpendicular
insertion: there was previously either a single lancet, or no window at
all.

3. THORNEY, Isle of Thorney, as 1.

4. THAKEHAM (a cross church), as 2.

5. COATES, E. a couplet, W. a single lancet.

6. W. DEAN, E. an unequal triplet, W. no window.

7. HARDHAM, as 6.

8. UP-WALTHAM (an apsidal church), E. two trefoiled lancets,
W. no window.

9. SINGLETON, E. Perpendicular insertion, W. a couplet.

10. BARLAVINGTON, E. a couplet, W. no window.

11. COLD WALTHAM, E. a decorated insertion, W. a single lancet.

12. MERSTON, as 6.

13. W. WITTERING, E. a single lancet, W. no window.

14. E. MARDEN, as 2.

15. E. BLATCHINGTON, E. (originally) an unequal triplet, W. no
window.

16. JEVINGTON, E. an unequal triplet, W. a couplet (blocked).
17. KINGRULE, as 6 and 12.
18. AMBERLEY, as 6 and 12.
19. HOUGHTON, ditto.
20. STEDHAM, ditto.

We believe that the Canons we have been endeavouring to establish may be more generally expressed, so as to include every class of churches ; thus—

In Early-English churches, the number of lights at the east end must exceed that at the west.

This, in small churches, where there is seldom more than a triplet at the east, will exclude it at the west: where there is a quadruplet or quintuplet in the former, the latter may have a triplet, as is sometimes the case in Cathedrals; and may probably be so in the instance adduced by Mr. Jebb.

We hope to return to this subject. In the mean time we solicit information as to western triplets ; we have heard that there are examples in the county of Oxford, which is out of the reach of our own general investigation. At any rate, even if our Canon were not for general observation, it will be most useful if it only prevents one unskilful adaptation of a Cathedral west end to a small parish church. —ED.]

EAGLE DESKS.
To the Editor of the Ecclesiologist.

SIR,—If the following remarks on Eagle Desks should appear to you to possess any interest, they are much at your service.

I remain, Sir, yours, obediently,
AETOPHILUS.

THERE can be no doubt that, previously to the great Rebellion, most village churches possessed their own eagle-desk or lettern, whence the lessons were read to the people. In some instances they were made of brass, in others of wood: and eagles were most usually adopted, as symbolising the angel flying "through the midst of heaven, having the everlasting gospel to preach." Those beautiful church ornaments were in many cases destroyed during the civil war; and those which then escaped, and those which have been made since, are alike disused in too many instances now.

Perhaps the most beautiful brazen lettern in England is that which belongs to King's College Chapel, but is now, unfortunately, lying useless in the library. It was the gift of that Provost Hacombleyne who has a brass in a south chantry of that Chapel; and is alike admirable for the boldness and the delicacy of its ornaments. It has been engraved in the *Cambridge Portfolio.*

Another fine brazen lettern is to be seen in the Cathedral church of WELLS. It was the gift of Dean (afterwards Bishop) Creyghton, one of the Confessors for the Church during the great Rebellion; and was an offering in token of thankfulness for the King's restoration.

This lettern is now disused; and being placed in the middle of the Nave, considerably impairs the effect of that unrivalled vista, by diverting and stopping the eye in its progress to the Altar.

There is a fine lettern in RAMSEY Abbey church: and one of Early-English date in the church of BURY, Hunts; the latter now serves as the clerk's desk. The remains of a fine wooden lettern in BRIDGEWATER church are used for the same purpose.

There are two very fine eagles in SOUTHAMPTON, neither of them now in use. The one, which is represented as trampling on a serpent, and has its stem supported by four lions, belongs to Holy Rood church; the other, which is somewhat plainer, to S. Michael's.

There was formerly a fine eagle in the Cathedral church of BRISTOL; it was sold by a late Dean for the purpose of being melted down; (though it is but fair to add, that the proceeds were devoted to the restoration of the fabrick.) An inhabitant of the city rescued it from this desecration, and presented it to the church of S. Mary-le-Port, where it now lies useless. In this case, as in that of S. Mary Redcliffe, BRISTOL, which has a fine eagle not now in use, steps have been taken with a view to their restoration.

In Trinity church, COVENTRY, is an eagle which formerly belonged to that Cathedral, and was dug up on its site: it is in use, though (contrary to primitive custom) it faces the east, and the prayers are read from it as well as the lessons.

MONKSILVER, Somersetshire, has a wooden eagle, which appears after the Reformation to have been used instead of the reading-pue; a hole being cut in the rood-screen to enable the people to hear with the greater ease, as the eagle is on its eastern side.

These wooden eagles are far more common abroad than in England: a substitute for these is, the wooden figure of a Deacon holding the volume in his hands; the ludicrous effect of which must be seen to be appreciated.

It appears from the accounts of Trinity College, in which an item occurs of a payment "for cleaning the brasse deske," that one, probably an eagle, once belonged to the Chapel of that society; but nothing is now known of its existence.*

The eagle lately presented to S. John's Chapel was described in

* The manner in which this disappeared, as traced in the accounts, is very curious and instructive. From 1580 to 1710, a distinct payment to different servants appears among the *Extraordinaries* for "skowering," or "looking after, the brassen deske." But in 1711 it appears for the first time under the head of *constant allowances*, coupled with another item, by that time probably considered more necessary, thus: "for looking after the charcoal *and cleaning the chappell deske*, £4 12s.:" and so it goes on till 1722, the two sums of £4, which had been paid for looking after the charcoal, and 12s. for cleaning the desk, being now paid in one sum to a person who probably had only the first office to perform. For in 1722, the "chappell deske" is transformed into a very suspicious "&c." thus; ("for looking after the charcoal, &c. £4 12s.);" and so it goes on to 1758, when even this little memorial disappears, and the whole £4 12s. is paid "to H. Gordon for making the charcoal fires." The precedent is still kept up: in 1841, "to W. Kemp for lighting the charcoal fire £4 12s." And this is the way that vanish and disappear from College Chapels, as well as parish churches, "Brassen Deskes," "Altar Candlesticks," and other "et cetera."

the last number of the *Ecclesiologist* : it is gratifying to be able to add that that in Christ's College Chapel has lately been cleaned and polished, to the great ornament of the Chapel.

To the Editor of the Ecclesiologist.

MR. EDITOR,—I need not attempt to prove to the members of the Cambridge Camden Society the value of our ancient sepulchral monuments, both as works of architecture, and as historical records. The importance of the subject will, I hope, induce you to insert the following extract from a recent work, in your valuable journal.

" Any shapeless fragment, any mean potter's vessel, any illegible inscription, provided it be *but antique*, will be deposited on a pedestal or within a glass-case in our national Museum. No price can be too great for a cameo or a heathen bust : but every object of Catholic and national art is rigidly excluded from the collection. In the whole of that vast establishment, there is not even one room, one *shelf,* devoted to the exquisite productions of the middle ages. In this we are actually behind every other country in Europe. At Paris, amidst all the Pagan collections of the Louvre, the Christian student will find exquisite specimens of enamels, ivory carvings, jewels, silver work, chasings in metal—all in the first style of Catholic art, and of every date. At Nuremburg, Rouen, and many more provincial towns, are public galleries of Christian antiquities of the greatest interest. England alone, the country of all others where such a collection could best be formed, is entirely destitute of it. In sepulchral monuments we are rich indeed. If correct casts of all the effigies of royal and ecclesiastical persons remaining in the cathedral and other churches were carefully taken, coloured fac-similes from the originals, and arranged in chronological order, what a splendid historical and national series they would form : and this might easily be done at even a less cost than the transport of a monstrous fragment of an Egyptian god from the banks of the Nile."—*Pugin's Contrasts,* (*new edition*), p. 16, *note.*

The value of such a collection would be greatly increased if casts were made of the tombs themselves and of their canopies, as well as of the effigies.

It is perhaps fair to state that the author has overlooked a few encaustic tiles which are preserved in the Hamilton room.

It is much to be desired that the rich architectural fragments of S. Stephen's chapel may be preserved in the British Museum.

I am, Mr. Editor,

Yours very respectfully,

✠ G.

[We thank ✠ G. for his letter. The subject is of importance, and we hope to make it the subject of a leading article in an early number.

CRYPT IN WARRINGTON CHURCH.

To the Editor of the Ecclesiologist.

SIR,—I have just read in the last number of the *Ecclesiologist* an account of some excavations in the north wall of the Chancel of S. Se-

pulchre's church : and knowing that the most imperfect hints are some-
times of use in such cases, I am induced to draw your attention, as far as
my imperfect recollection of the facts will allow, to a discovery made some
little time ago in Warrington church. In the course of some repairs a
monument was removed in the middle of the north wall of the Chancel,
and an opening found which had led from a stone pulpit in the wall by
a staircase to a small vaulted crypt which had been broken in and filled
up. I do not remember the date of the work, nor how my informant
accounted for the singular position of the pulpit.

Thursday, June 25, 1842.

DESECRATION OF THE LORD'S TABLE IN NEW CHURCHES.

To the Editor of the Ecclesiologist.

SIR,—We beg to acquaint you that a new church in the Early-
English style of architecture is now nearly ready for consecration at the
village of Lenton, about two miles from Nottingham, and we are happy
to state that in the design of this church some respect has been paid to
the true principles of Christian architecture, as it consists of Nave and
Clerestory, Aisles, Chancel, and Tower ; but we lament to add that
one glaring violation of good taste and propriety is about to be perpe-
trated in that which we are taught to regard as the most sacred part of
the edifice, viz. the Chancel, of which about one-third is screened off
for a vestry ; and in this vestry (we are almost ashamed to communi-
cate the fact) a water-closet is about to be fixed actually contiguous to
the holy Altar itself, nay occupying the place where the Altar ought to
stand : and this, too, when a large school-house stands within twenty
yards of the church, where, as we should imagine, ample accommoda-
tion might be provided.

We beg to apologize for troubling you with this communication;
but as we are enthusiastic admirers of the pure principles of Christian
architecture, we cannot endure to see such a violation of those princi-
ples without taking some step to prevent it ; and we can think of no
way so likely to be effectual as that of stating the matter to you, as we
have little doubt, provided you view it in a similar light, that if you
were to expose it in your excellent periodical, it might be the means
of preventing the evil ere it be carried into effect. Hoping the nature
of the case, and our interest in it, will be a sufficient excuse for thus
troubling you,

We remain, Sir, your obedient servants.

Nottingham, June 15, 1842. • • • •

[We insert the above letter, the writers of which have given us
their names, less with the wish of appearing to assume a power in this
particular case which does not belong to us, than with the hope of
calling general attention to the irreverent arrangement which it
describes. It is not the first time that we have heard of this sad
disregard to propriety in *new* churches; indeed in our immediate

neighbourhood we should have no difficulty in finding an instance. We have always spoken with the greatest boldness against the practice of building any sort of vestry behind the Altar; we now see what such a departure from ancient usage leads to. We cannot trust ourselves to speak in sufficiently strong terms against this desecration of GOD's House. It is an offence so extremely revolting even to our *natural* ideas of reverence, that to any who have learnt to feel the 'awfulness' of a church from their own experience, and from the example of those they respect, and from the repeatedly expressed statements of councils and fathers, it cannot be regarded without deep and painful indignation. Learned writers have shown most strikingly from Holy Scripture, from Canons, and a succession of authors, the relative sanctity of a church, and the especial holiness of the part set aside for the most solemn offices. This we have either forgotten or we despise. We cannot here quote passages, or enter fully into the proof of this. Alas, that it should be required to teach Christians that reverence which heathens with respect to their idol temples have enjoined and practised; which need not be inculcated upon any other Church in Christendom, neither upon Jews nor Turks. See what Bishop Montague, for one, says of churchyards: what would he have thought of a Chancel so profaned? "Is your churchyard, or any part thereof, made a laystall or dunghill? Or be any such impious nuisances laid neare unto the pale or mound thereof? Let the offenders be named upon inquiry and presented." (ii. 8.)

The following eloquent passage from the Concio ad Clerum delivered by the famous Mede in this University, upon occasion of his taking the degree of B.D. is much to the purpose. "Præsentiam Divinam minimè decet Immundities. Id adeò verum est ut Israelitarum castris Munditiem mandaret Deus, propter singularem suam in iis Præsentiam: "*Quia,* inquit, JEHOVA *indesinenter ambulat in medio castrorum tuorum, eripiendo te; ideò castra tua sancta sunto, neque conspiciat in te turpitudinem ullius rei* NE AVERTAT SE A TE. (Deuteron. xiii. 14.) Secundò, Templa honorificè habenda sunt; at immundities contemptum maximum et vilissimam vilitatem arguit. Unde Jehu (2 Reg. x. 27.) ædem Baalis contumeliâ quam potuit maximâ affecturus, in Latrinam vertisse dicitur. At ille Baalis Idoleum, nos CHRISTI (proh pudor!) Domum in Latrinas vertimus. Adeò nobis in Deum ignominia non est, quâ Nebuchadnezar majorem non invenit, quâ DEI nostri blasphematorum ædes conspurcaret, quàm ut in latrinas et sterquilinia redigantur? Postremò adeò Templis munditiem convenire putavit magnus ille Gentium Doctor, ut Corpora fidelium Templis assimilans, argumentum inde duceret de iisdem morum et vitæ impuritate non temerandis; *Vos Templum estis* DEI *Viventis; quapropter impurum ne attingite.* (2 Cor. vi. 16, 17.) Si imaginem Templi non deceat Immundities, certe non decebit ipsum." (Folio edition, lib. II. p. 408.)

We earnestly press the consideration of the texts here adduced upon those whom they concern.—ED.]

EXETER DIOCESAN ARCHITECTURAL SOCIETY.

\ THE first Annual Report of this Society has just appeared, and our readers will be glad to know that it is highly satisfactory. Our limits do not permit us to give more than a very brief notice of it. It opens with expressing a desire for a more immediate union with its kindred societies, as the only means of successfully "attempting what was so admirably accomplished by the Freemasons in older times." " Our general principles must be the same; our manner of executing the various details of the styles of Architecture must be harmonious; and we must communicate to each other and mutually agree upon the general external forms and internal arrangements of all Ecclesiastical edifices." We look with great hope to the effects which must follow the resolution of the Diocesan Church-building Society, which orders that all plans for the building and enlarging of churches and chapels shall be first submitted for approval to the Exeter Committee. In the first case brought before them, Arlington, it appears that a well-developed Chancel was secured.

The Society has visited the churches of S. Andrew, Collumpton, S. Mary, Ottery, and All Saints, Kenton, and excellent effects have followed in the neighbourhood from these expeditions. We should not omit that the usefulness of our Church-schemes for these examinations is kindly acknowledged.

It appears also that the Society has been mainly instrumental, by supporting the Archdeacon of Exeter, in preserving the beautiful Rood-screen at Bradninch: it has procured a design for a new Altar·screen at Ilfracombe; and brought about a thorough restoration of the Chancel of Exminster. It was not able however to secure a Chancel at Heavitree, where the church is rebuilding. The Committee have also successfully interfered at Tiverton, Exwick, and Puddington.

A volume of Transactions is announced; the first to contain seven elaborate views of S. Mary's Ottery with letter-press description. The elementary work by the Rev. J. Medley, one of the Secretaries, has already been noticed in the *Ecclesiologist*: papers by Mr. De la Garde and by Mr. Bacon on Monumental Architecture are promised.

The Society has had many valuable presents, and some from persons whose adherence is a matter of congratulation.

The Report concludes with some excellent general observations upon the importance of the principles of harmony and composition, as well as attention to details; a protest against pues and galleries, against deceptive imitations of wood and stone, and against the Pagan sort of monuments; a plea for our national styles in opposition to the fashionable Romanesque, and an urgent call for yet greater sacrifices on the part of its members.

The Society already numbers 151 members. We earnestly wish that it may increase and prosper, and that its next Report may tell of still greater success and usefulness than even the present gratifying statement of its operations and prospects leads us to expect.

NEW CHURCHES.

WE have been informed that most of the points in the proposed church at Westminster, animadverted upon in our last number, have been since altered by the architect.

A church is building at *Blindley Heath*, the following particulars of which we derive from a small lithographic view published in aid of the funds. It consists of a Nave, with a small apsidal projection scarcely to be discerned from the position of the drawing, which is taken from the S.W. The roof is of a higher pitch than usual: but, from the apparent breadth, it would seem that the area would have been much better divided into a Nave and Aisles, than arranged as a Nave only. This point has been well discussed in the Architectural article in the February number of the *Dublin Review*. The sides of the Nave are divided by buttresses into four compartments, in each of which is a single but inelegant lancet. There is no string-course whatever, or basement-moulding. The porch improperly occupies the last but one compartment towards the east: it possesses very little character. There is a thin western tower, somewhat clumsily made, of exactly the same height as the ridge of the roof, surmounted by a tall broached spire, seemingly of wood, of not unpleasing proportions. The Tower has angular buttresses; a belfry stage, with a double lancet window to the west, and a single one to the north and south, resting on the *one* string-course of the building, which however does not in any way range with the buttresses; tall lancets on each side in a lower stage, and a western door.

The estimated expense of building the church, parsonage-house, and endowment, is £3500.

WE have been much pleased with the following passages extracted from a circular put forth in behalf of the church of S. John the Baptist, now building at Eastover, Bridgewater.

" The Windows of the Chancel of the church will be entirely filled with painted glass provided at the expense of the Rev. J. M. Capes, and it is proposed to raise a sufficient sum to fill the whole number of windows in the body of the church with glass of a similar character. Mr. Capes is prepared to undertake the charge, and to provide the windows, on condition that not less than £150 be contributed and placed in his hands for that purpose. The glass would be purchased in France, and the windows executed from designs taken chiefly from the ancient painted glass in Amiens Cathedral.

" The proposition is made at the present time, because nearly three times the above sum would be necessary to fill the church with similar glass, after the building had been completed; the additional expense arising from the very heavy duty upon the glass, which would not in all probability be remitted, unless the glass were employed in the original building of the church: and also from the cost of the glass which must be made use of for the usual glazing of the windows, the before-named sum being only the *extra expense* of painted glass above that of the white glass generally employed in churches."

CHURCH RESTORATION.

WE are happy to be able to announce the removal of the Font at *Scraptoft* from the churchyard to the church. We hope it will be substituted in actual use for the modern one which has supplanted it.

The case of the restoration of *S. Mary's, Stafford,* already commented on in a former number of the *Ecclesiologist,* has been since formally submitted to the consideration of the Committee of the Oxford Architectural Society and our own. Since the verdict of both Committees agreed in the view advocated in the article alluded to, we hope that the matter will be now satisfactorily arranged, and that the restorations will proceed successfully.

NOTICES.

WE have great pleasure in announcing the formation of a branch of our Society in the united Diocese of Down, Connor, and Dromore, under the sanction and auspices of the Venerable Prelate who presides in that See. We hope that this may be the first step to an effective renovation of the fabricks of the Church in Ireland.

THE Committee of the Cambridge Camden Society have already forwarded to *Alexandria,* the general designs for the new British church, which they were requested to supply. The style is Early-English. We hope soon to give some further particulars.

WE have been informed that the description given in the British *Magazine* of the Chapel at *Aston Cantelow,* which gave occasion to some animadversions in our 6th and 7th numbers, is quite incorrect, and that the building in question is according to rule in the particulars there objected to. We shall be most happy to do justice, though the fault was not our own : and any friend who would favour us with an accurate account of the Chapel would be doing us a favour.

As a statement in the first page of our last number appears to have been misunderstood, we beg to explain that our meaning was simply this :—That supposing only a very small sum to be raised for building a new church, it might generally be laid out to more advantage by following exactly the model of some small and rude village church, than by affecting ornament or beauty of design which there are not sufficient funds to supply. That none but the simplest and smallest churches could be built for £800 we are well aware, and of course do not mean to advocate (as we distinctly said) any such niggardly system of church-building, being well aware that the noble old parish churches of England were raised at a vast expense, and that we can only hope to imitate them by equal liberality. The sum of £800 was merely mentioned *exempli gratiâ,* the object of the writer being to speak of proportionate rather than of actual cost. It cannot be necessary to ·caution our readers against the absurd idea that a spacious modern church can be built for £800; although we have no doubt that little village churches might be found for models, the cost of whose erection would be under £1000, and which it might be very advisable exactly to imitate where this very limited sum can be obtained.

[Second Edition.]
Published by T. STEVENSON, *Cambridge ;* J. H. PARKER, *Oxford ;*
RIVINGTONS, *London.—Price* 4d.

METCALFE AND PALMER, PRINTERS, CAMBRIDGE.

THE

ECCLESIOLOGIST

PUBLISHED BY THE CAMBRIDGE CAMDEN SOCIETY.

"Bene templa refeceris."

Nos. XII. XIII. AUGUST, 1842.

ON SOME OF THE DIFFERENCES BETWEEN CATHE-DRAL AND PARISH CHURCHES.

NOTHING, in the modern practice of church-building, is more common than for the architect, who fortunately finds himself able to bestow some attention on the ornamental features of his church, to adapt the western façade or tower of some magnificent Abbey to the little building intended for 400 or 500 worshippers. And the ingenuity with which the one is altered so as to suit the other is made the subject of frequent praise. We, on the contrary, have often had occasion (particularly in the matter of western triplets) to deprecate the introduction into small churches of features proper only to Cathedral or Conventual buildings : and we now proceed to make some further remarks on the general subject.

The modern architect, who has been commissioned to design a church for 300, and, having prepared his ground-plan and elevations, is afterwards informed that it will have to contain 600, would too often make no further change than by proportionally increasing his plan. But Poore, and Wykeham, and Waynflete, and Islip, would have gone very differently to work. They knew that an elevation suitable to a large, would be absurd in a small, church.

Imagine the sublimity of the west front of Peterborough Cathedral caricatured in a small country church! its glorious triplet diminished into three little western arches! Or again, look at Tewkesbury, and think of its towering western arch imitated in a similar manner. Or take an actual example; and see the base use which has been made of York Minster in a well-known Scotch conventicle; or contrast the outline of King's College Chapel with Christ church, Barnwell. And on the other hand, that Early-English gem, S. Andrew's Barnwell, would, if expanded into a large church, become meagre and unsatisfactory.

There are arrangements, too, which need not only a comparative but an actual size, to produce an effect. In that noblest of human temples, Glastonbury Abbey church, the effect of the rise of six steps, right across the building, at some little distance west of the 'Holy

Doors,' is inconceivably grand. Yet in a parish church such an arrangement, modified in proportion to its size, would be absolutely unnoticed.

There are, no doubt, examples of the modification or imitation of one church in another, executed on true principles, though not frequently occurring, in the best ages of architecture. The west front of Beverley sprung from that of York: and who will decide between them? They have the same magnificence, and the same peculiarities, namely, the great prominence of the buttresses. Again, the Tower of Gloucester was evidently the prototype of the glorious Towers of the west of England: but how beautifully is the idea modified in them. Look at S. Mary Magdalene's, Taunton; S. Decuman's; and Bishop's Lydiard. The latter we think inimitably beautiful; and it bears the same resemblance to Gloucester, that the feminine loveliness of a daughter might do to the manly beauty of a father. So who can doubt that the Lincolnshire spires had their origin in the spires of the Cathedral church, so ruthlessly and needlessly destroyed? We are bound however to say that this imitation was, even in the best times of architecture, not always successful. The position of the Towers of Exeter Cathedral is awkwardly repeated in S. Mary, Ottery; the reversed arches of Wells in Finedon church.

Western façades are less easily imitated than Towers, because their size depends on that of the church, while that of the Tower does not. And yet it is this portion of the building which is sure to be fixed on by way of an 'idea.'

While on the subject of imitations, it is worth while to notice the mannerism which prevails in most of the architects of the present day. We believe that, of the many designs which come before us, there are few that we could not assign to their right author.

Whether there may not be some principle of difference between Cathedral or collegiate, and parish, churches, founded on mystical considerations, is a point which we shall not here discuss. We believe that there is. One would *à priori* look for the same difference, as that which ought to exist between a popular discourse and a *Concio ad Clerum.* Suffice it to point out some of the effects, though we cannot explain the causes. Who ever in a parish church saw a double Transept, though double Aisles do occur? We believe, again, that the Transepts are never in a parish church placed so far east as at Westminster; that the T form is never in use, as at Durham; that there is never a western Galilee* or Ladye chapel, as at Glastonbury and Durham. The Chancel-arch is generally much better defined in the church than in the cathedral; the Rood-screen lighter in proportion; the Sedilia more universally on the south side.

Again, the next to universal occurrence in the one case of the Cross, a comparatively unusual form in the other, deserves notice. The Towers, too, with two exceptions, Exeter and Elgin, occupy, in our Cathedrals, no other position than the intersection or west end. This is, as all know, far from the case in parish churches. Though we

* We are aware of one so called in S. Mary, Snettisham, Norfolk, but this seems a somewhat questionable case.—ED.

must say, that the reaction from a supposed necessity of having the Tower in the middle of the west end, is now leading some architects rather too far : they seem to think it a forbidden position, though undoubtedly it was that adopted in three-fourths of ancient churches.

(*To be continued.*)

S. STEPHEN'S CHAPEL, WESTMINSTER.

To the Editor of the Ecclesiologist.

SIR,—It is with much pain that I have read in your number of May last, Mr. Barry's reply to your President's communication on the restoration of S. Stephen's Chapel, not only from its disappointing the hopes which had been entertained of the result of the applications made to him on the subject from both the Universities, but from its displaying a want of true feeling for ancient art, which I think is much to be lamented in an architect of such high standing and eminent talent. Though it appears that Mr. Barry did not from the first contemplate the retention of the original features of this once glorious Chapel, I cannot but think that, from some cause or other, the publick were under the impression that this was his intention, and that this impression, whether true or false, did much towards obtaining for his design the suffrages of the majority of those who took an impartial view of the subject. This however is not the question. That an architect seven or eight years since should have contemplated a change of style in rebuilding such an edifice, though certainly to be regretted, may still be excused. The study of our antiquities, and the consequent love and veneration for them, has however made such rapid progress since that time, that arguments which then might be considered passable are now seen to be futile : the question therefore at issue is, whether, with the feeling now happily existing, it would not be justly considered a heartless and barbarous act to neglect the present opportunity for restoring what is allowed to have been the most beautiful work of its extent ever erected in this, or perhaps any other, country.

The arguments used by Mr. Barry, though plausible at first sight, do not appear to me to possess any real value : and as Mr. Barry's feelings as a man of taste must necessarily be in favour of the restoration, if the practical difficulties could be removed ; and as his reputation would be greatly increased by it, he will no doubt readily excuse me in scrutinizing the objections he has raised.

The arguments adduced in his replies to the enquiries made on the subject I understand to be these :—

1st. That it is impossible to make a perfect restoration on account of the absence of all authority for many essential features, such as the window tracery, the roof, and many details of the east and west ends. That one antiquary has imagined that there has been a clerestory with a groined roof ; another has given a design for a wood roof of a very improbable character ; that innumerable suggestions have been made, on the comparative merits of which it would be impossible to decide ; and that it is useless to attempt a restoration where many important parts must rest wholly upon conjecture.

N 2

2nd. That its sacred purposes being abandoned, and the Chapel converted into a mere corridor, it would be inconsistent to restore features which belong to it essentially as a sacred building ; and that the mode of its introduction into his design requires an entire alteration of the east and west ends, the place of the Altar being occupied by a lofty portal, and the east window being entirely blocked out by adjacent buildings.

3rd. That the expense of the restoration would be enormous; and that under all circumstances it would be inexpedient to incur so many inconveniences, and to break the uniformity of the design for the objects which could be obtained.

To the first objection it may be replied, that though many parts are certainly wanting, those for which we have full authority are so extensive and of such wonderful beauty, as to claim preservation at any sacrifice. The whole of the side elevations for instance, excepting only the window tracery, were perfect till the fire occurred ; and it is only from what then *actually existed*, almost irrespectively of history, that the extraordinary merits of the design are known : and to sacrifice the majority which we know, merely because there are parts which we do *not* know, is absolutely absurd. Again, it is quite true that many improbable conjectures have been made by persons who ought to have known better : but is this a reason why, under the present advanced knowledge of the subject, we are not even to attempt to arrive at more correct opinions, and that the most exquisite work of our forefathers is to be sacrificed ? The window-tracery it is true is lost, but we have the beautifully-moulded and decorated jambs, arches, and cills, with the number and section of the mullions : and though it would be impossible now to recover the exact pattern of the tracery, a careful study of the existing remains would enable one to arrive at something which would, at the least, be in perfect harmony with the general design.

It is true that we have no means of knowing the exact construction and design of the roof; but as we have the pitch of the gable, and as the continued cornice of stone indicates what was the general idea, a careful comparison with works having similar features would, I am convinced, enable any careful and unprejudiced antiquaries to form a very correct idea of what the general plan must have been, while the details might be designed in unison with the character and feeling of existing portions of the works.

The design of the east end is obscure, but much might be done by a careful study of such portions of it as remain. Indeed I have no doubt that every part which is wanting might be supplied, if not with absolute correctness, at least in such a character as to harmonize perfectly with the design, and that the whole might be made in general to present a very correct representation of what the Chapel must have been in the days of its glory.

The second objection comes rather ill from Mr. Barry, inasmuch as the use to which the once sacred edifice is to be appropriated is not a matter of necessity, but of his own choice ; the infringements upon the original design, which he thinks fatal to any attempt at restoration, *ing his own act and deed.*

It is, I suppose, too late to think of retracing this false step, or it would be a most glorious improvement upon the design to restore the Chapel, not only to its architectural character, but to its sacred uses; setting it apart for those religious services which, though practically neglected, have always, in form at least, been kept up by the two Houses of Parliament.

That so fine an opportunity should have been neglected for putting an end to its long-continued desecration, and of appropriating it to so noble a purpose, argues ill for the state of religious feeling at the time the design was made; and it would be a noble proof of a return to more correct principles, if the utilitarian project could even now be abandoned. But if this is too much to hope for, we may at the least ask for the preservation of the ancient architectural design, so far as it is known. It is absurd to say, that because the purpose of the building is to be altered, no feature of its architecture can be retained; and it is adding insult to injury to plead the deliberate mutilation and desecration of the sacred edifice as an argument for depriving us of one of the most invaluable remnants of design and art which our country has ever possessed. As well might it be urged that because the original purposes of Westminster Hall have long since become obsolete, its only use being as a passage to the law-courts; because its sides have been perforated by modern door-ways, and its noble window is to be removed to render it subservient to Mr. Barry's design, the character of the remaining portion must also be altered to match its new neighbours, and its glorious roof brought down to a modern *slate pitch:* indeed, from the tone in which Mr. Barry mentions this wonderful building, he would appear to take some credit to himself for "*retaining*" what he seems to have felt to be an incumbrance to his design.

The objection on the ground of expense hardly claims a moment's consideration, even if the enormously exaggerated statements of it were correct. In a country which spends its thousands in importing mutilated remains of pagan art, it seems monstrous to give up for ever the infinitely more valuable remains of the best age of Christian and native architecture, sculpture and painting, to save a little increase in the cost of the most extensive and gorgeous building of modern times: indeed, if we may judge from the beautiful drawing now exhibiting at the Royal Academy, the difference of cost would be comparatively trifling, though the gain in other respects would be enormous. I cannot imagine that the existence of a portion of earlier date than that of the general style of the new buildings can by possibility have any injurious effect, particularly when that portion is so replete with historical interest and architectural beauty.

Mr. Barry's proposed substitute for S. Stephen's Chapel possesses beyond a question considerable merit, and, had not it been intended to supplant an infinitely more beautiful design, could only be spoken of with praise. The drawing now exhibiting naturally attracts much attention, and no doubt was made for the purpose of allaying the feeling in favour of the ancient design; but it must be borne in mind that much of its beauty is that of the drawing rather than of the building, and that the pleasing proportions of the apartment are those of the

original chapel on the foundations of which it is proposed to be erected: indeed, after a careful examination I can discover no intrinsic beauty but what is derived from its predecessor, and no fault but what is essentially its own: and were there a drawing beside it of equally artist-like execution, shewing a restoration, as near as may be, of the original structure, it would be found as far to eclipse Mr. Barry's design, as the latter now does the meanest drawing in the room. This drawing however is highly serviceable, as shewing how little comparatively the design need be interfered with in accommodating it to the new arrangement. Mr. Barry says that the east window could not be retained; but his drawing shews one of *ample dimensions,* and filled with stained glass. The only alteration rendered necessary (and bad enough it certainly is) is the substitution of a doorway for the ancient Altar: with this exception, hardly a feature of the old Chapel need be interfered with. The drawing also shews that the objection of the cost of restoring the ancient decorative painting is frivolous, inasmuch as the new design is shewn as elaborately ornamented with fresco painting. Mr. Barry seems to think these likely far to exceed in beauty those of the old Chapel; but few, I think, will be so sanguine as to expect that a newly-formed school will at once equal the finest work of the kind ever executed in this country: and if this could be hoped for, few would not prefer that its energies should be devoted to the restoration of a work linked with one of the most glorious periods of history, than expended on designs of modern invention, for which there is so ample a field in other parts of the building.

Under all circumstances, I cannot but think Mr. Barry's reply to your President to be unworthy of so eminent a man, and that the subject should in a more publick manner be urged by a memorial from your Society, and from any individuals who may choose to join with them, to the highest Government authorities. The object of this memorial should be to request the appointment of a committee, consisting of such members of both Houses of Parliament as are known to take the greatest interest in the subject, joined and assisted by a selection of most eminent ecclesiastical and architectural antiquaries, to enquire into the expediency of restoring S. Stephen's Chapel as nearly as possible to its original design, and to determine on the best mode of carrying it into effect. Such a committee ought to invite and receive evidence and advice, from every one who is willing to afford it, as to the probable design of the parts which are wanting; and by comparing the arguments on which such suggestions are founded, they would, I doubt not, with Mr. Barry's assistance, be able to come to a most satisfactory result.

I have the honour to be, Sir,
Your most obedient servant,
AN ARCHITECTURAL CONSERVATIVE.

[Plans, sections, and restorations of this once magnificent structure have been published by the Society of Antiquaries, and by Carter in his "Specimens of Ancient Architecture," Plates XVII. XVIII. XIX.

The latter took his sketches in 1791; but in 1800 many parts before concealed were exposed to view. The conjectural restorations of Carter would be well worth attention should the plan suggested by our correspondent happily be adopted. We quote from Carter the following brief account:—" The date of this Chapel is 1348. The history of it, with the parts remaining at this day, prove that it must have been, when in its pristine state, one of the most gorgeous scenes for devotion this country ever produced; the royal Founder, Edward III., having summoned the most eminent artists from all parts of his dominions for this purpose, and encouraged them by the most unbounded liberality to perfect a work which it appears he had resolved should be a master-piece of genius and of art. How well his commands were obeyed, every vestige now in existence sufficiently demonstrates. And if it is a gratification in the highest degree thus to contemplate on its various excellencies, how mortifying it is at the same time to witness its lines either mutilated, shut out from public view, or in part destroyed. The first havoc wrought on the walls was in Edward VI.'s reign; second havoc, William and Mary's reign; and the third havoc even under our own eyes, by men who, while they affect to give praise to each supreme object, ruthlessly decree, and absolutely stand over the destruction of them; the fragments of which have either been totally annihilated, or gathered from the rubbish, to enrich the collections of pious and curious antiquaries!" *—ED.]

* See also Vol. II. of Carter's Specimens of Ancient Sculpture, p. 27, where a history of this Chapel is given. The author (who stood almost alone at that tasteless period in his admiration for the beauties of pure Christian art,) concludes his account with these remarkable words, so applicable to the present circumstances:— "Whenever national conveniency shall require the re-edification of buildings in a serious state of decay, it is hoped there will not be found wanting also a portion of national taste, to rescue from destruction *the most beautiful specimen of architecture this country has to boast of.*"

GREAT S. ANDREW'S, CAMBRIDGE.

WE noticed, in our fourth number, the demolition of the old church of S. Andrew. We then expressed a hope that the western arch and the piers, all of them simple but beautiful specimens of Early-Decorated, would be preserved and made use of, as they might well have been, in the new church. Thus the necessity, real or fancied, for entirely rebuilding would have been at any rate less painful.

We have been somewhat disappointed by an inspection of the new building; of which we should have spoken earlier had we been allowed, when we made application, to see the design.

The plan of this church comprises a broad Nave and Aisles, forming very nearly a square, a shallow Altar recess, and a low western Tower. The latter, as in S. Paul's church, being neither a necessary nor particularly ornamental feature, has much better have been omitted, for the purpose of allowing space and funds for a full-sized Chancel. With the exception of this great fault, we are happy to see a decided improvement in external appearance upon the other two

churches recently erected in this town by the same architect. The windows contain good Perpendicular tracery, and the workmanship generally, though the details are somewhat meagre from the deficiency of funds, is of a much more satisfactory description. The side elevations now present a tolerably ecclesiastical appearance, and as far as they go we have little fault to find with them. We are sorry, however, to add, that the internal arrangements are in every respect objectionable. Huge tiers of deal galleries, which are supported by short cast-iron props, resting on square brick posts, encumber the interior; and the ugly brick doorway into the Tower, instead of the peculiarly fine belfry-arch of the old church (for whose preservation we vainly interceded, though it might surely have easily been spared and replaced in the new one), furnishes a painful contrast between ancient and modern church-building. The east window is not yet finished; we trust it will prove very different from those in S. Paul's and Christ Church, though the scantiness of the mullions, transom, and mouldings do not promise much. The windows on each side of it, at the ends of the Aisles, are blocked with brick up to their transoms—because the galleries come in the way. Sham windows, or parts of windows, are utterly at variance with the true principles of Gothick architecture. Smaller windows than those in the sides, though not usual in this position, would not have been inappropriate: the pretence of large, with the use only of small ones, is an unworthy deception, as injudiciously as unnecessarily introduced.

LEULINGEN CHURCH, PICARDY.

To the Editor of the Ecclesiologist.

SIR,—There is a little village on the high road from Calais to Boulogne, which, although scarcely known to our nation at the present day, has twice witnessed scenes of splendid conference almost rivalling the glories of the "Field of the Cloth of Gold." The name of this now obscure place is LEULINGEN; and it is situated just without that line of demarcation considered as the English pale, previous to the conquest of Boulogne by our Henry VIII. The face of the country is admirably adapted to the purposes of publick meeting, as a rivulet winds between two gently rising hills, whose summits are wide and open, and thus afford at once freedom from ambush, and a total separation of the adverse parties. As the conferences to which I allude took place in the *village church*, which stands in the valley between the hills just described, I apprehend the purport of this paper will not prove irrelative to the objects of your publication. The architecture of the church may be thus described:—It is a building of great antiquity, comprising a Chancel and Nave of the same width, without Aisles or Transepts, but has a strong Tower rising from the centre, of heavy but singular construction. This Tower is carried up in a square form to the apex of the roof, where it is surmounted by an octagonal incumbent, crowned in its turn by a short spire, or rather broach, composed also of eight sides. The roof is particularly high pitched, and the whole edifice exhibits a severe example of Norman architec-

ture. The eastern façade is lighted by a single round-headed window of very, small dimensions, finished with plain stone dressings. Two flat buttresses rise against the wall, which are graduated by two slight sets off, and die into the stonework before reaching the eaves. The windows of the Tower are few, and very small, of like character with the one just described; and there is a total absence of every thing like architectural enrichment throughout the building. The original, and, at the present day, the only entrance, is at the western end. The arches (semi-circular), which give passage under the Tower to the Chancel, are of vast thickness, and, like the rest of the edifice, quite plain. I have already observed that the only entrance is at the western front, but two doorways, now bricked up, are to be observed in unusual situations, and of singular construction; the first has been cut through the thick north wall of the Tower, and the other perforates the south wall, near the western angle. They are small, and precisely similar, each having a square lintel composed of a single block of stone. The situation and form of these entrances, which would defeat every attempt at elucidation, are fully explained by the following historical anecdote, which I translate from the *History of Calais,* by P. M. Lefebvre, 1767, vol. II. cap. iv. page 64.

" In 1383 the English, desirous of profiting by the minority of the French king (Charles VI.), and impressed with an opinion of their own superiority, poured fresh troops into France. An armistice was, however, concluded between the two nations from February till October in the same year. The mediators on the part of France were the Duke of Burgundy, the Count de Flandres, the Count d'Eu, the Bishop of Bayeux, Enguerrand de Coucy, Arnaud de Corbie, Robert de Bethune, the Viscount de Meaux, Nicholas Brague, Jean de Sempy, Renaud de Dormans, and Jean Tabary (afterwards Bishop of Terouenne). The conferences were held *in the church* at Leulingen, *in which they had two doors made,* one for each ambassador, and for their respective suites, according to the *sides of the church which each occupied.* To prevent disputes during the ceremonial, they had also their tents apart from each other. The Duke of Burgundy had one constructed which resembled a town; the interior of its walls were fortified with towers, and it was sufficiently capacious to contain three thousand men; the saloons and chambers were richly furnished with tapestry of wool, and with cloth of gold and silver. Some (of the tapestries) represented battles, and others the Mysteries of our Religion. The chairs were all of like pattern, and the floors covered with carpets of hair."

The church of Leulingen was also a second time witness to a ceremonious and important meeting between the two nations. In 1396, a truce having been concluded between the kings of England and France for twenty-eight years, Richard II. married Isabella, daughter of the French monarch, in the church of S. Nicholas, Calais; she being then but eight years old. But Richard having been murdered in Pomfret Castle, the king of France required the restoration of his daughter, who was accordingly given up, and landed at Calais in 1401.

" Henri de Lancastre avait été proclamé Roi d'Angleterre sous le nom de Henri IV., après avoir détrôné son cousin-germain Richard II., qui mourut assassiné dans sa prison; le Roi de France réclama sa fille Isabelle, mariée à l' infortuné monarque dès sa plus tendre enfance. Henri, qui désirait faire épouser la jeune reine à son fils ainé, et qui comprenait bien qu' on lui demanderait la restitution de l' argent que Richard avait reçu sur la dot, éléva de longues difficultés. De leur côté, les princes qui gouvernaient sous le nom de Charles VI. ne voulurent jamais consentir à l' union d' Isabelle avec le fils du meurtrier de son epoux; mais enfin la

restitution de la jeune reine fut réglée par les ambassadeurs des deux nations, réunies à *Leulingen*, et

Le dimanche après, dernier jour
De Juillet, sans plus de séjour,
Partit de Calais la Royne
Avec Englois

" Qui la conduisirent à *Leulingen*, où l' attendait Valeran, Comte de S. Pol, Capitaine et Gouverneur de Picardie,

Et les ambassadeurs de France
Avec lui, qui grant diligence
Avoient mis pour la ravoir.

" Isabelle descendit dans une tente préparée dans le vallon au dessous de Leulingen, où vinrent la visiter Mesdemoiselles de Montpensier, de Luxemberg, et les autres dames que la reine de France avaient envoyées pour la recevoir; on se rendit ensuite à *la chapelle*, où peu de personnes furent admises. Le Connétable d' Angleterre, Sir Thomas Percy, remit ' en plourant moult fort' la reine entre les mains du Comte de S. Pol."

Neither the church nor the surrounding cemetery possess any sepulchral memorials of interest.

I am, Sir, your obedient servant,
ALFRED SUCKLING.

Barsham Rectory, July 14, 1842.

AN ANGLO-SAXON CHURCH.

To the Editor of the Ecclesiologist.

MR. EDITOR,—As the Society appears to take peculiar interest in the discovery of Saxon churches, I beg to forward you a few observations upon what I believe to be a very perfect and curious, though it appears hitherto unnoticed, example of this remarkable style.

The church of S. MARY BISHOPHILL JUNIOR, in the City of YORK, first attracted my attention by the peculiar appearance of its Belfry windows, and by the masonry of the Tower, and of a portion of the south wall of the Chancel. The Belfry windows each consist of two rudely-formed lights, the heads of which are somewhat in the horseshoe shape, and are placed under a semicircular hood or arch of square rib-work, which is continued, with the intervention of oblong imposts, down the sides and below the sills, where it is blocked off on a square stone projecting endwise from the wall, precisely as in several of the well-known Saxon Towers described by Rickman and others. The windows are divided by a rude cylindrical balustre, of 11 inches in diameter, without capital or base, but supporting plain massy oblong imposts, 2¼ feet long (*i. e.* in the direction of the thickness of the wall) by 15 inches wide, and 10 inches deep, and having the lower edge chamfered. The span of each arch is 1 foot 8 inches. The side imposts are similar to the central one; the arches are of small irregular stones, and the masonry is exceedingly plain and rude. The Belfry-arch is a very interesting feature. It is semicircular, having one subarch, retiring within the outer arch towards the Nave, but on the same plane with the wall inside. The edges are square ; and the arch springs from a rude double impost, consisting of plain square stones, about 20 inches long by 7 deep, the upper of which projects a little over the lower. The jambs are heavy square ribs or pilasters, spring-

ing from rude irregular plinths; the height from the ground to the imposts being 10 ft. The walls of the Tower are 2 ft. 5 in. thick at the top, and 3 ft. 1 in. towards the bottom. The Tower is of two stages, and has no buttress or pilaster externally of any description. Some herringbone masonry may be seen on two sides. The Chancel door, and the quoins at the south-east angle, appear also to be of Saxon character. I have briefly mentioned some of the chief peculiarities of this curious church, because I have no doubt that it was erected before the Norman style, properly so called, was imported into England, though I am inclined to consider it as one of the later examples of Saxon architecture. I was unable at the time of my visit to examine the north side, which is so encumbered with houses as not to be very easy of access. I much regret this omission, for I find that Drake, in his *Eboracum*, p. 270, says, "The north side of this fabric is almost wholly built with large and massy stones of the grit, *on some of which may be traced the mouldings of the regular orders.*" If this be the case, there can be no doubt of the remote antiquity of this church. Mr. Rickman does not appear to have carefully examined it, for he simply describes it as 'Norman.' I have placed drawings of some details in the Society's folio volume, in order that others may form their own opinion of the correctness of my remarks, and be induced on the earliest opportunity to visit the church for themselves, which is in other respects an interesting one. The bells are of great antiquity, but I was not able at the time to decypher the legends. There are also a few ancient coats-of-arms in stained glass: I noticed the arms commonly assigned to S. Wilfrid, Archbishop of York, azure three estoils or; and those of Acklom, gules a manch between eight cinque-foils in orle argent, quartering Trussell of Notts, argent a cross flory gules.

I cannot conclude without expressing an earnest hope that some members of the Society will as soon as possible visit, and if they possess the smallest influence in that quarter, endeavour to interfere for the timely preservation of, the very beautiful and valuable stained glass which yet adorns so many of the ancient churches in the venerable city of York.* I lately spent several days in searching for and examining the windows in the various parish churches which still contain any; and I can truly say, that I was both amazed and delighted at the extraordinary beauty of many of them, though painfully struck with the miserably neglected and precarious state in which without exception I found them. In many cases the pieces are actually ready to drop out of the decayed leaden frames into the street: in others, the windows are coated externally with dust and filth; in all there are the marks of wanton breakage and mean repairs in paltry white glass—a fit substitute, truly, for the glories which once blazed from these storied chronicles of saintly atchievement, in scarlet and gold and blue of almost unearthly brilliancy. Most of the glass appears to be of

* It is singular that Drake in his *Eboracum* should do no more than casually mention these beautiful remains, which must in his time have been much more perfect than at present. It is pretty evident, however, from some of his remarks, that he did not understand the subject.

late Decorated date; but there are a few very fine pieces of Early-English art yet remaining. I may mention particularly S. John's church, Michaelgate; S. Denis, S. Martin-le-Grand, S. Martin's, the Holy Trinity, All Saints in North-street, S. Michael's, S. Michael-le-Belfry, and S. Olave's; besides which there are others which will richly repay a visit. The value of this glass is probably beyond estimate, yet it is suffered to go to decay as if a mere valueless relic of bygone 'superstition.' In one church two windows appear to have been recently sacrificed to make room for vile pagan designs of the modern school, and certainly among the very worst specimens even of that. Unless the stained glass in the parish churches of York be forthwith taken out, entirely new set, restored where mutilated, and protected by wire screens externally, it is probable that a very few years will witness either its irreparable mutilation, or total demolition.

I am, Mr. Editor, yours, &c. A MEMBER.

[The church of S. Mary Bishop Hill is one of those which were previously known to the Society as possibly of Saxon date: and the above account seems to place the matter out of doubt. It makes the forty-sixth Anglo-Saxon church of which we have accounts. Too much attention cannot be paid to the glass in that most ancient and glorious city; it has been recommended to the Society's especial notice by Mr. Pugin in his *True Principles*: and some of the specimens are almost unrivalled. We may particularly notice the *Fifteen Last Days*, in a window of the north aisle of All Saints, North-street.—ED.]

THE NOMENCLATURE OF THE DIFFERENT STYLES.

To the Editor of the Ecclesiologist.

SIR,—The proposed substitution by the Cambridge Camden Society, of the terms Plantagenet and Tudor for the earlier and later periods of that style of Christian architecture known since Mr. Rickman's time by the cumbersome, though not inexpressive, name of Perpendicular, has, I perceive, given rise to a little controversy. My object is to build upon this substitution a proposal for a still more extensive alteration in the nomenclature of the different styles of Christian architecture, which I would suggest should all be designated after the respective dynasties at the time of their prevalence reigning. The first plot of this has been already laid out in the recognised terms Saxon and Norman, which latter style is also recognisedly divided into early and late; "Early English" might be termed "Early Plantagenet;" "Decorated," "Middle Plantagenet;" "Early Perpendicular," "Late Plantagenet;" "Late Perpendicular," "Tudor;" and the buildings erected during the partial revival of Christian architecture in the reigns of James I. and S. Charles, be formed into a separate class, and denominated "Stuart."

To recapitulate, we should then have eight well-defined and symmetrically-named styles of Christian architecture prevalent of yore in this land; viz. 1. Saxon. 2. Early Norman. 3. Late Norman. 4. Early Plantagenet. 5. Middle Plantagenet. 6. Late Plantagenet. 7. Tudor. 8. Stuart.

The evils of the old nomenclature seem to me to be, that it is unsymmetrical (which though no fault in Christian buildings, is yet one in the science treating of them), being partly descriptive and partly historical: and that the descriptive names are objectionable on several grounds. First, on the general ground, that all designative names must be imperfectly so, and therefore liable to lead to misconception by their faulty generalization: secondly, because they are utterly devoid of historical association : thirdly, because (though I say so who have no right, from my knowledge, to do it,) one of these two seems in itself incorrect, as does one of the historical names.

That style is called *Early* English which prevailed nearly eight hundred years after the conquest of Britain by the Angles. Were any style to be so named, it should be the Saxon. Besides, it wants its antithesis. To what should be so we give the name Decorated—and yet this is a style not nearly so decorated as those that follow it—because, forsooth, it is more decorated than the one that preceded it (and not even universally so, as "Decorated" country churches, we are told, are often the plainest of any). If we must keep the term it should be applied to the Tudor style.

One is naturally fond of one's own invention, but the proposed nomenclature seems to me very full of historical association. Early Plantagenet recalls the memory of the Holy Wars, and the prowess of Edward the First. Middle Plantagenet tells of Cressy and Poictiers, and the foundation of the noble Order of S. George : while Late Plantagenet reminds us of Agincourt, of the saintly virtues of the sixth Henry, and the proud career of William of Wykeham. " Stuart" calls us to the martyr-blocks of Archbishop Laud and S. Charles. Worldly associations, some one may say, and therefore not to bind themselves up with churches. Yet far from entirely so ; and if we consider the days they point to, hardly at all. Indeed, save a few, they are altogether Church thoughts.

Excuse the length of this, and believe me,
Your obedient servant, A. J. B. HOPE.

Bedgebury Park, August, 1842.

P.S.—To come from a general to a particular theme. Rickman has laid it down, and it seems acquiesced in from his time, that long and short quoins show a building to be Saxon. Now, in examining the Keep of Rochester Castle the other day, I found long and short quoins employed in its construction, placed (if I recollect rightly, though I neglected making a memorandum) alternately. The difference of length is not very great. This Keep was built by Bishop Gundulf, the first Norman Bishop of that See, who likewise rebuilt the Cathedral (of which work the greater part of the Nave still remains), and the Tower of London. Perhaps this is but a common quoining, and not real "long and short work," and in noticing it I only show my own ignorance, especially as Rochester Castle is so well known ;—but I thought it worth while to hazard the communication.

[That long and short work must not *invariably* be regarded as a mark of Saxon work, we have mentioned in the " Hints on the Practical Study," &c. p. 4, ed. 3rd., though we were not aware of this example.—ED.]

NEW CHURCHES.

IN introducing a notice, we are sorry to say an unfavourable notice, of several new churches in the neighbourhood of Bethnal Green, we cannot refrain from again expressing our admiration of the zeal and energy of the present Bishop of London, as displayed in this his noble scheme of church-building. It is an interesting and cheering sight to witness, as one passes through this densely-populated district, or is whirled over it in the North-eastern railway, the numerous churches rising on every side. It is a sight which would disarm criticism, did we not feel it a solemn duty to protest against such faults in architecture and arrangement as are rife in these churches, and could we repress a kind of indignation that so good a scheme should be so unnecessarily, so heartlessly, marred in the execution. And now that we are on this subject it may be allowed us to say a few words on the state of another large district in the metropolis. We doubt if there can be a more painful contemplation for the churchman than the erection of that magnificent temple in S. George's Fields; not only that this beautiful building should be designed for a church not in our Communion, but that our own incredible apathy should have left the enormous population, in the heart of which it is rising, so absolutely without churches or clergy, as to make it almost a subject for congratulation that the inhabitants may at last obtain access to the Holy Sacraments, though at other Fonts and at other Altars. In strange and fearful contrast to the northern bank of the Thames, we believe that the only effort made of late years, in this most neglected district, to remove overwhelming spiritual destitution, has been the licensing of two small, inconvenient, and unecclesiastical conventicles as pue-rented episcopal chapels! When we think that in a few months, in the midst of this spiritual desert, there will be open to all, even the poorest, without the odious intrusion of pues or the yoke of pue-rents, a church such as S. George's, with an active and numerous clergy, continual services, and a solemn ceremonial, we are constrained to say that we *tremble*, as churchmen, for the consequences.

S. Bartholomew's, Mile-end, has a Chancel nineteen feet deep, a triple east window with original detached shafts, five brick panels below for the Commandments, &c., two tall lancets on the north and south sides of the Chancel, and no Chancel-arch. There are also two Transepts, projecting beyond the Aisles as far as three feet: the Transept arches unfortunately are not distinguishable from those of the Nave. In each Transept elevation are two lancets, the south having also a door. The Nave-arches are four, springing obtusely from stuccoed piers, which have octagonal capitals, but bases of no particular character. The roof is not yet put up. In the Aisles are three double lancets. There is a western gallery, and preparations for lateral galleries should they be wanted. The west end is not very well managed: there is a *triple* window in a recess for an organ gallery, over the western entrance, formed by an arrangement of vestries and rooms over them to the north and south. There is a clerestory of three double windows. The flat roof to the Transepts has a bad effect, and its pinnacles are wretched. The buttresses also, though better

developed than usual, are singularly ill-contrived. However, there are some points in this design, such as the projection of the Chancel, which show that better principles are gaining ground gradually, perhaps even without the knowledge of the architects themselves.

All Saints, Spitalfields, is a church already consecrated. The Chancel is still a 'budding' one, though better than usual. On its north and south sides are windows of two lights under a segmental head. The east wall is not pierced, but has a strangely irregular arcading for the Commandments, &c. We cannot but disapprove of sacrificing the construction of a church for the better display of these ornaments. The Chancel-arch is segmental, and of some pretensions. The Nave has an ugly roof with tie-beams, and galleries on three sides supported on cast-iron piers. The drawing-room appearance of a mere Nave with galleries, the piers of which do not reach the roof, is most detestable. The pulpit, reading-pue, and clerk's-pue, ranging one under the other, stand exactly in front of the Altar. The Font stands at the west end, but is particularly poor. A shallow square bason, not large enough for immersion, ornamented with a thin, straggling, single chevron-moulding, rests upon a large circular stem encompassed by four smaller shafts. The material is '*composition.*' There is here a western porch, with a parvise used for the gallery staircases. The roofing of this is very awkward. The Tower is engaged in the middle of the south side ; it is a poor Romanesque composition.

S. James the Great, Bethnal Green, has a Chancel eight feet deep, and two Transepts projecting nine feet from the walls of the Aisles. Within there are seven narrow arches, the span being eight feet, with thin octagonal brick piers. The disproportion of this form must be obvious. The place where the Chancel should have been is occupied by a parsonage-house! Viewed from a distance the Transepts appear to be the Chancel and Nave, and the real Chancel a shabby Transept. What then must be the effect when we find out the real plan, and that both Chancel and Transepts are equally miserable? Why, we may again ask, must so many new churches have Transepts? Independently of their less appropriateness to our services, we thus have four expensive gable elevations instead of one only at the west. The Transept elevations here have a *vesica piscis* above a row of windows consisting of one of two lights with a circle in the head, between two lancets. Below this row is a door, and a small window, as if to admit light beneath galleries, on each side. The east window is a sort of arcade of six lancets, the two exterior not being glazed, and the two central having a circle between their heads. The Aisles have four lancet windows. The roof, when we saw it, was in course of erection. It has tiebeams, but will be of very considerable height, without, somehow or other, producing a good effect. There is already built a western gallery, supported on ' cast-iron gothic' pillars, the bonding of which into the brick piers it is diverting enough to see. The church will hold 1300. The Tower, which is poor, is at the west end of the south Transept.

S. Andrew's, Bethnal Green.—The western elevation of this church is almost inconceivable. It is very broad, and the pitch of the roof

lower than usual. Towards the top is a round-headed aperture; under this, as if in a second tier, are three pierced round-headed windows; below these, a blank unequal round-headed triplet; and at the bottom, a similar door between two blank arches. Let it not be supposed that this front boasts of any string-courses: to be sure it does not face the street; yet the architect might have done better than to copy badly, because irregularly, the side of a pigeon-cote. There is a clerestory containing six couplets of round-headed windows. The Aisles, aspiring to two tiers, display, in corbel-panels, six broad windows, and below them a repetition of the clerestory arrangement. The whole is executed in uniform white brick: now-a-days variety is often sought by using different sorts of bricks. The east end is a sort of three-sided Apse, the sloping sides (which are absurdly small in comparison with the eastern one) being clumsily furnished with gables. The east window is an unequal triplet of round-headed windows, the central of which presents the original arrangement of capitals to its shafts, at the same level with the impost of the exterior lights, supporting an upper tier of shafts with its arch and imposts. At the north and south end of this apsidal recess are projecting octagonal buildings for vestries, &c., connected by a cloistral gallery running under the east window. This gallery is arcaded in six round-headed arches, all but the two exterior being pierced. At the north angle is a poor Belfry. The inside we did not examine.

S. James the Less, Bonner's Fields, Bethnal Green.—The church in course of erection here has a Nave and small trigonal Apse. The west elevation exhibits a *false* pediment, in which is a pretending wheel window of eight lights. Under this are six glazed poor round-headed windows, all in a row; and at the bottom, an unequal triplet of round-headed doors. The façade is flanked on the north by a nondescript sort of staircase structure; on the south, by a square Tower of very great pretension, containing five stages, and displaying all varieties of moulded bricks. On the north of the western gables, however, is a pinnacle, with a fair-looking pedimental capping, seemingly of masonry. The sides of the Nave are divided by buttresses and corbel-tables of white brick into eight compartments of a reddish brick. In each is a poor round-headed window of two orders, with a chamfered bit of stone at the impost. The same arrangement is repeated under a poor brick string-course. Under the east window is an entrance to the vaults! The inside has a heavy tied roof, a gallery on three sides, and *Norman pulpit and Altar-rails.* Alas, that the Altar should, as not being so visible, be made so much more paltry than the other woodwork! However, there is an open desk for the Prayers, and the Font, though very poor, is at the west end, and provided with a drain, and is large enough for immersion.

S. Peter's, Hackney-road.—Here a small Chancel projecting a few feet has an obtuse roof and an eastern round-headed triplet. In the apex of the gable of the Nave is a plain circle. In the angles between this Chancel and Nave are curious turrets serving for the ascents to the rival pulpits. A vestry on the north of the Nave was described by a person on the spot as being in the 'coal-hole' style: and the

epithet will be found very expressive. The sides of the Nave have
four compartments, each capped by a poor corbel-table; the inter-
vening buttresses are more than usually bad. Each compartment is
subdivided into two by another, a smaller, brick buttress. In each of
these is a tall round-headed window, with a dripstone continued in a
smaller corbel-table. The whole is unsuccessfully panelled in flint
and white bricks. The basement moulding is wretched, and the effect
of the flat slated roof, its gables unadorned with Crosses, most dis-
pleasing.

S. Peter's, Islington.—This church having been built seven
years ago in the plainest and most unecclesiastical style, it is now
proposed to enlarge and improve it by adding a Tower at the north-
west angle, two short and broad Transepts, a new west "lobby," and
a sort of Altar recess at the east end. The design for the "im-
provements" is by Messrs. Gough and Roumieu, and is said to have
received the approbation of Mr. Barry, from whom we are compelled
to differ materially, if any faith is to be placed in the small engravings
published in a little circular entitled "A plea for aid towards the
enlargement and improvement of S. Peter's church, Islington." The
Tower with its spire is to be 120 feet high. It is a complicated mass
of Early-English frippery, of that class in which nine-tenths of con-
ventional-Early-English churches are now built, without a particle of
the simplicity and grandeur which characterised ancient models. We
should recommend that the new part be built with the special object
of propping and strengthening the present frail structure, "for sub-
stantial repairs, painting, &c." of which £200 (in *seven years*) are
required!

Of the church of *S. Thomas, Bream's Buildings, Chancery Lane,*
we are sorry that we cannot speak in terms of commendation. Every
thing has been sacrificed apparently to the west front,—if it be a west
front, for we much doubt of the correct position of the church.
The west window is an unequal round-headed triplet, within a large
segmental arch of construction, and below it is a surface arcade of
intersecting arches. There are round-headed doors. The church has
been consecrated within these few days.

*S. John the Evangelist, Farncombe, in the Parish of Godalming,
Surrey.*—This is to be a small Early-English building, consisting of
Chancel (a full and deep one), Nave, and south Porch. The Tower
and Aisles will be added subsequently. There will be no pues or
galleries: and the whole will be built of stone, and oak or chesnut.
There will be an eastern triplet and a western couplet. The Font will
be of polished Purbeck marble, a copy of that at S. Margaret, Ifield,
Sussex.

The new church at *Cam, Gloucestershire,* though very similar to
the above, is, according to the proposed plan, inferior in some points.
It has a north Aisle, which is less in character with ancient buildings
than one on the south side.* It is not intended to add a Tower. The
whole will be built of stone, and, we believe, oak.

* Since the above was written, we are glad to hear that the ground-plan has been
altered in compliance with the suggestions of the Society.

In both these instances we anxiously hope that a Chancel-screen will be provided. There are very simple Early-English models at Old Shoreham, Sussex; Stanton Harcourt, Oxon; Stone, Kent. Or if a light Perpendicular one be preferred, we should recommend that at Horne, Surrey.

The church of *S. Andrew, Ham,* which has been built some years, may be referred to as an example of the worst sort of modern churches. We believe that it was designed by an amateur. Had his wisdom equalled his good feeling, we should not have had to deplore the result of his exertions. Much flaunting coloured glass has lately been put in the east window at the cost of a parishioner, a glazier. Here, again, the motive is as excellent, as the taste displayed defective. The reading-pue is far too high, the Font (alas!) close by the Altar, which is however made *Altarwise,* and there is a triple western gallery. The vestry, with the school, is behind the Altar. One of the escutcheons displays some false heraldry. We were informed that already serious cracks had manifested themselves in the structure.

Holy Trinity, Crockham Hill, Westerham.—This church appears, from a brief account we have received, to do credit to the taste of the architect, and to the piety of the 'only founder.' It is entirely constructed of ⸤stone and oak. We should be obliged by a detailed description.

S. Catharine's, Northampton.—The west elevation of this church exhibits a Tower, with octagonal lantern and short spire, at the southwest angle; a Decorated window, with a canopy over it, above a *square-headed* doorway, in the Nave, and a north Aisle corresponding to the base of the Tower. This injudicious uniformity is by no means to be commended. There is a west door in each of these sides, and above is a meagre Perpendicular window of two lights. Others of a similar description are placed along the north and south sides; they are destitute of mouldings, but have affected florid transoms. The pinnacles on the lantern of the Tower have neither crockets nor finials; these perhaps are some day to be added in patent cement. The buttresses are thin and poor: there is merely a shallow recess for a Chancel, with a wretched gable, and still more wretched east window, without mouldings or label. The east end however *is not much seen.* There is no Clerestory: a commodious vestry stands on the north-east end, the rather heavy appearance of which is delightfully relieved by a patent zinc chimney of some seven or eight feet in height. The interior we did not examine.

S. Andrew's, Northampton.—This is a large new church which would be deserving of some commendation, were there not some very great faults in arrangement and details. The latter, generally, are badly worked: the capitals of the shafts, whether plain or foliated, are clumsy and incorrect; indeed, they are nothing but miserable burlesque imitations of ancient work, not a single moulding being of the true form. The church has a western Tower, Nave with two Aisles, and a short recess instead of a Chancel. The Tower has some good points: but no Early-English Tower can ever look really complete without a spire. There are not less than five doors, three at the

west and *two at the east end:* we suppose for the sake of uniformity, as they are all of the same design, except the western entrance in the Tower, which is larger, and surmounted by a heavy canopy that might well have been omitted. All these doorways have mouldings and triple jamb-shafts; but the former are heavily grouped, and the latter should have been detached; the hollows between them are extravagantly deep. The Aisles are lighted with couplets of lancets, of cathedral proportions, that is, three or four times as large as an ancient church of the same si :e would have had. The pinnacle turrets on the Tower, and especially at the ends of the Aisles, appear top-heavy. We can say nothing in favour of the interior arrangements, except that the sittings are all open, though of no more costly or substantial material than painted deal. The pulpit is at the east end; and along three sides run painted deal galleries ornamented with an Early-English arcade. Instead of a lofty belfry-arch, a small lancet door opens aloft into the west gallery. The Nave-piers are pretty good; but the arches are wretched, having a single splay so wide that the archivolt is tapered almost to a point like a wedge, whereas an arch of two plain orders would have been perfectly correct, and we should suppose not more expensive. The church is faced externally with stone.

Radipole Church, Dorsetshire, has the usual feature of modern Early-English, couplets of lancets in the Aisles, and the usual fault, a western triplet. The side buttresses would be better with a second set-off, or with the present single one in each placed somewhat lower. A string should run under the lancets; an important, if not essential feature, too generally omitted by modern architects. Ancient lancets have not, indeed, *invariably* strings underneath them; but it was a principle with the architects of old, at present little understood, so to combine the horizontal with the vertical, that *the predominance of the latter over the former, as exhibited by contrast,* and not vertical ascendancy alone, should produce that peculiar effect which is so characteristick of Christian compared with pagan architecture. The western string-course, however, is very good. The Clerestory also deserves much commendation. The Tower is at the west-end of the north Aisle, and is not altogether a very successful composition. The belfry windows are placed too high, as we think we have noticed in other designs by Mr. Ferrey; and the pinnacles, with the pierced parapet between them, seem less appropriate than a simple broach-spire. Let it ever be remembered that *simplicity of composition was the prevailing characteristick of small Early-English churches.* The belfry windows and spire-lights should have foliated, or, better still, plain circles in the heads. The trefoil-headed doorway and the south porch are deserving of praise. We cannot say whether this church has any Chancel, as the engraving represents (as is too often the case) a south-west view. Let us hope that there is one of three bays, each lighted by a single lancet, say 5 ft. high by 9 in. wide; and three *separate* lights of equal height, 12 ft. by 18 in., at the east end.

Most people have already laughed at the church at *Friars' Mount, Shoreditch.* This is designed in the pseudo-Romanesque style. The sides have seven compartments made by buttresses and corbel-tables,

with round-headed windows of three receding orders, the arches above the imposts being made in bright red brick. The western front has a flat pitch, a plain window above, and an unequal round-headed triplet with red brick above the impost. There are *two* western Towers, square with three panel-like stages. In the top are three arches of construction, unequal in height and breadth, pierced for belfry windows. Below, three equal lights. In the lowest stage is a round-headed door, with reed capitals, nook-shafts, a plain tympanum, and iron scroll-work better than we should have expected. The bottom stage of the west front has a door, like that which we have described in the Tower, between two windows of three orders, resembling those of the Nave, only cut short. The Towers have pedimental cappings of a singularly clumsy and inelegant design.

CHURCH RESTORATION.

York Minster.—We have not hitherto had an opportunity of noticing the interesting report on the subject of this restoration, which was presented to a meeting of the subscribers held at York on the 31st of March last. It appeared that the sum then collected, £14,337 3*s.*, had been almost entirely exhausted in the repairs of the south-western Tower and the roof of the Nave. Indeed a small sum was wanted to meet the liabilities of the Committee. The following works of restoration still remain to be done: the whole *vaulting* of the Nave, the roof of the western part of the south Aisle; repairs of many parts of the piers, windows, &c., as well as of the stained-glass and pavement; and the completion of the peal of Bells.

A second report from Mr. Smirke, the architect, details many other restorations which the general state of the fabrick requires, particularly in the north Transept. The estimate for *these* is £28,200; which sum, together with £10,200 wanted for the completion of the parts injured by the last fire, and £7,000, an actual debt incurred on the fabrick-fund after the first fire, makes a total of £45,500.

It appears that the Dean and Chapter have resolved to meet this emergency by mortgaging the fabrick-funds; and the residentiary body have made very great sacrifices in addition to their individual donations. The non-resident Canons have also contributed nobly, and "in a similar spirit, under a sense of the ancient obligations resting on these revenues, the Ecclesiastical Commissioners, who have now in their hands about one-third of the property of the original body of the Canons of York, have agreed to contribute to this object the sum of £500."

The above-mentioned measures of the Dean and Chapter will produce £27,000, of which, however, after paying off the present debt, and after the necessary reserves for the current repairs of the Minster, only about £5,000 can be devoted to the restoration. We quote the conclusion of the able statement of the senior Canon residentiary.

"The case in brief is this: that after the Dean and Chapter have done their utmost, have made the personal sacrifice which I have described, have

mortgaged the property of the fabric and that of the residentiaries for many years; and succeeded, as they hope, in raising £26,000, the sum of £12,000 is still wanted—£6,000 to complete the restoration of the Nave, and as much more to accomplish substantial repairs of dilapidations for which the Dean and Chapter are unable to provide, and which are not ordinary repairs but of the extraordinary nature which I have described, such as could not have been prevented, and for which no provision exists.

" Thus if the public should think fit to supply the *whole* sum now wanting to repair *the damage from the late fire*, amounting to between £10,000 and £11,000, almost all that is essential to the substantial reparation of the Minster will be accomplished; and when the fabric funds recover from the incumbrance of the present annuities, the ornamental repairs may likewise be provided for. I must say, however, that there do appear to me to exist two reasons for not thinking the present the most favourable moment to press for subscriptions: the one, a point about which I am most anxious, that the country may first have the necessity of the call clearly before them; the other, that the measures which the Dean and Chapter propose, in order to render restoration practicable, have yet to receive the sanction of Parliament. The Dean and Chapter cannot now place the sums which I have mentioned at the disposal of the Restoration Committee: but we shall be ready to fulfil our undertaking as soon as the Bill which we have introduced shall have passed into an Act."

Yarmouth.—" In the autumn of 1841, the Dean and Chapter of Norwich ordered the restoration of four Early-English couplets in the north and south Aisles of S. Nicholas church. The Apse has been *embellished* for many years by a painted Grecian screen, which was removed from the south and north sides, when the *opus pretiosum circa magnum Altare*, mentioned by Swinden, was exposed to view. This part of the church is thus described by Swinden : " In the east end of the aforesaid *middle Aisle* stands the Communion Table, where formerly stood before the Reformation the great or high Altar, and over it a loft or perch, called the Rood-loft, which supported a large Crucifix, behind which was a vestry. Which said Rood-loft was erected by Roger de Haddesco, Prior of S. Olaves, in 1370, and ornamented with curious decorations and devices, at his own cost and charges." Of this there is no doubt that the work now discovered formed a part. In the westernmost arch is a small low four-centered archway, where was a door which probably led to the Confessional, as close behind the column on each side of the doorway the orifice still remains.

"The remains discovered on the south side of the Apse consist—to begin with the easternmost—of a piscina and five sedilia. The first being the Prior's seat, has an hexagonal back panelled, the upper panels being charged with the arms of the See, the Deanery, and the Priory. It was surmounted by a handsome groined canopy, which appears to have been of an ogee form, richly ornamented with crockets and finials, but the whole of the ogee arch has been destroyed, leaving only the groining remaining. The next three are handsomely decorated arches, with triangular heads crocketed and finialed, separated from each other by clustered columns, each cluster being surmounted with a pinnacle, and each arch with a handsome trefoil. The first and third of these arches are peculiar, having one side shorter than the other, whence it is supposed that the Prior's seat and the westernmost seat

were inserted after these three seats, which supposition is borne out by the fact that they are of a much later style of architecture. The fifth seat is a four-centered Perpendicular arch, inserted in a square moulding, with foliated spandrils, and is evidently of still later date. The piscina is contained in an arch similar to that of the third sedile. The original stone bason with the water-drain was found bricked up. The capital of the column separating the third and fourth is curiously battlemented. The backs of the sedilia have been tinted alternately pink and green, and the spaces in the wall over each seat, between the pinnacles, alternately green and pink, and the colours appear to have been extremely rich. Swinden says that there were originally three Priests and a chaplain, and is fully borne out by these sedilia, which we hope soon to see restored to their pristine beauty.

"Among other discoveries which have lately been made in this church is the original Altar-stone, which now lies in the north Aisle of the Chancel."

[We extract the above account from a provincial paper; and while we are glad to see that the spirit of church restoration is everywhere spreading, we hope that our friends at Yarmouth will so far add to their zeal knowledge, as not to speak of a Rood-loft over, or a Confessional near, the Altar.—ED.]

THE church at *Teddington*, Middlesex, has been just repaired and restored, unfortunately not in good taste. The Font would appear to have been lately removed to the eastern end of the Nave. The whole building is miserably pued.

THE cover of the Font in *S. Edward's, Cambridge*, is in progress : it is an adaptation from the magnificent Perpendicular one at Littlebury, Essex; and will stand five feet six inches high, including the figure of S. John Baptist on its summit.

THE spire of *Coton* church, Cambridgeshire, has recently been struck by lightning, and about four feet of the upper part demolished. We hope that steps will speedily be taken for its restoration.

THE glorious spire of *S. Mary's, Stamford*, has been injured in a similar manner. We have heard that the parish have resolved not to restore it; but we are unwilling to believe that so incredible a piece of meanness would be allowed in a Christian town possessing the wealth and population of Stamford and its neighbourhood, and we therefore wait for further information on the subject.*

WE regret that we can only call attention to the proposed restoration of the noble Decorated East Window in *Wareham* church, Dorsetshire. The Nave has recently been rebuilt; and we are most sorry to hear that galleries have been allowed; and the more so, because we are informed that had the architect, as he ought to have done, expressed any disapprobation of them, they would not have been erected. We are glad that the pues have been removed from the Chancel.

* Since restored—[2nd edition].

S. SEPULCHRE'S, CAMBRIDGE.

SINCE we last mentioned this church, the works have been proceeding steadily, and it even already presents a very beautiful appearance : and the number of visitors to see it at the Installation has added considerably to our funds. The latter now stand thus :

	£.	s.	d.
Donations towards the restoration of the circular portion	636	19	0
Three stained-glass windows about	54	0	0
Voted by the parish in vestry for the Chancel and new Aisle	300	0	0
Subscription within the parish for the same purpose ...	79	0	0
	£1069	19	0

It is not too much to say, that less than £1000 more will not complete the restoration as the Committee wish; for besides the 'necessary' expenses hitherto unprovided for, they earnestly desire to pave the whole building with encaustic tiles; to fill the five remaining Clerestory windows, and all those in the circular Aisle and Chancel, with stained glass; to provide a Font worthy of the church, and oak stalls and poppy-head benches; and, if possible, to rebuild the wretched North Aisle.

We were much gratified at the approbation bestowed on the restoration by several of our distinguished visitors, especially His Grace the Archbishop of Canterbury, and the Bishops of London, Winchester, Bangor, and S. David's; each of whom left us a substantial testimony of his good wishes.

The scaffolding is now removed from the circular part; and the whole of it, with the exception of the lower part of the Piers, restored to its original appearance. The Piers and Arches of the South Aisle are already completed, and the new walls raised as high as the window-sills.

The stained-glass, the gift of Mr. Williment, already filling one of the Clerestory windows, represents a Holy Lamb, with the scripture, **Agnus Dei, Qui tollis peccata mundi, miserere nobis.** The second window, the gift of the President, now in course of preparation, represents a Pelican in her Piety, with a Chalice, and the two Tables of the Law below. The former has the word *Ecclesia*, the latter *Synagoga*, attached to it; and the scripture is **Hic enim est Sanguis Meus Novi Testamenti, Qui pro multis effunditur in remissionem peccatorum.**

Some well-turned Early-English capitals and some tooth-work have been discovered in the course of the restorations; they retain much of their original painting, and are supposed to have formed a part of the Priory church at Barnwell.

We understand it to be the wish of the parishioners that the miserable vestry should be removed, and the North Aisle carried quite to the east end: and we earnestly hope that funds for this purpose may be ere long forthcoming.

[Since the above was in type, we have great pleasure in announcing the noble contribution of three *ancient* stained-glass windows, the gift of H. P. Oakes, Esq., of Nowton Court, Bury S. Edmund's. The subjects are—The SAVIOUR, S. Patrick, and S. Etheldred, with ornamental canopies, borders, and an additional figure in the head of each. These have already been placed on the north side of the Clerestory.]

NOTICES OF NEW WORKS.

Churches and Church Services. Parker, Oxford. pp. 63.

AN interesting little volume, by one of the Members of our Society. Its aim is to point out the various abuses by which, from time to time, the Catholick arrangements of our churches have disappeared. Chapter the first dwells on the evils of the pue system, the neglect of the Daily Service, the depreciation of the Holy Sacraments, and the undue exaltation of preaching. Chapter the second is occupied with the manner and place of saying service in the church; and chapter the third, on the internal arrangement of churches. We have only space for one extract; and that we give, because the horrible desecration of the churches in the Channel Islands is a subject to which we ought before this to have called attention.

 " In the reign of Edward VI. a commission was directed to certain persons ' *pour leur enquerir—pour les cloches, tant grandes que petites . . . et generalement pour extirper, ôter et abolir toutes idolatries, bigoterie, et superstitions, hors de la dite Isle de Jersey. A raison de quoy toutes les cloches des Eglises furent devallées et monsent (mises?) bas, sauf une cloche qu'on laissa pour chacune Eglise.'*

 " And accordingly the cheerful sound of Catholic bells is now unknown in Jersey; at least I have heard of no such a thing as a peal . . .

 " Fonts do not exist as such. In one church a good Font, lately discovered, has been placed near the vestry for safety, or some such other reason, and was supposed to have been a *Holy Water Basin.* A parish clerk asked the writer what a Font was. Holy Baptism is always given out of a basin, which is called the ' *Plat de Bâteme.*' "

 We may add, that a drawing of a very singular Font belonging to one of the Jersey churches, in the Society's portfolio, represents it as used for an ornament in a tea-garden !

 " In many, if not most, of the parish churches, of which the Decanal church of S. Helier is one, *there is no Altar nor Holy Table* as part of their visible furniture. The pues are continued straight up to the east wall. There stands in some churches at the foot of the pulpit, in the open Aisle, a largish table, not so broad as a carpenter's bench, looking exactly like a place on which to put hats and cloaks. On this thing the Holy Communion is celebrated, when it occurs."

 Those of our members will feel more indignant at these shocking accounts who heard the translation, from the *Black Book of the Bishop of Coutances,* of the consecration records of some of these very churches in the ' Holy Island,' read at a late general meeting of the Society.

Churches of Yorkshire. No. I.—ADEL. T. W. Green, Leeds.

WE are glad to be able to announce the publication of the first part of this series, which promises to be as interesting and valuable in its matter, as in its getting up it is creditable to the taste and liberality of the publisher. In the prefatory remarks, after alluding to the revival of architectural taste which has called forth the publication, the editor quotes Mr. Poole and Mr. Lewis in approbation of their opinions with respect to the symbolism of architectural design. The work, it appears,

is to consist chiefly of illustrations of the more beautiful of the *village* churches of Yorkshire.

The introduction contains a brief account of the first planting of the Church in Britain, with a list of the eighty-three Bishops who have occupied the See of York, from S. Paulinus to the present Primate.

We quote the following passage as likely to turn the attention of some of our readers to this and similar interesting speculations.

" The city of York appears to have been the centre whence the light was to shine which was to illuminate the dark and benighted parts of the north of Britain. It forms an interesting subject of enquiry, how far the character of the buildings dedicated to the honour of GOD may be considered as proof of the course which Christianity took. We find a very defined line marked out by the following churches, whose architectural features are of a very early and distinctive kind, viz. Norman: Healaugh, near York, Wighill, Thorp Arch, Bardsey, Adel, Guiseley, and Hartshead." (p. 17.)

Amongst the most interesting quotations is the passage from Mr. Churton's ' Early-English Church,' describing the dedication of Ripon Minster, A. D. 680. The following would be a good hint for the present day.

" S. Wilfrid, wherever he went, took with him not only his chaplains and clergy, who taught chaunting and psalm-singing, but a company of builders and stonemasons, plumbers, and glaziers, and carpenters, to build churches and baptisteries about the country."

The remarks upon the origin of parishes and church-patronage will be read by many with interest.

A brief account of the Norman style of architecture is introduced by a comparison of Rickman's dates with those assigned in the third edition of our *Hints on the Practical Study of Ecclesiastical Architecture.* We have again to lament the want of a consistent uniform nomenclature among architectural writers. Let us hope that Mr. Sharpe's paper, shortly to be published in our *Transactions,* and of which an abstract was given, supra p. 120, will help to define and classify the ideas of writers on this subject.

The editor prefers Adel as the spelling of the name of this church to Adle, or Addle, the form preserved in other places. He derives it from Adhill, as the word occurs in the Liber Regis, meaning the hill of Ada. This is different from the generally admitted etymology. The church is described in detail in the order of a Church-scheme. The window on page 35, line 7, we should have described as D. 2 L. 3f. a 4f. in hd.; or Decorated of two lights, trefoiled: a quatrefoil in the head. We rejoice to see that this publication begins by boldly taking up ground against pues; and in favour of high roofs. We well remember the deformity of the pues in Adel church; but amongst many excellent improvements effected or contemplated by the present Rector, let us hope that these will soon be demolished. The Chancel roof, it appears, is to be raised to its original pitch.

We must in conclusion repeat our commendation of this work, and express our best wishes for its success.

S. MARY, STOURBRIDGE.

To the Editor of the Ecclesiologist.

SIR,—I hope you will not take as an interference the following suggestion for a plan for the restoration of the Stourbridge Chapel, Barnwell; a relic, in my mind, scarcely less worthy of restoration than S. Sepulchre's church. Let the land around the Chapel be requested or bought of the University for a cemetery ; a clergyman might be repaid for his labours by a subscription of £5. 5s. from each minister in Cambridge for undertaking that part of their duties. The burial-fees might be returned to the incumbent of the parish to which the person buried might belong. I do not know whether Stourbridge is extra-parochial or not, or whether the incumbent of the parish in which a person is buried can demand the fees. I cannot help thinking many persons would willingly engage in it, as the *utility* is so apparent, and the crowded state of the church-yards in Cambridge must create no inconsiderable feeling of disgust to the most apathetic person. Any plan however would be highly desirable, which should involve the restoration of the Chapel as a matter of necessity, under the direction of the Cambridge Camden Society.

I remain, Sir, your obedient servant,

A MEMBER.

[We beg to call the attention of our readers to the above letter. The proposal it suggests appears to us so feasible, the ancient Chapel of S. Mary, Stourbridge, so peculiarly deserving of restoration, and the sum which would be required for this purpose so inconsiderable ; to which we may add, the necessity for a new cemetery in or near Cambridge is so urgent ; that we earnestly hope measures will be taken for carrying it into effect.—ED.]

CONFESSIONALS.

To the Editor of the Ecclesiologist.

SIR,—As you have given abundant proof of willingness to make your periodical a vehicle for the resolution of 'ecclesiological' doubts and difficulties, I beg you will allow me to request from some members of your Society information on a curious point to which hitherto but little attention has been drawn, and which is in consequence but imperfectly understood : I mean that of *ancient Confessionals.* This is, I admit, in the present discipline of our Church, a matter of antiquarian interest rather than one of the many neglected usages which you are more immediately concerned in endeavouring to restore; but the subject is curious as connected with these singular arrangements found in some few churches, which are traditionally called *Confessionals.* Upon recently viewing the repairs at Chesterton church, I was shewn by one of the workmen a small square aperture, which had just been discovered in the north Chancel wall opening into the sacristy, the inner side of which was fitted with a stone pierced with a quatrefoil, and having on its surface a kind of socket, as if it had been occasionally stopped by a board placed over it. The resemblance between

this aperture and the not dissimilar one, vulgarly considered as a Confessional, which opens from the Chantry behind the Sedilia in S. Michael's church in this town, immediately occurred to me; and though I can hardly imagine that Confessionals should ever have been placed near to a high Altar, I am totally at a loss to conceive any other use to which such an aperture can have been put; as the hole is a narrow slit in the wall, with a considerable splay on the side of the Chantry. Again, in the Tower of Trumpington church is a small arched recess, sometimes called a Confessional, which is just large enough to hold one person; and here likewise there is a small oblong slit in the wall.

Other similar apertures are known to exist: but the most curious with which I am acquainted is one at the west end of the North Aisle in Ryhall church, Rutland. Here there are distinct marks of a small building or chapel having been erected on the outside; and if I am not deceived, the foundations of a similar one may be traced at Trumpington.

My chief difficulty in this matter is, that in old missals and paintings Confession is always (as far as I have observed) represented as taking place *in the church*, the priest sitting on a stool or chair, and the person kneeling by him and speaking in his ear. This is clearly seen in an ancient fresco-painting given in vol. I. of Carter's *Ancient Sculpture*.

I observe that in the account of Trumpington church, published at the end of the last edition of the Society's ' Practical Hints,' no notice is taken of the so-called Confessional as such, but it is merely described as a recess in the Tower; while in a former edition it was recognized and described as such. This induces me to think that you have some valid reasons for rejecting the commonly received account of this peculiar recess. Any information on this subject will greatly oblige,

Your obedient Servant, Δημότης.

[There can be little doubt that the recess at Trumpington was intended for the use of the person who rang the *Sance bell*. The hole for the rope may still be seen in the roof, besides the slit communicating with the Tower.—ED.]

FOREIGN STAINED GLASS.
To the Editor of the Ecclesiologist.

SIR,—In page 179 of the *Ecclesiologist* is an extract from a circular regarding the church of S. John the Baptist, at Eastover. In it a fear is expressed that Government would not be willing to allow the drawback on painted glass imported for a church, supposing in the interim the windows had been glazed with plain glass. This might alarm some people, and for the good cause of Ecclesiology I am happy to be able to remove that alarm. In a church in my neighbourhood, under precisely the circumstances above stated, the drawback though not received has been allowed : so that no one need on this account be frightened from giving foreign glass to churches. The estimate of a temporary glazing, fixing, &c. entailing three times the expense the proposed plan would do, is a strange miscalculation. In the above-mentioned case there was certainly expense entailed on

this account, but to a comparatively very slight amount. If you think these facts worthy your notice, they are heartily at your service.

I remain, Sir, your obedient servant, CANTIANUS.

EXETER DIOCESAN ARCHITECTURAL SOCIETY.

IT is with great satisfaction that we announce a donation from this body towards the funds of S. Sepulchre's. The following resolution was past at the last quarterly meeting:—

" That in consideration of the great kindness shewn to this Society by the Cambridge Camden Society, and the peculiar interest which belongs to the ancient and venerable church of the Holy Sepulchre, Cambridge, now under repair, the Exeter Diocesan Architectural Society venture so far to depart from their usual course as to recommend that the sum of £5. be transmitted to the Committee of the Cambridge Camden Society, as a donation towards the completion of the work."

The report then submitted to the meeting opens with great congratulations on the change in the Rules of the Church-building Society. It is to be earnestly hoped that much good may follow from the remonstrances of the Committee on the dilapidations and desecrations of the churches at Sidbury and Lustleigh. As much doubt existed in the minds of the deputation as to the real age of the Tower at Sidbury, an exact model of it is to be made. In Lustleigh church, a monumental effigy of Sir William le Barose has been removed from its tomb to the eastern sepulchre, in which position it has suffered much from the damp arising from the accumulation of the church-yard outside. The Rood-screen is perfect, with the exception of holes cut by two farmers " who wanted to see a little more of their neighbours from above their great overgrown pues." The Incumbent here has lately disengaged from white-wash both the Font and Nave Piers and Arches. Some ancient stained-glass has been destroyed within the memory of some of the inhabitants, " because it made the church dark and the clergyman could not see his sermon." The Society has also made an additional grant of £3 towards the restoration of the Rood-screen at *Bradninch.* The account of S. Mary's, Ottery, will shortly be published.

CHURCH DESECRATION.

WE can hardly trust ourselves to speak of the disgraceful re-pewing contemplated, or perpetrated, in S. Nicholas, COMPTON, Surrey. This, as many of our readers may be aware, is one of the most curious churches in the kingdom. The Chancel, which is of Norman date, is very low, and groined diagonally; over it is the Ladye Chapel, opening westward toward the Nave, and fenced off by a low parclose of Norman woodwork (a thing perhaps unique), to guard the worshippers in the chapel from any accident. The Ladye Chapel is entered by an exterior staircase. *It is now to be turned into two pues !* and it would be too much to hope that the parclose will be spared. We shall recur to this subject as soon as we have more accurate information ; and beg leave in the mean while to assure the perpetrators of such an outrage on all ecclesiastical decency, that we shall spare no pains to make their conduct as publick as it ought to be.

WE have heard with feelings of the deepest indignation the horrible desecration of ELY chapel, the most beautiful Decorated building in London. It is said to have just been sold to some dissenting sect for £1000. [We are happy, in a second edition, to say that the Chapel was not sold as above described, although (as we understand) some dissenters, besides a Welch congregation, made application for it while it was proposed to sell it.—ED.]

NOTICES.

THE Society has just published *Twenty-three Reasons for getting rid of Church Pues;* price 1d. or 5s. per hundred. They are written in a plain style, and intended for the poorer part of country congregations.

Also, in one broad sheet, at the same price, for suspension in vestries, *Hints to Churchwardens;* abstracted from the first and second part of the *Few Words.*—Three errata in some of the earlier copies ought to be noticed here: one, where it is said (II.) that the *length* of an open-seat should not be more than two feet nine inches, for *length* read *height;* another in (V.), where for *unslate* read *imitate;* and a third in (VI.) asserting that the pitch of the roof "should be not *greater* [read *less*] than an equilateral triangle."

Also two new editions of the *Hints to Workmen engaged in Churches:* one suitable to those which are in course of building, the other to restorations. They are intended for suspension in some conspicuous part of the building; price 1d., or 5s. per hundred.

A CORRESPONDENT has called our attention to a passage in *Walker's Sufferings of the Clergy,* where it is stated, that the Parliamentary visitors at Cambridge broke down a magnificent Rood-screen in S. Mary's, though it contained no images. This shews that in 1641 there could have been no gallery occupying the place now filled by the Throne.

MR. FRENCH, of Bolton-le-Moors, whose Altar-cloths we have had occasion to mention, has favoured us with two specimens of a *pede cloth* or Altar carpet, of his manufacture. It is an imitation of encaustic tiles, and certainly has a handsome appearance; though our irreconcileable hatred to all imitations renders it impossible that we can recommend it. We hope that Mr. French will (as with his ingenuity he easily might) direct his attention to the manufacture of an Altar carpet which shall not be liable to the above-mentioned objection. We cannot at all recommend the last pattern for a Corporal: a Pelican would be very suitable.

WE have received a remonstrance from a valued friend against our indiscriminate censure of all cement. " It appears to me," he says, " that your Society is rash in condemning the use of Parker's cement. In justification of this remark, let me state that this county has no stone in it but what is as crumbling as clunch in the south: red sandstone only, (which, unless selected in the pit, melts like brown sugar,) and pebbles. Now twenty years ago I saw a fine specimen of Perpendicular moulding in the north door of the church of —— executed in this material, which had then stood several years, and still stands as sharp as ever, though exposed to the northern blasts."

Now we never objected to Parker's or any other cement on the score of durability, though we may have our doubts on this point; and certainly do not consider a trial of only twenty or thirty years sufficient. We protested, and must still protest, against it on much higher grounds: namely, that the offering to GOD materials which profess to be better than they are, and would fain be taken for that which they are not, involves a kind of hypocrisy from which we cannot but shrink. Cordially as we detest brick —and we do abhor it, whether black, red, or white, *most* cordially—we would rather build a church doorway of it, because it professes to be what it is, than of Parker's cement, because it professes to be what it is not.

Let us fall back, as usual, on precedent. We may boldly challenge any one to produce an instance where our ancestors, having employed an inferior material, strove to give it the appearance of a superior one. But of instances of their employing perishable stones there are many. There is something to us exceedingly beautiful in the faith which could rear, of such materials, such churches as S. Michael at Coventry, and S. Werburga and S. John, Chester. The architects of those stupendous edifices knew well the perishable nature of the stone in which they wrought; but knowing also that the Church for whose service they reared them was imperishable and indestructible, they cheerfully left the guardianship and restoration of the details, as they should crumble away, to future generations of her sons. They never thought that the days would come when a distinction would be drawn between necessary and ornamental repairs; but rather rejoiced in the anticipation that their children would one day become fellow-workers in the Temple which themselves had reared. In blaming them for using such materials, we do but confess ourselves to fall wofully short, not only of what they performed themselves, but also of what they expected us to perform.

We wish to solicit information from our readers on two points connected with ecclesiastical arrangements. From the Society's *Church Schemes* we find that in three churches, namely, SOUTHWICK in Sussex, BURSTOW in Surrey, and BLETCHINGLEY in the same county, there is a singular, and we believe unnoticed kind of recess. It resembles two Piscinæ, one placed above the other; and between the two is an embattled projection or transom. In both Southwick and Burstow there are two of these niches, one on each side the western face of the Chancel-arch: in Bletchingley there is one (much finer than in the other cases) which stands at the north-eastern extremity of the Nave, close to the Transept-arch. At Southwick there is an orifice both above and below: in the other instances there is none.—The other point relates to the tall narrow niche which in some churches appears on the north side of the Altar, and which may perhaps have served for the occasional reception of a pastoral staff or processional cross.

A CORRESPONDENT informs us that the Eagle in Peterborough Cathedral, though it continues to stand in the Choir, is disused.

We have great pleasure in learning that many considerable improvements in the details and arrangements of CHRIST CHURCH, WORTHING, have taken place since our animadversions upon the design as represented in the lithographed view.

We are informed that the church of *Ladbrook*, Warwickshire, (better known to our readers as Tadbrook, S. Antholin's,) is under repair.

We wish that those who have the preparations for the vignettes of such volumes as S. Antholin's, were more careful in their architectural details. In a little tale, *Waltham-upon-sea*, which has just reached us, (and which in all other respects appears an useful work,) the frontispiece represents Waltham church *as restored*. As restored! if such be restorations it were a difficult thing to choose between them and ruin. No Chancel, a Perpendicular arrangement with Decorated details, a Clerestory of no style whatever, and a Porch at the westernmost part of the S. Aisle, are the principal features.

Most of our readers have heard of the late accident at ANDOVER, where the two walls of a church lately building successively fell in during the progress of the works: and probably also of that case in the Isle of Wight of a church falling down so soon as the roof was put on. A mishap similar to the former happened not long ago at Northampton: and in the last week we have heard of another instance of the solidity of modern church-building. S. James, ENFIELD HIGHWAY, which has been consecrated six or eight

years, is already condemned as 'dangerous,' since the heavy tied roof is threatening to fall in from the rotting of the ends of the beams, which are said to have been laid in the most disgraceful manner upon the mere damp brickwork. Comment were needless.

WE are very sorry to be compelled to state yet more openly than in our former notice, our disapprobation of Mr. A. S. BRAITHWAITE's method of wood-stamping. We had heard that the patentee had represented that this ‑ invention was highly approved of by the CAMBRIDGE CAMDEN SOCIETY : and in the course of last week we were consulted by a Clergyman in treaty with Mr. Braithwaite, as to whether the method, which was said to be under our consideration, had yet obtained our sanction. We strongly suspect too, that this process is not so *cheap* as it professes to be.

A CORRESPONDENT informs us, that in a well-known watering-place an ' episcopal chapel' is now put up for sale, to be employed *for any purpose.*

OUR attention has also been called to the miserable effect produced in ROCHESTER Cathedral, by festooning a large red curtain round the Arch between the Lantern and Choir. This curtain it appears is let down in cold weather. A similar plan, we believe, is or lately was adopted in RIPON Cathedral.

WE mentioned, in our ninth number, the subscription which has been set on foot for the restoration of the church of S. BOTOLPH's, in this town. We are sorry to be forced to speak in terms of censure of any such design, and we know there are particular difficulties pressing on this parish ; but we are bound to point out the mischievous and dissenting tendency, to say nothing of the unfairness, of raising a general subscription *in order that* ‑ *the parish may not be burdened by a church-rate.* We hope that the Rector and Churchwardens will not sanction such a precedent : and they may be well assured that all sound churchmen will feel it their duty not to give any thing towards the work *till a church-rate has been passed.*

WE are glad to hear that a wooden Eagle has been carved in Bristol for the new church at HANHAM.

" A READER of the *Ecclesiologist*" is anxious to know what has become of the old Font of Wensley, Yorkshire. He states that a year or two ago it was carelessly thrown aside in the church as lumber, having been at some period removed to make room for a new marble Font not unlike a wine-cooler.

We have received the following information from a correspondent in reference to a letter in our last number: " In the church of S. James's, BERMONDSEY, there are two water-closets, one on each side of, and adjoining the Altar ; the one being for the use of the vestry, and the other for the congregation."

A CORRESPONDENT wishes to know " what authority there is for a rose window in the west front of a Cathedral." We believe that strictly speaking in English Cathedrals there is none : for the circular gable windows in the west front of Peterborough must evidently be regarded only as supplementary ornaments. We can at present recal to mind no instance except the Early-English west front of Byland Abbey, Yorkshire, which contained perhaps the most magnificent circular window in England. The question is asked in reference to a proposed plan of substituting a rose window, filled with stained glass, for the present wooden-mullioned window in the west front of Chichester Cathedral. In this case, as the window would not be a gable light, its size must of course be considerable, and larger than that of the rose window at the east end; which we believe would be contrary to the general principle of ecclesiastical composition. Without presuming to pronounce confidently on a question of such importance, we

should say that the insertion of good tracery in the present window, (if its mouldings and details be sufficiently good,) would be the safest and best plan to adopt, because this would probably be carrying out the original design of the architect, upon which it would be dangerous to attempt *to* improve by so extensive an alteration as the substitution of a rose window·

WE have been favoured with some specimens of a new kind of tiling for church roofs. The patentee, Mr. James Reed, of Bishop Stortford, Herts., has represented to us that the advantages of this method are manifold and important, the ware being peculiarly light, durable, and perfectly impervious to water. The material is *compressed clay*, of a whitish colour, and the shape (which however can be varied to almost any extent), resembles an escallop shell, giving the appearance of scales when placed on a roof. The dimensions are 11 inches wide by 14 long. The novelty of the invention consists in the scales fitting upon each other by a rim and socket, so that they cannot be disarranged by high winds, nor penetrated by the heaviest snow or rain. Specimens are deposited at the Society's Room; and we believe the Nave of S. Botolph's church is to be covered with them.

WE have to apologize for several typographical errors in the report for 1842. They occurred in consequence of our extreme anxiety that the Members of the Society should receive it before leaving the University, and the consequent speed with which it was 'got out.' One sentence in particular we wish to correct, in which several words were omitted, and the sense thereby much obscured. We print it entire, distinguishing by small capitals the words that ought to have been inserted :—

"The last thing to which your Committee would advert, is the presentation of a memorial to the Society for Building and Repairing Churches and Chapels, suggesting a modification of certain of its instructions. When this memorial had been forwarded, the co-operation of the Oxford, and other sister Societies, by the presentation of similar memorials, WAS SOLICITED BY US: THEY ACTED ON THIS SUGGESTION; and the example that we set was followed by all."

As the present number completes the first volume of the *Ecclesiologist*, an index and title-page (forwarded gratis to subscribers) may be procured by non-subscribers at the Publishers. From the quantity of matter on hand, it has been deemed advisable to publish this month a double number. The first volume will therefore contain thirteen sheets; but the last sheet will be considered as equivalent to the first number of the new series.

THE *Ecclesiologist* will continue to be sent to the former subscribers, unless countermanded. As a considerable amount of subscription for the first year remains unpaid, we beg to remind all our readers that the subscriptions for each year are *to be paid in advance.*

THE subscriptions to the *Ecclesiologist* for the second year will become due on the receipt of this number, and should be transmitted immediately, as before, to the Publisher, Mr. Stevenson.

A CIRCULAR on the subject of S. SEPULCHRE'S is also forwarded, in the hope that the members of the Society will exert themselves to the utmost in forwarding a restoration of so much general interest.

Price, with index, preface, and title-page, to subscribers 8d.; to non-subscribers 10d. The whole work has been bound in cloth, price 5s. 6d.

END OF VOL. I.

PRINTED BY METCALFE AND PALMER, CAMBRIDGE.